A

VINDICATION

OF THE

RIGHTS

OF

WHORES

Edited by
Gail Pheterson

Preface by
Margo St. James

For Jennifer who helped
get the ball Rolling!
Love
Margo
Margo
Maxt [illegible]
29/9/89

THE SEAL PRESS

Cover design by Clare Conrad

Library of Congress Cataloging-in-Publication Data
A Vindication of the rights of whores: the international movement for
 prostitutes' rights / Gail Pheterson, editor; preface by Margo St.
 James.
 p. cm.
 ISBN 0-931188-73-3
 1. Prostitution—Congresses. 2. Prostitutes—Legal status, laws,
 etc.—Congresses. I. Pheterson, Gail, 1948- . II. Title:
 Prostitutes' rights.
 HQ103.V56 1989
 306.7′4—dc19 88-33060
 CIP

Seal Press
P.O. Box 13
Seattle, WA 98111

Printed in the United States of America

First printing, May 1989
10 9 8 7 6 5 4 3 2 1

Contents

A
Vindication
of the
Rights
of
Whores

Acknowledgments

This book draws on the energy and expertise of a large and impassioned political network. Throughout the editing process, I have been moved by the courage and commitment of the contributors. I regret not being able to talk directly with those whose languages I do not know and sincerely thank the translators who made communication possible. I also thank many members of the International Committee for Prostitutes' Rights who supported this anthology in one way or another, including especially Annemiek Onstenk, Grisélidis Réal, Jan Visser, Lin Lap, Marjan Sax and Tang Unchana Suwannanond.

Margo St. James began this *Vindication* in 1973 when she became the first contemporary prostitute to speak out publicly for the rights of sex workers. Her disrespect for hypocrisy, serious good humor and political endurance are a constant inspiration to me.

Paola Tabet has been an invaluable writing support, intellectual partner and, yes, linguistic acrobat throughout this project. Spain, Brazil, Yugoslavia and Niger might not have been in the book without her.

Barbara Wilson, my editor at Seal Press, showed her commitment to prostitutes' rights by attending the Whores' Congress in Brussels and by supporting this project despite its cost in time and money. I appreciate the intelligence and integrity of her feedback and her genuine openness to a "new political line."

This anthology was dependent on a great deal of correspondence. I kiss all those who sent back their contributions promptly and forgive all those who relied on repeated telephone calls and letters from me. Also, I appreciate those who graciously shared their free access to international telephone lines and postal services. Such is the sustenance of a grass roots movement.

Gail Pheterson

Contributors

Alex, England, 49, now lives in Southampton and works as a free-lance writer. She was a street prostitute on the upper end of the market in London for ten years in her teens and twenties.

Annemiek Onstenk, Netherlands, 30, lesbian feminist in left-wing politics, works at the European Parliament (GRAEL/Rainbow Group) in Brussels. She is the International Committee for Prostitutes' Rights (ICPR) liaison to the European Parliament.

Annie Sprinkle (real name: Ellen Steinberg), U.S.A., 33, living in Manhattan, New York. "Presently I am working within the sex industry to introduce New Age sex concepts and philosophies. I am known as the 'Shirley McLainne of Porn.' I work free-lance and am a member of P.O.N.Y. (Prostitutes Organized in New York)."

Ans van der Drift, Netherlands, 58, worked for twenty-nine years as a window prostitute in Rotterdam, Amsterdam and Utrecht. She retired three years ago and co-organized *De Rode Draad* (The Red Thread), a prostitutes' rights organization in the Netherlands. As a sex worker, she "specialized in everything except anal sex, and felt great dedication, initiative and business sense together with sociability, discipline and humor."

Bianca, Curacao/Surinam/Netherlands, 37, immigrated to the Netherlands in 1966. After a few years in nursing school, she began working as a prostitute because she "wanted to be free and to decide her own things, her own hours, her own finances." She worked in different Dutch cities on the street and behind windows and then bought a house and organized a brothel. She is a member of *De Rode Draad*. Presently experiencing discrimination in the Netherlands as a black woman, she is considering moving to Surinam.

Brigitte Pavkovic, Austria, 42, has worked in the sex industry in different parts of Austria for the past six years.

Carla Corso, Italy, 40, born in Verona, has lived and worked as a prostitute (on the street and in cars) in Pordenone for fourteen years.

Together with Pia Covre, she is founder of the *Comitato Per I Diritti Civili Delle Prostitute* (Italian Committee for the Civil Rights of Prostitutes).

Christine, Switzerland, born in 1947, lives and works in Bern. She was a street prostitute at the time of the congress but has since gone on to do other work. She continues to be an active member of the prostitutes' rights group, Zenia Society.

Danny Cockerline, Canada, 27, lives in Toronto where he works as a free-lance prostitute soliciting through print media. He is an active member of the Canadian Organization for the Rights of Prostitutes (CORP), the Campaign to Decriminalize Prostitution (CDP), and, as coordinator, of the Toronto Prostitutes' Safe Sex Project (TPSP). He is also the ICPR gay prostitutes coordinator.

Dolly De Luca, Italy, 35, born in Lecce, Italy, currently lives in Treviso and is an associate of the *Comitato Per I Diritti Civili Delle Prostitute*. "I have been working in many cities of north Italy on the street as a transvestite prostitute."

Dolores French, U.S.A., born in 1950, has worked as a prostitute since 1978 in the United States and Puerto Rico, for escort services and in brothels and in various other settings. She lives in Atlanta, Georgia, where she was appointed to the Mayor's Task Force on Prostitution (1985-6) and was a consultant on the Center for Disease Control study on prostitution and AIDS (1986). She is president and founder of HIRE, Hooking is Real Employment, and author of *Working: My Life As a Prostitute* (New York: Dutton, 1988).

Don Des Jarlais, U.S.A., 43, social psychologist, epidemiologist, New York State Division of Substance Abuse Services Coordinator for AIDS Research, AIDS consultant to the ICPR.

Doris Stoeri, Switzerland, lives in Geneva and works as a social worker for ASPASIE, an organization which responds to various needs of street prostitutes. She also works for an association that reintegrates former drug addicts in society.

Esther Eillam, born in 1939 in Palestine, lives in Tel-Aviv, Israel. Her parents are Sephardic Jews from Greece. She is one of the founders of the Israeli feminist movement (1972), the Tel-Aviv Rape Crisis Center (1977), Women Against Violence Against Women (1982), the Women's Counseling Center (1986) and the Israeli Women's Network (1984); a member of the Governmental Committee for the Status of Women and participant in many global women's conferences; lecturer, organizer, researcher, writer, and

counselor; teacher of Assertiveness Training and Re-evaluation Counselling.

Eva Rosta, England, 35, is an Hungarian Londoner. "I started in the sex industry at seventeen for economic reasons and still use the industry to make money. I have done a great variety of work from model to dancer to whore. My main career is sex counselor and educator. I have been involved with several PROS groups both in England and abroad and am committed to the international abolition of laws against PROS."

Frau EVA, Austria, born in 1941 in Vienna, has been working as a prostitute for fourteen years. She founded the *Verbandes der Prostituierten Osterreichs* (Association of Austrian Prostitutes) in 1986 and has served as chairwoman of the association and as publisher of the journal *Horizontal* since that time. She represents her prostitute colleagues throughout Austria with government officials and at universities and social work schools. Frau EVA now works as a dominatrix. In the past, she has been a florist, welder, court recorder, car paint sprayer, state medical insurance administrator and store owner. Her two households, including dog, aquarium and flowers, help keep her active and young.

Flori Lille, Germany, 28, lives in Frankfurt and presently works as a telephone operator. Formerly a prostitute in an expensive city center private club, Flori is a member of the prostitute self-help group HWG in Frankfurt.

Gabriela Silva Leite, Brazil, 37, lives in Rio de Janeiro. She studied sociology at the University of Sao Paulo for three years, after which she worked as a street prostitute for about ten years. The first public prostitute in Brazil, she organized the first national congress of prostitutes and is the leader of the Brazilian *Rede de Prostitutas* (Network of Prostitutes).

Gail Pheterson, U.S.A./Netherlands, born in 1948, is co-founder/co-director of the International Committee for Prostitutes' Rights. She has been Associate Professor of Psychology and Women's Studies at the University of Utrecht in the Netherlands and Guest Professor at several universities in West Europe and the United States. As an activist and researcher, she is interested in the psychodynamics of oppression and alliance-building between women.

Gill Gem, England, 41, presently works in alternative medicine. In the past, she worked as a nurse and as a art school model and then, beginning at age twenty-seven, as a prostitute. She worked in hotels and

occasionally on the streets for eleven years and still has four or five clients for "massage and relief." She now owns her own flat in central London, has a "hopefully long-lasting" relationship with a man, and wishes to live in Mallorca, Spain eventually.

Gloria Lockett, U.S.A., born in 1946 in San Francisco, is "a black woman who has worked for eighteen years as a prostitute in different situations from the streets to hotels to bars in cities across the United States. Currently President of the National Task Force on Prostitution, Co-Director of COYOTE, and Project Director of CAL-PEP (California Prostitutes Education Project)."

Grisélidis Réal (work name: Solange), born August 11, 1929 in Lausanne, Switzerland, mother of four children, fluent in German, English and her mother tongue, French. She is a working prostitute in Geneva, founder of the *Centre de Documentation International sur la Prostitution* and member of the ICPR and of the Swiss Association of Writers. She studied at the Art School of Zurich, worked as a model for thirteen years in Geneva, Paris and Munich. She studied piano for ten years, played the flute and violin, and wrote the book *Black is a Color*, a true story about her time in prostitution in Germany. She has been a guest lecturer on prostitution, sexuality and love at the University in Geneva.

Hans-Guenter Meyer-Thomsen, Germany, is a medical doctor from Hamburg. He does research on professional diseases of prostitutes.

Helen Buckingham, England, founded the organization PLAN (Prostitution Laws Are Nonsense) in 1975. She is the "first prostitute in Great Britain to make prostitution a respectable issue to discuss, the first prostitute to come out with a good reputation and the first prostitute in Great Britain to go bankrupt."

Inge, Netherlands, 32, co-founder of *De Rode Draad*, ex-heroin addict, worked for two and a half years in different sectors of the sex industry.

Jean D'Cunha, India, living in Bombay, is a researcher active in the campaign for decriminalization (and against legalization or prohibition) of prostitution in India.

Laurel Meredith Hall, U.S.A., Fellow of the Watson Foundation 1987-88. Project: Evaluation of AIDS prevention and support for people with HIV related problems including AIDS in the Netherlands, Kenya and Sweden. Member of the International Working

Group on Women and AIDS (IWGWAA) and the health education coordinator of the ICPR.

Licia Brussa, Italy, born in Venice in 1956, has lived in Amsterdam for eight years. She is a sociologist and independent researcher who was active in the Italian women's movement. She is now involved in a Dutch national and international project about migration and prostitution and is an advisory board member of the Foundation Against Traffic in Women and a member of the Dutch National Platform Against Traffic in Women.

Lin Lap, Singapore, 43, moved to the Netherlands from Singapore in 1973. She is one of the founding members of the Foundation against Trafficking in Women and the migrant prostitutes coordinator of the ICPR.

Mae, Thailand, 29, is a lesbian activist for prostitutes' rights. She is presently researching the position of migrant Thai women in the Netherlands. She is a member of the Women's Information Center in Bangkok, Thailand.

Maggie, Austria/Germany, 23, now living in Germany, has been a hooker since age fourteen. She has worked in all areas of prostitution and is presently working in a peep show. She is a member of the prostitute self-help group HWG in Frankfurt.

Margo St. James, U.S.A., "ex-prostitute, born September 12, 1937 in Bellingham, Washington; farmer's daughter, married at seventeen, divorced at twenty, one son born July 3, 1955, graduate of Mt. Baker Jr. Sr. High School in the class of '55; from 1960-1980 a marathon runner, jogger and mountain climber; lover of cats, good mystery books; painter of watercolors; Private Investigator in the State of California, licensed in 1974; currently doing construction and decorating work in France."

Margot Alvarez, Netherlands, 28, works behind a window in Amsterdam's red-light district. She is one of the founders of *De Rode Draad*. She has been a consultant in a theater school to work with acting students on playing erotic roles. As a prostitute, she specializes in working with the handicapped.

Marjo Meijer, Netherlands, 36, is a family doctor in Amsterdam and a lesbian activist. She is the health coordinator of the ICPR and a member of *De Roze Draad* (The Pink Thread), a feminist sister organization of *De Rode Draad*.

Maud Marin, France, 43, worked as a prostitute for about seven

years in Paris (Avenue Champs Elysées), London and Brussels. She was the "first prostitute in West Europe" to become a lawyer. After practicing law for four years, in defense of prostitutes, she was expelled from the bar. Presently a writer living in Paris, her first book was a great success: *Le saut de l'ange* (Paris: Fixot, 1987).

Nel van Dijk, Netherlands, 35, is a Member of the European Parliament for *Groen Progressief Akkoord*. She is affiliated with the Green Alternative European Link in the Rainbow (Group in the European Parliament).

Nena, Philippines, 28, has pursued her case against the men who deceived and forced her into migrating to the Netherlands to work in a brothel. As of September, 1988, one man has been sentenced in the Netherlands to three years in prison and the other is being investigated in the Philippines where Nena plans to testify against him. Nena's story was featured in a film by Hillie Molenaar about traffic in women entitled *Cannot Run Away*. She is currently living in the Netherlands.

Norma Jean Almodovar, U.S.A., born 1951, traffic officer of the Los Angeles Police Department from 1972 to 1982, left the police force to work as a call girl. She is presently serving a three year prison sentence at the California Rehabilitation Center, Norco, California, for one count of "pandering." The charge of pandering, in this case offering to get a prostitution date for a "friend" still in the police department, was an entrapment scheme used to get a search warrant. She was arrested in 1983 and her book in progress, *Cop to Call Girl*, was confiscated by the police.

Odile, France/Switzerland, lived most of her working life in Geneva as a prostitute. She founded the *Association A.N.A.I.S.—Solidarité*, an "association for normalization and social action" to defend the interests and rights of prostitutes. Odile ended her life in December, 1986, and was buried in Brittany, France.

Paola Tabet, Italy, 53, lives in Tuscany and Paris and is a feminist researcher in anthropology. She is a professor at the University of Siena in Italy. She has written on the sexual division of labor, reproduction and the social organization of sexuality.

Pauline, Netherlands, 29, is now sculpting, stone carving and working behind a bar. "Eight years ago I worked in a club as a whore for nearly a year. I also worked for a few months in 1986 'cause my feet were hurting too much to stand behind the bar. What a bummer, I now make per night the same money as I made as a whore per half hour!"

Peggie Miller, Canada, 40, worked for many years as a streetwalker. She now works for an escort service in Toronto. She founded the Canadian Organization for the Rights of Prostitutes after being busted on a "bawdy house charge."

Pia Covre, Italy, 40, born in Milan, lives in Pordenone where she has worked as a street prostitute for fifteen years. She is one of the founders of the *Comitato Per I Diritti Civili Delle Prostitute*.

Pieke Biermann, Germany, born in 1950, "ex-whore and moved by/moving in and for the whores' movement," is a free-lance writer and member of HYDRA, West Berlin.

Priscilla Alexander, U.S.A. is Co-Director of COYOTE, Executive Director of the National Task Force on Prostitution (NTFP), Education Coordinator of the California Prositutes' Education Project (CAL-PEP), and a member of the National Board of Directors of the National Organization for Women. She "lives in San Francisco with her lover, Lyndall MacCowan, and her two cats, Meshugenah and Tchotchkele, none of whom see enough of her."

Roberta Tatafiore, Italy, 45, journalist for the women's magazine *Noidonne*, writing about prostitution and pornography, was the *direttore responsabile* of *Lucciola*, the magazine of *Comitato Per I Diritti Civili Delle Prostitute*.

Sai, Thailand, 19, is a go-go dancer and prostitute in a sex tourist area of Thailand. Following the congress she organized other prostitutes in her area together with the Women's Information Center of Bangkok.

Saraswati Sunindyo, Indonesia, 33, is a sociologist now writing a dissertation on prostitution in Central Java.

Sonia, Argentina/France, 34, transvestite, migrated from Argentina to Spain to France in 1981. S/he works as a beautician and sometimes as a prostitute in Paris. Sonia is now a contact person for transvestites in the International Committee for Prostitutes' Rights.

Susanna, Spain, lives with her children and works as an independent street prostitute in Madrid. She joined the international committee in April, 1987, and is trying to build a prostitute organization in Spain.

Syarifah Sabaroedin, Indonesia, 39, is a lesbian feminist who became interested in the subject of prostitution in 1983 when she and others started a feminist organization called "The Good Friend." Also members of this organization, lesbian prostitutes are among her good friends. She is a criminologist working at the university in Jakarta.

Tatiana Cordero, Ecuador, 27, came to the Netherlands in 1985 to study for a master's degree in women and development at the Institute for Social Studies in The Hague. She is presently working on a project with migrant prostitutes called PROJECT EMPOWERMENT.

Terry van der Zijden, Netherlands, 43, studied business administration before changing to the world of prostitution. She worked as a prostitute for fifteen years both in the Netherlands and in Belgium, mostly in clubs but also in private houses and behind the window. For ten years she worked in the double function of sex worker and club owner. Since 1976 she has been active in the women's movement and since 1985 in the prostitutes' rights movement. She is now policy coordinator of *De Rode Draad*, a position subsidized by the Dutch Ministry, Emancipation Affairs.

Truong Thanh-Dam, Vietnam/Netherlands, 39, is a Lecturer at the Institute for Social Studies in The Hague. She left Vietnam in 1968 and, after years in the United States and in France, she moved to the Netherlands in 1976 and became a naturalized Dutch citizen. Her dissertation and forthcoming book is entitled: *Sex, Money and Morality: The Political Economy of Prostitution and Tourism in Southeast Asia*.

Veronica Vera, U.S.A., porn star, is "a writer and a conceptual artist who firmly believes that the decriminalization of prostitution is not only a cornerstone of the feminist movement but necessary for the life and liberation of both women and men." She lives and works in New York City.

Violet (Ineke Mot), Netherlands, 45, worked as a street prostitute in 1972, as a window prostitute from 1973-74 and again from 1985-87. She was the first prostitute in the Netherlands to come out publicly as a whore in 1979. She was alone as an activist from 1979 to 1984 when she joined with other Dutch whores in *De Rode Draad*.

Zippy, Israel, a mother of three daughters, former kibbutznik. She worked in the military aircraft industry and then as a prostitute for some years in Germany and Austria. Presently Zippy is a prostitute in the beach area of Tel-Baruch. She and Esther Eillam have begun contacting government officials to discuss the needs/demands of Israeli prostitutes.

Preface

"What's a nice girl like you...?" was the usual reaction of men to my becoming a feminist as well as to my becoming a prostitute. The difference for me was that I *chose* to be a feminist, but I *decided* to work as a prostitute after being labelled officially by a misogynist judge in San Francisco at age twenty-five. It was 1962. I said in court, "Your Honor, I've never turned a trick in my life!" He responded, "Anyone who knows the language is obviously a professional." My crime? I knew too much to be a nice girl!

My politicization occurred over a three-year period, 1970-73. I was living in Marin County, north of San Francisco, with a carpenter/musician, Roger Somers. I also socialized with the housewives who were participating in consciousness-raising groups. Elsa Gidlow, a lesbian poet, lived next door and used to push feminist literature under my door. The forerunner of COYOTE was WHO: Whores, Housewives, and Others. "Others" meant lesbians but it wasn't being said out loud yet, even in those liberal bohemian circles. The first meeting of WHO was held in 1972 on Alan Watts' houseboat ("The Vallejo") in Sausalito. The name COYOTE came from the author, Tom Robbins, who dubbed me the "COYOTE Trickster" following one of our mushroom-hunting expeditions. Richard Hongisto, a liberal sheriff elected in San Francisco about that time, attended some of Roger's and my parties. A former cop with a degree in sociology, he was recently divorced and a little afraid to let it all hang out in the City since the cops didn't have much love for him; he preferred to party in Marin. I cornered him one night in the hot tub and asked what NOW was doing for the rights of prostitutes since he seemed to have the support of the women's movement and gay rights groups. He answered, "Someone from the victim class has to speak out. That's the only way this issue is going to be heard."

I decided to be that someone, even though I had worked only four years, and wondered about the effect speaking out would have on my life. I received complete support from most of my family: my mother

the housewife-secretary, my sister the gospel singer with eleven children, my sailor brother and my son the salmon fisherman—both with two children and wives. Together with a cadre of friends around the San Francisco Bay Area and across the United States, they convinced me that speaking out was the right thing to do. My father stopped talking to me.

In 1973 I decided to reconnect with the lawyers, bailbondsmen, journalists and cops I knew in the City ten years before and hoped some of the hookers would join me. The PR people responsible for getting the sheriff elected volunteered to help me with COYOTE. I rented a cheap hotel room on the waterfront and started collecting info by hanging around the Hall of Justice. It was easy...the same people were still working in the courts and remembered me as "the kid who got a bum rap." I had gained some notoriety at the time of my trial because I successfully appealed the conviction, but it didn't help me get other gainful employment.

A professor from the University of California gave me some good leads for resources, including an introduction to the treasurer of Glide Church who also handled the Whole Earth Catalog millions. The treasurer got me a personal grant for five thousand dollars. The other good score was the copy machine at the Gas and Electric Company which sat by itself in a small room on the 8th floor. During lunch hours for two years I dressed as a secretary and ran off the material necessary to be a successful rabble-rouser.

Another longtime friend got a job as the jail doctor so I had inside information as well as gossip from the women he examined. Prostitutes were still being quarantined at the time which meant you had to be examined for VD before you could get out of jail. We stopped the practice the following year. Steve the Pig, as he called himself, was a beat cop who gave me the straight scoop from the streets and the cops' locker room. A liberal mayor was elected in 1976, George Moscone, who appointed an out-of-town chief of police, much to the chagrin of the "good ole boy" cops who had run the city for fifty years, successfully keeping minorities and women from being hired on the force. The mayor and a gay supervisor, Harvey Milk, were assassinated on November 27, 1978 by former cop/supervisor Dan White. Following the murders, Moscone's successor, Diane Feinstein, caved in to cop pressure and fired the chief. The cops had felt that "the whores have the chief's ear." He had done much to straighten out the corruption and disorder in the department and he had transferred

many of the abusive vice cops away from hooking. The climate changed and the liberals who had been supportive of decriminalizing prostitution became unwilling to speak publicly about the issue. Even the sheriff backed down and claimed he never attended a Hookers' Ball, although he attended several before 1977. It became clear that outside pressure was necessary for any gain in the movement.

I began to seriously consider organizing internationally. Manipulating the press was very important because through the exposure other women in other cities and countries were inspired to form groups. It seemed that the people necessary to make a good start were a political hooker, a feminist, a friendly journalist and a lawyer.

Jennifer James, a professor of anthropology in Seattle, was very instrumental in getting things going there and nation-wide. She coined the word "decriminalization" and was responsible for NOW making decrim a plank at their 1973 convention. COYOTE published a newsletter, "COYOTE HOWLS" for five years from 1974-79. We reported national and international news on prostitution, first-hand accounts of abuses, feminist theory and research on prostitution and poetry by prostitutes. In order to expose the hypocrisies of the prohibition on prostitution and to make our demands for human rights, medical care, and working conditions palatable for the public, we solicited hip art work from cartoonists Robert Crumb, Trina Robbins and others to spice up our publications. We also compiled reading lists for those who wished to join the struggle and attended the major women's conferences around the country. We ran adds for t-shirts, posters and the Hookers' Ball which was our annual October fundraising event. The Ball became very popular, attracting 20,000 people in 1978 at the Cow Palace, grossing $210,000 (net $60,000), enough to pay five staff for our two offices (one at the waterfront and one uptown). Our mailing list exceeded 60,000 people, about three percent of whom were prostitutes.

Many non-prostitute women were instrumental in keeping the COYOTE offices functioning. Molly Rodriguez was the secretary for five years. Priscilla Alexander joined the office in 1977 and succeeded in getting NOW to form a committee on Prostitutes' Rights in 1982 and to get most women's conferences around the country to concretely address the issue. Priscilla and Gloria Lockett now co-direct the offices of COYOTE, U.C. CAL-PEP (California Prostitutes' Education Project), and the National Task Force on Prostitution, concentrating on AIDS prevention and education and on human rights of

prostitutes. A new development which could indicate a warming trend is that candidates for public offices now come to COYOTE for information and are willing, if elected, to carry bills to the legislature for decrim. And the best news is that, after I left the country in '85, the government and private foundations have given grants to COYOTE!

It became increasingly clear to me following the advent of the anti-porn movement in the States that an international movement was timely and essential. I attended the 1976 International Tribunal on Crimes Against Women in Brussels and the United Nations Decade of Women Conferences in 1975 (Mexico City) and in 1980 (Copenhagen). But it wasn't until I met Gail Pheterson, who had been working in the Netherlands on bridging divisions between women, that things started coming together internationally. We organized mostly by combining our networks, especially her feminist contacts and my hooker contacts in Europe. Also, Gail spent the year of '84 in California forming alliances between pros, ex-pros and non-pros out of which grew the Bad Girl Rap Groups hosted by COYOTE. The Women's Forum on Prostitutes' Rights and COYOTE Convention were designed by Gail in '84 to coincide with the Democratic Convention held in San Francisco. A Bill of Rights was born at the COYOTE Convention which became the underpinning for the First World Whores' Congress in Amsterdam in 1985 and the Second World Whores' Congress in Brussels in 1986.

The conservative swing in the States generally and in the women's movement in particular prompted me to move to Europe in '85 so that I could put more energy into the International Committee. Although those wanting to abolish prostitution are more active than ever, there are politicians and women's groups willing to stand up for prostitutes' rights in many countries. I enter a plea of innocence for all those incarcerated for prostitution and cheer on all those who have the courage to speak out on their own behalf. Hopefully this book will generate the kind of thinking and awareness and activism necessary to right the wrongs committed against whores for centuries.

Margo St. James
Montpeyroux, France
August, 1988

PART ONE
NOT REPEATING HISTORY

NOT REPEATING HISTORY
Gail Pheterson

"It is justice, not charity, that is wanting in the world!"
Mary Wollstonecraft, 1792
A Vindication of the Rights of Woman

This anthology is a chronicle of the international movement for prostitutes' rights. The book's starting point was the Second World Whores' Congress held at the European Parliament in Brussels in October of 1986 which I, as co-director with Margo St. James of the International Committee for Prostitutes' Rights (ICPR), helped organize. For those present the Whores' Congress felt like a milestone. It is almost unprecedented for prostitutes to speak on their own behalf and on behalf of other oppressed people in a large well-publicized forum. It is also almost unprecedented for non-prostitute women to work as equals with prostitute women in shared struggle. At the congress as well as in the process of making this book, women (and some prostitute men) worked together as organizers, writers and researchers. Prostitutes are the major speakers and sources of information; additional contributions come from feminist activists and scholars working closely with prostitutes.

There are no models for a prostitution politics from the perspective of prostitutes. At a presentation in New York City by U.S. delegates to the Second Whores' Congress, one of our finest feminist historians, Judith Walkowitz, said, "You are not repeating history!" From her research and the research of other scholars, we know that the history we are not repeating goes back hundreds of years. Be it the doctors and politicians who fought for state regulation of prostitution or the feminists and religious crusaders who fought for the abolition of prostitution, activists have historically worked to protect, supervise, reform and/or condemn those who sell sex. Never have prostitutes been legitimized as spokespersons or self-determining agents, not by those who defend them against male abuse and not by those who

depend upon them for sexual service. It is a radical political stance to
assume prostitute legitimacy.

The whore label is attached to anyone who works or has worked in
the sex industry as a prostitute, pornography model, strip-tease dan-
cer, masseuse, sexual surrogate or other provider of sexual service or
entertainment. The whore as prostitute or sex worker is the prototype
of the stigmatized woman or feminized man. But not only prostitutes
are labelled whores. Any woman may be designated "whore" within a
particular cultural setting, especially if she is a migrant, target of racist
discrimination, independent worker or victim of abuse. Rather than
disassociate from the whore label, contributors to the book identify
with all those branded persons and demand rights as whores.

This introduction sketches the history of prostitute self-
organization and the mechanisms of repression among prostitute ex-
ploiters and saviors since the late 19th century. It then elaborates the
specific consciousness-raising and alliance-building processes among
women that led to the founding of the International Committee for
Prostitutes' Rights (ICPR) and the organizing of the Second World
Whores' Congress. Next the book turns to a summary of the First
Whores' Congress which was held in Amsterdam in 1985. A section on
the Second Congress follows which is mainly transcripts of sessions on
human rights, health and feminism; the health session is supple-
mented with updated information on AIDS. The last two parts of the
book include material from countries not well-represented at the con-
gresses: One part focuses on the lives of migrant women in West
Europe and in Africa and one part focuses on outreach and political
developments in the international movement for prostitutes' rights.

PROSTITUTE SELF-ORGANIZATION

Margo St. James was the first contemporary prostitute in the United
States to speak out publicly for the rights of sex workers. In 1973 she
founded a prostitutes' rights organization in San Francisco named
COYOTE. She chose the name COYOTE (originally used by Tom
Robbins) to symbolize the animal which is forced by persecuting
ranchers to migrate and which, despite a promiscuous reputation,
mates for life. Also an acronym, COYOTE howls at society to "Call Off
Your Old Tired Ethics." St. James built an organization of sex workers,
artists, journalists, lawyers, researchers, social workers and politicians.
She raised funds for the movement with extravagant Hookers'
Masquerade Balls which drew up to 20,000 fun-loving, justice-seeking

supporters. COYOTE's purpose was to raise national consciousness about state and police abuse of prostitutes and to effect changes in laws and attitudes. St. James succeeded in 1974, for example, in a campaign to eradicate the quarantine of prostitutes forced to wait in San Francisco jails for the results of involuntary gonorrhea tests. In the late 1970s and 80s, organizations similar to COYOTE were formed in other U.S. cities, many inspired by a solitary prostitute activist brave enough to speak publicly. Organizations included New York's PONY, Massachusett's PUMA, Hawaii's DOLPHIN, Detroit's CUPIDS, Michigan's PEP, Florida's COYOTE, Kansas City's KITTY, Los Angeles' CAT, New Orleans' PASSION, Sacramento's COYOTE, San Diego's OCELOT, Seattle's ASP and others. Currently the most active sister organization to COYOTE is HIRE (Hooking Is Real Employment) which was founded by prostitute Dolores French in Atlanta, Georgia. In 1979, Margo St. James formed a National Task Force on Prostitution (NTFP) together with Priscilla Alexander, a lesbian feminist, in an effort to create a network of U.S. prostitute advocacy groups.

Beginning in the mid-1970s, prostitutes in other parts of the world began to organize as well. In 1974, Parisian prostitutes held a demonstration in Montparnasse as a revolt against police and court harassment. In 1975, French prostitutes in Lyon occupied a church. A number of women had been murdered in Lyon and the police were neither solving the murders nor offering adequate protection. In fact, the police added to the prostitutes' problems; fines and imprisonment had increased and the chief of police was implicated in the exploitation of prostitutes. Efforts to protest through government ministers were ineffective so the women decided to stage a dramatic strike in the sanctuary and moral center of the community, the church. For two months, the women took advantage of press interest to hold a massive educational campaign on prostitution. Public support for the French Collective of Prostitutes, as they called themselves, was strong. Some feminists rallied around their cause both in France and elsewhere.

Grisélidis Réal, a Swiss prostitute from Geneva, joined the French women in their struggle and, upon return to Switzerland, began to compile material on prostitution from newspapers and other media. Little by little, she created an International Prostitution Documentation Center in her Geneva studio and began giving numerous interviews to the media.

In 1975, some months after the Lyon manifestation, Margo

St. James met Grisélidis Réal in Paris at a meeting sponsored by UNESCO of the International Federation of Abolitionists (IFA, an organization devoted to eradicating prostitution). Neither of the prostitute activists had been formally invited to the meeting, but they were allowed to speak. A feminist lawyer with more legitimacy in the Federation than the prostitutes arranged entrance for St. James and Réal. During that visit, St. James and another COYOTE prostitute met with Sonia, a French prostitute, and Simone de Beauvoir to discuss the founding of an international prostitutes' rights organization. It didn't happen, not then.

From 1975 to 1985, organizations of prostitutes emerged in a number of countries. In England, Helen Buckingham came out as a prostitute at a press conference in 1975 and founded the organization PLAN (Prostitution Laws Are Nonsense). Helen Buckingham is recognized as the first prostitute in Great Britain to make prostitution a respectable issue for discussion. A second organization called PROS was started in the same year by prostitutes, social workers and probation workers. They set up a drop-in center for support groups and legal advice. Also in 1975, the English Collective of Prostitutes (ECP) was formed within the Wages for Housework Campaign. The ECP did not identify its members as prostitutes for fear of police harassment but it supported prostitutes' rights with actions and speeches against state abuse. The collective later developed chapters in Canada, Trinidad, Tobago and the United States.

In West Germany, Berlin's HYDRA was the first prostitutes' rights organization, founded in 1980, followed by HWG[1] in Frankfurt and other organizations in Stuttgart, Hamburg (*Solidaritaet Hamburger Huren*—Solidarity of Hamburg Whores), Munich (*Messalina*), Nuremberg (*Kassandra*), Cologne (*Lysistrata*), and Bremen (*Nitribitt*). Presently in 1988, new organizations are forming month by month and national meetings are being held regularly. Feminist nonprostitutes work closely together with prostitutes in most of the groups.

In Italy, prostitutes Pia Covre and Carla Corso founded the *Comitato Per I Diritti Civili Delle Prostitute* (Committee for the Civil Rights of Prostitutes) in 1982 during a protest against violence committed by U.S. soldiers against Italian prostitutes. They sent a letter to the military commander demanding measures to safeguard Italian prostitute citizens and accusing the soldiers of acting against the dignity of the American forces. The letter threw them in the public

limelight. They began to mobilize for recognition of prostitute rights under the Italian constitution and for changes in the laws that marginalize prostitutes.

Also in 1982, social workers, prostitutes, lawyers and feminists in Geneva, Switzerland, formed the prostitutes' rights organization ASPASIE several months after a conference that had been inspired by research and fictional writings about prostitution. About a year later in Geneva, Odile, a French prostitute living in Switzerland, founded the organization ANAIS for prostitutes only. Other associations followed in Zurich and Bern.

In 1983, prostitute Peggy Miller founded CORP (Canadian Organization for the Rights of Prostitutes) in Toronto after she was arrested on a "bawdy house charge." In Australia, ex-prostitute Roberta Perkins and university student Kerrie Carrington founded the Australian Prostitutes' Collective with the main goal of decriminalizing prostitution. In Austria, Frau EVA founded the Austrian Association of Prostitutes in order to participate in discussion of prostitution policies with public authorities. In Sweden, prostitutes founded Group O.

In the Netherlands in 1984, ex-prostitutes Inge, Ans van der Drift, Margot Alvarez and Joke founded *De Rode Draad* (The Red Thread), a prostitutes' organization; at the same time, Martine Groen and I founded *De Roze Draad* (The Pink Thread), a sister organization for all women. The Red Thread in Dutch is an expression meaning the "bottom line" or "central issue."

In July, 1987 the first National Conference of Prostitutes was held in Brazil. Prostitute Gabriela Silva Leite announced the formation of a National Association of Prostitutes with its main headquarters in Rio de Janeiro and regional offices throughout the country. Goals include legal reform, action against violence against prostitutes, health care and literacy programs.

Numerous attempts to organize have been blocked by violence or social control. In Ireland, for example, a prostitute who tried to organize her colleagues was killed; fire was set to her house and she was burned to death.[2] In Thailand a few women tried to organize a kind of union called the Thai Night Guard, but they failed because of family pressure, police harassment and threats from their managers. In Ecuador, brothel managers purposely rotate prostitutes each week to prevent them from grouping together and expressing their grievances about ill treatment and bad working conditions.

This account is not complete; undoubtedly, there are groups and

initiatives unknown to the ICPR. Some organizations of the 1970s disbanded in the 80s and many new organizations formed. In addition, more and more feminist organizations are becoming committed to prostitute self-representation.

REPRESSION OF PROSTITUTES
Institutional Exploitation
The history of prostitute self-organization has gained some public recognition only in the last fifteen years. Organized prostitution politics on national and international levels has a long history, however, among government, health and religious authorities. Governments have debated the advantages and disadvantages to the state of regulating, prohibiting or tolerating prostitution for centuries. Most contemporary societies combine inconsistent approaches to prostitution which both recognize the sex industry, often as a significant source of national revenue, and at the same time punish prostitutes for advertising or soliciting or earning money from sexual transactions. In many countries, such as the United States, Canada, Thailand, England, France and Queensland in Australia, everything necessary to work as a prostitute is illegal although it is not illegal to BE a prostitute. Such prohibition systems are hypocritical and are therefore invariably unenforceable and corrupt. They systematically exploit prostitutes and make it extremely difficult for them to organize either for political rights or for occupational safety. For example, in prohibitionist United States communication between any persons with intent to commit prostitution is a crime called "conspiracy" which may result in heavy fines and long prison sentences. Prostitutes explain the law as an institutionalized attempt to isolate and silence whores. The corrupt cop, they say, wants to hide his bribes and rapes of prostitutes and continue using them as informants, the exploitative boss wants to keep prostitutes from revolting against bad working conditions, and the customer wants to prevent prostitutes from revealing his sexual dependence, perversion or impotence.

Some governments, such as those of West Germany, Austria, Switzerland and Ecuador, are more committed to regulating than prohibiting prostitution. Rather than place prostitution under business codes, those governments place the sex industry under police-controlled state regulations. The main obstacle to self-organization under a regulationist system is social control and stigmatization of prostitutes through registration and surveillance. Although prostitu-

tion is legal in a regulation system in certain places under specific conditions, it is illegal to sell sex if one does not follow state guidelines and it is restrictive to one's rights and freedoms if one does. In Ecuador, prostitutes are allowed to work legally only in supervised brothels but the majority work on the street. Streetwalkers say that the police arrest women every night, extort money from them and rape them. When women protest, they are put in jail. In Switzerland, prostitutes wishing to leave sex work are supposed to officially de-register and wait three years for a "letter of good conduct" before entering other sorts of employment. If caught selling sex before the probation is over, they must again begin proving their goodness for three years. In West Germany and Austria, forced medical checks deny registered prostitutes privacy and choice of doctor. Those compulsory tests not only violate prostitutes' rights to medical confidentiality but also give customers the illusion of health safety. Prostitutes in West Germany, for instance, say that customers resist condoms because they rely on the state to assure prostitute health; of course, in reality examinations detect rather than prevent disease.

Prostitutes working in a regulation system are treated like contagious criminals when they defy the many rules governing their lives. Often they are viewed as worse than non-sexual criminals because they offend moral as well as legal codes. Prostitutes are put in separate detention centers in Ecuador so as not to corrupt or contaminate other women; significantly, their cell mates are political prisoners. Likewise, before the late 1970s in Seattle, Washington, U.S.A., prostitutes had to wait in jail for a court appearance until "Ladies' Day" on Thursdays so that they wouldn't offend people dealing with other charges in court.

Despite certain regulations and prohibitions of prostitution, some governments operate basically within a framework of toleration. In the Netherlands, for example, prostitute businesses are illegal but they are widely tolerated. Prostitutes are not persecuted but they are also not granted worker rights because prostitution is not recognized as employment. They have no right to demand good working conditions from their employers nor to demand the same social benefits as other workers. Nonetheless, their income is taxed. Self-organization occurred later in the Netherlands than in several other Western countries because the situation was not "bad enough" to motivate public protest among prostitutes, especially at the risk of public shame. However, when Dutch prostitutes met their colleagues from more repres-

sive countries, they realized that toleration, like prohibition and regulation, works to isolate and silence whores. The Dutch government is now in the process of eliminating the official prohibition of prostitution businesses which has existed since the beginning of the century. The opportunity finally exists to respond to the needs and rights of prostitutes. Still, decriminalization might be used by municipalities to create regulations which further governmental control, especially of migrant prostitutes.

Like prohibition and regulation, toleration is always discriminatory. Euphemisms for prostitution are a typical cover for toleration of those levels of the sex industry that benefit the state and its dominant classes. In Thailand, for example, prohibitions control and punish the sex worker but leave the "entertainment managers" untouched. Likewise in the United States, "massage" and "escort" businesses are free to operate; if one of the employees is caught negotiating sexual commerce then she is arrested and her employer goes free.

Abolitionism: Nineteenth Century to the Present

While governments throughout the last hundred years exploited prostitutes by regulating, prohibiting, and/or tolerating their commerce, some activists rallied for prostitutes' rights. Josephine Butler, a 19th century English feminist and moral reformer, is the person most associated with the crusade against state control and mistreatment of prostitutes. As founder of the Federation for the Abolition of Government Regulation of Prostitution, Butler inspired thousands of middle-class women, radical working men and nonconformists to campaign for the human rights and civil liberties of prostitutes.[3] Her Federation gained a significant following throughout Europe and in international organizations which later became influential in 20th century world politics. Butler's movement was sparked by the Contagious Diseases Acts passed in England in 1864, 1866 and 1869. Those acts imposed police-enforced vaginal examinations and registration on working-class women suspected of being prostitutes. Referring to the examinations as a "sacrifice of female liberties," "instrumental rape," and "espionage of enslaved wombs," middle-class women protested the class and sex discrimination of the Acts in 1869 with a "Ladies Manifesto." At the time, it was a radical political move for women to speak out on any issue, let alone issues of sexual, medical and police control. Giving full credit to their initiative and courage, it is nonethe-

less important to note that prostitute women were not invited to participate in the movement created in their behalf.

After the Contagious Diseases Acts were suspended in 1883, and totally repealed in 1886, Josephine Butler and her circle turned their attention to the "traffic in women" (from England to Belgium, for instance) and to the "entrapment of children" into prostitution (in London). Research indicates that most migrants in prostitution were adult women prostitutes who travelled of their own accord in hopes of better working conditions (which they did not find), but sensationalist journalism portrayed a vastly distorted picture of widespread female slavery. That picture supported a growing social purity crusade against prostitution per se instead of against government regulation of prostitution. Although Josephine Butler and like-minded feminists denounced male sexual license and idealized female chastity, they favored reform through education and not through legislative control. In 1897, Butler warned her political associates to ". . . beware of purity workers (who are). . . ready to accept and endorse any amount of coercive and degrading treatment of their fellow creatures in the fatuous belief that you can oblige human beings to be moral by force" (Walkowitz, 1980: p.252). Unfortunately, many feminists had already joined the purity crusade and would continue to do so.

In 1885, the feminist campaign against child abuse and trafficking backfired with the passage of the Criminal Law Amendment Act. The Act granted police greater control over poor working-class women and children, something Josephine Butler and her feminist circle had always opposed. The Act also outlawed "indecent acts" between consenting men which became the basis of legal prosecution of male homosexuals in Britain until 1967. Like other repressive social purity measures, the anti-homosexual clause was accepted by feminist reformers although they had not proposed it. The reformers lost more and more power to the purists until the abolitionist movement strayed entirely from its original intent. Preservation of female liberty had been twisted into a drive for male chastity, male protection and control of women, and state restriction of working women's social and sexual behavior. Josephine Butler and other leading spokeswomen resigned from the movement they had inspired when its repressive nature became apparent at the end of the 19th century. An uneasy alliance between feminists and social purists persisted, however, into the 20th century with the crusade against "white slavery." Once again

attention focused on a sensationalized denouncement of criminal men and rescue of "fallen women" and "wayward girls" rather than on official laws and practices which discriminated against prostitutes. As Sylvia Pankhurst remarked in 1912, "It is a strange thing that the latest Criminal Amendment Act, which was passed ostensibly to protect women, is being used almost exclusively to punish women" (Ibid: p. 256).

The movement founded by Josephine Butler to abolish state control of women dissolved into a social purity crusade to abolish prostitution. An International Federation of Abolitionists exists to this day as a significant ideological force in many world organizations (note the change in name from "Abolition of Government Regulation of Prostitution" to "Federation of Abolitionists"). The shift of attention at the end of the 19th century to migrant and foreign women forecast a 20th century Western preoccupation with the condition of women and girls in developing nations and a denial of public voice to prostitutes at home. Although activists in developing nations are likely to understand the reality of prostitution as the best or only work alternative for many women, they have absorbed much of the Western abolitionist language. That language blurs distinctions between women's economic decisions (given their perceived possibilities at the time) and institutional or individual male abuse of women. Like social purists a hundred years ago, abolitionists today condemn male vice and advocate female reform regardless of the wishes or realities of the women for whom they presume to speak. Also reminiscent of the past, feminists are leading participants in public debates on prostitution and prostitutes are absent or ignored.

The most important document of this century to emerge from the abolitionist movement is the "Convention for the Suppression of the Traffic in Persons and of the Exploitation of the Prostitution of Others" which was adopted by the General Assembly of the United Nations in 1949. That document was derived from a series of earlier international agreements beginning with the "Suppression of the White Slave Trade" passed in 1904. Undoubtedly, many well-intentioned reformist and feminist leaders were instrumental in supporting this convention aimed at punishing:

. . . any person who, to gratify the passions of another:
1. Procures, entices or leads away, for purposes of prostitution, another person, even with the consent of that person;

2. Exploits the prostitution of another person, even with the consent of that person. (Article 1)

The parties to the present convention further agree to punish any person who:
1. Keeps or manages, or knowingly finances or takes part in the financing of a brothel;
2. Knowingly lets or rents a building or other place or any part thereof for the purpose of the prostitution of others. (Article 2)

I have cited those two first articles because they are of utmost significance to working prostitutes. Although the Convention was supposedly drafted to eliminate violence against women by reinforcing already existing legislation against deceit, coercion and child abuse, it succeeds in officially denying autonomy and contractual rights to women. It specifically denies prostitutes the right to work indoors in a club, brothel, hotel, private home or other potentially warm, safe, clean facility and it denies prostitutes the right to work with others or to hire business associates (labelled enticers or exploiters if they collaborate or profit from the business). Since most prostitutes work either indoors or cooperatively or both, their activities are defined by the convention as criminal and many are therefore forced to depend upon criminal men for protection from law enforcers. Prostitutes' activities are outlawed regardless of conditions of force or agreement. Painfully reminiscent of the Criminal Law Amendment Acts at the turn of the century, the United Nations Convention effectively works to punish rather than protect women. Prostitutes were never consulted during the process of drafting or ratifying the convention and, indeed, the convention has had and continues to have disastrous consequences for working women throughout the world. According to one Thai woman:

> In Thailand at the moment, prostitution is a crime. It may sound unbelievable because everyone must have heard about Thailand as a paradise for sex, but it is a crime. It was the pressure from the United Nations about the abolition of prostitution which brought about the new act. Under the Prostitution Suppression Act, a woman who works as a prostitute will be arrested and given a penalty of three months imprisonment and a fine of one thousand Thai baht or given both a prison sentence and a fine... In addition to the three month imprisonment, prostitutes might be sent to a rehabilitation house for a one year program without their con-

sent. That house is more like a prison than a helping place. So, under this law, a lot of women have to rely on the brothel owners or on pimps and other agents who have good contacts with the local police. There is a lot of bribery going on which is why these entertaining places can operate.

The Convention Preamble proclaims that "prostitution and the accompanying evil of the traffic in persons for the purpose of prostitution are incompatible with the dignity and worth of the human person and endanger the welfare of the individual, the family and the community." Women in prostitution, especially if they are migrants, emerge as undignified, worthless dangers to society or as permanently damaged victims of abuse. The International Abolitionist Federation entitled their 29th congress held in Stuttgart, Germany in 1987: "Prostitution: A World Problem, A Threat to Humanity." Prostitutes and prostitute allies were indignant. One prostitute said:

> They get hysterical about us! I am tired of all these people who lie all the time. It is not right to call prostitution a threat to humanity. It is ridiculous to mix up forced prostitution and child prostitution and slavery and exploitation with *us*: I am a free and conscious adult.

Typically, abolitionists reply to such self-defense by saying that freedom and consciousness are exceptions within prostitution and that the majority of prostitutes are victimized women and children. But when asked whether a prostitute can ever be a self-determining agent, the abolitionists reply in the negative. Persons in the sex industry are thereby denied adult status and denied the right to migrate of their own accord. They are defined as violated persons or trafficked persons whether or not they themselves experience or report abuse. If actually abused, prostitutes cannot demand recourse without implicating themselves as unworthy participants in illicit (i.e. commercial) sex.

Influencial world organizations such as the United Nations, UNESCO, the World Council of Churches and the International Abolitionist Federation have taken the social purity anti-prostitution ideology to heart. Many members or supporters of those organizations are genuinely concerned about violence against women and children but they fail to acknowledge that prostitutes share their concern and their integrity. Prostitutes' lives depend upon healthy, safe and economically viable work conditions for adults and true protections from child abuse, deceit, force and violence. They are not satisfied with the

laws that govern them, nor with their exclusion from public debate. Protection is meaningless without rights to work, reside, travel and participate in social security programs. At minimum, prostitutes need relief from official harassment and persecution. They will never be safe as prostitutes until no more laws are made which punish them and their chosen associates. Prostitutes are now asking those who have spent years debating prostitution without worker representation to suspend their preconceptions and their protectionist ideology and, for the first time in history, to recognize prostitutes' right to sexual and economic self-determination. Some international organizations are joining prostitutes in their struggle. The Green Alternative European Link in the Rainbow Group of the European Parliament that hosted the Second World Whores' Congress sent an "Anti-Solidarity Statement" to the 29th abolitionist congress which read in part: "We consider your congress a declaration of war against prostitutes as well as an attempt to reinforce repressive (state) policy against them." Prostitute Grisélidis Réal attended the congress despite refusals to let her speak. More indignant that ever, she reported, "They treated us like dogs, but we fought like tigers! We won some allies and we need many more."

Pimps

Institutionalized exploitation of prostitutes on the one side and ideological salvation of prostitutes on the other squeeze whores between two lethally legitimate mechanisms of control. Official laws and socially sanctioned attitudes *justify* the oppression of prostitutes. Prostitute activists view institutionalized abuse as the prime source of whore oppression. However, public concern about the abuse of prostitutes, when it exists, rarely focuses upon such systematic violation. The state and society are generally absolved of responsibility while individuals are blamed as either victims or villains. Discussions most often target unfortunate or bad women and cruel or inept men. The figure most often blamed for the oppression of whores is the pimp. No discussion of prostitute oppression would seem complete without examining myths and realities about pimps. That examination requires distinctions between legal definitions, popular portrayals and prostitute experiences.

Within a prohibitionist system, a sex worker's earnings are illegal. Any recipient of those earnings (except the state) is defined as a pimp. The pimp could be a roommate, lover, friend, male child over eigh-

teen years old, parent, babysitter or business partner of a prostitute. In France and the United States, for example, the freely chosen associates of prostitutes are routinely fined, arrested and imprisoned under the charge of pimping. French prostitutes are outspoken in protesting the state's invasion of their privacy by criminalizing their lovers and family members. If the alleged pimp is a child of the whore, then she or he may avoid criminal prosecution but the prostitute mother may lose custody and the child may be forced to forfeit whatever was financed by her or his mother's sex work. In Sweden, a prostitute's daughter was expelled from the university because her tuition was paid by her mother. Examples abound of the state using pimping laws to undermine a prostitute's economic sovereignty and personal/work relationships. Some pimps may be dependent boyfriends who have no control over their girlfriends' business. A Dutch Salvation Army social worker who worked in Amsterdam's red-light district for thirty years referred to those boyfriends as "househens." Frequently, the laws are applied against prostitutes themselves. If prostitutes work together, for example, the one who owns the work place or runs the administration can be charged with pimping. Or, if a prostitute is given a referral fee for introducing a client to another prostitute, then she is accused of pandering. Women are serving prison sentences throughout the world for such "crimes." It is important to stress that pimping is defined economically. Whether the prostitute engages in prostitution by force or choice is irrelevant under anti-pimping laws; it is her business and not her subjugation that is illegal.

More in line with popular portrayals of the pimp are the men who beat women into sexual service and exploit their labor. There is no doubt that such men hold control in certain countries and in certain sectors of the sex industry. Throughout our years of organizing, some prostitutes have fearfully turned away from political work because of pressure from "their man" or "their boss" and some did not attend the Whores' Congresses for fear of losing their job, or even their lives. Ironically, laws against pimping often force prostitutes to depend upon illegal "protection" against state control. Exploiters thrive on the state's hypocrisies; the very regulations and prohibitions that supposedly safeguard prostitutes from abuse deny them the right to good work facilities and legitimate services and push them into a criminal world. Furthermore, sex workers associated with violent men cannot report the abuse in most countries without jeopardizing their own in-

come, safety or freedom. Rarely are men prosecuted for violence against prostitutes except as an excuse for racist discrimination or unless they are wanted by the police for some other reason, such as drug traffic.

In reality, millions of prostitutes are controlled by men and millions of prostitutes work independently. The exact figures in each category and along the continuum from force to freedom vary widely from country to country and from one sector of the sex industry to another. Many pimp-controlled women escape the domination of their pimp and remain in prostitution as independent workers. Others exit the sex industry when they are able to do so. Although some prostitutes are held back from political organizing by pimps, some find enough support and strength in political work to become independent. Like women in other political movements, prostitutes often become more autonomous from either violent or dependent men when they bond with other women and enter public debate.

ALLIANCES BETWEEN WOMEN

Women's liberation movements throughout the world have not been immune to social, legal and ideological distortions of the lives of prostitutes. Like women reformers in the 19th century, most contemporary feminists are isolated from women in the sex industry. A common misconception among feminists is the belief that women are protected by efforts to abolish prostitution (efforts like "reformation" of prostitutes and punishment of customers). Two movements of non-prostitute feminists are particularly vocal and influential in putting forth a 20th century abolitionist line: the anti-trafficking movement against female sexual slavery and the anti-pornography campaign, both finding their strongest spokeswomen in the United States.[4] Those groups portray all prostitution and pornography as violence against women. Like 19th century social purists, they do not distinguish between conditions of force or free will, insisting that sex workers who claim autonomy lack consciousness about their actual subjugation. The movements emerged in the late 1970s in a context of increasing feminist activism against rape, battering, sexual abuse of children and other forms of male violence. Together with struggles to define female sexuality, anti-violence activism led some feminists to equate heterosexuality, especially commercial heterosexuality and marital heterosexuality, with female sexual slavery. Other feminists rejected

those formulations and warned against anti-violence strategies which sacrifice women's sexual choice, economic security, free speech and/or erotic pleasure.[5]

Sex workers were rarely visible at feminist meetings. Given the dominance of abolitionist feminism during the late 1970s and early 80s, those feminists with either histories or present jobs in prostitution, were careful to conceal their "politically incorrect" occupation. However, concurrent and separate from feminist debates on prostitution and pornography was a growing movement of political prostitutes, especially in North America and Western Europe. Some individual prostitutes identified as feminists and some individual feminists allied themselves with whores, but feminist and prostitute movements were basically divided from one another. Feminists who followed the anti-prostitution and anti-pornography line were often viewed by political prostitutes as naive or self-righteous agents of control and condemnation. Prostitutes were viewed by the same feminists as either victims of abuse or collaborators with male domination.

One particular event sponsored by anti-trafficking feminists in 1983 transformed the politics of a number of women from the United States and the Netherlands. The event inspired a snowballing of alliances between women inside and outside the sex industry which eventually led to the formation of the International Committee for Prostitutes' Rights. The following story begins personally with a few individuals, including myself, but it was the parallel thinking and activism of women in many different countries that fueled the present integrated movement for prostitutes' rights.

Rotterdam Conference on Female Sexual Slavery

In 1982, I met Margo St. James in San Francisco during a brief visit to the United States from the Netherlands. She told me about a conference to be held in Rotterdam, the Netherlands, the following year on the subject of "Female Sexual Slavery." Kathleen Barry, who had written a book by the same title, inspired the conference which she planned to organize together with Charlotte Bunch and Shirley Castley. I knew Charlotte Bunch as a pioneer lesbian feminist and had respect for her political writing and organizing. Barry and Bunch were working hard to raise travel funds for conference participants from thirty-five countries. Margo St. James was one of the two invited representatives of the United States, or intended invitees, one year before the event. She had given Kathleen Barry many contacts for her re-

search on forced prostitution and was the most public prostitute rights activist and self-identified whore in the United States. After talking with St. James in San Francisco, I called Barry and offered to help raise funds by organizing lectures for participants during their stay in Holland. She was pleased to have fundraising support. Once back in the Netherlands, finding small funds for Margo St. James and her co-director of the U.S. National Task Force on Prostitution, Priscilla Alexander, was not difficult. Besides lectures at Dutch universities and feminist cafes, there was a possibility of a television show. I formulated a proposal for a round table discussion on television including Barry, Bunch, St. James and Alexander:

> The discussion will focus on both sexual slavery or involuntary prostitution and on the right of women to work voluntarily as prostitutes. The tension between feminist struggle *against male violence* and feminist struggle *for female self-determination* will be explored. In other words, how can we de-stigmatize and legitimize whores and protect their right to work while increasing their choice, freedom and safety?

Both the television network and the discussants agreed, at least initially. Later it became clear that the proposal touched a sensitive and historically rooted tension.

As the event grew near, a severe conflict began to develop. No prostitutes other than St. James were among the representatives and her status was changed from participant to resource person. She would be allowed to attend only one morning during which she would be asked to give her report and then leave. Furthermore, Kathleen Barry had changed her mind about the television discussion. She would not appear on television together with a prostitute or ex-prostitute. She explained to me that the conference was feminist and did not support the institution of prostitution. She found it inappropriate to discuss sexual slavery with prostitute women either at the conference or on the air. After much conflict, a compromise television program was arranged in which Barry and Bunch spoke separately from St. James and Alexander.[6]

Lectures in the Dutch feminist community were scheduled for Margo St. James, Priscilla Alexander and Dolores French (U.S. prostitute activist from Atlanta). The lectures focused on the relation of prostitution to feminism, of sex to money, and of women's public lives to women's private lives. "Whores should be on the frontline of

the women's movement," said St. James, "but we can't gain political power if it's short-circuited by stigma." And: "One of the reasons the prostitute is punished is the puritanical fear that she's enjoying her work."

Many feminists attended the prostitute lectures and some of them "came out" themselves as sex workers or former sex workers. A small Dutch-American network inside and outside the sex industry began to develop. The feminist conference participants in Rotterdam did not hear the prostitute lectures, and the prostitutes were not allowed to hear conference participants exchange information on the global condition of women in prostitution (except during a public presentation). There were active prostitute advocates at the conference from around the world, many of whom do work closely with prostitutes in their countries.

One year after the conference, the proceedings were published by the organizers.[7] The ideological framework elaborated by Kathleen Barry in the opening paper of the report explains her exclusion of prostitute women. She invalidates the words of prostitutes by pointing to their histories of abuse, their poverty and/or their inability to be objective about their situations. And, beyond victimization and subjectivity, she denounces any woman who would choose to sell sex as irresponsible:

> When the question of "choice" is taken beyond how it is determined by previous sexual exploitation and violation or by poverty, it brings us to an examination of the validity of the institution from the standpoint of women's responsibility. We do an injustice to our sex if we do not ask women to be socially responsible for the choices they make.

Barry goes on to argue that the United Nations and the World Council of Churches do not go far enough in condemning prostitution because they distinguish between children and adult women and between force and free will. She criticizes those who fail to denounce the institution of prostitution strongly enough out of their protective concern for the prostitute.

For her efforts, Kathleen Barry was awarded a $7,500 "Wonder Woman Award." In an interview with the *The New York Times* entitled, "A Personal Crusade Against Prostitution," she says, "Margo St. James was very helpful in providing information about women being victimized and exploited by police. But we basically disagree be-

cause I want to end prostitution and she regards it as a viable profession."[8] Asked to comment, St. James replied, "A blow job is better than no job. In trying to stop abuses in prostitution, one should not try to put the women out of work because the job is all they have."

Consciousness-Raising

Several months following the confrontation in Holland, I wrote a proposal for an alliance group of women in San Francisco inside and outside the sex industry. The group was modelled after a Feminist Alliance Project in the Netherlands which was designed to study and bridge divisions between women.[9] Entitled: "Alliance Between Whores, Wives and Dykes: Work Group to Demystify and Eliminate the Division of Women into Bad, Good, and Perverse," the proposal addressed women's mulitiple oppressions:

> The oppression of women working as prostitutes is intimately linked to class oppression, sexuality oppression and race oppression. It may not be accidental that an alliance group between "madonnas" and "whores" evolves now after years of groundwork around other oppressions. Since prostitution taboos and coercions unavoidably confront the economic and sexual realities of women, they may underlie the social control of all women.

And further:

> Good women (wives and other women assumed to be possessed by individual men) are legitimized by the patriarchal system; their function is to model subservience. Bad women (whores and other women assumed to be "loose" or for hire) are stigmatized; their function is to serve as an example of the ostracism awaiting any woman who strays. Perverse women (dykes and other celibates of patriarchy) are ignored; their function is to demonstrate that a woman who rejects men loses her status as a woman. All women are eligible for all functions so it is no wonder that we shrink from assuming or even associating with any additional burden to the one(s) we already carry. Functions are external impositions, however, which are used to divide us from our capacities and to divide us from other women. The challenge of alliance between women is to demystify our behaviors and distinguish external functions they serve from the internal strategies for self-determination they could be.

The proposal was distributed among sex workers. A group was

formed of eight prostitute, five ex-prostitute and three non-prostitute women. The goal of the group was "self-examination, collective analysis and exercise of a strategy for demonstrating the relevance of prostitution to all women and for including the rights of prostitutes in the forefront of feminist struggle. . . ." From the beginning, the meetings were informally preceded by an update of local political realities such as recent arrests of prostitutes, new legislation and police practices as well as an exchange of shop talk such as going rates, disease prevention, client needs and safety precautions. We also planned various protest actions, conferences and fundraising activities. The group was balanced along dimensions of class, race, sexual identity and work. Among the prostitutes, a broad range of the sex industry was represented from streetwalking to sensuous massage to escort service. Most women inside and outside the sex industry had histories of geographical and occupational mobility. Every woman had experienced abuse (in varying degrees) and autonomy (in varying degrees), whatever her job. Ages ranged from early twenties to late forties. About one-third of the participants were lesbian. While recognizing that prostitution was work and that it provided an income, women both inside and outside the sex industry agreed that they had internalized, more or less, society's contempt for the whore. The first meeting was opened on April 7, 1984 as follows:

> Our purpose is to go through the stages of feminist consciousness-raising without excluding or isolating prostitution. Let's re-do feminism with prostitution in the center of our experience. What is your first memory of the word, woman, or image "whore"?

Everyone had not only a first memory of the word "whore," but also a whole whore/madonna life story. After about two months of exploring feelings about ourselves and other women, I proposed that we start additional groups, called "Bad Girl Rap Groups," which could include more women. In May of 1984, the Bad Girl Rap Groups were advertised in publications read by feminists/prostitutes:

> BAD GIRL RAP GROUP: For anyone whose work, color, class, sexuality, history of abuse or just plain gender has ever stigmatized her as bad. An introduction to alliance-building among women against sexual stigmatization with a focus on prostitution, racism, lesbianism, incest and violence against women. . . COME OUT AS A BAD GIRL for the safety and respect of all girls and for the right to self-determination of all women.

Every two weeks, between twenty and thirty women met with an agenda that ranged from work to money to racism to power to sex to abuse to love to pleasure to police to feminism to work to money. About two-thirds of the participants were sex workers. We had four facilitators, two prostitutes and two non-prostitutes, all feminist-identified, three of the four lesbians. On the first evening, every woman told why she had been stigmatized as bad. Although the majority of women were prostitutes, most women had been stigmatized before starting to work for:

> getting raped, being smart, having an abortion, being a lesbian, being black, sleeping with lots of men, talking too much, running away from home, getting divorced, leaving my children, being an unwanted child, having a child without marrying, hanging out with the wild girls in school, being Jewish, having an affair when I was married, leaving the Catholic church, going to a college that didn't have a curfew, getting beaten by my husband.

As the group progressed, we realized that *blame* (for abuse such as rape or battering), *shame* (for sexuality such as lesbianism or promiscuity), and *punishment* (for independence such as financial initiative or intellectual curiosity) were mechanisms of control and subordination. Stigma was attached to our strength, our sexuality and our suffering. We were less divided into our separate social identities than in the alliance group because everyone had joined as a "stigmatized woman." Nonetheless, alliance group participants acted as leaders in showing the relation of diverse women's experiences to the "whore stigma."[10]

With both our Alliance Group and Bad Girl Rap Group in full swing, we organized a Hookers' Congress and a Women's Forum on Prostitutes' Rights in July, 1984. At the congress, about fifty prostitutes and ex-prostitutes and about ten invited non-prostitutes drew up policies on prostitution laws, taxation, city planning/zoning, criminal justice, ethics, safety, health, AIDS, drugs and pornography. Only working prostitutes voted on policies.[11] We maintained a large majority of prostitutes and a minority of non-prostitutes because that balance had proven so critical in the alliance group. At the forum, topics included stigma, working conditions, services, history, law, strategies for change and organizing. Speakers included prostitutes, lawyers, service providers, anti-racism activists and researchers. A Dutch feminist, Marjan Sax, attended the forum and covered it for a Dutch lesbian magazine.[12] Concluding the three-day event, we formed

the Feminist Alliance for Prostitutes' Rights and we held a fundraising Hookers' Ball. At the Ball, women sold buttons, t-shirts and COYOTE cups with slogans like: "It's A Business Doing Pleasure With You," "My Ass Is Mine," "Outlaw Poverty, Not Prostitutes," "Ignorance Is No Excuse For A Law" and "Good Girls Go To Heaven, Bad Girls Go Everywhere." We did not yet realize that our alliances and policy decisions would be instrumental in creating the International Committee for Prostitutes' Rights.

"AU MOUVEMENT INTERNATIONAL DES PROSTITUÉES"

During the year (1984) of the alliance group in San Francisco, eight Dutch ex-prostitutes began a support group in Amsterdam. Upon my return to the Netherlands, three of the group members (Ans van der Drift, Inge, Margot Alvarez) and the group facilitator (Martine Groen) met with me to hear details of the U.S. Hookers' Congress/Feminist Forum and to brainstorm about setting up a Dutch prostitutes' rights organization. In order to structure the organization both for self-organization of prostitutes and for alliance between women, we decided to form two sister organizations: The Red Thread for prostitutes and ex-prostitutes only and The Pink Thread for all women. The Pink Thread would work toward integrating whore rights in the Dutch feminist movement. As mentioned earlier, the "red thread" is an expression in Dutch meaning "central idea" or "bottom line." The name of the organization was meant to reflect the centrality of whore rights to the economic and sexual self-determination of any woman.

Ans van der Drift (a sex worker for twenty-nine years) popped The Red Thread into life with a magnum of champagne amidst an energized crowd in Amsterdam on December 14, 1984. As in future meetings, all prostitutes and ex-prostitutes were welcome to the celebration; other guests were present at the invitation of prostitutes. Feminist activists, prostitute rights advocates (especially Jan Visser), prostitute social workers (especially Marjolijn Keesmaat and Ceceil Brand), migrant women activists (especially Lin Lap) and government emancipation workers (especially Helene Buijs) were invited by the whores to kick off the first broad-based prostitutes' organization in the Netherlands. There had been a predecessor of The Red Thread, called the VIP (Very Important Prostitutes), whose membership had remained small and mostly closeted. VIP members were present at the celebration, including Violet who had been the first whore to

speak out in Holland and Anja, an ex-addict streetwalker, who was a spokeswoman for addicted prostitutes.

The U.S.-Netherlands cooperation which began during the Rotterdam Conference was also visible at The Red Thread Opening. Margo St. James came to the Netherlands for the occasion as did Dr. E. Kitch Childs, black psychologist COYOTE board member. Following the celebration, St. James, Childs and I travelled to Switzerland and France to meet other European prostitute activists. The Red Thread was planning a National Whores' Congress for February, 1985, and we were given the go-ahead to invite a few foreign guests. In Switzerland, we met with Grisélidis Réal whom Margo St. James had met in Paris ten years before. Through Grisélidis we met Doris Stoeri in Geneva, one of the founding members of the prostitutes' rights group ASPASIE. Also through Grisélidis we made contacts in Paris with streetwalkers on the Rue St. Denis. Both Swiss and French prostitutes were eager to hear about the whore struggle in the United States and the Netherlands and were excited by the possibility of attending the Amsterdam Congress. In fact, not only did they want to come as guests, but they imagined coming to start an international movement. Constance, a sixty-five-year-old working prostitute activist, toasted enthusiastically at an informal meeting of prostitutes on the Rue St. Denis: "*Au mouvement international des prostituées, a notre mouvement international!!*"

Back in the Netherlands, Dutch whores were excited by the prospect of forming an international movement at their congress, but slightly overwhelmed. After all, they had just formed a national organization and had not yet held a congress for Dutch sex workers. The event became a three-day affair with a Dutch national congress on the first day, an international congress on the second day, special meetings on the third day and a Benefit Masquerade Ball on the third evening. In six weeks, we organized everything and on February 14, 1985, The Red and Pink Threads together with COYOTE welcomed prostitutes from eight countries. The international congress, called the World Whores' Congress, focused on drafting a Charter of Demands (see next chapter). At the end of the meeting, we founded the International Committee for Prostitutes' Rights or ICPR.

Although our organizing had snowballed beyond anyone's imagination, we were certainly not yet representative of the world at large. Only a few Asian countries were represented, and then not by prostitutes themselves; Africa and South America were as yet totally

unrepresented; North American and West European countries were represented but not by more than several sex workers each. Participants did cross class, race, sexuality and work divisions. And feminist migrant women did emerge as a strong base for future networking with prostitutes in as yet unrepresented world regions. Hundreds of journalists attended the press conference and communicated our demands, especially to newspapers in West Europe and Asia.

The Netherlands was a generous and kind host to our congress. The Dutch Ministry of Social Affairs and Employment provided funding for the facilities that made the event possible. Also, a government-subsidized documentation center, the De Graaf Stichting, provided invaluable logistic and research support. And a Dutch lesbian feminist subsidizer of women's projects, Mama Cash, provided travel money for prostitutes of color from North America. Such support from the Dutch government and the Dutch feminist movement was not incidental or accidental. Many people thought that the congress "never could have happened anywhere other than the Netherlands." We did in fact move the next congress to another country, but we maintain our coordinating base in the Netherlands for good reason. The Netherlands has a history of less violence and fewer repressive policies against prostitutes than other countries, which is not to suggest that Dutch society is free from stigma, injustice and abuse. Significantly, unlike most other countries which have provided support, Dutch subsidies have come not from the Bureau of Criminal Justice or the Bureau of Public Health but from the Bureau of Emancipation Affairs within the Ministry of Social Affairs and Employment. The recognition of prostitutes' rights as an emancipation and labor issue rather than as an issue of criminality, immorality or disease reflects a recognition of the whores' struggle as a liberation movement.

That recognition is rare indeed. As prostitutes and prostitute allies, we are charting a course between those who consider us outlaws, those who consider us a financial asset, those who consider us a health menace and those who consider us sinners and victims. While organizing the First World Whores' Congress, we were immediately confronted with the repressive attitudes and practices operating against us. Despite extreme care in protecting the anonymity and safety of participants, some prostitutes could not afford the slightest risk of disclosure. A Swedish prostitute was afraid to attend for fear of losing custody of her children to the Swedish authorities. She decided to at-

tend nonetheless with her face hidden from press cameras while entering and leaving the congress hall. Three German prostitutes were afraid that the German press would expose them and cause them public shame, loss of job and perhaps loss of child custody. Their fears were not unfounded; the German newspaper *Bild* located our private meeting hall and tried to photograph every person who entered. An English prostitute was afraid that her practice as a sex counselor would be threatened if her clients learned that she was also a provider of sexual service; she wore a wig at the press conference. A Dutch woman couldn't attend because her manager refused to hold her window position open for her if she missed three days work. Another Dutch prostitute called to say that she had better not attend a meeting in Holland for fear of jeopardizing her future university career but would attend the next congress if held elsewhere; a Danish prostitute who was also a primary grade school teacher felt free to attend because the congress was being held outside her own country. Before the Second Congress in Brussels, a French prostitute from Marseilles hesitated attending for fear of police and pimps, both of whom objected strongly to prostitutes speaking publicly about the daily harassment they endure. After she decided to attend, French officials withheld the identity card she needed to cross the Belgian border. Many Belgian prostitutes did not attend formal meetings because they feared exposure on television, but several did attend sessions held in private settings. A Philippine migrant prostitute with a case pending against a man who deceived her did not want to turn the court against her by appearing as a political activist. A Thai prostitute feared losing her job at her club in Bangkok if her manager thought she was a troublemaker. Police, courts, social welfare bureaus, families, managers and neighbors were all mentioned as obstacles to public disclosure and debate. Danger to loved ones or threat of forced separation from loved ones, especially children, was a deep worry, as was loss of employment and income. But by far the most common reason for not attending was lack of money. Many prostitutes would have risked the dangers, ranging from murder to loss of child custody to dirty looks from neighbors, had they had the funds to attend. An Irish prostitute asked for a subsidy to cover travel and lost income. Many prostitutes worked extra hours in order to finance their trip. All ICPR fundraising was used for "Third World" women and their interpreters, but our resources were minimal.

The Second Congress was a more significant step forward in our

movement than we had anticipated. Assembled in an official conference hall of the European Parliament, prostitutes from over sixteen countries presented violations of their human rights, realities and mythologies about their health, and the relation of their struggle to feminism. Echoing in six simultaneous languages, their voices seemed to break a sound barrier.

TOWARD A NEW POLITICS OF PROSTITUTION

By the time of the Second Congress, the AIDS epidemic had reached alarming proportions. Prostitutes were being scapegoated for spreading the disease. Like a hundred years ago during the syphilis epidemic, many governmental and medical establishments reacted to AIDS with calls for increased regulation of prostitutes (e.g. registration, mandatory AIDS testing and even prison sentences for those carrying antibodies to the virus). Religious and reformist activists reacted to the epidemic with renewed calls for the abolition of prostitution. Pressures toward regulation of prostitution on the one side and abolition on the other side are presently exerting strong controls on prostitutes and denying them basic rights. Unlike a hundred years ago, prostitutes in many countries are responding publicly in their own behalf. They are demanding the same medical confidentiality and choice as other citizens and putting themselves forth as safe sex educators. They are contesting policies which separate them from other sexually active people, emphasizing that charging money for sex does not transmit disease.

The movement for prostitutes' rights is forging a new politics of prostitution. Self-representation of whores and alliances between women are the heart of the new politics. Two hundred years ago in 1792, Mary Wollstonecraft wrote the classic *A Vindication of the Rights of Woman*. Her book is women's first declaration of independence. Wollstonecraft's contemporaries called her a "shameless wanton," a "hyena in petticoats," a "philosophizing serpent" and an "impious amazon."[13] In modern times, she might have been called a whore. Writing at the time of revolutions in the United States and France, Mary Wollstonecraft protested the exclusion of women from man's quest for human rights. Although she claimed to "speak of the condition of the whole [female] sex, leaving exceptions out of the question," she distinguished prostitutes from worthy women and portrayed them as "poor ignorant wretches." Two hundred years later, those wretches—those whores, are standing publicly with their sisters

and demanding inclusion in the Vindication of the Rights of Women. Together, we are not repeating history.

Footnotes

1. HWG is publicly known as an abbreviation of the law for protection against venereal diseases. It stands for persons with *Haeufig Wechselndem Geschlechtsverkehr* (frequently changing intercourse = promiscuity). Typically the law is applied according to political rather than public health criteria: Only prostitutes are subject to the controls of registration and forced medical testing. "They are the only ones that we can get hold of," argue the authorities. The Frankfurt women have "squatted" the letters and transformed their meaning into *Huren Wehren sich Gemeinsam* (Whores Fight Back Together). Activities against the forced health control of prostitutes has had some success. In several big cities authorities no longer insist on weekly check-ups and check-books (inspected by civil servants and police).

2. See June Levine and Lyn Madden, *Lyn: A Story of Prostitution*. London: The Women's Press, 1988.

3. This account of Josephine Butler's campaign is drawn from: Judith Walkowitz, *Prostitution and Victorian Society: Women, Class and the State*. Cambridge: Cambridge University Press, 1980. See also: Judith Walkowitz, "Male Vice and Female Virtue: Feminism and the Politics of Prostitution in Nineteenth-Century Britain." In: Ann Snitow, Christine Stansell, and Sharon Thompson (eds.), *Powers of Desire: The Politics of Sexuality*. New York: Monthly Review Press, 1983, 419-438.

4. The main anti-trafficking spokeswoman is Kathleen Barry; see: *Female Sexual Slavery*. New York: Prentice-Hall, 1979. The main anti-pornography spokeswomen are Andrea Dworkin and Catherine MacKinnon; see: Andrea Dworkin, *Pornography: Men Possessing Women*. New York: Putnam, 1981.

5. See especially: Varda Burstyn (ed.), *Women Against Censorship*. Toronto: Douglas & McIntyre, 1985; Ann Snitow, Christine Stansell, Sharon Thompson (eds.), *Powers of Desire, The Politics of Sexuality*. New York: Monthly Review Press, 1983; Carole Vance (ed.), *Pleasure and Danger*. Boston: Routledge & Kegan Paul, 1984.

6. "The Madonna and The Whore," Humanistisch Verbond, TV broadcasting on June 3, 1983; interviews by Jeanne Wikler; transcript available in Dutch or English from the Humanistisch Verbond, Postbus 114, 3500 AC Utrecht, Netherlands.

7. Kathleen Barry, Charlotte Bunch and Shirley Castley (eds.), *International Feminism: Networking Against Female Sexual Slavery, Report of the Global Feminist Workshop to Organize Against Traffic in Women, Rotterdam, the Netherlands, April 6-15, 1983*. The International Women's Tribune Centre, Inc., 1984, pp. 24-28.

8. Judy Klemesrud, "A Personal Crusade Against Prostitution," *The New York Times*, June, 24, 1985.

9. See: Gail Pheterson, "Alliances Between Women: Overcoming Internalized Oppression and Internalized Domination," *Signs: Journal of Women in Culture and Society*, 1986, vol. 12, no. 1, pp. 146-160. An earlier version is published in Dutch in: *Psychologie en Maatschappij*, no. 20, September 1982, 399-424. The project included

groups of black and white, Jewish and Gentile, lesbian and heterosexual, and disabled and able-bodied women as well as one group of women in the presence of men and one group of women outside the sex industry exploring the "whore-madonna" split within themselves. The "whore-madonna" group was conceived by Gosina Mandersloot.

10. For an elaborated analysis of the whore stigma, see: Gail Pheterson, *The Whore Stigma: Female Dishonor and Male Unworthiness* (also in Dutch and forthcoming in Italian). The Hague: Ministry of Social Affairs and Employment (DCE), 1986. (Forthcoming in expanded form from The Seal Press, 1990.)

11. Those policies of the First Annual COYOTE Hookers' Convention in 1984 and subsequent policies drafted at annual conventions are available from: The National Task Force on Prostitution, P.O. Box 6297, San Francisco, California 94101-6297, United States.

12. Marjan Sax, "Wie gaat er mee een nummertje maken?" *Diva*, no. 2, maart 1985, 6-11, 14. (Also available in English from the author or from the ICPR.)

13. See Miriam Brody Kramnick's introduction (p.717) to Mary Wollstonecraft, *A Vindication of the Rights of Woman*. New York: Penguin Books, 1975 (first published in 1792).

PART TWO

THE CONGRESSES

TURNING OUT THE CHARTER
AT THE FIRST WORLD WHORES' CONGRESS
Amsterdam, February 14, 1985

The First World Whores' Congress set the International Committee for Prostitutes' Rights (ICPR) in motion. Prostitutes and ex-prostitutes from eight countries° drafted a charter of demands (see pages 40–42) which was presented to the press on the fifteenth of February in 1985. Among prostitute participants were some gay men and a large majority of women who work (or had worked) on the street, behind a window, in clubs, massage parlors, brothels, bars and hotels, independently or with a manager. There were about seventy-five congress participants including invited advocates. This chapter summarizes the internal dynamics of the congress that are not apparent from the charter. It is such "growing pains" that helped define the politics and structure of the ICPR. More detailed elaboration of issues is left for the chapters on the second congress.

The Issues

Although general agreement was reached about the the contents of the charter at the afternoon plenary session, congress delgates debated specific clauses until five the next morning! Only prostitutes and ex-prostitutes voted on each point. Certain phrases were discussed for an hour or more. For example, after careful deliberation, the first line of the charter was changed from "Decriminalize all aspects of adult *voluntary* prostitution" to "Decriminalize all aspects of adult prostitution resulting from *individual decision*" (italics are mine). Some representatives stressed the fact that truly voluntary choices for women were uncommon at best and that especially poor women in poor countries had few or no alternatives. Nonetheless, the right to make economic decisions in a climate free from criminaliza-

°Participants included prostitutes and ex-prostitutes from the Netherlands, France, Switzerland, Germany, England, Sweden, the United States and Canada as well as prostitute advocates from the above countries and from Singapore, Thailand and Vietnam. Translation was available in Dutch, French, German and English.

tion and social control of sexuality was considered fundamental to human rights by representatives of all participating countries. Everyone therefore agreed that prostitution per se, i.e. commercial sex, must be decriminalized and that existing laws against fraud, coercion, violence, child abuse, rape and racism should be enforced both inside and outside the context of prostitution. Participants from each country gave examples of the way criminal sanctions against prostitution worked to deny them both rights and legal recourse following abuse. They insisted unanimously on the recognition of prostitution as a legitimate work decision for adults, be it a decision based on choice or necessity.

Some issues were omitted from the charter because a consensus was not reached. Drugs, AIDS and pornography were the three "hot issues" that set off a confusion of mixed feelings and divergent opinions. Significantly, when position papers were drawn up for the second congress, those issues could no longer be ignored. The reasons given for omission in 1985 were the following: In relation to AIDS and drugs, some prostitutes felt that mention of disease and addiction would reinforce the distorted portrayal of all hookers as sick and stoned. They insisted that drug abuse is a problem in many professions, such as nursing, and that it should not be tied specifically to prostitution. Others felt that although addicts are a small minority among the total population of prostitutes, they comprise a significant and vulnerable group in some street areas and should have the support of the prostitutes' rights movement. A statement of solidarity with drug-addicted prostitutes was proposed. In opposition to that statement, other prostitutes drafted a statement which disassociated "professional whores" from "junkie whores." On another level, some favored a call for placing heroin under medical rather than criminal codes of surveillance (both to dismantle the criminal milieu of the streets and to prevent disease-spreading practices like sharing needles). Others feared that such a stance might jeopardize public support for prostitutes' rights. Among those who fought for inclusion of a clause about drugs were two ex-heroin-addicted prostitutes. One woman who began using heroin after becoming a prostitute wanted to stress in the charter that isolation and not sexual service drove her to drugs. Speaking of isolation and bad working conditions, discussion turned to alcohol. Prostitutes protested club regulations which force them to drink alcohol while working. There was agreement on the importance of health and sobriety for prostitute work and general well-

being. In the end, however, no policy agreement led to no mention of drugs.

It is significant that AIDS was not a major topic at the first congress whereas it became a central issue at the second. Tragically, AIDS had become a tragic reality throughout the world by 1986.

Pornography was a different kettle of fish. At the first congress, the pornography industry was scarcely represented. Prostitutes in particular from the United States, Canada and England (one of the English prostitutes was a former porn model) put forth a statement of solidarity with workers in different sectors of the sex industry, including pornography. They argued that the separation of pornography from prostitution was hypocritical and fundamentally divisive to women. As Margo St. James said, "By legalizing pornography and keeping prostitution illegal, the government legitimizes white men selling women's sexuality while criminalizing women for selling sex on their own terms." Peggy Miller, prostitute representative from Canada, wanted the charter to point to the damage that the feminist antipornography movement does to the movement for prostitutes' rights: "Anti-porn feminists think that pornography is directed against women. But if they're against pornography, then they're against the whole sex industry, thus also against me. They are wrong to oppose sex workers. I too am a feminist!" French prostitute representatives from the Rue St. Denis in Paris resisted any association with pornography. They were furious about being harassed and fined on the street every day while porn models are tolerated. Their experience demonstrates the way laws which discriminate against prostitutes create resentments and divisions between women. As a compromise, a general statement with no mention of pornography was written into the charter: "We are in solidarity with all workers in the sex industry." Conspicuously, this is the one clause which speaks of a "We." Over the next years, that "we" would expand with increased self-representation of diverse sex workers, including pornography models.

Camouflage versus Visibility

From the beginning, we tried to ensure a majority of sex workers at every ICPR meeting. At the First World Whores' Congress, we succeeded only in creating a 50/50 balance between sex workers and invited advocates. In facilitating the introductory session of the one day international meeting, we erred in judgment and suggested that all

participants introduce themselves. After introductions we intended to give the floor exclusively to prostitutes and ex-prostitutes who could ask for advocate input if they chose. Our reason for including the advocates in the introductions was the expectation that prostitutes would want to know who was present before beginning the conference. However, sex workers were so eager to meet one another that they (and others) were bored by the advocate introductions. Given the uniqueness of the occasion, any waste of time felt unbearable. A few prostitutes interceded and asked the advocates to leave. The organizers, both prostitutes and non-prostitutes, felt that it was a good idea to separate for the morning session. Everyone agreed, except representatives from the English Collective of Prostitutes.

A slight digression about the English Collective of Prostitutes (ECP) and the tension between the ECP and the ICPR is relevant here. The ECP was formed in 1975 in England within the Wages for Housework Campaign to fight for the legal, civil and economic rights of prostitutes. The founder of Wages for Housework, Selma James, became the first spokeswoman for ECP. A U.S. sister organization called U.S.PROStitutes Collective worked cooperatively with Margo St. James and her organization, COYOTE, from 1976 to 1980. In 1980, a serious conflict at the United Nations Conference on Women in Copenhagen severed the working relationship between COYOTE and the two collectives. To be brief (though surely both sides of the conflict have detailed stories to tell), Margo St. James was trying to work with anti-trafficking activists, most notably Kathleen Barry, at the UN Conference and the ECP was trying to halt Barry's growing crusade. The ECP opposed the UN resolution against traffic in women unless a clause was added that said prostitute women and children should not be treated as criminals. St. James agreed with the addition but disagreed with the ECP's confrontational style. She felt that everyone should have a right to speak and she hoped to combine anti-violence and anti-criminalization in one platform. The ECP denounced St. James for supporting the anti-traffickers and St. James denounced the ECP for their disruptive behavior. In years following, St. James saw that the anti-trafficking laws intended to protect women worked to control and criminalize them and that Kathleen Barry's initial differentiation of forced prostitution from prostitution per se emerged as an uncompromising condemnation of commercial sex under any circumstances. COYOTE and the ECP now shared the opin-

ion that Barry's crusade worsened the lives of prostitutes. Nonetheless, the collectives refused to resume cooperation with St. James.

We invited the ECP to the First World Whores' Congress despite their suspicion of our new committee. We hoped for a reconciliation between Selma James and Margo St. James and for a fortified international movement for prostitutes' rights. Several women from London came to Amsterdam for the event. However, conflict flared as soon as the prostitutes asked the advocates to leave the meeting. Whereas the ECP has a policy of not revealing which of its members are prostitutes, the ICPR has a policy of prostitute self-representation. So when the whores at the congress asked the advocates to leave the room, ECP representives objected; they wanted to participate in the discussion among prostitutes without disclosing whether or not they themselves had ever worked in the sex industry. Finally, they did leave the self-professed whores to consort in closed chambers. But rather than return that afternoon when invited to do so, the ECP put out a press release denouncing the ICPR for "forcing women to identify themselves as prostitutes and for cooperating with the police and the media." Women's right to speak out as prostitutes if they choose and their right to meet with other prostitutes for personal rather than abstract discussion were portrayed as women's subjugation to organizational coercion. An English prostitute at the congress responded in a letter to the press: "Women are not required to reveal whether or not they are 'on the game'—however, many women want to and one of the points of the congress is for women to come out *if* they want to. Many pros believe they should have respect and credit for their work."

As to the charge of cooperation with the police, the ECP was reacting to one Dutch social worker present at the congress who was an employee of the police department in The Hague. The police department in The Hague is very progressive and had funded an experimental project of support services for women on the street. Local prostitutes trusted the social worker and choose to invite her to their congress.

The general media was invited only to the press conference. We did invite one trusted photographer to our closed meeting and asked those who wanted to be photographed to sit in certain places. There was no problem with unwanted exposure but we found the camera presence irritating and asked our photographer to leave.

Tension between non-disclosure and self-representation is a criti-

cal issue for the prostitutes' movement. Clearly, there is political
rationale for non-disclosure. The threat of stigmatization, criminaliza-
tion and violence to "known prostitutes" is devastatingly real. Many
ICPR members, like many if not most working prostitutes, use "trade
names." And many wear masks or wigs at press conferences and dem-
onstrations. Some actually attend only those meetings held outside
their own country. Encouragingly, the desire for self-representation
has increased amazingly quickly within just a three year period. We
are reminded of the "coming out" of lesbians in certain countries a
decade ago. While the ICPR understands and respects the ECP's in-
sistence on camouflage as a strategy against state control, we have
chosen a strategy of prostitute visibility. When sex workers cannot rep-
resent themselves, we encourage other sex workers to represent them.
Contrary to the belief that self-representation is possible only for the
sex industry "elite," it is often the highest status prostitute who is the
most invisible and the most resistant to public exposure. As the tran-
scripts of the second congress will illustrate, personal experience of
state abuse is usually the catalyst for political action among prostitutes.
Such abuse weighs heaviest on the most oppressed and most visible of
sex workers, in particular street workers, women of color and drug ad-
dicts; nonetheless, anyone accused of being a whore is vulnerable to
institutional and social mistreatment. It might be added that our com-
mitment to prostitute self-representation does not exclude non-
prostitutes from the movement. There is need for many and diverse
people to speak, not only about the oppression of prostitutes but also
about the effect of the whore stigma and anti-prostitute laws on their
own lives. The International Committee for Prostitutes' Rights is a
first person movement.

Political Supporters

There are definitely moments in a political movement when one
person makes all the difference. Annemiek Onstenk of the Women's
Bureau of the Rainbow Group in the European Parliament is such a
person. She was present during the first congress at an extra meeting
designed for a dialogue between Dutch policy-makers and prostitutes
of the ICPR. The dialogue had been organized by Jan Visser (another
person who makes a difference) of the De Graaf Stichting, Amster-
dam's Prostitution Documentation Center. That meeting was interest-
ing in itself, mostly as a model of interaction between prostitutes and
politicians. A representative group of prostitutes sat at a forum table

and an audience of diverse policy-makers were invited to pose questions. After the meeting, Annemiek Onstenk walked up to me and said, "I have decided to make prostitutes' rights my priority at the European Parliament." And so she did. She deserves total credit for bridging the ICPR and the Parliament. Her close allies at the parliament, in particular Annette Goerlich, Margret Krannich and incoming Dutch parliamentarian Nel van Dijk, responded to her convictions with the support that opened the parliament's doors to prostitutes from sixteen countries at the Second World Whores' Congress.

G.P.

WORLD CHARTER FOR PROSTITUTES' RIGHTS
International Committee for Prostitutes' Rights
Amsterdam, February 1985

LAWS

Decriminalize all aspects of adult prostitution resulting from individual decision.

Decriminalize prostitution and regulate third parties according to standard business codes. It must be noted that existing standard business codes allow abuse of prostitutes. Therefore, special clauses must be included to prevent the abuse and stigmatization of prostitutes (self-employed and others).

Enforce criminal laws against fraud, coercion, violence, child sexual abuse, child labor, rape and racism everywhere and across national boundaries, whether or not in the context of prostitution.

Eradicate laws that can be interpreted to deny freedom of association or freedom to travel to prostitutes within and between countries. Prostitutes have rights to a private life.

HUMAN RIGHTS

Guarantee prostitutes all human rights and civil liberties, including the freedom of speech, travel, immigration, work, marriage and motherhood and the right to unemployment insurance, health insurance and housing.

Grant asylum to anyone denied human rights on the basis of a "crime of status," be it prostitution or homosexuality.

WORKING CONDITIONS

There should be no law which implies systematic zoning of prostitution. Prostitutes should have the freedom to choose their place of work and residence. It is essential that prostitutes can provide their services under the conditions that are absolutely determined by themselves and no one else. There should be a committee to insure the protection of the rights of prostitutes and to whom prostitutes

can address their complaints. This committee must be comprised of prostitutes and other professionals, like lawyers and supporters. There should be no law discriminating against prostitutes associating and working collectively in order to acquire a high degree of personal security.

HEALTH

All women and men should be educated to have periodical health screening for sexually transmitted diseases. Since health checks have historically been used to control and stigmatize prostitutes, and since adult prostitutes are generally even more aware of sexual health care than others, mandatory checks for prostitutes are unacceptable unless they are mandatory for all sexually active people.

SERVICES

Employment, counseling, legal and housing services for runaway children should be funded in order to prevent child prostitution and to promote child well-being and opportunity.

Prostitutes must have the same social benefits as all other citizens according to the different regulations in different countries.

Shelters and services for working prostitutes and re-training programs for prostitutes wishing to leave the life should be funded.

TAXES

No special taxes should be levied on prostitutes or prostitute businesses.

Prostitutes should pay regular taxes on the same basis as other independent contractors and employers, and should receive the same benefits.

PUBLIC OPINION

Support educational programs to change social attitudes which stigmatize and discriminate against prostitutes and ex-prostitutes of any race, gender or nationality.

Develop education programs which help the public to understand that the customer plays a crucial role in the prostitution phenomenon, this role being generally ignored. The customer, like the prostitute, should not, however, be criminalized or condemned on a moral basis.

We are in solidarity with all workers in the sex industry.

ORGANIZATION

Organizations of prostitutes and ex-prostitutes should be supported to further implementation of the above charter.

SECOND WORLD WHORES' CONGRESS
AT THE EUROPEAN PARLIAMENT
Brussels, October 1-3, 1986

The next three chapters present congress sessions on human rights, health and feminism. Position papers drafted by the ICPR on those topics follow the transcripts of each session. This event was the culmination of organizing efforts in the European Parliament, in the international women's movement and, most essentially, in communities of prostitutes.

ORGANIZATION

In the European Parliament, Annemiek Onstenk introduced the ICPR charter and the politics surrounding it to her colleagues in the Rainbow Group and also to her colleagues in the Socialist Fraction. During the spring of 1986, a Dutch feminist parliamentarian of the Socialist Fraction, Hedy d'Ancona, drafted a resolution on violence against women. Whereas most feminist texts on violence against women include prostitution as a form of violence, d'Ancona's text respected the ICPR's differentiation between prostitution per se and violence against women in the context of prostitution. The d'Ancona resolution (document A2-44/86) reflects prostitute demands for self-representation and for rights and protections as ordinary citizens:

National authorities in the [Common Market] Member States [should] take the necessary legal steps:
a) to decriminalize the exercise of this profession,
b) to guarantee prostitutes the rights enjoyed by other citizens,
c) to protect the independence, health and safety of those exercising this profession,
d) to reinforce measures which may be taken against those responsible for duress or violence to prostitutes, notably those forcing women to practice this profession for their own financial gain,
e) to support prostitutes' self-help groups and to require police and judicial authorities to provide better protection for

prostitutes who wish to lodge complaints against pimps in or-
der to reduce their fear of being threatened by them.

And further, the European Parliament "considers that Member
States' policy with regard to prostitution should come within the
framework of policy on emancipation and that when establishing pol-
icy on prostitution the women concerned should be involved in the
deliberations."

Clauses were added for the protection of children, for the rehabil-
itation of drug-addicted prostitutes and for the re-training of
prostitutes who leave prostitution. However, the resolution was not
adopted without the following phrases, both of which revert to a defi-
nition of prostitution per se as violence and to an abolitionist rather
than an emancipatory perspective:

> . . . the existence of prostitution represents a further form of ex-
> ploitation of women. . . . [And, the European Parliament] urges
> the authorities of the Member States to give support to organiza-
> tions whose aim is to prevent women from taking up prostitution
> and to help those who have already taken it up to leave the profes-
> sion.

The document is ambiguous, if not contradictory, in supporting
both the right of women to work as prostitutes and the right of orga-
nizations to prevent women from working as prostitutes. Nonetheless,
working women took the resolution's support for self-organization
seriously and so did the European Parliament. The Green Alternatives
in the Rainbow Group (GRAEL) invited Margo St. James to speak at a
hearing in Strasbourg in June, 1986, on the violence against women
resolution. Her presence in parliament presaged the whores' congress
four months later.

After much discussion, GRAEL invited the ICPR to hold the
whores' congress on human rights, health and feminism at the Euro-
pean Parliament and offered their full organizational support. That
support meant the availability of critical resources, including simulta-
neous interpretation in six languages, some travel money for "Third
World" prostitutes and a half year of labor from the Women's Bureau
of the Rainbow Group. Most significant, GRAEL sponsorship meant
European institutitonal backing for the "decriminalization and destig-
matization of prostitutes" (press release, September 28, 1986).

We also solicited logistic help from two feminist organizations in
Brussels which would provide housing and facilities for informal meet-

ings. The first group was the Women's Organization for Equality (WOE), an international feminist group. Ten years earlier, WOE had supported the International Tribunal on Crimes Against Women. WOE coordinator Marijke Harst initiated contact with the ICPR for lectures on prostitution before we knew that the congress would be held in Brussels. The topic of prostitution was as slippery within WOE as within most feminist groups; due to controversy about whether feminists should support whore rights, the group decided that *members* of WOE rather than the organization as a whole would lend their name to our cause. Also for those members, participating in the conference and meeting prostitutes for the first time raised many ambivalent feelings (see "The Big Divide": Feminist Reactions to the Second World Whores' Congress).

The other feminist organization involved in the congress was 29, Association Rue Blanche, the beautiful women's center in which WOE held their meetings. The President of the Association, Mousa Winkel, took great interest in the whores' struggle. She succeeded in securing a grant from the Belgium Ministry of French Cultural Affairs to cover rental and staff expenses for our evening facilities.

Amsterdam remained the coordinating base of the ICPR. Members of The Red and Pink Threads of the Dutch prostitutes' rights movement worked to raise travel money for prostitutes, to network with prostitutes throughout the world and to formulate working papers for the congress. Mama Cash, a Dutch feminist subsidizer, granted travel money for prostitutes of color to attend the congress.

Objections to Whore Visibility in Parliament

At the European Parliament, the suggestion and then decision to sponsor a meeting of whores was neither a miracle nor an ordinary affair. Discussions were legitimized by the d'Ancona Resolution which was worded to satisfy various (even contradictory) political lines. Perhaps only the direct sponsors, the Green Alternatives in the Rainbow Group, fully realized that prostitutes themselves would dominate the congress and that legitimization of sexual labor would stand next to condemnation of sexual coercion.

The only public objection to the congress came from (1)Conservative MEPs (members of parliament); (2)The English Collective of Prostitutes (ECP); and (3)"Femministe in Rivolta" (five Italian women).

Conservative members of parliament were apparently among

those who had not realized until just before the event that prostitutes themselves would be participants at the congress. In a press release on September 17, they blamed "fringe left groups" for the "prostitutes' jamboree" and demanded "a full investigation into the use of tax-payers' money to finance a so-called Whores' Congress in the European Parliament." They were especially indignant about "an offer of assistance with fares for those who cannot afford to travel." Annemiek Onstenk responded to the angry conservatives in an interview with Brussels reporters: "They like to find whores in their beds, not in the corridors of the European Parliament."

The second protest came from the English Collective of Prostitutes (ECP). In an interview in London with *The Observer* on September 21, spokeswomen Nina Lopez-Jones denounced the second congress on the same grounds as she had denounced the first (see preceding section). English prostitutes at the congress opened their presentation with a disassociation from the ECP. One delegate from England, Lily, wrote a response to *The Observer* in objection to the ECP's misrepresentation of ICPR policies and in irritation with "their personal attacks on individuals at the First Congress and at other prostitutes' meetings all over the world. . . . The ECP does not represent the general consensus of prostitutes and feminists in this country."

A third reaction came during the press conference on the last day of the congress. "Femministe i Rivolta," a group of five Italian women, gained entry with a press card. They marched up to the front table screaming that "sex with men is rape" and throwing coins at the Italian prostitutes, supposedly as a symbolic gesture of contempt for sex workers. The audience, crowded with prostitutes and over a hundred reporters, stopped short for a few seconds until Dutch feminist Marjan Sax grabbed the leader by the arm and escorted her to the exit. Italian congress participants, including feminist prostitutes and non-prostitutes, had experienced similar disruptions from the same women in Italy. According to them, the group has no political base either among Italian feminists or among other activists.

THE SETTING: FACILITIES, SAFETY PRECAUTIONS AND SPEAKING RULES

Formal sessions were held in an elegant conference room at the European Parliament in Brussels on Rue Belliard with simultaneous

translation in French, Dutch/Flemish, English, German, Italian and Spanish. There were 120 seats arranged in a large center and two side sections; each seat was equipped with earphones for the various languages, pencil, paper and cups for the coffee and tea and orange juice that would be served during meetings. Above and surrounding the hall were glass-enclosed interpreter rooms. The aisles and window sill could hold, we discovered, another eighty or so persons, although they would be without translation facilities.

In addition to the main building of the conference hall, we had a number of smaller rooms at our disposal in a second building. We structured each day so that the press would be at one building while we were at the other. Specifically, we welcomed and registered the participants at the second building while reporters waited outside the doors of the first. We gave participants the option of walking publicly to the main building or walking with covered faces or going in total privacy through a back door and back elevator. All options were used.

Before arriving in Brussels, those enrolled in the congress received the following instructions:

Entrance Procedure

There are security guards at the entrance of the European Parliament to keep certain people **out** (such as the Belgium Police since the parliament is European and not Belgium territory) and to know the identity of those **in** the building. We have explained to the guards that the participants of our congress could be endangered or stigmatized by the usual procedure of collecting passports or identity cards at the door. They have agreed to waive that requirement, but you will have to show identification. No passport names or numbers will be recorded. We will give the guards a list of congress participants in advance. If you registered for the congress with your work name (and not legal name), that's fine. They have been told that some passports or identity cards will not correspond to the registered name. The guards have sworn that no one will have access to their list (and we will have someone of the ICPR at their side), but if you nonetheless prefer a different name on that entry list, let us know. No one will be admitted who has not registered with us in advance unless admitted by the ICPR. You will receive a card which will grant you entry to both European Parliament buildings we will be using for three days. If the above procedure worries you, call us. We take your privacy and safety very seriously.

Press

We have excluded general press from all sessions. Prostitutes from some countries have chosen to invite trusted journalists as advocates and a few part-time or retired prostitutes who are also journalists plan to write articles. **No photos are allowed by anyone during sessions**.

Mini press conferences on October 1 and 2 have been arranged in a different building than our sessions in order to try to keep the press away from those participants who want to avoid them.

At the international and national press conferences on Friday, October 3, many speakers will want to hide their identity. We ask those women to bring their own masks, scarfs or other camouflage. We also ask non-speaker prostitutes, ex-prostitutes and non-prostitutes to bring masks in solidarity with the prostitutes for whom disclosure is a physical, social, economic and/or legal risk. If only prostitutes wear masks, then more rather than less press attention will be drawn to them. For some women, self-disclosure (no mask) is a more important political statement than self-camouflage. We leave it to everyone to decide for herself.

Participants and Guests

All prostitutes and ex-prostitutes are welcome to participate actively in all sessions of the congress. Non-prostitute advocates are invited to listen and to contribute information or experiences when asked to do so by the prostitutes/ex-prostitutes; if you are not working or have never worked as a prostitute (meaning sex worker in any part of the industry), then you are a guest.

The center section of the conference hall is reserved for participants and for a few guests who are specially invited. We expect the center section to be 80% pros and ex-pros [it turned out to be 100% pros and ex-pros]. The side sections are for guests who are asked to remain silent [pros sometimes sat on the side for lack of space in the center]. Only Thursday afternoon, the session on prostitution and feminism, will be open to discussion among all women, participants and guests.

The first priority of the International Committee for Prostitutes' Rights is giving **voice to whores**.

SESSIONS

Prostitution and Human Rights

The first full day of the congress was devoted to presentations on human rights violations in each country. Terry van der Zijden, Dutch prostitute, facilitated the meeting. Given our time restrictions, we had to limit each report to fifteen minutes. Of the eighteen presentations, fifteen were made by prostitutes themselves; reports from Ecuador, India and Vietnam were made by prostitute advocates. Advocates were asked to divide their time into five minute presentations and ten minute discussion periods in which prostitutes could ask questions according to their interests. That procedure, as all others, gave the voice and control to whores. In some countries, such as Germany and Switzerland and Australia, the laws and practices are drastically different in different cities. Delegates planned in advance whether to deliver one fifteen minute report or whether to divide the time between three or four speakers. In the case of France, Swiss prostitute Grisélidis Réal presented for her French sisters who were unable to attend. French women were well-represented at the first congress and continue to work with the ICPR. The Belgium report comes at the end of the session because only then did a Belgian prostitute speak out. Her presentation led to a plenary discussion about the conspicuous absence of more local sex workers. We had contact with a number of Belgian prostitutes who came to the informal evenings but who did not participate in public debate.

Country reports are presented here in the order of their actual delivery at the congress. An alphabetical presentation might be easier to follow but I've nonetheless chosen to stay with historical reality because a few speakers refer to a prior speaker and because certain ordering decisions, such as prostitutes speaking before non-prostitute advocates, were political in nature. Reports on Vietnam and Sweden as well as additional reports on France have been added from the first congress since those representatives were not present in Brussels.

Prostitution and Health

Due to the world AIDS crisis, health was a highly charged topic at the congress. Gloria Lockett, United States prostitute, facilitated the meeting. As in other sessions, prostitutes were the primary speakers for the health discussion. Invited researchers and medical prac-

titioners also played an important role. In editing this session, topics have been rearranged for the sake of clarity and cohesion. A short supplementary chapter on HIV infection and prostitute women has been added which is drawn mostly from the Fourth International Conference on AIDS.

Prostitution and Feminism

The feminism session was open to more women than the other sessions. Aisles and window sills were crowded and some women shared seats and earphones. Margo St. James and I facilitated the meeting. As with the other sessions, the poignancy of the event loses some intensity in the translation from tape to print. Many prostitute participants identified as feminists although most felt unwelcome in the women's movement. Non-prostitutes spoke very little. Later that evening at the Rue Blanche Association, discussion groups between prostitutes and non-prostitutes gave all women more opportunity to talk. Several weeks following the congress, feminists of the Women's Organization for Equality (WOE) met to discuss their reactions to the congress as a whole; those reactions are transcribed in the chapter entitled "The Big Divide."

Press Conference and Strategy Meeting

The main press conference was held the third morning of the congress. Guards at the European Parliament said that more journalists attended than for the visit of the President of the United States. The ICPR and the European Parliament have hundreds of articles in their archives which were published on every continent. Those articles were based on the main press conference, two mini press conferences and numerous privately scheduled individual and small group interviews. On the afternoon of the third day, following the press conference, congress participants met to discuss future strategies. Participants decided to hold regional meetings before the nextWorld Whores' Congress and to publish a newsletter. Outreach to more prostitutes of diverse circumstances was reaffirmed as a priority, especially outreach to migrant prostitutes and prostitutes in developing countries.

Since prostitution is illegal in many countries and since prostitutes are subject to profound abuse all over the world, naming the speakers at the congress could jeopardize their safety, social standing and

livelihood as well as that of their families. All participants have therefore checked their citations for information that could be used against them or their loved ones and decided whether to use their own names or to protect themselves with pseudonyms.

G.P.

HUMAN RIGHTS: "SIMPLE HUMAN RESPECT"

Nel van Dijk (Netherlands): I wish you all a very warm welcome. We are here as guests of the GRAEL, the Green Alternative European Link in the Rainbow Group of the European Parliament. Our group is extremely happy to be able to arrange this conference together with the ICPR. The European Parliament adopted a resolution on women's rights, the d'Ancona resolution, in which there are several paragraphs dealing with the rights of prostitutes. We are here to hear testimonies about violations of those rights. When it concerns prostitutes, human rights hardly exist. The GRAEL will do its best in the European Parliament to use all the means available to it to improve the situation of whores. That means obviously working to decriminalize prostitution via legislation. Also, we must work to eliminate the present stigma on prostitutes. In order to change the mentality of people, we have to increase dialogue between whores and politicians. We hope that such dialogue will take place not just in the working situation of prostitutes but in this kind of conference.

Margo St. James (U.S.A.): It is such a thrill, that's the only word I can think of, to be here and to finally have a voice, to be welcomed in parliament, especially by the women parliamentarians, although there are not that many. We are here to forge alliances, to list our grievances and to work for change . . . in our lifetime, let's hope. I think our being here represents a great step forward. I see this as the beginning of the mass movement that is so long overdue for prostitutes' rights. Hopefully, this meeting will help prioritize our rights in each country. And next time, wherever and whenever it might be, I hope we have more than the eighteen countries represented here today. Maybe the condom companies will fund that meeting.

This session is about violations of human rights, racism and institutionalized discriminations that work against prostitutes. We are here to talk about the violence that we feel and know in our hearts is promoted by criminal sanctions and regulations used against us. Be-

fore we start with the country reports, I want to introduce Gail Pheterson who built the alliances that are responsible for this event.

Gail Pheterson (U.S.A./Netherlands): After the last months of intense preparations in many countries, I congratulate all of us, even before we begin, for being here. I appreciate what many of you went through to make it possible to come and the risk you may be taking by participating in a whores' congress. Besides everyone here, there are many prostitutes and ex-prostitutes who wanted to attend but were prevented from doing so. Either they were unable to afford the travel or loss of work time or they were not allowed out of their country or they were at too great a risk of social stigma, physical abuse or loss of child custody. There are also many non-prostitutes who wanted to attend but for whom there is not enough space. We have a broad base of support outside this room. People are waiting to hear prostitutes speak about their lives and their politics.

During the last weeks, I realized that this is a major transition, an historical one. Up until now, the prostitutes' rights movement has been predominantly the voice of a few courageous spokeswomen. We are now moving into a genuinely grass roots movement of diverse and often isolated sex workers. Also, the increasing commitment of non-prostitute women to whore rights is an historical sign of the growing awareness that every woman's freedom is tied to the freedom of prostitutes.

The whores' voice is going to dominate this meeting, as it should. Those people on the sides, mostly women, have been invited as silent, but not as neutral, guests. Their presence, like mine, is an affirmation of whore dignity in behalf of all women.

Before turning to the country reports, I want to thank our interpreters because there is no way that we, divided by language barriers and yet united in purpose, could be talking together without them.

ITALY

My name is **Pia Covre**. I am the Secretary (Director) of the Italian Committee for the Civil Rights of Prostitutes. Our association fights *for* decriminalization of prostitution and *against* stigmatization of prostitution for anyone involved, such as gay prostitutes, transsexuals and so forth. We have all sorts of people supporting our committee including people entirely outside the trade. I'll just give you an idea of the situation in Italy today and of how we girls work.

Houses of prostitution were closed by law in Italy in 1958. The battle in Parliament for their closure was led by a socialist woman, Senator Lina Merlin, who opposed state exploitation of prostitution and who saw brothels as prisons where prostitutes were forced by law to live. It was a difficult battle with strong opposition from both Catholics and Marxists. The Merlin Law, as the 1958 Act of Parliament is commonly called, is still in force. It closed the brothels, which was an important reform, but, due to the climate of compromise in which it was passed, the law is flawed by contradictions. We prostitutes have asked that it be modified because of these inherent contradictions. On the one hand, the law sanctions prostitution unless it involves bothersome soliciting; on the other hand, it reserves a stiff penal treatment for anyone who favors or exploits prostitution. In effect, this law as well as other laws to which I shall refer, favor the repression of prostitutes. An article of the law states that "anyone who in any manner whatsoever favors or exploits the prostitution of others" is liable to punishment (about two years in prison) for aiding and abetting prostitution; this includes anyone who accepts gifts coming from the practice of prostitution or who accompanies the prostitute to the place where she works, even if only a passing motorist accompanying a hitchhiking prostitute free of charge.

Although prostitution strictly speaking is not unlawful, the married prostitute cannot contribute like other married women to meet the needs of her family with her earnings as this would make her husband liable for the crime of exploiting prostitution. For the simple fact of being paid with the earnings from prostitution, a baby-sitter working for a prostitute also commits the crime of exploitation (if she knows her employer is a prostitute).

Further, the prostitute cannot stipulate rental contracts "to prostitute herself," as the contract would be considered unlawful. If she signs a normal rental agreement for living purposes, but uses her apartment for business, she can be evicted for having altered the purpose of the rented dwelling. If the apartment owner rents the flat to one or more prostitutes, knowing that they will be practicing prostitution in it, he makes himself liable to grave penalties. And the hotel owner or manager who allows the use of his premises by prostitutes with their guests will also be potentially open to the same penalties before the law. In all these cases, the owner of the building and the hotel manager risk prison terms, seizure of the premises, and closure of their businesses (in addition to disqualification from holding public of-

fice). Thus, it can be seen that prostitution, while not a prohibited activity, is almost impossible to practice legally and anyone who associates with a prostitute runs serious risks of legal punishment.

Obviously, we carry on just the same, but we are subject to all sorts of blackmail. The police can threaten to arrest us, or not, for "enticement to licentiousness" (soliciting) or "obscene deeds" or whatever; it depends entirely on the indulgence of the policeman. This makes the whole situation very precarious and unpredictable; if a policeman lets you go one time, he may still come back in five minutes and arrest you.

Moreover, there are Public Order police laws in our country of a very fascist nature passed in 1956 which are deplored by democratic magistrates and intellectuals. Those laws declare that street prostitution is a practice "contrary to public morals and common decency." The chief of police can officially warn a street prostitute to "change her life." Once you have been "warned," you are in serious danger and you can get all sorts of civil rights withdrawn from you: they can cancel your driver's license, for instance; and, if you are not a resident in the city you're in, you can be ordered to leave and to return to the city you come from; and, if you're not a resident in Italy, then you can be just kicked out of the country. If the prostitute does not comply with the expulsion or repatriation order, which is valid for three years, then she can be arrested. There are specific courtroom procedures whereby the prostitute can be held even if she has not broken any of the provisions of the law. When the charges brought against her are unprovable or unfounded, they can be substituted by other charges resulting in an endless case and a criminal record.

Another thing in Italy is that the approach of the police ranges widely from one region to another and from one police chief to another. And various commissioners determine how they are going to interpret the law and how they are going to apply it. Well, this situation is no longer acceptable. A state must decide if an activity is legal or illegal and regulate its practice, but it cannot repress it indirectly by denying the civil rights of prostitutes in areas that are constitutionally guaranteed such as freedom of movement and freedom to have a family. Clearly, a state has the obligation to fight against real and violent exploitation of persons but it should not make moralistic pronouncements. The state cannot declare prostitution legitimate in theory and then make it impossible to practice before the law. This is unjustified and unacceptable to us. This inevitably creates situations of abuse,

vexation, social disruption, illicit concessions, and sudden arbitrary repressions. You cannot have this threat hanging over the head of somebody carrying out their daily activity.

During the last few years, prostitution in our country has changed considerably. The number of women working the streets is decreasing and, especially in the big cities, they are partly replaced by transvestites and transsexuals. The new young recruits of female prostitutes are mostly drug addicts (heavy users of heroin and cocaine). A good forty percent, I think, of the prostitute women working the street are now drug addicts. Many clandestine houses of prostitution have sprung up since the closure of the brothels. Women work there who would never be suspected, like students and middle-class housewives who occasionally resort to prostitution for greater financial independence.

There is also a circuit in the trade which provides a rotation of prostitutes among the various houses in Italy every fifteen days. The prostitutes in this circuit are generally very young, sometimes minors, many of them foreign girls from African and South American countries. Working full-time, these girls yield large profits for the house managers, circuit organizers, and those who guarantee protection and cover from the institutions.

There is less and less control of streetwork by the rackets because drugs make more money for them than prostitution. There is a minimal degree of organized crime in the big cities, particularly Genoa/Milan/Rome, which encourages the import of foreign women to exploit them, mostly in prostitution.

In all cases, the status of prostitutes is always at the limits of legality, and, as a consequence, prostitutes are often subject to extortion and exploitation. Presently, the most vulnerable elements among them are the prostitutes with a drug habit. They are subject to extortion from their clients, with whom they are often unable to assert their will due to their condition, and they are doubly open to police blackmail because the police can harass them both as drug addicts and as prostitutes. The drug-dependent prostitute often does not respect the rules of the market and in this sense creates very serious problems for all the other prostitutes.

Transvestites and transsexuals are less exposed to exploitation by racketeers and pimps, but are subject to an awful lot of extra violence by both hooligans and police who feel their masculinity is being attacked. It's a question of mentality, a fear of sexual diversity.

Also, the police exercise control with their files which are illegal since the law on prostitution forbids any police or health files on prostitutes.

Every year, many prostitutes are murdered by maniacs. In the course of their investigations into these murders, the police carry out raids and inquisitions among the girls, almost as if wishing to show that we are killing each other off, that we are freaks and criminals, and that brutal murders occur only among us and not in the so-called "civilized" society.

It is a sad fact that society is becoming increasingly violent and that this violence also emerges more frequently in the institutions. Those who pay are always the weaker elements at the margins of society. This does not only involve violence of a physical kind, and it does not always come from private citizens. I am thinking, for example, of the institutional violence against prostitute women when they are denied custody of their own children on moral grounds. This is the same moral matrix as genocide by famine, robbing of resources, nuclear threat of war and radioactive waste, and destruction of the environment. We reject those morals.

Since 1982, our group has been asking for changes in the existing law, and in particular for the abrogation of the crimes of enticement [soliciting] and of aiding and abetting prostitution ["pimping" and "pandering" by consensual contract to be distinguished from "pimping" by force or deceit]. And, we have asked that restrictive police measures, such as banishment to one's home town, be no longer applied against prostitutes.

Our principal objective is the respect or, better, the realization of what is proclaimed in Article 3 of the Italian Constitution, which in fact guarantees the "equal social dignity" of all citizens, without distinction due to sex or personal or social conditions.

AUSTRALIA

My name is **Roberta Perkins** and I am a representative of the Australian Prostitute Collective which is based in Sydney, Melbourne, Adelaide, more recently in Perth and Darwin, and until very recently, also on the Gold Coast in Queensland. The Australian Prostitutes' Collective was formed three and a half years ago as I lobbied for decriminalization. Decriminalization has been our basic aim from the beginning.

Recently we in Sydney were fortunate enough to receive a rather

substantial grant from the state government and the commonwealth government on matters of health. My colleague, Julie Bates, will speak tomorrow more fully about that particular aspect. I will concentrate here on the situation in Australia, legally, and I will concentrate on activities of the law enforcement in each state and territory in Australia. I will proceed by drawing a general outline of the legal situation. It is extremely diverse from state to state. There are six states and two territories and they each have very different sets of laws to control prostitution and they control through the law enforcement in very different ways. I will not have the time to cover all of those. Let me just say very briefly that four states (namely South Australia, Queensland, Tasmania and Western Australia) and the two territories (the Australian Capital Territory and the Northern Territory) all have laws to do with criminalizing people in various degrees who work in prostitution. The most repressive state by far is Queensland; the least repressive it seems at the moment is the Australian Capital Territory. Of the two remaining states, Victoria and New South Wales, Victoria has at the moment a kind of legalization or regulation type system in which people can work in prostitution only if they work in a brothel. And that is the legal term in that state: "brothel." They have received a permit through the state government that permits them to work. Anyone else that does not work within that particular system, the permit system, is considered to be working illegally and they are subject to very stringent laws with very steep penalties.

Now the remaining state, New South Wales, is by far the most progressive of all the states in Australia and it would seem that it is amongst the most progressive legal systems at the moment in the world. In 1979, a largely left-wing oriented state government decided to reform the laws on prostitution so virtually overnight we saw a change from an extremely repressive system. To give you an example, in the 1960s some five hundred women working in prostitution were receiving penalties at the rate of 10,000 arrests a year in Sydney alone; after 1979, the legal system was basically decriminalized. What it meant was that people could work in any type of prostitution in New South Wales. But there were certain laws which were forgotten in the great rush for reform. For example, there are certain areas where people can't work on the street. By and large, it's okay. People can go and work on the street if they want to. But you can't work in front of a ground floor dwelling; you can work in front of an upstairs dwelling.

Nor can you work in front of a church or a store regardless of whether that church or that store are occupied or unoccupied. And you can't work in front of a hospital. But people do work in front of a hospital. And there's even an example of one hospital where the nuns who run the hospital actually take cups of coffee out to the workers outside who happen to be male prostitutes. But in other areas, the police keep a close eye on things to make sure that the workers don't spill over from a commercial area or shopping center into a quiet residential area, particularly an area of middle-class trendies 'cause they don't like it very much.

Now I will just outline very briefly what happens in Sydney. In Sydney, there are at any one time about a thousand women who work in various forms of prostitution. About one third of those work in the inner city part of the metropolitan area which is very well known as the unofficial red-light district. The other two-thirds work in various suburbs of the metropolitan area. There could be at any time up to about two hundred males who work in prostitution. That includes about five male parlors and a couple of areas where they work on the streets. Male prostitution is much more casual than female prostitution; the men kind of cross over from prostitution to non-prostitution activities without a great deal of difference. There are about twenty, perhaps somewhat more, transsexuals who tend to work in a particular area at any one time. About every kind of prostitution you can possibly think of is carried out in Sydney: There are streetwalkers; there are a large number of women who work in parlors (they're called parlors rather than brothels but they are brothels); there are a number who work independently, the call girl type (to use an American expression); there are those who work in hotels; I mean they work just about anywhere. About two-thirds of women work indoors such as in parlors. At the moment there are about ten percent who work on the streets, mainly in two areas, and about eighty percent of those women work because they have a drug addiction.

Now for the police activities. Although the New South Wales police have jurisdiction over Sydney and over a number of other towns on the East Coast, they really have very limited powers over prostitution. They can't, as they used to in the old days, go around indiscriminately and charge and arrest women as they feel like it and hold out their hands for freebies and also for money and things like that; they don't do that quite so much anymore. Unfortunately, there seems to be

some kind of collaboration between the more powerful parlor owners and the police, and the police do get paid, we know that. But the women that have the most freedom tend to be those who work on the streets, those who work independently rather than in the parlors. The one complaint that we have about the police, and it is a nagging complaint, it goes on and on, is that the police provide the women no protection whatsoever. Last year there was a series of very bad outbreaks of violence, particularly against women working in one particular area on the street in Sydney.

We asked about twenty-three streetworkers what kind of violence they received over the last six months and they gave us examples of twenty-six really outrageous forms of violence like women being lassoed and dragged behind a car. And some women actually have disappeared. A lot of this was the work of three men who were doing all the damage. Now in February these same three men murdered a woman who wasn't working in prostitution (not at that time anyway so far as we know); she was a nurse and she was an ex-beauty queen, she'd won an award as a state beauty of South Wales or something. Her body was mutilated and the press made a great deal of fuss. Even the premier of the state declared his revulsion. The three men were arrested in a very short period of time and the trial is still going on. Now when their pictures appeared in the papers, all the women we knew said, "That's the guy, those are the men who have been committing violence on us." We, the Australian Prostitutes' Collective, had been making complaints to the police about the violence and their attitude was—they said this to our face: "Look, if these women weren't here in the first place, this sort of thing wouldn't happen." They just don't care! It is very likely that these men have actually killed prostitute women. There's no doubt about it that they practiced on prostitute women before getting around to murdering non-prostitute women. So we see the contrast between the police attitude toward violence on all these women on the streets and the murder of the one single woman who was a beauty queen and how the police quickly reacted and captured those three men afterwards.

Violence is a big issue with us. We have approached the vice squad and asked them why they arrest the women. For instance, a woman who works in prostitution walks into a police station and says, "Look, I've been raped" or assaulted or something like that and she wants to give a description of the perpetrators. Invariably what hap-

pens is that the police immediately press a button on their computer files, ask for her name, and find some misdemeanor or something in the past and they arrest her on the spot in the police station. This goes on all the time. So, what we the Australian Prostitutes' Collective did was approach the head of the vice squad and ask him if he would have an amnesty period for women who were ready to act as witnesses for some crimes of violence and whether the police would wave the unpaid fines of the past. And his reaction was: "Look, we are policemen and this is our job and we've got to make arrests." We asked him: "What do you think is more important, the murder or rape or assault of women or the failure to pay a fine?" He said it does not matter, we have a job to do, and it is obvious that he does not care. So, what we are doing is taking action by going to the minister of police and going over his head. . . without a great deal of result, I fear.

Let me just give you some contrast with other states in Australia to give you some idea of the enormous diversity. Briefly, West Australia is a police state where the police brand the women "common prostitute" and where women who work in prostitution immediately have to register at the local police station; the police have absolute control over their lives. In Queensland, which is the most repressive state of all, the police pick women up on a rotation system, like every week a woman has to be arrested somewhere. In South Australia, the times are changing. They're heading for decriminalization but the police are a bit angry about all this and they're doing what they can to get in before they lose their power. They have been known in South Australia to torture women; we know of a couple of cases where they've thrown prostitutes on fires and burnt them with their cigarettes and stuff like that. In Queensland, incidentally, there was a very strong independent woman who refused to budge to police rule and we know, though it is certainly not documented, that this woman was murdered and everybody knows that she was murdered by the police, and, of course, you know, nothing is done.

Finally, very briefly, the police in the Australian Capital Territory on the surface seem to be very good even though there are laws that say that you can't work, you can't solicit, you can't do this or anything else. Still, there has not been an arrest for prostitution since 1978. The police do keep a keen eye on prostitution businesses and exercise their powers of entry periodically.

°

AUSTRIA

My name is **Frau EVA**. I was born in Vienna. I have been in the business for eleven years and I founded the Austrian Association of Prostitutes. We organized in order to have a voice with public authorities.

Austria, like West Germany, is a federation of states. Prostitution politics differ from one state to another. In Vienna there are toleration zones and toleration times for prostitution. Prostitution is allowed only when it is dark outside and only in the police-controlled neighborhoods. Also, prostitution is allowed only in houses where no one lives, not even the prostitutes themselves, and only in areas where no kindergartens or schools or churches are nearby and where it is not too settled. Registration with the police is required including registration of your work place. If you decide to de-register, it takes five years to get a letter of good conduct, something required for various jobs such as nursing or driving a taxi. The registration includes a photo, just like with criminals. This is one of the things we want to eliminate.

If women are caught working without being registered, they can be fined or, if they don't pay the fine, given prison sentences. The maximum sentence is really high. If you are caught working outside your registered zone and you are registered, then the penalty is much lower than when you are working illegally. But, if you don't pay the fines as a registered prostitute, then your work permit is taken away.

Prostitutes have to carry a little book when they're working that records weekly required medical checks. If you are shown to be sick, then your book is confiscated and you are not allowed to work. The police can demand to see your book anytime. At present prostitutes throughout Austria are also required to get a monthly AIDS test. If they fail to comply, they are fined up to the equivalent of $7,000 or given a prison sentence. There is no real choice of doctor because the AIDS test is free only when done by a state-designated agency.

Taxes are a major problem for us. There is a constitutional law which says that income from prostitution is commercial income. But there is also an administrative law that says that prostitution cannot be considered a trade in the sense of the trade law and that therefore no commercial activity is involved. Our association hopes to get a lawyer and to get a real court decision on this contradiction. Taxes are usually fifty-four percent of gross income. Not only are we taxed, but we are taxed more heavily than other people since our income is overestimated. We don't have receipts and we are allowed few deductions.

The financial office objects to our estimates of what we require for living expenses and then, for example, the police collect clandestine fines. They tell me what kind of money I need to live and this is just absurd, I'm sure you will agree. And, despite the high taxes we are made to pay, they deny us representation and deny us social benefits. So, many women work illegally and avoid registration.

Our association strongly opposes the hypocrisy of making prostitution legal in relation to taxes, while denying social rights to prostitutes. What we want to do is to build a life for ourselves that will be based on a proper social production plan. But we are being stopped in this by the police and by public authorities. The most important objective of our association is a health insurance law and an old age protection scheme. We've asked for support from various levels in the government, the social ministry and so on, but we are not taken seriously. No one can say that we are entirely asocial since we are definite taxpayers. And we should have the same rights as other taxpayers. We have absolutely no rights, everything is dictated to us by the law. All of this is of course unconstitutional. With married prostitutes, the law says that the husband takes everything that goes beyond normal living expenses as a kind of gift for tax purposes.

We have no official representation as a business so that public authorities cannot deal with us as an association. We have absolutely no financial support from any sides so the association is able to get by only from members' fees. We are considered to be living an immoral life, therefore to be people with no official status in relation to the government. And so, in many areas of the country, people who work in this trade are forced to submit to these very difficult and unfair conditions. There were about 6000 registered prostitutes in Vienna, but with taxes and so on there are only 3500 now and they are all working off the books, sort of moonlighting. In parts of Germany, you have two-thirds of the prostitutes who are afraid of the tax office, whose lives are made difficult by the tax people.

What else can I tell you? The press came to the foundation of our association but were not interested in our problems at all. All they did was use cliches to get people in front of the tv screen and to sell newspapers. When we were invited to be on tv, I said that I hope to have serious discussion with the authorities. What they said was, "We don't want any technical discussions." So I said that in that case, I won't go.
Brigitte Pavkovic: I had to give up my activity as a prostitute in order to keep the custody of my daughter. Why cannot a prostitute be a

mother? I had to leave my home since there were three of us working in my house. So I had to rent a house very far away in order to be able to keep my daughter. Why may a prostitute not be a good normal mother? I chose this profession for my own reasons, without any pimp, without any man. I got myself a house and now the financial authorities are slapping on back taxes, going back to 1983. And, in this way, I cannot have any savings, I must work off the books, and as a woman with a child, I'll be left with nothing, no pension and I will have nothing to show for all my work.

THAILAND

Hello, my name is **Sai**. I am very very happy to sit here and see other prostitutes from all over the world. Right now I want to speak about my story, what I have experienced and what I have seen. I started to work when I was fourteen years old. I worked at a "steakhouse," an entertainment place which was half a nightclub and half a restaurant. During this time, I went out with customers only when I wanted to. I had worked there for about one year before I met one man who took me to a brothel. This man was a friend of my friend. He said he would like to show me the beach. He took us four girls. He did not take us to the beach but to a brothel and he sold us to the owner. I had to stay in that house, in the brothel. Every day I had to receive fifteen men, fifteen men. If I did not obey the owner or did not get many men, I got beaten. I could finally escape from that brothel because one man helped me.

I would like to speak about my work now. I am working in a dancing show, as a go-go dancer. I work with tourist men. I start work at six o'clock in the evening and finish at two o'clock in the night. I have the day off for three days in a month. About the work, the tourist men come into the club. We earn from the drinks they buy us. When they take me out, they take me out from the bar. When they take us out of the bar, they have to pay a "bar fee," a certain amount of money to the bar owner. For our own earnings, we have to speak with the man about how much we want for the one night in the hotel. In a month, we have to have ten men who take us out and pay the "bar fee" to the bar owner. If you don't have ten men in one month, the bar owner cuts our salary for that month. The boss never takes care of us when we are sick, or when we have problems in the hotel, the boss never cares for us. This is what I see and what I think. Also the police never

help us. Most people think we are whores and so never worry and never care. This is all I want to say.

Mae: I work for the feminist group based in Bangkok. One of our priorities is to work with prostitutes, women in the sex industry. In Thailand at the moment, prostitution is a crime. It may sound unbelievable because everyone must have heard about Thailand as a paradise for sex, but it is a crime. The Prostitution Suppression Act, which was written in 1960 and is still in effect now, made the profession of prostitution a crime. Earlier, prostitution was not a crime if it was done in a registered brothel by a registered prostitute who had to go through regular medical examinations. That was before 1960. In 1960, they enacted this new act; actually, it was the pressure from the United Nations about the abolition of prostitution which has brought about the new act. Under the Prostitution Suppression Act, a woman who works as a prostitute will be arrested and given a penalty of three months imprisonment and a fine of one thousand Thai baht or given both a prison sentence and a fine. There is also a penalty for other parties involved in prostitution, except for the client. In addition to the three month imprisonment, prostitutes might be sent to a rehabilitation house for a one year program without their consent. That house is more like a prison than a helping place. So, under this law (the Prostitution Suppression Act), a lot of women have to rely on the brothel owners or on pimps and other agents who have good contacts with the local police. There is a lot of bribery going on which is why these entertaining places can operate.

Although there have been prostitutes in our society for as long as we know, the biggest prostitution boom was during the Vietnam War when there were a lot of American G.I.s at their military bases and at their rest and relaxation centers in Thailand. During that time, there were a lot of prostitutes working for the G.I.s. The Thai authorities even set up another act referring to entertainment places saying that anyone can open an entertainment place which provides women as partners for dancing or massage or escort to sit and drink and entertain the guests. The entertainment places could even provide a sleeping room for guests to lie down and relax. The Prostitution Suppression Act was and is still active but the owners of the entertainment places are not arrested because they say that they provide these facilities according to the later act. And, if sexual service is ever given in the entertainment places, the owners say that they don't know about it and

that it is the woman who did it. So, whenever the police raid these places, the women will be punished but not the owners or the pimps. In 1964, there was one nationwide survey which found that there were 450,000 women in sexual service. We estimate that there are about 700,000 women in prostitution, maybe more. The population as a whole is fifty-five million.

Talking about the situation of prostitutes we might distinguish three main types: one is forced prostitutes, the second is so-called free prostitutes and the third is migrant prostitutes abroad. Most of the first type who are forced are from the countryside and mostly they are deceived by agents or sold by their parents. The agents usually deceive them and say that they will be working in a restaurant or somewhere else other than prostitution. Often they are kept in a house of prostitution and not allowed to go out; they are given no freedom and many times little or no earnings. Like Sai just said, they will be beaten if they don't receive guests or if they don't obey the owner. And, they have to work very hard; they have to receive at least ten to fifteen guests a day. The living condition is awfully bad. Many women have to sleep in one small room without enough air circulation; they get only two meals a day (usually we have four warm meals a day in Thailand) and not enough medical care. You can get away from the forced condition only by running away or when your body is not fit to work anymore. There was one very sad case of forced prostitution: In January, 1984, there was a big fire in Phuket Island in the South, in a tourist area. The fire broke out during the day and burnt down many houses in the area where there are a lot of brothels. Most of these brothels hold forced prostitutes. Five women were burnt alive because they were sleeping after working the whole night and after taking sleeping pills. They were locked in behind iron gates and some of their bodies were chained.

Talking about working conditions for free prostitutes, most of them work for tourists in tourist areas. They work as go-go dancers and they sit with guests to persuade them to drink and to take them out. Their working places are sometimes like German beer gardens where women sit around and persuade the guests to take them out. They earn a salary which is actually the collection of the money the tourists have to pay to the bar owner. Within one month, the women have to get at least ten guests and the payment of the ten guests make up their salary. If they don't reach the minimum of ten guests, they get fired. And what they earn extra depends on their own negotiations

with their tourists. Many times the tourists do not pay the woman if they have already paid the bar owner, they do not understand the system. The women have to work quite hard because they have to work twenty-eight days a month; they have maybe two or three days off in one month. If they are absent more than the three or four days that they are allowed, even if they are sick, they have to pay the bar fee to the bar owner. Their salary gets cut every time they are absent. And, they cannot choose the clients because the bar owner can force them to go with any client even if they do not want to go with him. There is no welfare whatsoever. They have to get their own medical check-ups. Some bars have the regulation that the women have to show the examination paper every week and, if they do not have it on the day that they have to show it, they get fined from the bar.

Another place for the free prostitutes to work is on the streets. They are often harassed by the police and by the pimps.

There are also women who want to go abroad to earn their living. Some are deceived that they will earn a good salary and some do not even know what they are getting into. Even if some are ex-prostitutes, many of them want to get married and lead a so-called good life abroad in Europe. Now that this phenomenon is happening, we hope to find a way to inform the women who want to go abroad to have better information so that they can really succeed in getting what they want.

There is one last thing about the efforts among free prostitutes who wanted to organize. In March, 1984, there were a few women who wanted to organize a kind of union called the Thai Night Guard. After that effort, they were pressured by their families to stop being active because the family would lose face and the stigma was too much. Also the police had been harassing them and the bar owner where they worked tried to stop their organization. Therefore, they broke up in the end.

FRANCE

Grisélidis Réal: I am a prostitute in Geneva, Switzerland. Carole called me last night from Marseille and she asked me to represent her. She was crying because her documents were not organized, her papers were not legal, she could not leave France. She said she wanted to send a telegram. If there are not other French prostitutes here, then I will have to speak on behalf of my French prostitute friends because I have fought with them. Since 1975 and still today, I

have been fighting with them. I know the problems inside out. Carole spoke to me on the phone and I took notes on what she wanted to say.

One of the principle reasons for French prostitutes not coming to this congress is that they are so discouraged, so harassed by daily fines which are higher every day, that they have been totally demoralized. They're fed up. They almost no longer believe that the situation can improve and yet, on the other hand, Carole said to me, "We are absolutely determined to go as far as the Court of Justice, to the World Court in The Hague, to get our rights honored from the point of view of simple human respect." They are determined to tell the injustices which they are subjected to and to win recognition of the fact that a prostitute is a mother like any other mother, a worker like any other worker, a woman who does harm to no one, a woman with rights who is perfectly normal from a human point of view.

In France, the worst is not only the fines but it is also the fact that they cannot occupy working premises without the possibility of being expelled; the person who rents the locality to the prostitute is declared a pimp or someone who is pimping in one way or another. The woman may simply be paying rent in order to have a home. There are specific judgments which can be applied immediately to evict women from their areas of work and from their houses. Even if the women have saved and bought themselves a studio or small apartment, it can be taken away from them. And even the bank which has given them a loan or a mortgage can be attacked legally as a participant in prostitution. It is an absolutely untenable situation, unacceptable, and it has to change. Carole has also protested the fact that a woman soliciting on the street can be immediately fined and hit by special taxes. Then she can no longer solicit on the street even if she is not shocking anybody or doing anything at all. Even if she is simply walking on the street, she can be fined.

Another point which is extremely inhuman as far as the conditions of the prostitutes in France is concerned is that under French law a prostitute has no right to live with anyone. It's called the crime of cohabitation. If you cohabit with your son, for example, or your mother or sister or any child over-age, or friend or anybody, it does not matter what your relationship is to that person, these people are declared to be living off immoral earnings because they are living with a prostitute. Of course, anybody who is a man, whether they are a son over age or a brother or any person of the family or simply a man whom the woman loves and chooses to live with are declared pimps.

Anyone is prohibited from living with a prostitute; anyone over-age can be imprisoned because they are supposedly living off immoral earnings; this situation obviously leads to enormous costs in legal fees and so forth. The person who lives with the prostitute will be under continual surveillance and will be constantly harassed. The prostitute cannot allow herself even to have friendly relations with a man or friend simply because he will be supposed to be her pimp and to be living off her earnings. This creates problems in relationships and destroys the life of the couple. So, this is what's happening in France. This is what has been going on for years. It means that women have been condemned to absolute solitude. It is unbearable, sometimes so much so that they prefer or cannot avoid living with a man who is in fact a pimp. They become entrapped in this way by men who are not with them out of love, men who are aggressive and violent. This is because they have little choice.

Also, if the fines which are imposed on prostitutes, day and night, are not paid, the prostitutes can be imprisoned. And, the women can be brought to court and made to continue paying.

<center>∗ ∗ ∗</center>

French prostitutes at the First World Whores' Congress, 1985:
Constance: In 1975 there was the revolt of prostitutes. We had been sitting in churches. We had huge conferences in Lyon and Paris. But, ever since, nothing has changed! The French government had mandated a high magistrate to discuss with the prostitutes what could be done to improve our situation. His report was about only taxes and fines, which increase and increase all the time.
Katya: We want to be recognized as full citizens. We want to pay normal taxes, but we don't want to be fined. We want to be able to live with the person we choose to live with. In France, any man who lives with a prostitute is considered her pimp and pimping is illegal.

We learned from the press that the mayor of the second district in Paris, which is a sort of red light district, wants to reopen brothels and ero-centers. The issue was already raised in 1976 and we are against it.
Isa: Strasbourg is an Alsacian city. It is in France but it is not under the Genevian Convention; it is under the Vichy Convention. It is the city of the Council of Europe. Prostitution itself is not prohibited; it is tolerated in all places: studios, cars, hotels, etc. We do not get many fines. The police are very easy in Strasbourg because of all the diplomats. On the other hand, a prostitute does not have the right to live with a man; usually he is arrested after a week or two. There are spe-

cial police brigades which register a girl in a special dossier after three
years as a part of state and tax records. Taxes fall according to every
trick each day. The taxes are an average of 72,000 French francs a
year, which is a lot of money. It all accumulates, sometimes up to four
or even eight years. Women go to jail in Strasbourg for non-payment
of taxes. All of their possessions are taken.

WEST GERMANY

My name is **Flori**, I'm from Frankfurt. I'm an ex-call girl. I'm speak-
ing for the following organizations that are represented at this con-
gress and have elected me spokeswoman: HYDRA in Berlin; HWG in
Frankfurt; Rotstift in Stuttgart; Counselling Centre, KOBER, in
Dortmund; Women's Refuge Home, catering specifically to the needs
of prostitutes, in Hamburg; individual hookers from Essen, Nurem-
berg and Cologne.

West Germany is a federation of eleven states and within those a
multitude of cities, districts and regions have local authority. Thus
prostitution, though generally legalized all over Germany, is subjected
to a vast amount of differing laws, often conflicting and distinctly un-
centralized. This makes a statement covering all the human rights
violations in the Federal Republic of Germany and West Berlin within
the short time period we have been given slightly difficult. I shall try
to limit it to three central complaints that apply though in varying de-
grees of harshness to all of us.

The working position paper on human rights that has been circu-
lated by the organizers reflects practically all the violations we suffer
in Germany but needs to be specified. Rather than prohibition and
abolition, in Germany regulation and registration are the means and
tools used by the authorities to limit, minimize and in effect prevent
prostitution as well as criminalize and harass the prostitutes. How
does this function?

The first aspect is the "Zoning Laws" that divide practically every
German city into "off-limits" and so-called "tolerant" areas. Municipal
regulations as to when and where prostitution may take place are in-
fringing on our right to free movement. The "Tolerant Zones" are in
fact ghettos and women who operate and live in these small districts,
that might be on the fringe of the city or segregated by a wall, as in
Hamburg, may be picked up and harassed by the police if spotted out-
side these areas. It does not even have to be proven that they prac-
ticed prostitution; it is enough for them to be caught outside the

specified red-light district. Another disastrous aspect of the Zoning Laws is that they naturally limit or even determine the various forms of prostitution work that we can engage in. In Frankfurt, for example, there is a new Zoning Law which forces us to operate along deserted roads in the harbor area. This means that we cannot work in houses as many of us would like to; instead we have to do business in difficult, dangerous and unhealthy places, walking the streets or sitting in cars.

Summing this up: Zoning laws ghettoize and stigmatize hookers, whose freedom of movement may be impeded. Prostitution outside these narrow areas is illegal which serves to criminalize hookers. The placing of prostitution in specific areas stipulates limited forms of prostitution, thus infringing on our right of free choice of the kind, intensity or length of service we want to provide.

My second point is with regard to health surveillance. Germany's *Gesetz zur Bekamfung von Geschlechtskrankheiten* (Law for the Prevention of Venereal Diseases) furnishes the only legal instrument available to government bodies for registering, detecting and filing information about prostitutes. Since, as just mentioned, prostitution is legal, there should be no basis for the authorities to even attempt going after hookers, yet this reactionary law, originating in the twenties and never altered—also not by the Nazis—provides the background of many human rights violations of prostitutes in the Federal Republic of Germany. Mandatory health checks are required on average once weekly (smear test) and once quarterly (blood test). Observation of this—our—duty is carried out with utter rigidity and falls under the authority of health officials. These officials are often in alliance with other government bodies and do not only supply them with information as to the profession of citizen X but often delegates the entire health surveillance to the police, which of course results in the unbearable situation that you have cops checking the outcome of your last syphilis test or filing your finger prints in data banks alongside other "criminals."

Conclusion: Compulsory medical checks are the state's deepest invasion into the private world and rights of prostitutes. The complete destruction of our anonymity is a violation of our right to protection of personal data and provides the background to stigmatization of hookers by government authorities as well as criminalization by the police.

My third point is about the non-recognition of prostitution as a profession. Despite its legality, prostitution has never been considered

a profession and has never shared the benefits of public recognition. Our working relationships with club owners or bar proprietors are not recognized as legal, which results in the fact that we cannot get into the National Health System nor into the Government Pension Scheme. These services, just like the Unemployment Benefits, are based on regular contributions deducted from a wage packet. Without government and public recognition, workers in the sex industry cannot contribute to nor benefit from any of these institutions that form the backbone of Germany's internationally known social system.

Our summed-up demands are: NO ZONING LAWS, NO COMPULSORY V.D. CHECKS, RECOGNITION OF PROSTITUTION AS A PROFESSION.

Before two more speakers illustrate these human rights violations in the Federal Republic of Germany with tales of their own personal experiences, I would like to draw your attention to the situation and status of foreign women in Germany. I think the earlier speakers have already given you an idea of the extreme forms of degradation, e.g. slave trade, torture and abuse as well as involvement with drugs. The legal sitution in Germany is that no foreigner may be a prostitute regardless of whether from a Third World country or from the Common Market. Of course there is plenty of prostitution within both groups but their status is definitely illegal. Only marriage to a German can legalize the hooking foreigner. This is a federal law. Even Austrians are forbidden to work in Germany. One of the members of our group, an Austrian, has an entry in her passport designating her as a hooker. It reads: "Registered under paragraph XXX, Foreigner Law." This paragraph refers to prostitution. Although there is a lot of friction between German and foreign whores at home, we wish to say that we consider all laws restricting foreign women to illegal work as racist and as collusion with the business of traffickers, pimps and other profiteers. Already stigmatization of immigrant women at the borders is a shocking violation of basic human rights.

Ina Maria (Stuttgart): We have strong restrictions imposed by the police which means that we are no longer guaranteed the privacy of our homes. We are subject to compulsory health examinations which are supposed to be in the interest of the public and public health. Once I had missed my doctor's appointment and the results were not at the health office on time. So they sent the police around to my house. I was only scarcely dressed and I opened the door halfway. They pushed the door in, damaging it, entered the flat and told me to

get dressed. They stood there watching me. When my boyfriend yelled at them, they called him a "pimp swine" and beat him. As I was trying to stop them, they beat me too. Later I was taken to the health department where I was checked. Was this in the public interest?

Prostitutes in Germany should have full rights as far as work and their private lives are concerned. Why can we not have men—male friends, husbands—without them being categorized as our pimps?

Katie (Essen): In the beginning of the year I had a court case. In the nightclub where I worked, a man had spent roughly 10,000 German marks on a friend and myself as well as on alcohol. He had paid with several Eurochecks and an American Express card. The next day he sealed his bank account and the checks bounced. I took him to court. . .and lost. The court ruled that we had no right to collect that money because it was immoral earnings from an unrecognized profession and that we had acted with impure intentions when we incited the man to spend more money.

I'm sure that in other countries the same kind of thing is possible and does happen. All people in our profession should go to court when they cannot collect their money.

One last note on this subject: A man in Stuttgart thought he was charged too much money for the service he received, so he didn't pay up. When the prostitute complained to the police, they told her she should go to bed with him again so that he would be satisfied. There are also policemen in Stuttgart who arrest prostitutes in order to blackmail them for money and sex. That's how they get their freebies.

ENGLAND

Eva Rosta: I am so happy to be here and see so many of my friends [from the First Congress in Amsterdam]. I am really excited to see so much interest and support. Briefly I feel it as essential to disassociate Alex [another English prostitute representative] and myself from any connection with the English Collective of Prostitutes who have chosen to boycott this congress. Also, Helen Buckingham from a group called PLAN [Prostitution Laws Are Nonsense] who was due to come here was unable to come and I would like to make a few statements from a letter she sent us. [Helen Buckingham did manage to attend the congress beginning the second day].

Helen Buckingham was made bankrupt in 1985 by the Inland Revenue because she failed to find the money out of the proceeds of prostitution to pay their tax demands. She is the first of others in a

pipeline whose tax demands are specifically based on earnings from prostitution. She goes on to say that if governments are prepared to tax such incomes, then governments must make provisions for women to earn this money in some way which is not illegal. At the moment in Europe prostitution is either illegal or prohibited (amounting to the same thing) or it is legalized (and restricted with police control which also amounts to illegal). Helen has a quote from one of the tax collectors which we think should be made into a t-shirt: "One man is love, more than one man is work."

Until a couple of years ago, women could be put into prison for soliciting on the streets. Now this no longer happens but what has replaced it is fines double and triple the amount two or three years ago. The fines are from five hundred to a thousand pounds per citation, heavy heavy fines. And, if you don't or can't pay, you go to prison for six, nine months up to a year for non-payment.

Another new law is that of "curb crawling" which gives the police the power to stop men in cars or if they are walking by the side of the road. What has in fact happened is that the new law has given even more power to the police to harass particularly the black and immigrant community in England. A few years ago, we had another law called "sus," which allowed the police to arrest you on the spot if they *suspected* you of being on the verge of committing a crime. That law was scrapped but now it has been replaced by the curb crawling law so it's the same thing with another name. In the last few years, under the Tory government, these police powers have really vastly increased. Another issue which is quite prominent is that of "immoral earnings." A prostitute cannot live with a woman, whether she be her cleaner or her sister or her cohabitant or another working girl; it is considered to be a brothel. Two women living together who are known to be prostitutes is brothel-keeping. A woman cannot live with a man who is over eighteen years old whether he be her son, her lover, or her brother; he can be done for living off her immoral earnings. And, a lot of prostitutes are losing custody of their children. They also confiscate the property of prostitutes, saying it has been bought with illegal money. And yet in England it is legal to be a prostitute but you are not allowed to get the work—you've got to live alone and you've got to do it by telepathy. I think the case of the Yorkshire Ripper highlights very clearly the stand that the police, the law and the press take: The murder of a prostitute is not such a bad thing; to murder a "good" girl is a crime, but a whore, well maybe it's not so bad. In the last two or three

years, particularly in London, there has been a massive cleaning up, especially on the streets. Women have just vanished off the streets of the big red-light district of King's Cross which is in central London. The residents have made a big fuss about it, they don't want to see the prostitutes anymore. The prostitutes are being moved from one district to another. In Southampton, every time there is a new council, they start talking about forming a legalized red-light district, Eros Centre style, but then the idea fades away. Nobody seems to want to do anything. But, of course, we don't vanish, we don't disappear despite the clampdown on the streets and in the agencies (because many of the agencies have closed down). Women have now started finding new ways of getting around these laws and problems. They started putting adverts up as masseuses in newsagents. Massage parlors have now become a way for whores to work. It makes a good cover, a good front. Many of these businesses are run by men and their families, men and women, mothers and fathers. And some of them are really rip-offs. Women are working in these massage parlors having to pay exorbitant fees to the owners of the business, having to pay for their drinks, for the towels, for the oils, for their soaps. . .pimps, pimping. A lot more of the underground people, criminals, have entered into the business in London especially where the cocaine drug business has increased phenomenally in the last year; a lot of these gangsters have tried to move in on the whores. And there has been an increase in violence, a lot of shootings, a lot of killings, and of course the police love it, they don't have to do any more work.

My last point is about the skills and talents of women and the main skills we whores gain through our work. I myself now am working, am trying to establish myself, as a sex counselor for women. I am also providing sex education counselling services for disabled people. A lot of my knowledge and my experience and my education have come through working as a whore. But, of course, I cannot come out and say this in public. What credit would I get as a whore who is a sex counselor? People just can't understand it and yet, I really would like to have the credit and the respect that goes with both jobs.

CANADA

Danny Cockerline: I want to give you a brief history of the group that I am a member of. It is the Canadian Organization for the Rights of Prostitutes and is based in Toronto. It was founded by Peggie Miller after she was busted on a "bawdy house charge" (bawdy = obscene,

indecent) in 1983. The group meets about once a week. One meeting per month is devoted to a project for prostitutes who are working on the street. We've got various community members who are helping us out with this. The other meetings are devoted to trying to change the laws in Canada which criminalize prostitution.

Prostitution isn't illegal in Canada, it never has been. But, I don't want to give you the wrong impression. There is a lot of action around prostitution that is illegal. For example, keeping a "bawdy house" is illegal. The other law which bothers us a great deal is the pimping law because that says that anyone who lives off the avails of prostitution or who is habitually in the company of a prostitute is a pimp. That means that all I have to do is hang around with somebody and that person is a pimp according to Canadian law whether they get money or not. The law that bothers us the most at the moment though because it's the one that's being enforced the most is one that was recently passed. It was designed to take prostitutes off the streets of the major cities in response to complaints from a small fringe group of rate payers who are complaining that the prostitutes are lowering their property value, causing a nuisance and that sort of thing. The new law makes communicating for the purpose of prostitution a crime. So, while it is legal to be a prostitute, in much the same way as in England, it is not legal to communicate your profession.

There was a raid a couple of weeks ago where twenty-five street prostitutes were charged under the new communicating law. A condition of their bail was curfew saying that they could never go into the areas of the city where prostitution takes place and that they had to be off the streets of Toronto by nine at night. So you can't even go out for a cigarette or a cup of coffee. These women haven't even been convicted; the curfew is just a condition of bail until they go to court. CORP (Canadian Organization for the Rights of Prostitutes) had a press conference in response to this and did a poster campaign in downtown Toronto urging prostitutes to plead not guilty and back up the courts. The press response was generally favorable except the one right-wing paper in the city was hysterical that we used the word "fuck" on the poster and they attempted to get the right-wing aldermen to ban the poster. As a result, the next night two of the prostitutes in our group who were putting up the protest poster were arrested by the police, beaten up, strip-searched at the station and held for several hours without being allowed to call a lawyer. So, they've lodged a complaint against the police and we started a new

poster campaign about that harassment; the police went ahead again anyway last week and arrested forty-nine women on the same charge and gave them the same curfews only this time they have a choice of the curfews or ten days in jail. You can serve ten days in jail without even having been convicted. A lot of the women are taking the ten days in jail rather than the curfew because they can't work with the curfew. This one alderman in the city, the most progressive alderman actually, is trying to get residents stirred up against male prostitutes who work in an area of the city that nobody lives in at night and that nobody complains about, but there hasn't been too much harassment around the male prostitutes although it seems that this could start up.

What CORP intends to do in addition to the press conferences and the poster campaign is to challenge the law in court on constitutional grounds, that it's an infringement on the rights of prostitutes, on the rights of women, and on the rights of all Canadians. This project is going to be funded by a feminist women's legal group in Canada.

One other project that we've been working on: We had the National Action Committee on the Status of Women in Canada pass a recent emergency resolution saying that they would help us fight to decriminalize prostitution and to promote prostitution as a legitimate profession. This was a major accomplishment for us considering that the feminist movement in North America is very conservative and anti-pornography and tends to view prostitutes as victims. Unfortunately, it seems like it's going to be a short-lived accomplishment because there is a lot of ferment within the organization to undo the resolution. We are currently lobbying with the National Action Committee on the Status of Women to uphold the resolution but we are not confident that we will be successful.

The one other major issue that's facing us at the moment is the AIDS issue. The government has attempted to fund a study that will target prostitutes to find out whether they carry the HIV virus which is believed to cause AIDS. Our organization met with officials from the government health department and has so far successfully managed to encourage them to target sexually active women rather than prostitutes because whether you accept money or not is irrelevant to the AIDS virus. It is the *kind* of sexual activity that you have. Our group is working to promote safe sex and to encourage the government to give us money to do that.

UNITED STATES OF AMERICA

Margo St. James: The U.S.A. has fifty states, all of which prohibit prostitution except for some counties in Nevada which license brothels. All states tolerate some form of brothels mainly under euphemisms like escorts and massage. Most newspapers and telephone books carry adds promoting sex services which are obtainable on a credit card.

Normally, talking about money and sex in the same breath is deemed a crime of soliciting. Soliciting is a misdemeamor which is punishable in California and a few other states with a mandatory sentence of fourteen days in jail even on the first conviction. The second conviction means forty-five days in jail, the third, ninety days. There are about 200,000 arrests annually. Charges can be stacked and the sentences made to run concurrently or consecutively depending on the discretion of the judge. Fortunately, most judges will not impose the harsh laws on novices and generally give probation...which, according to many women, is worse because there's no due process when one is on probation: If a cop wants to put the squeeze on a woman for information, he simply has to bust her again and she goes straight to jail. Cops are very reluctant to give up their stranglehold and are constantly lobbying for tougher laws. Most of their arrests are made from entrapment (cops posing as clients), something California just legalized. Washington state and Arizona even allow the cops to have sex in order to make a better case! Of course, in court they claim that they didn't ejaculate! Sometimes civilians are hired to do the dirty work so it becomes very confusing as to who is pimping whom. Customers are usually coerced into giving testimony against prostitutes by threats of arrest and exposure to their bosses and wives. Actually, only five percent of arrests are customers and they never face jail time.

Felony charges are levied against women who work together in an apartment, one of them usually being accused of pimping or pandering...this could simply be an exchange of names of clients! Federal racketeering laws are also being used against prostitutes who work in one state and mail the money home or travel from state to state on business...but usually only if they are women of color or white women involved with a black man. Tax laws have also been used against some women who have been too political or who have connections with people the cops want to get. All in all, the use of the prostitution laws in the U.S.A. is a means of social control of women as a class. This systematic abuse is justified by the assertion that all

whores are druggies, damaged children and thieves and that the laws are necessary for their own good.

The prohibition against prostitution is absolutely responsible for violence against women. We have more murders of prostitutes in the U.S. than in any other country at the present time. Over the last few years, with more repressive measures being taken against prostitutes such as street sweeps being ordered by mayors of various cities, psychopathic killers have been stimulated to come out and "help" in the clean-up campaign.

Dolores French: I started an organization in Atlanta, Georgia, called HIRE, *Hooking Is Real Employment*. Last year I was appointed to a city task force on prostitution by the mayor, Andrew Young. There was a lot of controversy about a prostitute being appointed to an official government committee. Shortly after my appointment, I was arrested and, of course, Mayor Young was told that I should be removed from the committee because I was obviously a person of improper character. He responded officially that, "She was only doing her job." We now have a t-shirt that says so. I was arrested for "escorting without a license," but you can't get a license and I wasn't even escorting. Also, they stack charges which is very common in the United States to raise the cost of people's bail; drug charges and distribution of obscene material were added to the escorting charges against me so that it would make better headlines and further discredit me in the public's eye. When it was proven that none of this was true and when they had to drop the charges, it had already cost me ten thousand dollars in legal fees to fight them as opposed to paying a three hundred dollar fine which would have gotten me off if I had pled guilty. All that explains why I wasn't at the last congress, which I'm sorry about, and I'm glad I'm here now.

The report that finally came out of the mayor's task force on prostitution ended up recommending the harassment of street prostitutes and the toleration of prostitutes who are not working the streets. This, of course, was not my position. What's been happening throughout the United States is pressure to get prostitution that is visible away from people being able to see it. Those of us who are working on prostitutes' rights in the United States are having growing concerns that the United States is quickly moving towards legalized controlled prostitution, as it is in Nevada, which is very oppressive. We are working hard to stop that from happening. The minority report from the task force on prostitution recommended decriminalization of

prostitution and giving all the participants in prostitution the rights that are guaranteed to American citizens under the constitution. Before I turn this over to Gloria, I just want to point out that whether individual prostitutes have been arrested or not in the United States, most of them are being harassed on the basis of laws that were originally put in place for the purpose of protecting women and protecting prostitutes, such as the trafficking laws, the pimping laws and the licensing laws. For example, any two women who go on a call together can be charged with pimping each other. If you live in a city which is on a state line and you cross that line, then trafficking charges are put on you for taking yourself across the border.

Gloria Lockett: I will start by talking about a case that I had in San Jose, California in 1978. I got charged with "pimping," "pandering," "prostitution" (soliciting), "running a house of prostitution," "being in a house of prostitution," and "being around a house of prostitution." There were six of us who were arrested, one black woman— me—and six white women. I was the only one who was charged with pimping; the other women were charged with just being in the house and being around the house of prostitution. There were also six tricks in the house. They didn't arrest them; they told them that they'd have to come back and testify against us, so they cut them loose. The case wound up taking about a year to fight, costing the state over a million dollars. We wound up winning the case but they told us that they were going to get us because . . . they didn't like it that women were that smart. So what happened was that they did come back and get us. Two years later they busted me, my man and another black woman. At the time we were also working with seven white women. We were all working together. They made the white women testify against us. My man is now serving twenty years in jail for mail fraud and for crossing the state line. Prostitutes in the United States have like a track; they go from state to state; you work wherever you can work without the police getting on you, because prostitution is not legalized anywhere in the United States except Nevada. And Nevada is all brothels and it's no freedom working in a brothel at all.

If they can prove that you have earned anything at all for prostitution or that you are a prostitute—not even prove—they want to take everything away from you. The things that we had established while I was working as a prostitute were: a Rolls Royce automobile, a three hundred and fifty thousand dollar home, a condominium, several other apartment buildings . . . and, they have taken all of it away. So we

have some horrible laws that we are fighting. And, we'll have to keep fighting. They don't want women to think, they don't want women to like what they are doing. One of the reasons why they were so hard against us is that none of us were IV drug-users, none of us were on drugs; none of us were dependent on anybody but ourselves to make our living and we liked what we were doing and we did it without robbing people and without taking advantage of people. But they couldn't understand that, we didn't fit the stereotype, there must be something wrong. So they came after us and they think they got us. I don't think they have, I don't think they ever will.

Norma Jean Almodovar: I'm from Los Angeles, California. I am a prostitute, but currently I am running for political office (Lieutenant Governor of California) because the state won't let me practice my profession. I am running for political office in California. I have to tell you, there's a difference between a prostitute and a politician: There are some things a prostitutes won't do for money. I used to work for the Los Angeles Police Department and I wrote a book about police corruption (called *From Cop to Call Girl*). The police didn't like the book and they set me up for a pandering charge, that is, encouraging an act of prostitution. I am now a convicted felon. I spent fifty days in state prison being studied to see if I am dangerous to society and, by the way, I am the only politician running for office with papers to prove that I am not dangerous. The judge gave me three years probation but the district attorney decided to appeal on the grounds that pandering is worse than rape or robbery. California law reflects that thinking because pandering carries a mandatory three to six year prison term on the first offense with no prior convictions. There is a fifty-fifty chance that I will go back to prison.°

I would like to address the issue of violence towards prostitutes, much of which comes from the police. I speak from experience both in a police department and as a prostitute. Policemen force prostitutes to have sex with them before arrest. We call that rape! Women who dare to tell on the police and try to get them fired are often found murdered. If they are not murdered, sometimes their children are taken away. We want these things stopped. We have serial murderers, with eighty women murdered in Seattle, around twenty-five in Port-

°Norma Jean did not become Lieutenant Governor of California but she did win 80,000 votes. She lost her case in California's Appellate Court and is now serving a three year sentence.

land, ten in the Oakland-San Francisco area, another sixteen in Los Angeles and nine in San Diego. That's just on the West Coast. There's the usual racism because most of the women who are murdered are black street prostitutes. The police and society don't seem to care; they feel that since these women are prostitutes, they deserve whatever they get. In California, a law was just enacted that legalizes entrapment. It was introduced by a liberal democrat; most people think that it is the moral majority that is introducing these horrible repressive laws. What this law does is allow a police officer to solicit a prostitute or (occasionally) a client and if the prostitute or client merely manifests an acceptance of the offer, in other words if they raise an eyebrow or if they smile, they can get arrested for prostitution. The stated purpose of legal entrapment is getting prostitutes off the street for their own good because someone will murder them. Rather than go after the murderers, the state spends millions of dollars trying to round up prostitutes and does nothing against those who violate their rights.

We have filed a lawsuit because the police are now using the pimping and pandering laws against actors and actresses who are making adult movies. Also, now the police are arresting adults, including married people, who make movies of themselves under the charge of distributing obscene material.

One more thing: There is a madam in Palm Springs who was sentenced to eight years in prison for running an escort service; at the same time, a police officer that I used to work with was accused of having sex with a ten-year-old for five years, until the girl was fifteen, and he was given no jail time because he repented of his act.

SWITZERLAND

Christine (Bern): I work for the Zenia Society, a prostitutes' rights organization in Bern. I am a prostitute myself and I am very happy to be here with so many fellow fighters for this cause. In Switzerland, we have at least three linguistic areas where there are prostitutes: French-speaking, Italian-speaking, German-speaking. There are twenty-three cantons and a good deal of federalism. Every canton has its laws and rules that are different. So, that's why there are several prostitutes' associations. Christa and Yolanda from Zurich and myself will talk about the situation in different parts of our country.

Christa (Zurich): This year we have organized the Zurich city prostitutes and we want to act against the arbitrary actions of the pol-

ice and of public authorities. Recently the city told us that we must be off the streets during certain hours and if we are not then we will be very heavily fined. A thousand francs is a typical fine for violating this law. I myself paid eight thousand francs. That's why we organized this association. There's a double standard being used here. We must pay very high fines and we have to limit our working time. There are many prostitutes in Zurich, there are many of us, and we don't have much room to work in. We have to fight for our right to work around the clock; otherwise we can't make both ends meet.

Yolanda (Zurich): I'm a mother of four children, I have three children at school and one at home plus I have my mother at home. Also, we have the same problems as in Austria and Italy with losing our homes. I have been divorced for fourteen years, I raised the children all by myself, and I had to move very often because people discovered that I was a prostitute. So, I'm not even entitled to my own private home. I have to pay three thousand francs rent in order to be left alone—yes, as soon as they know that you are a prostitute, they charge more, you are discriminated against. This is true for all women who are prostitutes. But, we are the oldest profession of the world and everybody knows that. So it is time for all of us to stand up for our rights. We are people just like all other people. We have our profession, we make a living. A normal woman can buy what she wants, but we prostitutes cannot act as we want. We should be able to act as the others do! I also have a friend. We have a very good relationship. He comes and sees the children. I give my children love. They have parents. I didn't have that love when I was a child but believe me, I am giving my children plenty of love.

Christine (Bern): I want to condemn the state that discriminates against us, that uses a double standard. I condemn the state and the government for considering us to be evil people. Our taxes are set much too high. Also, the state forces us to work in specific districts where we have to operate in dangerous areas, for example auto highways and in woods and forests and so on.

Since no one is here from the canton of St. Gallen, I will tell you that prostitutes get fined for soliciting there. In Fribourg there is a bill that is similar to the one that is enforced in Zurich, that is women do not have the right to walk outside during the day. Of course, this is a complete aberration. This forces them, if they work during the day, to take apartments or studios. So, the freedom of trade is infringed upon.

In Geneva, they always have the problem of the "certificate of

good living." A prostitute who stops working must wait three years (after she "de-registers" with the police) before she gets that certificate of moral living which is asked for by several employers. Let's not overestimate the nuisance value of this because many employers don't request this paper; but, it does nonetheless constitute a kind of psychological block. Prostitutes are considered unusual work-seekers. This is a perfect example of the double standard because customers are never refused a certificate of good conduct on the basis of engaging in prostitution. I'd like to have the difference explained to me between the morality of a customer and the morality of a prostitute. Is it not exactly the same? Each one contributes their half of the business. I made a slight calculation: I asked how many prostitutes were operating in Switzerland and I was told that there are about three thousand. I won't debate whether that figure is accurate or not; it is certainly not too high and probably too low, but let's take three thousand anyway and let's estimate three clients per prostitute per day. That is almost ten thousand clients each day; you multiply by thirty because the clients don't return everyday but rather about every week. That brings the number of clients to three hundred thousand per month, just in Switzerland which is a small country of six million people. Now, I leave it to you to draw the conclusions from this calculation. You can make your own calculations for your own country. I do assure you that it is very interesting to do this because you will see that what is involved is not just a handful of so-called prostitutes but rather the whole population. That is something that has to be seen very clearly.

One final word: I had a good time comparing the laws of the different states in Switzerland. Some cities are less repressive than others. For example, in Geneva it is possible to work peacefully; there are no fines and women can be outside all day and so on. Not to be too idealistic, there is a form of free trade that is respected in that city, more or less. In other cities, there is much more repression. I compared the number of pimps in different cities and I found that the more repression there is by the police, the stronger are the so-called pimps and the shadier are the businesses. This is important to recognize: If a woman must fight the police above all else then she is going to seek protection. She is going to seek the protection of the pariahs of society and that means that she is going to fall back on a pimp. That will send her into situations where she will be even more repressed. I think it's very important to see this and to think about it clearly. I agree with Gloria when she says that when women prostitutes show

that they are women like all others and when they say it often enough and loud enough and emphatically enough and credibly enough, that then people begin to understand. People begin to hear that prostitutes are women like all other women and this brings a message of hope for the future.

NETHERLANDS

Terry van der Zijden: I have worked as a prostitute for fifteen years and been active in the women's movement for ten years. I have been with The Red Thread since it was founded and am now paid with our government subsidy as the policy manager. You may think that everything is marvelous for prostitutes in the Netherlands. Some things may be better than elsewhere but prostitutes are stigmatized in Holland and we want many changes. Time is now ripe to put us on a par with normal working people. That means that we will be able to insure ourselves, we will have possibilities of benefiting from the social protection network like other people, and, if we do have to pay taxes, we will do so under a normal framework. Also, we should be able to work among ourselves, that is set up our own houses for business, something which is very difficult at present.

We are concerned that black whores are treated differently from white whores and that it's harder for black women to get out of prostitution and harder for them to set up houses (prostitution businesses). We had not expected that in the Netherlands, but I have to admit it's true. What we are also concerned about (to be discussed at length in health session next day) is our clients' ignorance concerning their health and the health of their families. Our clients are responsible for the health of the whole Dutch population. We whores know that we have to keep ourselves healthy and protect ourselves against disease. People say that the Netherlands is a progressive country and the world is looking to the Netherlands. Our clients, especially those in positions of power such as the politicians, should be our allies in the move toward legitimization and change in mentality. We have many allies now. I am thinking of the women's movement which is really an ally in the Netherlands. But also our clients in political life should support us and take responsibility for public health.

Bianca: I have been working for four years in the city of Den Bosch on a street with several brothels. I used to work in one of the brothels and later I started my own brothel. For one and a half years I ran it and then two weeks ago it was decided that my house will be closed.

There were six women working in this house; Miriam, one of the workers, is sitting next to me. The community decided to close *my brothel* in particular. In my actual street, the prostitutes and even the inhabitants support me. The residents there stood up for me. For financial reasons, I wanted to also start a cafe, but since I was a prostitute, I was not allowed to do that. I was treated as a criminal, you know. But not everyone in that street is considered a criminal. The other brothels are allowed to operate as always. I am no longer able to earn anything. I have the feeling that my colleagues and the other brothel owners and the community in Den Bosch are afraid of me. They've done everything in their power to force me out because I'm black, as you can see, that's the color of my skin. I want to defend myself, as a black prostitute. I am fighting. I refuse to accept this. I think that there are many black women in Holland who have similar experiences as mine, but little is said about it. I think that black prostitutes are treated even more unjustly than white prostitutes. My colleague Miriam will continue. I'm sorry that I am incredibly nervous.

Miriam: Hello sisters. I'd just like to talk about the point of discrimination. It is very heavy in Holland. You don't see it face-wise but it's always going on behind your back. When I went to work at Bianca's place, she greeted me with the news that she had to close down. I asked her why and she couldn't give me a specific reason, except that the police had said that her house was a troublesome house. But, having worked there myself, I know that it is one of the most peaceful places I've worked and one of the cleanest places I've worked so I couldn't find any truth in that statement. What was obvious to me was that there was a case of discrimination going on. I notice it not only in prostitution but in a lot of different ways in Amsterdam. If a black person wants to open a cafe or a shop, they are immediately put under suspicion. I'd like to see us women, not only us immigrants but European women too, all come together and fight for our rights, our rights to be human, our rights to be human in our own way and to express ourselves the way we like to express ourselves.

Violet: In the Netherlands, prostitution in itself is not forbidden but "facilitating" the practice of prostitution is illegal. Bianca was closed down under this law. Mostly the police intervene only in cases of 'public nuisance.' Otherwise, brothels, clubs and private houses are tolerated. Since sex businesses are actually illegal, they can't be obliged to follow regulations. In practice, managers are free to operate as they choose and prostitutes have no rights.

There seems to be a tendency toward more acceptance of prostitution in the Netherlands but at the same time you see that the most visible forms of prostitution are not tolerated. For example in Amsterdam, the place with the famous "red-light district" where hundreds of women work behind windows, the toleration zone for street prostitutes was eliminated in January, 1986. Recently I spoke on television about the injustice of this Amsterdam action. It was a structural act of violence against women. The women were rounded up and driven out. Women don't stop working but they take more risks because they're afraid of getting picked up by the police. This makes their work conditions even less safe. I was surprised that other women didn't give us more support because it involves the human rights of women.

Street prostitution and window prostitution are forbidden also in other cities besides Amsterdam. For that reason about eighty percent of the prostitutes in the Netherlands work in closed clubs, private houses and via escort services. That means by definition that you work for a boss, that you've got to hand over a bigger part of your money, and that you have less say about your own work. The system in the Netherlands thereby reinforces the dependence of prostitutes.

I wonder why we have to work so hard to get something that should be automatic. We want respect for our work and workers' rights like most people. As for taxes, we cannot deduct overhead costs as can every little businessman. And we get pursued by the financial office. Also, as a prostitute you cannot get insurance and you have no assistance if you get sick. We need social aid. Another problem is that we are very often not allowed to raise our own children. I know that this is a common problem for prostitutes in our country and in other countries. And, recently, it came out that sexual abuse of prostitutes by male social workers is common.

Just like in other countries, we are registered with the vice police. What exactly that registration is used for and who has access to the information is unclear. It happens often enough that the information is given to social services or, after a woman has stepped out of prostitution, to her employer.

For years we have been demanding the elimination of Article 250 of our criminal code which says that it's legal to be a prostitute but not to operate a business. [In April, 1987, the Dutch Parliament made a proposal to eliminate the brothel prohibition which was first implemented in 1911. This proposal has been adopted and applications are

in progress.] We hope that through the elimination of the brothel prohibition prostitution will be recognized as work and prostitutes will get the same rights as other workers. We also hope that it will become easier for prostitutes to start their own businesses. We realize very well however that judicial recognition doesn't yet mean social acceptance. We still have a long way to go.

MOROCCO

I am German. I worked in Germany but I also worked for a year in Morocco and I can describe the situation there because I have some contact with Moroccan prostitutes.

Morocco is an Islamic country. It is governed by religion, the Islamic religion, and this means that prostitution is absolutely forbidden. It is totally illegal. There are women in Morocco who engage in prostitution. They are persecuted for violating religious laws. In general, the Moroccan prostitutes are widows who are stuck because they cannot remarry. Prostitution is a matter of pure survival. Sometimes the women have children. They work in hotel bars with tourists or in places they rent which have awful conditions. They have no money. They do it for survival, just in order to eat, maybe for lunch. In Tangier, there is a health office which loads women up in wagons under inhuman conditions and which gives out health cards. If the women get sick, they are separated and detained in prison where they have to remain for many years because they are guilty of prostitution, guilty of violating religious laws. Officially, there is no prostitution in Morocco, but since the tourists arrived it is very obvious.

I, as a foreigner, could not be made to suffer from the repressive measures. I have worked with sheiks and with Arab people in Tangier. There are also Arabic-speaking women from other Arabic countries who are dealt with by the sheiks as "delicacies." Foreigners are not arrested much. Perhaps, on the beach for instance, one can be arrested but even then you are detained only for three hours or so. If you rebel against the sheik, he has his own bodyguards to impose discipline. Otherwise, nothing happens to Europeans because the sheiks themselves are very Europeanized.

ECUADOR

Tatiana Cordero: I am an Ecuadorian lawyer. This is the first time that I am in a prostitution conference. I would like to talk about the

situation in Ecuador, about the legal situation and about the violence against women and their rights.

Prostitution in Ecuador is concentrated mostly in urban areas. In the rural areas we can see prostitution increasing where multinational companies have been set up which is basically where oil companies are located in the country. This has brought about many problems for the indigenous community and particularly for women; it seems that there's one person organizing the situation. Prostitutes are prevented from organizing themselves. The managers have five or six prostitutes working for a week and then different women are brought in so that the prostitutes cannot group together and express their grievances about the ill treatment and bad living conditions.

Prostitution is not a crime in Ecuador. Supposedly it is not a crime or a misdemeanor but a sexual offense, an offense to proper behavior. Supposedly the prostitutes are not "honest." There is a deep-rooted Catholic tradition in the country which is reflected in the moral values underlying the laws of the country. Prostitutes are allowed to work only in a brothel although the majority of prostitutes do work on the street. And, it is accepted that pimps can work, but again only in brothels. If prostitution isn't organized within a brothel or within a special house, then it is penalized. There is a health code, Article 77, which makes women have check-ups and registers them. There is a great deal of supervision of the prostitutes by the government and by the police.

The problem is how to draw a parallel between a criminal and a prostitute because, in reality, the pimps in my country are the police. Every night the police go to the streets where the women are working and they always arrest the same women. They try to extort money from them and they try to get "favors" from the women (which indeed is rape); when the women refuse them, they are put in jail. There is a continuous blackmail going on between police and prostitutes which is a major problem in the country. Of course, there is the stigma of being a prostitute.

As far as sentences for trafficking or pandering or pimping, there would be sentences only in the case of minors. There's really no such thing as pimping for adults, there's no such thing as trafficking for adults (that is, people over eighteen years old).

Women who are not prostitutes are sent to jail, that is to regular prisons, and prostitutes are sent to detention centers. So, they are split

up, they are separated. In my work in my country, I have contact with women who are in prison. I think that it is very important that there are organizations for prostitutes because they are not recognized and they do not have proper rights. Prostitutes are often penalized and they are not aware of the fact that they can bring their case to court.

I would just like to conclude by saying that women's organizations already exist in my country and that those of us who feel linked to prostitutes in whatever way it might be are willing to do whatever we can so that prostitution in my country would be a matter of everyday survival.

Gloria Lockett: What is the difference between the jails and the detention centers?

Tatiana Cordero: The actual difference that exists is mainly a kind of moralistic bias. For example, when the nuns were in charge of the prison—before our fight which led to their leaving the prison—they did not want the prostitutes to get mixed with the other women even though they equate prostitutes with criminals and criminals with prostitutes. The prostitutes had to go to this center of provisional detention with the political prisoners because the two groups were both seen as dangerous.

Roberta Perkins: Can you tell us the difference in treatment between the Indians of Ecuador, the Mestizas and the whites? I mean, do the white prostitutes get treated better by the police and the Indians the harshest?

Tatiana Cordero: In my country, we have been a mixed culture since the Spanish colonization. We are a Mestiza culture, but there are still Indian groups. There is no prostitution within the Indian groups. Women from the Indian groups leave their group to become prostitutes. Within the groups, there is another vision of life and of production and of everything. In Ecuador, there are Indians and Mestizas; there are no whites. People may say they are white but it is not true; all Latins are mixed. As for the treatment of Indians and Mestizas, there is a popular saying: "The law is just for the one with the poncho." Poncho is a thing the Indians use. What the saying means, of course, is that the law is just applicable to the ones that do not have resources. If you are a prostitute plus an Indian then you are doubly charged. The understanding is that first of all prostitution is not work and that a woman has to be a psychopath or a nymphomaniac or whatever but never a human being if she is a prostitute. And, if you are an Indian then you are seen as wild. Of course, within the society

as a whole apart from prostitution, the ones that feel the weight of the law are definitely the Indians. They are definitely the lowest strata of society.

[About three hundred women in the coastal province of El Oro demonstrated in Guayaquil in July, 1982 and formed an organization called the "Associated Feminine Union." Prostitutes stated their goals as (1) "to have group strength with our sisters; (2) to be respected by the owners of the hourly rooms, the authorities, the police and the scoundrels that abuse us; (3) to find ways of getting benefits for our children and; (4) to be protected and feel secure in our old age" (*Connexions*, Spring, 1984, p. 23). According to one source, their association was recognized by the state in 1987 under the name "Association of Autonomous Women Workers."]

INDIA

Jean D'Cunha: There is no prostitute who is here from India but I'd like to share the experiences of prostitute women to whom I have talked in the course of a research project that I have been doing on the anti-prostitute bias in the Indian law. I'd like to talk about the abuse of women in prostitution and the kind of prostitution that exits in India by sharing with you an interview with one such woman:

> **Asha:** My parents are very poor. They are landless workers and live in Ahmednagar. A woman who used to visit our village occasionally brought me to Pune, promising me a good job. On reaching Pune, I was sold at a brothel for four hundred Rs.. I was shocked and bewildered at first. I never wanted to become a prostitute. I began resisting. Every time I refused a client or cried, the *gharwalli* rebuked me and beat me. I was forbidden to stir out of the brothel. I looked for means of escape but I was closely guarded by the paid *goondas* of the brothel. This went on for a few days till all my resistance was broken by the *gharwalli's* hired *goondas*. They gang-raped me. I have never experienced greater shame and humiliation in all my life. I wanted to die. But as time went on, I got used to the idea of living in a brothel.
>
> I share a room with three other women. Our room is dark, dingy and ill-ventilated. The drains below overflow and the stench of sewage is nauseating. We have no privacy and each of us entertains our clients behind a curtained partition. I entertain six to eight clients a day, mainly at night. I earn ten Rs. a day and give half of this to my *gharwalli*. The rest of my income is spent on food, bribes to the police, rent, and paying back debts to the *ghar-*

walli. It is common practice for the *gharwalli* to loan money to the girls initially in order to purchase clothes and other articles of personal use. Alternately, these goods as well as food may be provided on condition that the girls pay for it. Financiers also extend goods on credit to them. I usually eat *rotis* and *bhajias* and drink tea. I sleep for most of the time during the day as I entertain clients till around three A.M.. Twice in a month I go for a movie with the others.

My work is tiring and disgusting. I have to entertain clients even when I'm worried, upset, exhausted and ill. I am forced to take clients even during my menstrual cycle. I cannot reject a client even if he is diseased or if I am repelled by him. The *gharwalli* beats me up if I do not give into every demand of the client. Our clients do not use any contraceptive devices, nor are they examined. It is because of this that I have contracted VD. I am also anaemic and have suffered from TB. The doctor says that this is due to poor food, late nights and numerous clients of all kinds. I am in my seventh month of pregnancy. The medical social worker has advised me not to have a baby (the baby could be stillborn, mentally retarded, physically deformed or syphilitic), but I want the baby. My *gharwalli* says that my baby is a bad omen, and I must therefore pay for the painting expenses of the room when my baby is born. I am going to sink into further debt but I still want my baby and I'll look after it. I'll never go back to my family. They will never accept me. I'll remain in this business. God, I know, will help me.

I will now talk about the law regarding prostitution in India. The Indian government, like governments the world over, has used the instrument of law in the form of the Suppression of Immoral Traffic in Women and Girls Act 1956 (SIT Act) to deal with prostitution. The act claims to abolish trafficking of women and girls in prostitution and criminalizes the activities of brothel keepers, pimps, procurers, and renters of premises for forced prostitution. It does not seek to abolish prostitutes or prostitution per se and hence the practice of prostitution individually and voluntarily is not an offense under the act. However, sections seven and eight of the act penalize a prostitute for practicing prostitution in a public place and for soliciting for prostitution respectively. These sections of the act deal with prostitutes as criminals and, interestingly, the client is not an offender under the act. All this aside, the act is tardily implemented. Brothels are mushrooming and trafficking in women and girls for prostitution continues unabated. Relia-

ble sources maintain that the city of Bombay alone has about 50,000 brothels in which twenty percent of the prostitutes are minors. Records in Bombay reveal that only 409 brothels were raided in the five year period from 1981-85. Taking the estimate of 50,000 brothels in existence, each brothel would be raided once in 600 years. In its implementation, the act operates specifically against the prostitute while allowing the brothel keepers to go free. Records reveal that only two out of 409 brothel keepers arrested were convicted between 1980 and 1986. The rest were let off on bail or acquitted. Not a single landlord was arrested under the SIT Act between 1980 and 1984. On the other hand, 4139 prostitutes were arrested for soliciting under section 8B of the SIT Act and 44,633 under section 110 of the Bombay Police Act. There was one hundred percent conviction of these women. These records show that it is the women rather than the prostitution racketeers who are arrested and convicted.

SWEDEN

Lilian [speaking in Amsterdam at the First World Whores' Congress, 1985]: It is not illegal to be a whore in Sweden, but everything around us is. We can't work together because then we are charged with pimping each other. Even our children can be punished: If they are small they can be taken away from us; if they are older and they have gotten something from us—for instance, a car—they can be punished by taking that away. Older children can even be kicked out of college if their mothers are suspected of paying tuition with prostitution earnings. It becomes more and more difficult to organize because the feminist organizations strike against us. The government did an investigation and made some new laws. From now on, we have to be completely invisible because we can't rent a place to work in, that is forbidden by law. But, though we can't exist, we have to pay huge sums of taxes. In one incident, the Swedish police started counting condoms in the garbage to see how many clients a prostitute was seeing in one day so they could estimate earnings. If a prostitute is on welfare and is caught working as a prostitute, either her welfare is cut off or a social worker will come and see if she is living with a man. If she is living with a man, the social worker will determine if he is eating the food bought with welfare money and then the money will be taken away.

o

VIETNAM

Truong Thanh-Dam [speaking at the First World Whores' Congress in Amsterdam, 1985]: In Vietnam since 1975, bars and brothels have been closed down and hundreds of thousands of prostitutes who formerly serviced the American military have been sent to rehabilitation programs. They are taught skills such as sewing, typing and so forth to "regain their dignity." The socialist government promised them work so that they don't have to go back into prostitution. However, given the difficult economic situation Vietnam has been facing since 1975, there are reports that the incidence of prostitution has been increasing, though it is not so institutionalized.

BELGIUM

At the beginning of the congress, no Belgian prostitutes publicly spoke or identified themselves. The organizers did have close personal contact with several Belgian working women who felt participation at the congress might endanger themselves or their children or might jeopardize their jobs. A couple of non-Belgian prostitutes did share their work experience in Belgium and, on the last day, a Flemish prostitute did publicly announce herself and speak. Other Belgian women attended the evening informal sessions anonymously.

First day, October 1:

Terry van der Zijden (Netherlands): I worked in Belgium for ten years. I left about six years ago and maybe the situation has changed some, at least we could hope so, but I doubt it. Often those who work in clubs and nightclubs don't particularly identify with prostitution. Sometimes they live about fifty kilometers away from their place of work. I worked in a nightclub and we used terms other than prostitute to describe our work, such as hostess. I also worked in clubs and in high-class cafes. In all cases, it was a very discreet profession. We did not consider ourselves prostitutes; we worked just for entertainment purposes, so to speak. We'd have a drink with a customer and then after a certain amount of time he would indicate that the deal had been agreed upon and we would leave the club or cafe. Nobody really knew what went on. It was just basically part of our work. The Flemish mentality is such that, on the one hand, the profession is taken seriously and, on the other hand, it is ignored. In the ten years that I exercised the profession, I must admit that I was always afraid somebody I didn't know would enter the room, perhaps a police inspector

or a tax inspector or a member of some organization that tries to stop prostitution. We never knew who was entering the cafe. We didn't know if it was a customer or somebody who was going to come back the next day accompanied by a policeman or somebody who would take you right off to the police station. In Flanders, we feared oppression and repression and rightly so. I stopped working because I couldn't live in fear anymore and I couldn't bear double taxation any longer either (under the table as a prostitute and over the table as a citizen). Very often the national and local police tried to use my services without paying and I would have to comply to continue working. They would try to intimidate you.

Margo St. James (U.S.A.): Several Belgian prostitutes told us that they are afraid to come to the congress, afraid to be visible. They license the women who work in the cafes (as "nightlife workers"). In certain cities (Brugge and La Louviere), they make the women get ID cards with "artist" stamped on as a euphemism for "whore." They also fingerprint the women, take mug shots of them and clip their passports—not everywhere or all the time, but it's a great threat.

German speaker: I would like to share a thought. I wonder whether if I was still a prostitute I would agree to show my face if this congress was in my country. I know the press might print my photograph which could be read by my neighbors, shopkeepers and so on. This is something one has to take into account. What does it mean that the prostitutes of the country in which this conference takes place are not here today? One of the reasons may be that the press would exploit them and they do not wish to be seen as prostitutes. How many women are there who are afraid to fight, whereas they have the right to do so? They want to protect themselves.

Third day, October 3:

Linda (Belgium): I am a Flemish prostitute. I live in the north of Brussels. In Belgium, my profession is banned, but it is also accepted. We prostitutes in Belgium have to pay high taxes. We have got to pay about two million Belgian francs over a period of five years. We say that if we've got to pay all these taxes, then we ought to be free to practice our profession properly. But our mayor, Mr. Claudel, wants to close all the brothels so we are asking what we ought to do. We want to work, but it's not fair that we have to pay such high taxes and then not be allowed to work properly. It's not like in the Netherlands and Germany. The police here come to a brothel and say, "We are

shutting up the shop and you can't work." We have to pay a great deal of money for our rent, but when there are two of us (i.e. more than one equals a brothel), the police come along and shut our place forever. I'd like to know if also in other countries you are not allowed to work together with another girl and if you also have to pay such taxes.

Margo St. James (U.S.A.): Yes, other countries do assess taxes from the prostitutes, for example in Austria and France they estimate the earnings of a woman and, if she does report her income, they don't believe what she says. The women are forced into bankruptcy in England. The United States, Italy, Sweden—almost every country has an abusive tax system besides the other regulations that discriminate against prostitutes. Also in the Netherlands and Germany, prostitutes are not treated as other workers.

Pauline: (Netherlands) I am from Amsterdam. Many things have been said about the fact that the Belgian whores were not present here. But, I'd like to know from Linda why she thinks the women did not come.

Linda (Belgium): Not one single working girl out of my area came because of the mayor. He wants to close all the brothels and that's why we were afraid of coming. Also some people from television told us that you needed a special card to come in. We were told that Belgian prostitutes were not allowed, that the congress was just for foreign working girls.

Margo St. James: (U.S.A.) We are very sorry that you were given that misinformation. We did distribute about two hundred flyers inviting prostitutes here in Belgium. It's regrettable that there was this misunderstanding.

Terry van der Zijden (Netherlands): It's possible that another source of misinformation was the "Assistance Lending" groups that try to integrate prostitutes into so-called "normal" society. Prostitutes here might not have believed that this conference was a forum for us to speak rather than for others to "save us." The first night of the conference, I walked around the prostitutes' area in Brussels and I did manage to talk a little with the women. A lot of them were interested but they were nervous and suspicious. They were afraid and well, let's face it, if you are working the whole night long, nine-thirty A.M. is not really a very good time to turn up.

Austrian speaker: I think it's great that we have a Belgian prostitute here today. If she can't answer this question, she doesn't have to, but, what is the position in Belgium with pimps?

Linda: (Belgium) Well, of course, pimps…you've got them in all countries, haven't you? I don't think we're here to talk about pimps. I thought we were going to talk about the freedom to work as prostitutes. There is no prostitute in all of Belgium who has a proper protector. We're not here to talk about our men. We're here to talk about our way of life and also the freedom to be able to exercise our profession.

Doris: (Switzerland) We're here to discuss why pimps exist, not to decide whether or not they exist. We know they exist but that's what we're trying to change.

Grisélidis Réal: (Switzerland) We have to just abolish these words, "pimp" and "protector," from our vocabulary, whether we have one or not, whether we've chosen one that we like, whether we can decide to get rid of him when we don't want him. Whether we have a man or not, he should not be called a "pimp" or "protector."

Lynn Hampton: (U.S.A.) A question to Belgium: You said that in Belgium, prostitution was banned. By that, did you mean illegal? And, if so, what are those taxes that you have to pay? Are they income taxes? Because also women in other countries have talked about paying income taxes on earnings from a supposedly illegal profession and I'm having a hard time understanding that.

Linda (Belgium): In Belgium, if you are á prostitute, you must pay professional taxes. They just tax you on your income, no matter where you get it. From 1982 to now, I've paid 2.8 million Belgian francs for professional income tax. Here is my tax form. I'll give you a copy after the meeting.

Odile (Switzerland): I want to say something about Belgium because I worked as a prostitute here for two years. In the newspaper, you can see lists: "Waitress wanted, waitress position available," etc.. Those women are employees in a bar, so to speak, even though they are clandestine prostitutes. The Belgian police know that prostitution goes on in these bars and cafes, but they close their eyes to it. Obviously, these waitresses pay taxes and social charges and also get some benefits, as I did in 1973. The reason they have not come, I think, is that they are clandestine. They are afraid they might threaten the people in the bars and cafes that they are working for and then get fired themselves, especially if pictures of them are seen on television. That's the main reason they're not here.

German speaker: Is it actually possible for foreigners to work here in Belgium, even though prostitution as such is supposed to be illegal?

Linda (Belgium): As a foreigner you can work in Belgium so long as you are married to a Belgian and you've got a residence permit and the rest of it. But all people, like Spaniards and French and Moroccans, can sort of work illegally. If you want to work legally, you've got to get married to a Belgian and you've got to get your identity card and everything and then you'll have the same rights as a Belgian. Otherwise, you can be expelled from the country. Sometimes you can get a temporary residency permit for about five years. Also, there's a difference for women working the street and women working in a bar. I am a streetwalker, but the woman who spoke before was working in a bar. A bar is more legal because you just drink with a client and are not supposed to make a pass; legally you are a waitress or whatever but not a prostitute. Streetwalkers are considered prostitutes. That's the difference.

Julie (England): I am English and I have worked in Belgium for about six months on the streets. I am frequently stopped by the police. They check my papers, but that's all. I've never had any problems. Just one time they took me into the station, which is quite regular. They take girls in every four months to take a photo in case anything happens, so they know who it is that it happened to.

Lin Lap (Singapore/Netherlands): I'd like to know whether there is any difference between the treatment of white foreign women and black foreign women working in Belgium.

Linda (Belgium): Someone told me that as a black person she had to have her residence permit and was harassed by the police. I must say that as a Belgian, I have to contend with those things too. I have been photographed three times in three different areas of Brussels. The police take my number and all the rest of it.

Priscilla Alexander (U.S.A.): Is there a problem in Belgium with prostitutes being accused of spreading AIDS?

Linda (Belgium): "No...no...Before we used to have to go for compulsory health checks but now it is voluntary. In Belgium, we say that "A whore is cleaner down-below than up-top." We say that the clients bring the disease, not us.

"TRAFFIC IN WOMEN"

Nena: I am from the Foundation Against Trafficking in Women. I want to speak for the right to choose not to work [as a prostitute]. I come from the Philippines. I was born in the provinces and grew up in the countryside.

I was ambitious and wanted to make something of my life. I went to school in one of the bigger cities of the province. I managed to finish my high school and get a job. I worked in several jobs and always earned enough to keep myself. In 1981 the shop in which I worked burnt down. I was in charge and I had to report the fire and make all the official arrangements. At the government office which was in charge of the investigation I met a high official. This man is well-known and respected in that town. After we had met several times, he asked me whether I would like to work for a friend of his in the Netherlands. This friend, he said, owned a five-star hotel and needed a receptionist very quickly. He also said that there were other girls who had been offered a job so that I had to make up my mind as quickly as possible. I did not have much time to think about it. I spoke with a good woman friend of mine and we decided that it could be the only chance I would get to earn a lot of money. The salary I would receive was one thousand U.S. dollars a month. In the Philippines, that is a fortune. I was very excited and had all these dreams of being able to start a business of my own. This was my chance to earn my capital. Of course, because of the fire, I was also out of a job. So, I accepted to go to the Netherlands.

The high official arranged everything for me: my passport, tickets, and etcetera. But as soon as I arrived in Netherlands, I realized that something was wrong. I was brought to different sex clubs to watch what was happening and I was told that that was the work I had to do. I started crying and said that I would rather go back to the Philippines. The boss said that I would first have to pay back the amount of 30,000 guilders, because that was the cost of all the arrangements and the ticket to bring me to the Netherlands. Since I had no money, I had no choice but to work for him in order to pay back this so-called "debt." He has made more than that amount of money from my work. Whenever I think about how it all happened I get very frustrated and sometimes I get depressed, but sometimes I really get very very angry. Because what happened has ruined my life. I cannot go back to the Philippines because I have reported the Philippine official to the police in the Netherlands and I am afraid that he will take revenge on me. Because of his high position, it is useless to report him in the Philippines; he could "buy" his way out of any court. The Dutchman who was my boss in the Netherlands is also in the Philippines where he has opened a club. So I am afraid to go back. But in Holland I am not sure for my future. I also feel very frustrated because the Dutch system of

justice does not seem to take notice of us. Actually, three women have already filed charges against the same boss last year. But until now, nothing has happened. The police released the boss after a few days and he has left Holland. Why do they seem not to believe us? Is it because they do not trust women who came from a foreign country? Or is it because we are not white? Or do they think that we are prostitutes so they don't believe we are forced to do the work? We feel cheated, humiliated, angry and afraid. Today we are talking about human rights. Yes, I believe too that all people should have the same rights to a good life and to choose the kind of life they want to live and the kind of work they want to do. Well, we know that not everybody can do the kind of work they want; some don't get any work at all, especially in countries like the Philippines, what they call poor countries. I know that the Philippines is not poor, but many millions of people in the Philippines are poor. Because the politicians and the rich people—those in power—keep the riches for themselves. They don't care about others, only about getting richer and more powerful themselves. But even poor people in the poor countries should have the right not to be forced to do something they do not want to do. Even poor people have dignity and can choose at a certain moment. Those people who deceived me took advantage of my difficult position. Then after that, when I refused to do what they wanted me to do, they beat me and threatened me and, even when I gave in and started working, I was threatened by other women, Dutch women who worked in the same club.

Lin Lap (Singapore/Netherlands): I am in the same group as Nena. I am going to talk a bit in general about the situation of migrant women in the Netherlands. In the last two years, our group has met a number of women who, like Nena, have been trafficked to the Netherlands. They were deceived by promises of good well-paying jobs which did not exist. They were brought to the Netherlands and they were forced to work as prostitutes. If they refused, they were beaten and threatened. Their passports were taken away from them and they were kept completely isolated and told lies about the police being either corrupt or powerless to help them in case they would try to escape. In 1984, four Columbian women could escape from the place where they were working only when police raided the place and arrested the traffickers. In the same way, two more women could escape when their traffickers were arrested. A Chilean woman could stop working when her pimp disappeared for unknown reasons. This

woman has in fact been forced to work twice, the second time by the so-called friend who had helped her to escape the first time. In April and December, 1985, two women from the Philippines separately filed charges against the same trafficker. In August, 1986, one more Filipina filed charges against him. This time the local police has been instrumental in helping the women escape and make their report. But the attorney general still has to decide whether to prosecute. Also in August, 1986, a woman from Thailand came to Holland under the illusion that she was going to get married and live happily as a housewife; she was forced by her boyfriend to work alone as a prostitute in a flat. A customer helped her to escape. After filing charges, she went back to Thailand.

Under the law in the Netherlands, trafficking with or without the consent or knowledge of the woman involved is a crime and punishable by a maximum of five years in prison. In practice, the prosecution demands that force or coercion be proved which is very difficult to do. There are various forms of coercion: economic, emotional, social. They also require proof of physical violence against the victim and proof that the trafficker has received money from the prostitution of the woman. Well, you know that all these things are almost impossible to prove. In most cases the defense attorney tries to throw doubt on the character of the complainant, the woman, by saying that she had been a prostitute before and that she knew very well what work she was going to do in Holland. This has led to the acquittal of several traffickers whom we know to be guilty.

We want to state that we are not agitating against the fact that thousands of women are leaving their homes and countries looking for means of subsistence and a better life somewhere else. This migration of women is an expression of women's desire to overcome the difficulties, to sacrifice even their homes in order to support their families or to be with their families when they follow the migration of their menfolk. But what we resist and what we consider as a violation of human rights, and in particular the rights of women, is when outside or external factors come in to play and take advantage of the weak position of women, especially women in the so-called Third World in order to make profit out of their work. Very clearly the modern industries and multinationals have done this. All over the Third World the big companies are operating almost solely on the labor of young women and girls. In fact these industries, I mean the chips and the textile industries, have been designed in order to make use of the

cheap labor of thousands of women who are driven to find work in the industry due to the failure of the traditional means of subsistence which they previously had. Another obviously international industry is the tourist industry. And the tourist industry, just like other multinationals seems not to be able to function without cashing in on the attractions of the "feminine qualities" in the different countries which have grown to be tourist attractions. For example, women in Latin America, Africa and Asia are explicitly flaunted for their specific feminine qualities. In the publications and advertisements of the tourist industry, Latin American women are "passionate and inflamable"; Asian women are supposed to be "gentle, tender and submissive"; African women are supposed to be "dark, mysterious, magical types." There is no need for me to say or prove to you that these are lies, illusions created to sell a product, this time black women to white men. Similarly, the presence of these industries, the products and the tourists of the rich white countries in the Third World, has created another illusion to attract poor black women: the illusion of the rich white male who takes vacations and enjoys life far away from home, who seems not to mind having a relationship with a prostitute and who promises her everything under the sun.

In the second half of this century, these two developments, global industry and false image-forming aggressively promoted by the tourist industry, have led to the further objectification and commercialization of women and women's sexuality. As poor countries get poorer and poorer, more and increasingly younger women are regarding themselves and their sexuality as the only commodities which are marketable. And the market has surpassed all barriers today and all boundaries. This market is international. Criminal rackets and individual exploiters are also organized internationally to cash in whenever they can. And in order to resist this we have to organize ourselves internationally too. And that is why we are here today. So, whores of the world and all women let us unite!

STATEMENT ON PROSTITUTION AND HUMAN RIGHTS
International Committee for Prostitutes' Rights
European Parliament, Brussels
October 1-3, 1986

The European Convention on Human Rights was drafted within the Council of Europe in 1950 and came into force in 1953. All twenty-one of the member States have ratified it. Those States include: Austria, Belgium, Cyprus, Denmark, France, Federal Republic of Germany, Greece, Iceland, Ireland, Italy, Liechtenstein, Luxembourg, Malta, the Netherlands, Norway, Portugal, Spain, Sweden, Switzerland, Turkey and the United Kingdom.

The International Committee for Prostitutes' Rights (ICPR) demands that prostitutes, ex-prostitutes and all women regardless of their work, color, class, sexuality, history of abuse or marital status be granted the same human rights as every other citizen. At present, prostitutes are officially and/or unofficially denied rights both by states within the Council of Europe and by States outside of it. No state in the world is held accountable by any international body for those infractions. To the contrary, denial of human rights to prostitutes is publically justified as a protection of women, public order, health, morality and the reputation of dominant persons or nations. Those arguments deny prostitutes the status of ordinary persons and blame them for disorder and/or disease and for male exploitation of and violence against women. Criminalization or state regulation of prostitution does not protect anyone, least of all prostitutes. Prostitutes are systematically robbed of liberty, security, fair administration of justice, respect for private and family life, freedom of expression and freedom of association. In addition, they suffer from inhuman and degrading treatment and punishment and from discrimination in employment and housing. Prostitutes are effectively excluded from the Human Rights Convention.

The World Charter of Prostitutes' Rights which was adopted by the ICPR in 1985 demands that prostitution be redefined as legitimate work and that prostitutes be redefined as legitimate citizens. Any other stance functions to deny human status to a class of women (and to men who sexually service other men).

The European Parliament recently took a step toward decriminalizing prostitution and prostitute workers by adopting a resolution on violence against women which includes the following clauses (see Hedy d'Ancona resolution, Doc. A2-44/86):

> In view of the existence of prostitution [the European Parliament] calls on the national authorities in the Member States to take the necessary legal steps:
> (a) to decriminalize the exercise of this profession,
> (b) to guarantee prostitutes the rights enjoyed by other citizens,
> (c) to protect the independence, health and safety of those exercising this profession...
> (d) to reinforce measures which may be taken against those responsible for duress or violence to prostitutes...
> (e) to support prostitutes' self-help groups and to require police and judicial authorities to provide better protection for prostitutes who wish to lodge complaints...

Concrete implementation of those steps requires specifications of the violations in each state. One goal of the Second World Whores' Congress is for prostitutes from countries represented within the Council of Europe and outside of it to specify those violations. The summarized list stated here will be elaborated at the congress.

Violations of the Human Rights of Prostitutes:
1. *The right to life*
 Murder of prostitutes is a common occurrence throughout the world. And, those murders are commonly considered less offensive than other murders, as evidenced by the fact that prostitute murderers are often not sought, found or prosecuted.
2. *The right to liberty and security of person*
 The physical safety of prostitutes is threatened by the criminal sphere in which they are forced to work.

The physical liberty of prostitutes is restricted by state and city regulations which prohibit their presence in certain districts or at certain times. For example, a woman standing on the street "looking as if she is a prostitute" can be fined for passive solicitation in France even if she is not negotiating a sexual transaction. Or, a prostitute in Toronto, Canada can be given a curfew (nine P.M.) by the court if she hasn't paid three or four solicitation tickets; if she disobeys the order, she can be sentenced to six months in prison for disobeying a court order.

The right to liberty and security of persons is totally denied to women who are deceitfully or forcefully made to practice prostitution. In particular, the common transport of "Third World" women to the West under false pretenses denies both liberty and security to women. The right *not* to work as a prostitute is as essential as the right to work if one so decides. Sexist and racist denial of both rights is widespread.

Prostitutes usually do not enjoy the same police protection of their liberty and security as other citizens. Due to the criminalization of their profession, they risk fines or arrests so they avoid calling upon police for protection. Police are frequently known to grant immunity from criminal action in exchange for information and/or sex, i.e. rape by the state, as the cost for liberty.

Forced medical testing which denies choice of one's own doctor and medical facility denies liberty to prostitutes. Denial of worker's compensation prevents prostitutes from liberty and health security in case of illness.

Forced or pressured registration with the police stigmatizes prostitutes and frequently violates their privacy and liberty to change professions if they so choose. Prostitutes are denied job mobility by requirements for letters of good conduct which are granted only to those who can prove that they have not engaged in commercial sex for at least three years (for example, in Switzerland and Austria).

3. *The right to fair administration of justice*

Application of laws and regulations against prostitution is usually arbitrary, discriminatory, corrupt and hypocritical. In Paris, for example, street prostitutes are given an average of three tickets per week for passive or active solicitation; at the same time, they are heavily taxed for their prostitution earnings.

Prostitutes who are raped or physically battered are unlikely to succeed in bringing charges against the rapist or batterer. The prostitute is considered fair game for abuse even by state and judiciary authorities.

Foreign women who were deceitfully or forcefully transported for purposes of prostitution rarely succeed in bringing charges against the violating party.

Male law enforcement officials, like other men, are frequently customers and/or violators of prostitute women. Police, for example in the United States, Canada and Great Britain, regularly entrap women by posing as customers and arresting them as soon as they mention a price for sex. Even if the prostitute is careful not to men-

tion a price (many have learned to expect police deceit), she may be convicted because a police officer's word carries more credit than a whore's word in court. Prostitution laws are discriminately enforced against women, especially "Third World" and poor women, and against "Third World" male associates of those women.

4. *Respect for private and family life, home and correspondence*
Laws which criminalize those who profit from the earnings of prostitutes are frequently used against the family of prostitutes, for example in the United States and France. Such "anti-pimping" laws violate a prostitute's right to a private life by putting all of her personal associates, be they lovers or children or parents or roommates, under even more risk of arrest than exploiters and physical violators.

Confiscation of personal letters or literary work of prostitutes, for example in the United States, is a clear denial of respect for home and correspondence, not to mention a denial of freedom of expression.

5. *Freedom of expression and to hold opinions*
The word of prostitutes is generally assumed to be invalid in public, for example as evidence in court. The opinions of prostitutes are rarely given a hearing, even in relation to their own lives.

In private, prostitutes are often used as police informants and as counselors to male customers. In public, be it on the street or in court, their testimony and opinion are silenced.

6. *Freedom of peaceful assembly and association, including the right to join a trade union*
Prostitutes are prevented from working together for purposes of safety, cooperation and/or commercial advantage by specific statutes which criminalize "keeping a house" or other necessarily cooperative work forms.

Until prostitutes are recognized as legitimate workers, rather than as outlaws or vagrants or bad girls, they cannot officially form trade unions.

7. *The right to marry and found a family*
Both the right to marry and the right not to marry are frequently denied to women, in particular to the prostitute woman. Marriage is impossible if husbands thereby become outlaws, i.e.

pimps. The denial of rights and legitimacy to unmarried women, on the other hand, can force women to marry against their will. A prostitute may also be denied the privilege of motherhood when the courts declare her unfit on the basis of her professsion.

8. *The right to peaceful enjoyment of possessions*
The possessions of prostitutes and their associates are confiscated on the ground that they were obtained with "illegal" money; they are also confiscated when a prostitute cannot pay the fines levied against her for the practice of her profession.

9. *The right to leave a country including one's own*
Prostitutes are denied the right to travel across national borders by signs or cuts on their passports (or identity cards) which indicate their profession. Also, police records registered on computers at certain borders will prevent prostitutes from leaving or entering the country.

10. *Prohibition of torture and inhuman or degrading treatment and punishment*
The above mentioned violations indicate inhuman treatment. Degradation of prostitutes is the norm both among official bodies, such as governmental and judiciary institutions, and among community bodies, such as neighborhood committees and social service agencies.
Forced prostitution should be recognized as a case of torture.

11. *Prohibition of slavery, servitude and forced labor*
Servitude exists both in cases of forced prostitution and in cases of voluntary prostitution under forced conditions. State regulated brothels such as found in Hamburg, Germany and Nevada, United States allow no choice in clientele, no right to refusal, no right to a fair share of the earnings, forced isolation and forced overwork. Most brothels in the Netherlands force unhealthy practices such as no condoms (or less earnings for condom sex)° and/or forced alcohol consumption.
Juvenile prostitution is a case of forced labor but the managers, be they managers of pornography or prostitution, are rarely prosecuted whereas the children are often stigmatized and punished.

°It should be noted that, since the writing of this charter, safe sex campaigns in the Netherlands and elsewhere have decreased but not yet elimianted forced denial of condom use.

12. *Prohibition of discrimination in the enjoyment of rights and freedoms guaranteed by the Convention*

Prostitutes are discriminated against in the enjoyment of every right and freedom. Prostitutes of color, foreign prostitutes, street prostitutes, drug-addicted prostitutes and juvenile prostitutes suffer extra and often extreme discrimination.

13. *Prohibition of the collective expulsion of aliens*

Expulsion of foreign women who entered the country under conditions of deceit or force and who often await persecution in their native country is a violation of human rights.

HEALTH: "OUR FIRST CONCERN"

GENERAL HEALTH ISSUES

Ans van der Drift (Netherlands): I am speaking from twenty-nine years of experience as a prostitute, both on the street and behind a window in different Dutch cities. Our profession is not immune to disease. But, if you are careful, you do not have to get sick at all. I am full of information on VD and about how to avoid it. We have got to protect ourselves from the diseases that men, and I say men, can bring to us. If you want to exercise this profession for any length of time and you want to take care of your health, you have got to use a condom. We should not let men who pay us perhaps a hundred guilders more detract us from using a condom. In the Netherlands, everything looks as if it is so well regulated. We don't have forced VD checks as a national regulation, but in many clubs doctors come around and check the girls. Well, this sort of check does not mean that the girls can work without condoms. Let's face it, any man could come along with a disease and infect you. Also, there are other health factors in our work besides VD, such as the condition of the beds and showers. Sometimes they are in an awfully bad state. And, as far as I'm concerned, there is spiritual health. In our job, you can laugh a lot. I am proud of my work, but you've really got to have a sixth sense for people's negative attitudes. I don't want to be moralizing or anything, but one of the sick-making facts is the attitude of society toward our profession. Most of us are independent, free-thinking people. In this congress, we've got to talk about how we can possibly change the mentality of people regarding our profession.

Marjo Meijer (Netherlands): I'm a general practitioner in Amsterdam. I have clients who are prostitutes and clients who are not prostitutes. From my experience, I have noted that both groups have sexually transmitted diseases. The idea that especially prostitutes have sexual disorders is a misconception. What I have noted is that prostitutes use condoms far more frequently than women who have sex but are not paid for it. In my practice, I have about twenty or

twenty-five cases of gonorrhea and chlamydia a year and, for example, this year only one case was a prostitute; all the others were not prostitutes. We've got to forget the idea that there's something special which has to be organized just for prostitutes. All women have got to be aware, all of them.

I have learned a great deal by working with the women of The Red Thread. What we doctors have to do is inform our colleagues that prostitutes are not limited to sex organs or genitals. Very often prostitutes are spoken about derogatorily as spreaders of venereal disease. In Amsterdam, doctors go into the clubs or bars and carry out check-ups every two weeks. These doctors are very well paid. The women who undergo these check-ups and examinations on a regular basis are told that they are protected in this way against any form of venereal disease. But that is not true. They can contract diseases despite these check-ups. As doctors, we must participate in public debate and we must show respect for sex professionals.

Carla Corso (Italy): I think that separate clinics for prostitutes are just ghettos for us. I think that we've got to talk about general agencies for all women. All women have a vagina, all women have an uterus, so why should we divide ourselves into prostitutes and non-prostitutes? I think it is absurd.

Geoffrey Fishe (Australia): I am from the Australian Prostitutes' Collective. I'm going to talk briefly about the male prostitutes in Australia and their relationship to health education. The gay community is far more advanced than the general community as far as AIDS education goes because AIDS has been in the gay community for a longer period of time. It is a common belief that male prostitutes are all gay and that they are therefore covered by the gay community in regard to education. But some of the male prostitutes are not gay and they never will be gay and they never have been gay; they offer services for gays. And some male prostitutes who may be gay don't identify with the gay community and therefore have no access to this community and to the information that supposedly filters down within it. These people operate in their jobs in virtual isolation from an organized community. Gay men and male prostitutes have been represented within our collective for only a very short time. One of the differences probably between the clients of male prostitutes and the clients of women prostitutes is that education for the client of male prostitutes is probably a lot better as they have been aware of the AIDS virus for a longer period of time. This leads to the point that a lot of the problems lie

with education of the client as opposed to the education of the prostitutes. Prostitutes, both men and women, have been looking after their health for many years. It's time the clients started to insure their own health as well as the health of the prostitutes. In our country, many of the boys that are working are stigmatized by their own community. They don't fit into the gay community and they don't fit into the broader community which leads to a double bond of isolation. We are trying to break down this problem and the only way it can be done is by making sure that all areas of prostitution are represented and have a voice in such places as this.

Lin Lap (Singapore/Netherlands): I'd like to say two things about the situation of migrant women who are working in prostitution. The first thing I'd like actually to address to the people here who are working in the medical profession. In the Netherlands, several women have said that they told doctors who came to the clubs that they were not happy in their work and that they were working against their will, but the doctors did not respond. Some doctors even denied later that the women had tried to communicate with them.

The other point is to remind the conference of the presence and increasing number of migrant women working in prostitution and the importance of taking into consideration the language difficulties these women have in receiving information, such as safe sex guidelines, if given in just the one language of the country. In this context, there is a Thai folder made on AIDS available outside [other participants announced the availability of flyers in numerous languages].

Hans-Gunter Meyer-Thomsen (West Germany): I am from Hamburg. This will be about to what extent professional conditions of prostitutes lead to professionally caused illnesses. Prostitution is work and every work has its occupational hazards. This is true, for example, of the painter who works with dangerous substances or the carpenter who cuts his finger or the saleslady who has to stand for hours on end. Every accident you have on the way to work is an occupational accident. The work of prostitution likewise has occupational hazards. There should be health protection and health insurance for prostitutes. There should be social benefits. Prostitution is difficult work. If we look at medical literature, then we find a tremendous amount about venereal diseases and a great deal about the so-called psychopathology of prostitution. But, there is almost no single investigation of the work itself, of the task that is involved. Everyone of us knows that certain diseases invariably appear under certain work con-

ditions. Venereal disease is one occupational hazard in prostitution. Stress and other occupational difficulties lead to irregularity in sleep and eating habits. We know that working outside day and night leads to health disturbances. Prostitutes often have chronic bronchitis and kidney inflammations. And, more problems arise with increasing years of professional activity. It's not just a matter of the physical violence of customers or pimps that is involved. People who write in scientific literature are concerned about public health but not from the point of view of the prostitute. They always take the point of view of other people. It would be good if we could show the occupational hazards of prostitution. Then you admit that prostitution is an occupation and then you've got to protect it. Socially, you've got to provide health protection.

Peter Greenhouse (England): It's certainly a great honor to be invited to speak firstly because I am not a woman and also because I am not a prostitute. I am happy to report that the sexually transmitted disease service, the STD Service, in England, was the first set up in the world and is probably the best in the world. Its practice already agrees with your Human Rights Policy. Treatment is completely free for everybody, including foreigners. There is a free choice of clinics to attend. Also, the service is completely anonymous. Now, having said that, you would have thought, Everything is fine. There is no problem. But, you are wrong. The real reason that you are wrong is that there is very very poor public education about sexually transmitted diseases. There is also, until recently, very poor education of medical students about sexually transmitted diseases. And thirdly, there is a completely artificial and unnatural division of medical specialization between gynecologists and sexually transmitted disease doctors. Very few sexually transmitted disease doctors have any formal gynecological training. And almost no gynecologists have any sexually transmitted disease training. Most senior gynecologists are extremely conservative and certainly very few gynecologists in England would be sympathetic if you said you were a prostitute. In fact, they would probably just tell you to go away, not to waste their time, just not to bother them. Therefore, there are some very serious potential gaps in medical management of prostitute problems. Most prostitutes are very sensible. They go to sexually transmitted disease clinics. But thest clinics cannot handle all of these women's problems. They may need help from gynecologists in two very important areas: the first area is the problem of pelvic infection and the second is precancer of the cervix. Pelvic in-

fection, infection of the uterus and of the tubes, causes severe long-term pelvic pain with intercourse. It also causes ectopic pregnancy, that is pregnancy in the tubes, and infertility. It is sexually transmitted. The most common agent is called chlamydia which is five times more common than gonorrhea. Chlamydia causes NSU (non-specific urethritis) which is the commonest of all sexually transmitted diseases. And, a quarter of the men who have it have no symptoms and can therefore pass it without knowing it. Most prostitutes go to special clinics. Of one hundred prostitutes followed at the St. Mary's Clinic, which is the biggest in the world, eighty percent had deep pain and fifty percent had chlamydia at the time of their first visit. Some of these women will get long term pelvic pain with intercourse and will require gynecological help, with surgery to cure the pain. But the attitude they get will be very bad. Most other women who are not prostitutes go not to the special clinics but to gynecologists and, because the gynecologists have no training, these women get the wrong treatment, the wrong tests, and no contact tracing. A woman's partner will therefore not be treated and he will give the infection to you prostitutes. Aside from pelvic infection, the second area in which prostitutes may need help from a gynecologist is precancer of the cervix. This is a sexually transmitted disease causes by genital warts called condyloma. They are very common; they're very similar to the warts you get on your fingers. The vector is the man, or the male penis. Screening by papalicolo smear is notoriously inaccurate. In the prostitutes' group that I described, about thirty percent had abnormal smears and screening by pap smear seriously underestimates the extent of the abnormality.

In conclusion, pelvic infection and cervical precancer are the two biggest sexually transmitted disease problems for prostitutes. They are much more significant than AIDS in terms of numbers and probably even in terms of future implications for all of you sitting here at the moment. Service in these areas, as I've already told you, is very poor. You are the customer and you have the right to expect a good service. So you must go out and educate for it, you must go out and agitate for it, you must go out and fight for it. You are my customers. You are my clients. I am at your service.

Priscilla Alexander (U.S.A.): The problem of health care for prostitutes in the United States is a little bit different in the U.S. than it is in many of your countries because the U.S. does not have any kind of government subsidized health care for the whole population. There

is some subsidized health care for poor people but you have to be very very poor in order to get it and not all services are covered. So most people in the United States have to have private health insurance which is usually affordable if you get it on the job and your employer pays half or all of your premiums. But prostitutes who work in an illegal industry do not get access to group health coverage so medical care for prostitutes in the United States is prohibitively expensive. Workers' compensation and disability are two kinds of insurance in the U.S. that are available to people who become ill or who are injured on the job. Again, prostitutes are not eligible for workers' compensation or disability because they are working in an illegal industry. So, if they lose time from work for a sexually transmitted disease that they get from a client, they cannot get payment from the government or from insurance during the time that they are out sick. If they are raped and battered on the job, similarly they get no access. If they are beaten by the police when they are arrested, they similarly have no insurance to help them get through the time when they are unable to work.

Micaela (West Germany): Also in Germany, we are not covered by health insurance. Without health insurance we are *forced* to work even when we are sick because we have to pay the doctor. And that means sloppy work. . . that's true.

COMPULSORY MEDICAL CONTROLS

Maggie (West Germany): In the city of Frankfurt we have a general health monitoring, a registration which is done by the health office. We are obliged to be tested once a week. That is, we are picked up every week for venereal disease tests except syphilis which they do a blood test for once every three months. This goes on anonymously but my doctor knows me so it is not really anonymous. We are registered with the health office which must not transmit any information and hopefully it works that way because otherwise we have big problems. Now, if a woman does not take the tests, then she is taken to the health office by the police. It may happen that the police break into her house and take the woman with handcuffs. This has happened. You also have to report before taking a vacation and you have to write a postcard telling them greetings from wherever. This is all an invasion of privacy, a violation of human rights I would say. In any event, we run around with inspection cards and we would like that to be abolished. There is a crazy project in Berlin where social workers start

talking to you and then you are picked up and tested. It should be that a woman is only tested of her own free will.

Micaela (West Germany): I would like to add that in the Federal Republic of Germany, the checking of prostitutes for disease varies from one section of the country to another. In much of the country, it is better than what Maggie described, but still there are criticisms one can make. What is positive is that there is the possibility of having free health protection in an office where there are social workers present to help you. It's not just a matter of cards and taking blood samples. There is also the possibility of discussing one's problems with professionals with whom one can have a confidential relationship. For the most part, these are women which is another good thing.

Brigitte Pavkovic (Austria): Austria is a country in which the Health Ministry forces all sex workers to have medical examinations whether they are on the street or in private clubs or elsewhere. We all have compulsory tests, but we demand a free choice of doctor and anonymity. We think that these tests are for our own protection. We also think that foreigners coming into the country should be tested. We don't want to stop foreigners from coming into the country, but now, with the AIDS epidemic, they should be tested when they enter.

Danny Cockerline (Canada): I think that testing people at the border is discrimination against people who have AIDS as well as against people who may simply test positive for the AIDS virus which does not necessarily mean that they've got AIDS. Just because you have a virus or an antibody to a virus does not mean that you should be refused entry to a country because it does not mean you are going to be practicing unsafe sex anyway. So, I don't think that's the answer.

Frau EVA (Austria): My colleague emphasized that we don't want to stop foreigners, that is a misunderstanding. But testing of travelling men who go on vacations abroad is especially important. We feel that there is great danger of propagating sexually transmitted diseases through these travelling men. What we want is a general compulsory test for everyone including the customer and the marginal prostitute operator. Of course, we demand anonymity and free choice of doctor.

Julie Bates (Australia): I challenge the Austrian delegates regarding compulsory health checks. I am a bit horrified about what they said. I am an ex-worker from Australia. I returned to work to earn the money to be here today. A prostitute worker's livelihood depends on her sexual health protection and she is generally more aware of the risks than

other people and therefore she will visit a clinic or a doctor of her own accord. In fact, she will do this more than any other sexually active woman may do in her entire lifetime. The reason some prostitute women put off visiting clinics and doctors is the lack of rapport that exists in the clinics for them. I'm pleased to say that we of the Australian Prostitutes Collective work with the clinics, we give workshops and we give the necessary understanding for the clinics to treat people with a great deal of respect. When there's respect, prostitutes feel comfortable and they will come and be tested.

Pia Covre (Italy): In Italy the obligatory health control of prostitutes is actually banned by the laws approved in 1958. We think that controls of prostitutes are strange and wrong because, after all, it's the client who spreads the disease. Either you have to check all people who are sexually active or you've got to educate people to go and have voluntary checks. In Italy there is a social reform law for sexual education in schools which has been floating around the parliament for about four years with nothing being done. There is no progress.

CONDOMS

Maggie (West Germany): We have talked a lot about protecting ourselves by using condoms. Well, perhaps we stand alone here but there is hardly any work done with condoms in Germany. If you work with a condom in Germany, you will make very little money, in any part of the sex industry. I mean, it's not just fewer marks but no marks.

Ina Maria (West Germany): Customers consider condoms as inferior. People who work with condoms barely make enough money to pay for their expenses. Condoms are out in Germany.

Another German speaker: In sex clubs in Germany, you are not even *allowed* to work with condoms. If a woman tries, she will be kicked out and will be fined.

Dolores French (U.S.A.): I am shocked and horrified. Why isn't the German government making it a law that the customers who refuse to wear prophylactics should be penalized? The United Nations should take action against this kind of violation of the human rights of prostitutes. I don't know what we can do about it, especially in a country where prostitution is legitimized, or legalized. I don't understand this. Maybe we should send a letter of condemnation to the German government for not supporting women's use of condoms in the professional brothels. I am outraged that the government is not helping you

in that way [see telegram sent to the Federal Republic of Germany at the conclusion of this session].

I'd like to demonstrate what I've learned to protect my health in countries where the men resist using condoms. In a whore house in Puerto Rico, a woman showed me how you can get a prophylactic on and off without the customer knowing about it so that you can avoid getting infected. It took me probably five or six tries to practice and several months to perfect it. The men I was practicing on would say, "What are you doing?" and I would explain, "I'm practicing." I would just jolly them on about it, you know. So, I want to show you what I've learned and if you can apply it in your situation, that's fine. I am very nervous because I would be immediately arrested in the United States for doing such a demonstration. It's sort of like a magic act. I think I'm probably gonna need to stand up to do this. [She stands and exposes a large banana]. I'm going to need some help too, somebody's gonna have to hold this banana. [Lynn volunteers] Okay, hold my banana. This is my lovely assistant, Lynn Hampton. [Lynn: "And this is my dick."] [Laughter] Can I have it in the right position please. Okay, that's good, that's fine. Now, first of all, you've got to get the prophylactic in your mouth. [Dolores puts the prophylactic in her mouth and continues explaining and demonstrating each step of the procedure on Lynn's banana; the audience howls with laughter; some interpretors are laughing so hard that they cannot translate].

After he ejaculates, you reach down and hold the prophylactic which will pull off very easily since, unlike this banana, the dick will be deflated. You have to flick the prophylactic around your finger like this so that nothing leaks out onto your vagina as you're pulling it out. Then I always keep some water nearby with a washcloth or something and I reach over into whatever and the prophylactic's gone and I have a washcloth that I'm washing them off with and very few are ever the wiser. Many customers have said, "Gosh, that really felt different" [laughter] and I say things like, "Since I'm not your wife, it probably feels different, you know." After I have seen my customers many times, they may notice that I am doing it and then they want to know why I'm doing this since I never did it before. At that point I usually explain that we've always done it, and they get over it. I have all the sympathy in the world for those of you who are working in Germany because I've worked in countries where men don't want to use prophylactics. I understand that from time to time you are going to get

caught and he's going to want his money back. I'd rather lose the money one time than lose my life or risk getting incarcerated in an AIDS concentration camp because I test positive for AIDS. I think these are really gruesome thoughts but they're fears I have and things I'm trying to avoid.

Gloria Lockett (U.S.A.): I can't top Dolores' demonstration, I'm not even going to try. . .but I have a little different style, and I do have a bigger one (she holds up a huge zucchini). I really don't care that much about the guy being upset because I put a condom on him. But I try to do it as discreetly as possible. What I do is. . . . (and she begins to demonstrate) I just stick it in my mouth, in the top of my mouth, like so, and I roll it on. I press it down there, to there, and then I just. . . And, this is for head or whatever. I roll it down. Usually the lights are off and usually the guy does not know he has it on. Of course, I get him all hot and bothered, whatever, and I keep his mind off it. I have a lot of guys who say afterwards, you know, "What is this thing doing here?" I say, "What do you mean what is this thing, this is a condom. You just had an orgasm." If he asks for his money back, I tell him I'm sorry, I really am.

Grisélidis Réal (Switzerland): Personally speaking, I have many foreign or immigrant clients who will not under any circumstances accept any fellatio, they don't want you to even hold it in your hand, they've got their own way of making love. If I want to keep those customers, then I have to respect their traditions. As a fifty-seven-year-old prostitute, and therefore a bit older than many of you, I cannot always use condoms. I have clients from abroad, they have never used them. I would not even be able to make a penny. I could not make any money at all. So, I very rarely use a condom. As long as my clients respect me and pay me for my work—because I don't do this out of charity—as long as they are not aggressive, drunk, or sick—and believe me, I check to make sure—then I respect them also. It's very difficult to impose the use of a condom and well, I don't know what to do.

I think that an important point of disease prevention is eating only natural substances to eliminate all toxic substances from the body. In addition to condoms as a preventive measure we could also try to bring down the huge consumption of chemical products such as antibiotics, tranquilizers, sleeping pills, etc. which bring down your resistance and completely destroy the resistance of your metabolism.

Lynn Hampton (U.S.A.): I would like to say something to the women who work with men for whom condoms are not acceptable. I

believe that the reason they are not acceptable is because the client is ignorant of the truth. We, as prostitutes, are in the position of being teachers. We can simply explain to our clients that since people carry the disease for years without knowing they have it, that out of respect and caring, we much prefer to use the condom because we think much too much of them to take a chance. I don't know of a man who isn't flattered by that kind of crap.

Terry van der Zijden (Netherlands): It is not right that we have to educate the clients because, after all, we are paid for sex and we never get paid for all the educating we do, for example by government information services. There should be general educational programs in each country that break through men's resistance to using condoms.

Dutch speaker: I just want to say that also in the Netherlands there are clubs, the fanciest clubs, that do not allow women to use condoms. And, most of the clubs have different prices for "with" and "without" so we're pressured to work without condoms because we earn much more that way.

Priscilla Alexander (U.S.A.): In the United States in many cities, when police arrest prostitutes, they confiscate the condoms to use as evidence in their trials, which is obviously a human rights violation. If they don't do that, they puncture the condoms full of holes.

Gloria Lockett (U.S.A.): I have myself had as many as twelve dozen rubbers poked holes in at one time. What COYOTE is trying to do now is to go to different police chiefs and stop this. We have to fight hard because they are the police and they have all the power. But we are continuously trying to fight against this because it's terrible. I mean this is life! A few years ago, I'm talking about 1978, all you were talking about was venereal diseases which was bad enough. But now we're talking about AIDS. So we are definitely fighting because they are still doing it.

Dolores French (U.S.A.): In Atlanta, Georgia, we have a motion before the courts right now which will prohibit prophylactics from being used against women as evidence that they are prostitutes and we're on the verge of winning that case. The judge has assured us that he will uphold our request.

Roberta Perkins (Australia): In Sydney there are certain parlors or brothels where the managers simply refuse to allow the women to wear condoms. The women who work in these parlors or brothels are not aware that they can actually move out and go someplace else. We hear of all these strategies that are suggested by women on how to get

men to use condoms and I mean there is really a broad range. One of the best I heard was a woman who said that when a customer adamantly refuses to use a condom, she says, "Oh, that's okay, but then give me the name of your wife and your girlfriend and their phone numbers because I will have to tell them in case I've got a disease and pass it on to you." And she claims that every time the man will turn around and use a condom.

Gloria Lockett (U.S.A.): A line that I have used for years, many years, is, "The fuck is for you, the condom is for your wife, okay?" and that's that, there's no discussion.

Priscilla Alexander (U.S.A.): One woman I know says to the customer, "Now we've got to wrap this up to keep it safe." She does a whole thing on how she's taking care of his penis.

Doris Stoeri (Switzerland): I'd like to speak about my experience and particularly tell you how in Switzerland we have managed to cooperate both with medical authorities and governmental authorities. At the onset, when I learned about AIDS, I thought, Oh boy, that is really going to affect prostitutes. However, I soon realized that it is not really the risk but the stigma that prostitutes face. It was clear that once homosexuals and drug addicts were involved, prostitutes would be added because they are the links so to speak between these marginalized groups and the population as a whole. I was very worried about the evolution of this situation so I very quickly tried to fight for anonymous tests for those who want them and now anonymous tests are available in the neighborhood. We've published a brochure, we have made contacts with municipal authorities, we have received about 10,000 Swiss francs in funds for our work. We have done a great deal. We have met with government health authorities and medical specialists and well, they were totally unaware of the problems of prostitutes. They did not know anything about the profession. I think it is very important to bear in mind that prostitutes have potential knowledge, information that they can provide. But there must be solidarity concerning condom use. Prostitutes need assistance, they need information that they can provide to the customers and the customers have to be receiving information from other sources. There is a great risk here and I realize that when we just speak about customers or clients and not about men in general, then obviously we are stigmatizing prostitutes again and we are talking about a risk factor in prostitution. I feel that we must campaign for the whole population and provide information across the board to all men and women who

are sexually active. I realize that the problem is not essentially a medical problem but a human problem. Also, when I hear women say that they cannot use contraceptives or condoms, I think that we have to discuss it and speak openly and realize that they are afraid and realize that it is first and foremost a human problem. We must consider that ninety percent of the people who are dealing with AIDS are doctors and doctors speak in figures, they speak about research studies and things of that type, but I think what is most important is that we speak about the experience of women. For example, we have to listen to an older woman like the woman here who says, "I can't use condoms, I can't ask my clients to use them." The Germans have said the same thing. That's the way things are and it's not enough to say, "Well, you should use them."

Miriam (Cyprus/England/Netherlands): I would like to say that one solution to the condom problem is solidarity between all us workers. As we are the commercial providers of sex, we are the ones that should say how we provide the service, not the customer. I think a unanimous attitude towards the use of condoms is something that can solve parts of our problem and solve the problem of the myth of prostitutes being the age-old carriers of disease. I know, for example in Holland, there are some streets where all the girls work with condoms. And customers still come. But it takes solidarity. We all have to agree as workers that we use condoms and not give the free choice that you can have sex without condoms. We can still make our money.

Gill Gem (England): I'd like to know which other countries have free condoms. We can get free condoms in certain amounts in family planning clinics but you can't get them all the time and you can't get them in large amounts. I'd like to know what's being done to get free condoms out of the government since they are forcing people on the game in the first place.

Gloria Lockett (U.S.A.): We don't have free condoms in the United States but we do have a place where you can get these condoms at seven cents; they will sell them to us at cost. There are different places where you can get them free like the health department but not in general.

Roberta Perkins (Australia): We are able to get free condoms out of the government in New South Wales. We are a bit fortunate in having a government since '79 which began to decriminalize prostitution laws and which is basically on our side, working for us rather than against us. That allowed us in recent times with the AIDS hysteria to put pres-

sure on the government itself. After the hysteria of the government saying things like, "Oh, these prostitutes have got AIDS and are now passing it on to the nice heterosexual community," we said, "Well, give us a million dollars and we'll stop it." They did not quite give us a million dollars but they gave us 120,000 dollars which is not a bad effort. What it has enabled us to do, next to our basic lobbying for removing further laws on prostitution, is to reach every single parlor, or brothel if you like, in the metropolitan area of Sydney and in some major country areas of New South Wales—which is the state of Sydney — and Canberra—the national capitol. At this stage we have been inside something like 152 brothels. You have to pander to the managers because the managers are the ones who say, "You use condoms" or "You don't use condoms." So you go in there and convince them that condoms are going to make their business better, like it is going to make their business healthier and therefore they are going to make more money out of it and all that sort of thing. They aren't too sure that we aren't an arm of the government now that we've got money from the government so they are a bit unsure of us. We use all these sort of things to get them on our side and it is working very well. Out of the 152 brothels, we have been rejected by managers on only seven occasions and we know damn well why that is. They don't allow the women to check their clients or use condoms. But seven out of 152 is not too bad and we are still going strong. I would convince the government that if you give us free condoms, we'll distribute them widely throughout the community and we'll educate the workers or prostitutes. In fact, we don't go up there and educate the workers or prostitutes. What we do is tell prostitutes how they can convince the customers to use condoms. So, I mean the bottom line is to educate the customers and that is what we are doing.

Miriam (Cyprus/England/Netherlands): I sympathize with all the women who have the problem of putting condoms on their customers. But the way I see it is that we have to make it universally known that we don't want to work without condoms because our first concern is our own health and that of our families. We must remember that WE are the ones that provide this service, WE are the ones who set the terms. What's available to buy is really up to us!

AIDS

Pia Covre (Italy): I would like to say something about the personal experience of our committee in Pordenone which is a small northern

Italian city of about fifty thousand inhabitants. We participated in an experiment and went voluntarily to be tested for AIDS antibodies. The research was carried out by scientists on homosexuals, prostitutes and drug addicts. At the same time, there was a survey on sexual habits. All of it was published in the *Lancet*, a well-known British medical journal. I will just talk about the results for the prostitutes. Seventy-one percent of the drug-dependent prostitutes were carriers of the antibody and none of the non-drug-dependent prostitutes were carriers. Also, most of the drug-dependent prostitutes rarely used condoms while all of the non-drug-dependent prostitutes *always* used condoms when they had sex. We know perfectly well it is not the choice of the drug-dependent prostitutes not to use condoms but the choice of the clients. It is the clients who need to be educated because they take advantage of the weakness of drug-dependent prostitutes by saying, "Oh, I'll pay you a bit more if you don't use a condom." This obviously has a great impact on the spreading of AIDS.

Inge (Netherlands): I am an ex-heroin addicted prostitute from The Hague. I want to stress that all heroin addicts are not AIDS carriers and that it is men who are not wearing condoms, not addicted whores, who are spreading AIDS.

Gail Pheterson (U.S.A./Netherlands): I would just like to make one comment: It is not drug dependency per se but the sharing of needles that spreads the AIDS virus, except perhaps in so far as drug dependency can lower one's immunity to disease and thereby leave one more vulnerable to infection. Of course, sex without condoms opens a second route of contagion for intraveneous needle-users.

Priscilla Alexander (U.S.A): As in other countries, prostitutes in the United States are blamed for sexually transmitted diseases although public health figures indicate that only five percent of sexually transmitted diseases are related to prostitution in the United States. Still, prostitutes are blamed. In the case of AIDS there is enormous scapegoating of prostitutes in the United States based on absolutely no evidence. The studies that have been done indicate that the only prostitutes who have been found to carry AIDS antibodies are some IV-users. The one study that compares prostitute and non-prostitute women, which is in San Francisco, shows no difference between groups; in both cases those who test positively for AIDS antibodies are either IV-users or in regular sexual relationships with IV-users or bisexual men.

The issue of "Blame The Prostitute" is the same all over the

world. We are opposed to any kind of mandatory testing of prostitutes for any kind of sexually transmitted diseases. *Condoms prevent disease; mandatory tests do not.* The only thing that prevents the spread of AIDS, the only thing that prevents gonorrhea, syphilis, chlamydia and the whole range of sexually transmitted diseases is the use of condoms backed up by a spermicide containing nonoxynol-9. There is need for massive education of the straight community in the United States because they think that they are not at risk for AIDS and so they are the ones who are not using condoms. All the studies indicate that prostitutes in the United States are using them. The practices have changed drastically in the last five years.

The studies out of Africa are very misleading. In one study in Zaire, 88% of prostitutes were positive on the AIDS antibody test and only 28% of customers. In Kenya, 54% of prostitutes and 9% of customers were positive. Everybody says that this is proof that prostitutes are transmitting the disease and I say that *this is proof that the customers are giving the disease to the prostitutes*.

And finally, there was a test of prostitutes in Seattle (U.S.A.) that was mandatory in the jail. The first available test, called Alisa, was used. The results showed 5.5 % of the prostitutes to be carrying AIDS antibodies and those results were widely published as proof that prostitutes are infected. The same samples were retested when the Western Block Test was made available and all the samples were negative. The head of Public Health in Seattle, Dr. Hunter Hansfield, has refused to go public with that information because he is embarrassed that he did such a terrible thing. So, that test is a lie and I think that many of the tests are lies and they lie about prostitutes and that is what has to stop.

Gloria Lockett (U.S.A.): I would like to speak for a few minutes about the work that I am doing in San Francisco. I work for Project Aware which is a women's AIDS research group. It is run by women and it is for women. We run AIDS tests on women in general and on women in the sex industry. None of those who have shown positive results on the antibody test have been prostitutes who are not IV-users. In total, four percent of the 400 women we have so far tested are positive and they are either IV-users or sexual partners of IV-users or bisexual men. AIDS is not an easy disease to catch. Most prostitutes, as has always been said, take care of themselves. Our bodies are our tools and we know how to take care of our bodies.

I want to talk about AIDS in the black community for a little bit. In the United States, 25% of all cases of AIDS are in the black community, 80% of the children with AIDS are in the black community, and 75% of the women with AIDS are black and brown women. Of all the AIDS cases among blacks, 43% are IV-users. The black community is from two to three years behind in AIDS education and prevention. The reason why we are behind is because there is a lack of information and education going out to our communities. So, blacks go to the doctors late, they wait until the disease is very advanced before getting any medical attention. One of the things that I have been doing with Project Aware is doing outreach. Outreach and education and grassroots work is what has to be done about AIDS. I am not that concerned with prostitutes. I am concerned with IV drug-using people in general.

I am also working with people who sell condoms, called Safe Sex Products. I pass out condoms on the streets because condoms are the only way we can protect ourselves. I just want to let everybody know that unless everybody in the world starts using condoms, it is all going to snowball down on us.

Don Des Jarlais (U.S.A.): I'd like to make just a few comments about AIDS in New York. It is undoubtedly the city with the largest number of AIDS cases. We have almost 8,000 cases of AIDS in the city. In that 8,000, about 150 are cases in women where heterosexual transmission is believed to be the way in which the women contracted the disease. Clearly that is not a large percentage of the 8,000 but it is one of the faster growing groups of cases. In terms of AIDS in New York, we are now considering it to be a disease that is transmitted heterosexually as well as homosexually. It is transmitted primarily through unsafe sex practices and also through unsafe drug injection practices, the sharing of the needles and syringes. It is possible to stop both the unsafe sex practices and the unsafe drug practices and it is important to realize that it is in everybody's interest to work on both those areas. If we do not stop the unsafe drug injections, we will not only have more sexually active women but more sexually active men, more potential sex customers, carrying the AIDS virus. In terms of stopping heterosexual transmission, we need to encourage all people to use condoms, to practice safe sex. Money being paid for the sexual activity is irrelevant to the transmission of the virus. Regular partners are perhaps less likely to practice safe sex, to use condoms, and that

will have to be a very important point of education for the community as a whole.

In terms of analyzing statistics from AIDS cases, it is useful to realize that for every person who has developed AIDS there are probably fifty additional people who are actively carrying the virus and who are capable of transmitting it. So, when you see numbers as to cases of AIDS, it is a very very small percentage of the problem in terms of the potential future number of cases and in terms of the potential of transmission.

I'd like to make one final comment on the recent developments in terms of treatment for AIDS. You may have seen the newspapers and television stories about AZT which is a drug that is currently being studied in the treatment of AIDS. That drug looks very promising. It looks, however, like it will halt the progression of the disease but not cure it. In terms of the way the virus is integrated in the cells, there is probably no chance that we will ever develop a successful cure of AIDS. This is not going to be a disease for which we will come up with a cure that you take for two weeks and then are fine. These anti-viral treatments will probably require people to take the anti-viral drugs for the rest of their lives to simply control the infection.

Kate (Australia): I would like to ask how many of the women with AIDS engage in anal sex.

Don Des Jarlais (U.S.A.): The studies that have been done in women who have received the virus from men do not show anal intercourse as an important factor. So far, anal intercourse between a man an a woman does not appear to be a major additional risk over vaginal intercourse.

Gill Gem (England): What about oral sex? What about the dangers of sperm in your mouth, when you have a mouth wash straight off and you spit it out, you know. Is there much research on this? Heterosexual I'm talking about, though it doesn't really matter.

Don Des Jarlais (U.S.A.): The research that has been done on oral sex has really been primarily oral sex compared to anal sex among gay men. And clearly among gay men oral sex is very very insignificant compared to unprotected anal intercourse without a condom. In terms of the studies that have been done on heterosexual transmission, no particular type of sex has been identified as more or less risky, but all of the biology would lead you to assume that oral sex is probably safer than other forms of sex.

Gill Gem (England): Especially if you didn't swallow it.

Don Des Jarlais (U.S.A.): Especially if you don't swallow it, if you use mouthwash. . . .

Lynn Hampton (U.S.A.): Since oral sex comprises about eighty percent of our work in the United States, let me tell you that if you brush your teeth before you see a client, if you abrade your gums, even microscopically, which will certainly occur when you brush your teeth even when there is no visible sign of blood, then the introduction of sperm into your mouth containing the AIDS virus will surely infect you through that open abrasion in your mouth as it would through an open abrasion in your vagina or wherever. So, rather than brush your teeth—and this is also recommended in the safe sex pamphlet that is given to gay men in the United States—just use a mouthwash and then use the mouthwash again after oral sex. But, above all, don't brush your teeth and abrade your gums and then get semen in your mouth.

Helen Buckingham (England): I'd like to ask about oral sex from men to women. This is a very popular form of activity of clients with their prostitutes. They like to lick women. I would like to know what the risk to women is from the saliva, a man's saliva, amongst those rather delicate moist tissues.

Don Des Jarlais (U.S.A.): There is basically no data on that right now. Clearly, if it were going to be a major risk factor, we would have expected to see it in New York where we have had the virus for at least eight, maybe ten years.

Frau EVA (Austria): I would be interested in knowing what countries already have an AIDS law. We as prostitutes in Austria are required by law to get a blood test for AIDS each month; if we don't get tested, then we are liable to very high fines of about 12,000 Austrian shillings or we can be put in jail.

Julie Bates (Australia): In New South Wales in Australia we do have a similar legislation which was strictly implemented because of the belief that prostitutes were going to be the dreaded AIDS spreaders to the rest of the nice clean community. We have similar laws and fines about knowingly transmitting the virus. There are jail terms and so forth. We lobbied to stop this legislation along with a number of other health officials and other people but nonetheless we now have this legislation.

Priscilla Alexander (U.S.A.): Nevada is the only state in the United State that has legal brothels. A law has been passed that all the women who work in the legal brothels have to be tested. They have all tested negative. There have been laws introduced in a number of states that

would mandate testing for prostitutes. So far, none of them have passed. Some judges have ordered prostitutes to be tested as a condition for a shorter jail time. There will be additional laws coming up I am sure in the future.

Lynn Hampton (U.S.A.): I read a recommendation recently which has not been put into effect as a law but the recommendation said that if a prostitute should be found positive with AIDS, she should not be allowed to work anymore as a prostitute. And, if she refuses to stop working as a prostitute, it was suggested that—and this will really blow you away—that an electronic device be attached to her body that will admit a beeping signal if she is more than five hundred yards away from her telephone. The beeping sound rings in the police station and the police will come and arrest her. This is a recommendation, not a law, as I said, but I have heard of one woman in Dade County in Florida who is in fact wearing a beeper device on her ankle. Furthermore, the same recommendation said that after the third warning that a woman should stop prostitution, if she refuses and she is positive on the antibody test and symptomatic, then she should be given a jail sentence from three to five years. And they say in just about these words, "Since the life expectancy of an AIDS victim is usually less than three to five years, she will undoubtedly die while in prison thereby no longer being a threat to the public."

Maggie (West Germany): Up until now, there are no federal health laws for prostitutes in Germany. The forced medical registration and testing is city by city. But the politicians are discussing a law and they are not sure whether the discussion will enter parliament. We prostitutes feel that it should not be part of federal German law but should be left to the people concerned. This should be a personal anonymous matter and should go no further.

German speaker: Although we don't have a federal law in Germany, the individual health offices have already acted on a massive scale. There have been arrests, often brutal ones on the street, people have been taken to the hospital, fastened and tied up. This is a form of rape, forcing someone to undergo an intimate physical examination.

Micaela (West Germany): I am connected with the German AIDS Association. I lead an AIDS consciousness-raising group among prostitutes and this is being financed by the government. What annoys me in the whole philosophy is that only prostitutes are supposed to be informed about this. There is no thought of informing the customers as well. I get no money for a leaflet that would be for men who could

be potential customers, for example with the slogan: "Sei kein Dummi, nutz ein Gummi!" (Don't be a Jerk, Use a Condom!).

Italian speaker: In Italy there is no legislation concerning AIDS but there is a free test which is also anonymous for anyone, not just prostitutes. You can have this test in public hospitals. I think all women have got to fight for this kind of test and make sure it is free and anonymous for everyone. In the end the statistics will show us to be right because it will prove that prostitutes are not carriers. Then we can show this statistic and we can show that we are not the guilty ones. Then people won't be able to point the finger at us saying that we are the ones spreading the disease.

Carla Corso (Italy): I would be in favor of every test if women want to take it voluntarily and if the test were anonymous and free. But, results that we could use as a means of pressure could be used against us as a means of coercion. I believe that every form of material scientific statistic can be used against us as evidence in favor of coercive measures.

Annie Sprinkle (U.S.A.): I just want to put in a good word for the AIDS antibody test because I just had mine. There is a lot of reason for not taking it and for a long time I did not want to. But I just took mine and thank goodness I'm fine. This is really a kind of miracle to me. I think that those of you who are thinking about taking it, might really want to. It's the best thing I've done in a long time because if I had it, I would know, and since I don't, I am very happy.

French speaker: I would like to say something about AIDS laws in Switzerland. In our country, there is no law yet, although there is talk of coding a data bank on an anonymous basis. Until now, everything is done on an anonymous basis. Personally, I am against the AIDS test because if I have the test, I still cannot be sure that I won't get AIDS. Also, we have to pay for it ourselves and impossible questions are asked such as, "How many customers do you have on a night?" That is unacceptable.

German speaker: I am not against the AIDS test provided that customers have to take it too, because obviously we get it from the customers.

English speaker: About the embarrassing questions the health officials ask like how many men have you slept with and things like that, I think that if we are not embarrassed to be prostitutes, why should we be embarrassed to answer the questions? Someone has to ask the questions to get the statistics.

German speaker: I would like to know why people ask prostitutes how many men they have slept with because there are other women who are not officially prostitutes who sleep with many men too.

Don Des Jarlais (U.S.A.): Just one comment: In good research, those questions will be asked of everybody and I think it is important to bear with the embarrassment and get the answers to those questions, realizing that without additional knowledge of how this virus is transmitted, it will be much harder to get people to change their behavior.

Doris Stoeri (Switzerland): I fear one thing: There is only twenty minutes left of this session and tomorrow we have a press conference. I am sure the press would be very happy to have headlines about prostitution and AIDS because people have been thinking that AIDS is a problem which is linked to prostitutes. This is a link I have been trying to avoid. I would really like to make sure that tomorrow at the press conference we clearly state that the problem for prostitutes is not that they are infecting the population with AIDS but that they fear contracting it. We must make a declaration or statement to our governments calling on the authorities to have an information campaign so that all men will be informed—not only prostitute clients but all men—of the risk that they can transmit the disease to women. I fear that the press is going to manipulate us and use the prostitutes' movement and not inform the people. They're waiting outside, they're waiting for us to give them the information, the newspapers the world over are going to be speaking of the world prostitutes' congress. So I ask you, please, tomorrow at the press conference, bear this in mind. Don't increase the stigma by speaking about prostitution and AIDS, but let's say "Men and AIDS." In that way we can really inform the world and this can help our cause.

Dutch speaker: At the press conference, I want to address ourselves not just to the authorities, but also to the feminist movement in all countries. It's not right that men should impose their will on women. I think this is very important for women the world over, not just for prostitutes. The feminist movement should support our struggle.

Helen Buckingham (England): I have been campaigning about the prostitution laws for ten years. My experience has taught me that we have to be very careful with the press. One of the points I think we should make with the press is about legalized prostitution such as in Germany. The state is supposed to be controlling prostitution and making it safe and all the rest for everyone. And look what the Ger-

man people are saying about their situation. We who have been campaigning know this about Germany. We know that legalized prostitution does not protect anybody's health and it does not protect anybody's psychology or private life or anything. It is a ruination to the whole community. Legalized prostitution will not help the spread of AIDS. We must *decriminalize* prostitution. I think that we should be very careful how we get this across to the press. Otherwise they will be saying, "Yes, now because of AIDS, we must round up all these women into state-run brothels, that's the way to contain the disease." And that is not the way to contain it!

Telegram sent to Federal Republic of Germany Chancellor Helmut Kohl and to Minister of Youth, Family, and Health Rita Suessmuth and to the Central Bureau of Health Information and Education:

We are astonished to learn in this conference from the working women of all cities of the Federal Republic of Germany that your public health is relying on tests and not on the prophylactic use of condoms to prevent sexually transmitted diseases, including aids.

Regular check-ups should be voluntary and serve only to help working women to remain healthy and to give them treatment.

Regular check-ups do not prevent sexually transmitted diseases and condoms do.

We urge massive education of the general public on the use of condoms and spermicides with nonoxynol-9, in order to prevent the spread of all sexually transmitted diseases.

International Committee for Prostitutes' Rights
Congress in Brussels
October 3, 1986

UPDATE ON HIV INFECTION
AND PROSTITUTE WOMEN

The Fourth International Conference on AIDS was held in Stockholm, Sweden, June 12-16, 1988. The following presentation by Laurel Hall, Health Education Coordinator of the ICPR, was delivered at session 23 on "HIV Infection and Prostitute Women." Due to the focus of the panel, prostitute men are not included in this discussion. Following Laurel Hall's presentation is a brief supplement on actual incidence of HIV infection among prostitutes and on prevention activities in some additional countries. Conference participants Judith Cohen (epidemiologist) and Elizabeth Ngugi (community health worker in Nairobi) are speakers for the supplement; additional material is provided by Priscilla Alexander (Executive Director of the U.S. National Task Force on Prostitution).

Laurel Hall: First I would like to mention a regret that there is no one on the panel who is now working or who has worked as a prostitute. I would like to emphasize the need to include prostitutes in any work that is done involving prostitution and AIDS, whether it is developing educational materials, carrying out a study or having a discussion on HIV and prostitution as we are today.

I am going to break my talk into two portions: In the first portion I will talk about the civil rights of prostitutes, in particular violations of their rights with regard to HIV and the resulting scapegoating of prostitutes for the spread of AIDS. In the second portion, I will mention some of the work that is being done by prostitutes as sex experts to promote safer sex and to educate their clients, each other and other members of the public. At this point I would like to clarify that I will refer mostly to the countries and groups with which the International Committee for Prostitutes' Rights has already established contact and that the ICPR is particularly interested in building better communication and contact with women working in the Third World.

Prostitutes everywhere are vulnerable to discrimination and blatant violation of their civil rights. Prostitutes have been the first in

many places to be subjected to mandatory testing for HIV antibodies and even compulsory isolation. In Austria, for example, prostitutes are obligatorily tested every three months for HIV and prostitutes there have reported that they feel there is nothing they can do to resist. In Germany there is bimonthly obligatory testing which HYDRA, a prostitutes' organization there, is trying to stop. In the Philippines, thousands of women have been arrested and tested for HIV antibodies although it is still unclear what happens to those testing positive.

In South Korea, mandatory testing of prostitutes has been implemented and prostitutes can be isolated if they are HIV positive. They are given a blue card if they are negative and a red card if they are positive. Clients are encouraged to check the cards, which are official IDs with photos, for reassurance; this suppposed security for clients has already proven in other countries to make clients even less willing to use condoms because they assume the women are "clean."

In the United States, Georgia was the first state to pass mandatory testing for prostitutes and bills for the same have been proposed in both California and New Jersey. In California the bill includes boosting prostitution charges to felonies for those who test positive to HIV. On the other hand, clients are left untouched who engage in unsafe sex with prostitutes, offer to pay more money for unsafe sex or even refuse the use of a condom (not to advocate police action against clients any more than against prostitutes). In the United States as in England, police still confiscate condoms as evidence against prostitutes, undermining their safer sex practices. As far as I know, San Francisco is the only city that has successfully stopped this practice in the interest of AIDS prevention.

In Sweden, although broad-scale mandatory testing has not been employed, it is possible to require a person to be tested for antibodies to HIV if it is thought that they may have been exposed to the virus at any time. If someone does test postive then they are given personalized guidelines which are established by their individual doctor about what they are no longer allowed to do. The guidelines are generally set with regard to each individual case. It has been made illegal, however, for anyone who is antibody positive to work as a prostitute regardless of what services they render, and regardless of whether or not a condom is used. If there is merely "reason to believe" that the individual has not followed the guidelines set by their doctor then they will be issued a warning. Following a second warning they can be confined to

isolation; proof that they were actually working as a prostitute or disobeying the guidelines set for them is not required before they can be picked up and confined.

The law has been applied four times already; in every case the law has been applied to people who had a history of IV drug use. In one case the woman who tested HIV positive was accused of working as a prostitute because she was seen in the areas where the prostitutes hang out. She maintains that she was not working and that she was just hanging out with her friends who work and socialize in the area. She has been in isolation for two years now. Although she does not have symptoms of HIV at this time and is not ill, she is kept in a hospital room with two guards outside the door. Another woman who tested positive for antibodies to HIV who is reported to be mentally impaired was also put into isolation. Although officials have not disclosed her whereabouts of late, she is thought to be in isolation within a Swedish mental institution.

One Swedish prostitute said that because of the scapegoating of prostitutes as culprits of disease, there is less concern for their well-being and they are subject to more and more violence and less and less protection from the police. The same thing is happening in many countries: For example, in England, there has been an increase in murders of street prostitutes and a big increase in the number of attacks. Women reported fearing that a man was on an "AIDS revenge mission." Medical checks on two recently murdered victims revealed that neither had AIDS. In Hamburg, Germany, last year, a man shot a prostitute when he claimed that she had given him AIDS. He then shot himself and another person. After death, a test revealed that he was not even HIV positive.

Regardless of the fact that various studies have shown that prostitutes in many places are not more likely to have been exposed to HIV than other women in the same geographical areas (see below under "actual incidence"), prostitutes continue to be discriminated against with regard to HIV testing and scapegoated for the heterosexual spread of AIDS. The media has played a significant role in this. Scapegoating prostitutes causes further oppression of women, forcing prostitutes underground, making it more difficult for them to work safely, be able to maintain their dignity and to promote safer sex. It also leads people to assume that the AIDS problem is taken care of, which is by no means true.

So, now let's look at some of the positive work that is being done.

In several countries prostitutes are working in education and prevention of HIV infection. Some examples include the Safer Sex Corps, a part of the Whores' Corp in Toronto, Canada, which distributes safer sex information and runs a telephone hot line. In the United States CAL-PEP (California Prostitutes Education Project), an offshoot of COYOTE, distributes condoms, spermicides and bleach kits for cleaning needles to women and men street prostitutes.

In Switzerland prostitutes wrote a public letter and put it in the newspaper asking clients who still refused to wear condoms to please use them to help in their own fight against AIDS. They had a positive response and Belgian and German prostitutes have now written similar letters. In Germany a group of prostitutes held a press conference about prostitution and AIDS and followed it by handing out safer sex pamphlets and condoms in a red light district and shopping area. They also received positive responses from the people. In England prostitutes have done a television program talking about safer sex and have also put pressure on an AIDS committee to avoid the scapegoating of prostitutes.

In the Netherlands The Red Thread has introduced safe sex stickers which are meant for the general public; the women can also put them in the windows to indicate that they practice only safer sex. The Dutch government now includes prostitutes in AIDS education advisory boards. And the Association of Junkies in the Netherlands is involved in educating IV-users about AIDS-safe drug use as well as safer sex. Here I'd like to emphasize that drug-users being involved in education programs for IV-users who may work as prostitutes is just as important as prostitutes being involved in education for and about other prostitutes.

In Australia prostitutes have secured government funding for a safe sex education program; they also organized a national conference called "Sex Industry and the AIDS debate, '88." In the Philippines more and more women are demanding that their clients wear condoms, but efforts by some church members to stop the distribution of free condoms may stifle their efforts.

Elizabeth Ngugi is doing excellent work together with prostitutes in Kenya (see below for her report on condom use). In Rwanda films and discussions are being used to educate women and to encourage information and support exchange among them. In Sierra Leone prostitutes are meeting in small groups to discuss health and AIDS in particular. Similarly, in Tanzania a doctor in Moshi has worked with a

group of prostitutes discussing AIDS, distributing condoms, and promoting condom use as a preventive measure. An increase in condom use was noted, but a limited supply of condoms has threatened the success of such programs in Tanzania. In most parts of the country condoms are not available and when they are in the stores they are often too expensive to buy. However, messages about the dangers of HIV infection appear to have been successful in Tanzania and there is a demand for condoms. Europeans who leave Arusha for vacation say that condoms are one of the most commonly requested gifts for them to bring back. The word in 1988 was that condoms were on their way, and a press release announced that the government would be distributing free condoms to all students, soldiers and policemen in Tanzania in the interest of AIDS prevention.

In Thailand women are reported to be afraid of AIDS and to be having a problem getting foreign men to wear condoms; it is common practice for Thai men to use condoms with prostitutes.

In conclusion, I would like to remind you that prostitutes are calling for decriminalization of prostitution, not regulation of prostitution, and that feminists who call for harsher pimping laws or the abolition of prostitution must realize that such laws are invariably used against the women who they claim to be supporting. And I'd like to ask you to assist the prostitutes in your locality in the fight against AIDS by sharing this information with others, explaining for example why allowing the police to confiscate condoms merely creates a health hazard for all concerned, by supporting the allocation of funds for projects which directly involve prostitutes, and finally, by speaking out against mandatory testing and the scapegoating of prostitutes.

ACTUAL INCIDENCE OF HIV INFECTION AND PREVENTION ISSUES

Judith Cohen: . . . The rates of infection among prostitutes vary about as widely as the range permits from zero percent in a number of studies to above eighty percent in a few. . . . Given this extraordinary diversity in rates and reporting, certainly an important issue is whether prostitutes are usefully seen as a single risk group. To the degree you choose subsets of the possible full range of women who work in this business you do so at the risk of obtaining limited and biased information about the occupation. For example, if you do, as several studies have, recruit women from IV drug treatment centers, what you get is a sample of IV drug-users or ex-IV drug-users, some of whom have

engaged in prostitution. I'm not saying this is a bad sample of IV drug-users or IV drug-users in treatment, but it's a pretty limited sample of prostitutes. Similarly, if you look at women who you recruit, more or less voluntarily, while they're in jail, you run the risk of obtaining information about women whose lives are such that they're likely to end up in jail which means that they are different in a number of important ways from women who don't end up in jail but still expect money for sexual behavior. Finally, if you do as some early studies of infection rates in prostitutes do, recruit women who attend screening clinics for STDs or, worse yet in terms of bias, screening clinics for AIDS, you will get samples of women who represent those who attend these clinics but you will not get representative samples of prostitutes. And if you find correspondingly high rates in some of these subgroups, the rates you are really speaking of are the rates of those recruitment situations; they are not descriptive of all women sex workers.

Let me talk briefly about some of the epidemiological information there is on prostitution and HIV infection. In the United States, the benchmark study is certainly the one reported in March, 1987, in the *Morbidity and Mortality Weekly Report* on the seven-city study funded by the Centers for Disease Control, a so-called collaborative study. The range of infection across those seven cities was 0% in Las Vegas, where the sample was of women employed in legal brothels,[1] to very low rates of 1.1% in Atlanta (which was a community study) 1.4% in Colorado, 4% in Los Angeles, and 6% in San Francisco, to relatively high rates of 34% in Miami where the sampling was done in jail and 57% in the early portion of the New Jersey study where thirty-two of fifty-six women recruited at IV drug treatment programs tested positive. In general, the variation in the rates reflected almost entirely the extent of drug use in each population and the extent of drug use-related AIDS rates in those cities.

There was standarized information requested of all women who participated in the study and, just briefly, the reports from all cities were a rather high use of condoms with customers but much less use of them with steady partners.[2] Also (HIV infection had) a direct association with other serological measures associated with drug use such as hepatitus-B infection.

There has been very little research on the actual occupational circumstances and almost no studies of customers, except a study by Joyce Wallace in New York who looked at three hundred male customers of prostitutes, six of whom tested positive, two of whom

revealed on further questioning additional risk circumstances, two of whom did not return for test results and therefore could not be questioned furthered and two of whom denied any other risk behavior.

The studies in Africa seem to consistently report higher rates of infection among the women themselves than among their customers. And there are a number of reports in various parts of the world—in the Philippines, in Latin America—where proximity to air force and other military bases funded by the country I have the disgrace to come from seems to be a direct factor for infection for women working in these areas.

The only United States study that has found significant numbers of infected women in the sex business who have no history of IV drug use is in Florida, which is different I think in two important ways from other AIDS epidemic areas in the United States: One important difference is that there's a major pattern of back and forth migration from the Caribbean where heterosexual transmission is much more frequent than it is in the United States, and the other is that prostitution, particularly in Miami, conforms more closely to the stereotype which is not so true in other areas of young women drifting into cities unqualified for any other kind of work and ending up on the streets with very little awareness of transmission of STDs (sexually transmitted diseases) or how to take care of themselves or their health. The geographic areas with the highest rates of infection are those in which awareness of sexually transmitted diseases is low, and/or ability to utilize treatment for these is relatively rare. Studies of women in these groups like studies of other women at risk certainly find that untreated STDs and extensive histories of STDs are highly associated with the risk of the most recent and most dangerous STD, that is HIV infection.

KENYA

Elizabeth Ngugi: I started working with prostitutes, with them and for them, in 1983, for control of sexually transmitted diseases. . . . In order to be able to educate prostitutes, there are several ingredients that are required. Service needs to be taken to where they live and work. They need to be accepted for what they are; any level of rejection will inhibit or will create a barrier in education. This then will create a climate for education and communication. . . .

Where occasional condom use (among prostitutes in one area of

Nairobi) was 8% in January 1985, overall condom use was 50% and condom use now and again was 90% by November 1986. Two things happened here: One, the prostitutes themselves were insisting that the clients use condoms, otherwise no sexual relationship would take place. Men, because of general education that was going on in the country, started also demanding use of condom. So there was a lot of spillover of education both ways. . . . It seems that since condoms are the only alternative we have at the moment, it is efficacious that a better condom be produced. When that condom is produced I would like to suggest that all the other (inferior) condoms be removed from the market, so that they do not find their way to developing countries which cannot afford to have the standard condom. . . .

Some Information from Other Countries

Mexico: Authorities are working with prostitutes and drug-users to teach AIDS prevention. The National Center for AIDS Information has established a program to teach prostitutes and IV drug-users to become health care promoters. According to Dr. Glorias Ornells Hall, director of the program, "We believe that using the media to give information is not enough to change behavior patterns. Only face-to-face contact can do that. The best way is for them to reach their own communities in their own language. That includes prostitutes reaching out to prostitutes."[3]

The Population Council, funded in part by U.S. AID, has been organizing prostitutes AIDS education programs in Mexico City, Lima, **Peru**, and Bogota, **Columbia**. Interestingly, because of the fact that these projects are funded by U.S. AID, which also funds many family planning programs in the industrializing countries, the word "prostitute" could not appear in the funding proposal. U.S. AID has also denied funding to family planning programs throughout the world that provide abortion.[4]

Brazil: There are condoms in Brazil but they are expensive for the average citizen let alone the poorest of prostitutes. Moreover, the church is actively resisting public promotion of condom use since it opposes every sort of contraceptive. Nonetheless, prostitute activists are working to encourage condoms and many sex workers are using them (see article by Gabriela Silva Leite).[5]

Israel: In January, 1988, the Health Ministry authorized obligatory HIV antibody testing every six months for all prostitutes, women and

men. One Israeli physician objected to the measure on the radio for "practical and moral reasons." He said that prostitutes were chosen to calm the public and because they are easy scapegoats, not because they are at higher risk for AIDS.[6]

Footnotes:

1. When compared with some of the other studies, these results support the conclusion that, at least for prostitutes, number of partners does not correlate with antibody status. Priscilla Alexander, "Response to AIDS: Scapegoating of Prostitutes." CAL-PEP: San Francisco, August, 1988.

2. To give the statistics as of 1987, 80% of prostitutes in the United States use condoms at least some of the time; 16% use them with all customers; 4% use them with all sex partners, including their lovers. Centers for Disease Control, "Antibody to Human Immunodeficiency Virus in Female Prostitutes," Centers for Disease Control, *Morbidity and Mortality Weekly Report* (MMWR), March 27, 1987, 36:11, 158-161.

3. Associated Press, reported in the *Oldest Profession Times*," May,1988. See Priscilla Alexander, *op.cit.*.

4. Luis Varela, MD, Population Council, Mexico City, personal communication to Priscilla Alexander.

5. Sjef Ramaekers in conversations with the Brazilian Network of Prostitutes in Rio de Janerio, 1988.

6. Communication from Esther Eillam in Tel-Aviv.

STATEMENT ON PROSTITUTION AND HEALTH
International Committee for Prostitutes' Rights
European Parliament, Brussels
October 1-3, 1986

Prostitute health and prostitute access to health care services are deeply affected by social stigma and legal discrimination. Those injustices function not only to deny healthy work conditions and effective services to prostitutes, but also to foster distorted beliefs about prostitutes among the general public. Historically, prostitutes have been blamed for sexually transmitted diseases and authorities have justified social and legal control of prostitutes as a public health measure. The assumptions that prostitutes are more responsible for disease transmission than other groups and that state control of prostitute behavior prevents such transmission are contrary to research findings. Presently, the assumption that prostitutes are carriers of AIDS and that forced AIDS testing will prevent the disease have been shown to be unfounded in the West. The situation in various "Third World" countries is as yet unclear. Female prostitutes in the West are not a risk group for AIDS. The small minority of prostitutes who are needle-using drug addicts are at risk from shared needles, not from commercial sex.

The ICPR demands realistic portrayals of the health of diverse prostitutes and implementation of effective health education and treatment services. Those services must respect prostitute dignity and foster customer responsiblity for disease prevention (e.g. condom use) in sexual transactions. A list follows of injustices and rights which are crucial to prostitute health and public responsibility.

HUMAN RIGHTS VIOLATIONS IN HEALTH POLICY AND PRACTICE

1. *Discrimination* against women in public health laws and practices is a basic violation of human rights. The ICPR demands:
 • Repeal of regulations which deny free choice of a doctor to prostitutes.
 • Abolition of compulsory medical certificates.

• Repeal of laws to combat venereal disease which are invoked only against prostitutes.
• Prohibition of forced or incentive testing of prostitutes in prison for any purpose.
• Free, anonymous and voluntary testing for venereal disease, including AIDS, at easily accessible health facilities available for all people, including prostitutes.
• Widespread education and regular screening for sexually transmitted diseases among all sexually active people. Note that venereal disease is a risk for different groups of sexually active people (especially young),that condoms are the best known preventive measure against VD and that prostitutes are more likely to be aware of sexual health care than other persons.
• Health insurance and compensation benefits for all workers, including prostitutes. Note that the stigmas and regulations which prevent job mobility for prostitutes (such as the denial of required letters of good conduct to prostitutes) make it extremely difficult or impossible for prostitutes to change work when desired or when necessary for health reasons.

2. *Registration* of prostitutes with state and police authorities denies human rights to privacy and dignified employment. The ICPR demands:
• Independent and confidential public health services for all people, including prostitutes. Collaboration between health providers and public authorities, such as police or researchers, should be illegal.
• Abolition of mandatory registration of prostitutes and interruption of unofficial pressure on prostitutes to register with the police.

3. *Criminalization* of prostitutes for purposes of public health is unrealistic and denies human rights to healthy work conditions. As outlaws, prostitutes are discouraged, if not forbidden, to determine and design a healthy setting and practice for their trade. The ICPR demands:
• Decriminalization of all aspects of adult prostitution resulting from individual decision. Specifically, prostitutes must have the right to work indoors and the right to advertise; they must also have the right to solicit outdoors according to general zoning codes (e.g. active solicitation should be allowed in areas zoned for businesses). Denial of those rights forces prostitutes into medically unhygienic, physically unsafe and psychologically stressful work situations.

• Application of regular business codes to prostitution businesses, including codes for cleanliness, heating and leave for sickness and vacation. Also, codes for mandatory condom use should be enacted. Regulations should be enforced by worker organizations and not by state authorities.

MEDICAL AND COUNSELING SERVICES

• *Education* of health workers about the realities of prostitution health issues is necessary to combat prejudice and misinformation within medical and counselling services. Prostitutes and ex-prostitutes should be employed to participate in such training.

• *Integration* of prostitutes in the medical and counselling services is essential for effective policy-making and service delivery.

• *Vocational counselors must respect a woman's decision to work as a prostitute or not.* Leaving prostitution must never be a prerequisite for counselling service.

• *Health authorities should disseminate information about safe sexual practices.* In particular, condom use should be recommended for all vaginal, oral or anal sexual transactions.

DRUGS AND ALCOHOL

• Those prostitutes who are addicts, a minority in most branches of prostitution, usually entered prostitution to support their habit. Inadequate drug policies are responsible for addicts practicing prostitution; *prostitution is not responsible for drug addiction.*

• *Social alternatives to prostitution are needed for addicted women.* Both drug laws and drug treatment programs need to be re-evaluated. A clinical and social rather than a criminal model should be considered for controlling addictive substances. Treatment programs should be given adequate funding and research support.

• There are no inherent connections between drug addiction and prostitution. Laws which criminalize both and practices which utilize addicted prostitutes as police informants are largely responsible for the connection between drugs and sex work on the streets. *Prostitution must be decriminalized and police must stop using prostitutes for illicit criminal investigations.*

• Addicted prostitutes who use needles, like other needle-using addicts, must have *access to legal, inexpensive needles* in order to prevent the spread of disease (specifically, hepatitis and AIDS).

• It should be *illegal* for any employer, including managers of sex businesses, *to force employees to drink alcohol.*

FEMINISM: "CRUNCH POINT"

Gail Pheterson (U.S.A./Netherlands): This meeting, like the others this week, is a statement of resistance against violence and oppression. This meeting on prostitution and feminism is also a statement of solidarity between women. Solidarity between women is a radical feminist stance. As women in the sex industry and women outside of it, we are breaking strong social taboos by exchanging information and consorting together. Prostitutes are supposed to hide in shame from other women; wives are supposed to stay at home in isolation; lesbians are not supposed to exist at all. And surely, prostitutes and wives and lesbians are not supposed to be the same women. The purpose of this meeting is to give visibility to all of us. We need to know our commonalities and our differences. The strength of the prostitutes' rights movement rests on the strength of alliances between women. We can agree with those authorities who charge us with conspiracy. This meeting is a conspiracy against the attitudes, practices and laws that divide us.

Our first presentations this afternoon will be from women who work or have worked in pornography. We are beginning this session with pornography workers because those women have not yet spoken at the congress.

PORNOGRAPHY

Eva Rosta (England): I will start by telling you a short story about myself, about how I started as a photo model when I was eighteen. It was mainly to get some money so I could have a holiday. I worked in the business whenever I needed extra money and then I became regular and I started doing resident work in studios. I kept all of it secret from my friends. I often worked in porno films, what we call "downtown films," kind of poor quality, amateur, less exposed movies. They were usually films which had a storyline and it was all simulated sex, so it was really kind of hilarious work because you had to pose in front of the camera in most awkward positions. It was just totally un-

144

real. I worked as a go-go dancer. I worked as a stripper mostly abroad in Zurich and Munich. It was usually to get out or to move on somewhere. All throughout the ten years that I worked in this business, mostly as a photo model, I kept it secret. When I did tell my women friends, they were shocked or horrified. Most of them called me a whore. They felt it was dirty work, that it pandered to male sexual fantasies and that it was destroying the feminist cause. Most men were fascinated or turned on by it. I felt very isolated and alone and I started to feel ashamed for my work and for myself. I lost a lot of confidence.

Then I went to a party which was a women-only party and it turned out to be a whores' party. While I was there I met fantastic women, one of whom is actually here today. I told her that I was a photo model and she said something which changed my life. She said to me, "Don't you feel like you are taking your clothes off in front of too many for too little, don't you feel vulnerable, don't you feel exposed?" It was a question which stuck in my head. But what was important to me at the time was all these wonderful whores I met who talked about the business with pride and respect. I had support and I felt that all those years of shame and secrecy and isolation were over. Within a month, I did my first job as a whore and I knew exactly what she meant. It was quicker, it was more money, and it was definite. I felt like: Okay, now I am a whore and if anyone calls me that, they are right. Of course, not all women have this experience of feeling more or less dignity in the different areas of the sex industry. I just want to stress that from society's point of view, and I mean also from the point of view of feminists, anti-sexists and so-called left-wingers, we are all whores. And we have to recognize how important it is to have solidarity between women in the sex industry. There are many difficulties and problems in reality between whores and other sex workers—strippers, dancers, etc.. But a lot of this comes from society's attitude in the first place. It's like a kind of hierarchical system with prostitutes at the bottom and, I don't know, maybe dancers at the top.

As I said yesterday, I am working as a sex counselor. I have often done workshops on sexuality and brought up the subject of prostitution. Most of the women who came to these workshops were mothers or feminists or just women generally, whatever you want to call them. These women often came to the group because they had specific sex questions or sex problems. They were preorgasmic; they were frigid; they were I don't know what. I used to do a lot of word games with

them around the subject of prostitution. I never, of course, told them that I was a whore. These women all expressed different hang-ups about the subject of prostitution. And, in many cases, it was a definite case of envy and jealousy. Maybe they just can't understand a whore's ability to expose herself and have sex so easily. At this point I have to stress the need for women not involved in the sex industry to sit down and listen to our side of the story. It is about time that they recognized the knowledge and the information that we have about sex. We, as sex workers or whores, have a lot of knowledge about men's business. We know about economics, we know about the social sides and sexual sides, we know what's going on. I think women and men and feminists have to realize that all work involves selling some part of your body. You might sell your brain, you might sell your back, you might sell your fingers for typewriting. Whatever it is that you do you are selling one part of your body. I choose to sell my body the way I want to and I choose to sell my vagina.

Annie Sprinkle (U.S.A.): I am from New York City. I have been in pornography for thirteen years. I've done over a hundred feature-length porno movies and about fifty of those eight-millimeter loops. I've also worked as a nude model for just about all the men's magazines in the States and I have also worked as a stripper. Porn stars are the highest paid performers in burlesque. And, I've published my own porno magazines. I've been really lucky in the business. It's been really a good life for me. I was never forced. I was never raped either in the business or out. I have never been beaten. I was arrested one time for a sex magazine I was making and—I won't go into details—the charges were dropped. I was also a prostitute for about seven years, mostly in massage parlors. I personally find making pornography a whole lot more fun and more creative than being a prostitute. It's been really exciting; it's been sexy; the money's been pretty good. I would much rather make a film any day than turn a trick. For a long time, I basically ignored any negative sides about the business. I was the happy hooker, the happy pornographer, you know. But, as I grow older and wiser, and perhaps more honest, I know that there are negative sides. And, I agree with a lot of the arguments that people tend to have about pornography. But, to each of those arguments which they have, there is a positive side. Maybe I was exploited financially or however, but pornography paid my bills for thirteen years. Maybe pornography caused a few rapes, I don't know, but it most likely prevented a few as well. Pornography in some cases did make me look

like a piece of meat and a sex object; but pornography also made me feel more beautiful and glamorous than I ever thought I could be because I was very shy and insecure and it really did bring me a lot of confidence and attention that I needed. It probably does confuse people about sexuality but it probably also solves sexual problems for other people. I have to admit I made a lot of garbage, a lot of really horrible pornography, but I've made stuff that I'm very proud of, that I really like and that I find very creative. Sometimes I think that my work in pornography may have hurt the women's movement somehow as I become more aware of it, but sometimes I feel like I contribute a lot to the women's movement and maybe even somehow to women's sexual freedom. For me personally, it is very important to express myself through pornography. What we are really talking about here—let's not forget—is sex and sex is really not such a horrible thing. Probably everybody in this room has had sex in one way or another—the translators and these orange juice men [loud laughter as the workers serving orange juice, who are not wearing the translation headphones, go about their business unaware of Annie's reference to their sexuality]— everybody's done it. So, why is it so bad if some of us like to show ourselves doing it?

In the United States, I am experiencing a lot of censorship now in my work. Luckily it is still better than many other countries. There are a lot of things I cannot do right now. For example I can no longer show two men with one woman, because that is defined as a "gangbang" and is considered violence against women; we can't show anal sex in magazines or even write about it, because anal sex is supposedly violence against women. We can't even say the word "ass." In fact, we can't even show a photographic story with say lesbian women using foods and vegetables. So, I am getting nervous. How far is this going to go? Soon maybe I can't even voluntarily show my own nude body to people who want to see it unless I use a soft filter and artsy lighting.

To sum it all up, I believe that people have the right to buy, sell, see and make pornography, and a lot of people want to take that right away. For better or for worse, I want to continue to express myself with pornographic images and to earn my living doing something I am good at and something that people want.

Veronica Vera (U.S.A.): I make a major part of my living in the U.S. porn industry or sex media. I have performed in about a dozen x-rated movies and videotapes, but my specialty is writing stories about myself and accompanying them with photographs (flashing my sex parts usu-

ally draped in garter belts). I write about my life as an erotic adventure. What I have found is that I learned a lot about my own sexuality by being involved in "porn." I learned that one reason I showed off my sex parts was to be able to see them myself because I had always been told not to touch them, that part of me was dirty. In my heart I could never believe that was true. Now that I start to understand what was going on with me in regards to porn and what porn is about, I understand that for me it has been a form of creative expression, a way to communicate, as well as a way to work out my own sexual issues. The ideas that I want to express are that sex is not separate; it is a powerful, nourishing fact of life; it is something not to hide but to celebrate. I went into breaking all the taboos because that was very exciting to me. It was the lure of the forbidden fruit. In one stage I was into kink (bondage and discipline) because that seemed to fit in very well with my life. It was partly I think because I was afraid of sex and being dressed as a powerful dominatrix made me feel powerful. Now, although I do not like seeing these images of people tied up or in bondage, I understand how they fit into my life at one time and how they may fit into other people's lives right now. It is important that we do not censor sexual expression because this is how we learn about ourselves and others. I prefer to create images that I like and communicate my understanding of what is going on. Censorship will only reinforce sexual guilt and the power of the shady image. The sex-is-dirty philosophy is the adrenalin that pumps the blood of both the censor and the most sex negative pornographer.

It is very popular on television talk shows to get a feminist involved in a debate with a sex worker. It is considered good entertainment to pit one woman against another and to encourage a verbal cat fight on the air. To me this is a real smoke screen about what is going on. Besides being a legitimate form of personal expression, there is a lot of money to be made in the sex business. By putting it down as something that is wrong to do, it maintains the status quo where men have the money and power and women own nothing, not even our bodies. So when feminists side with the censor and see the sex industry as bad and the women who are in it as poor duped pawns, I ask them to consider that there is another side of this issue. Do not be put off by the images. There are women who enjoy what they do in this business. I am one of them. And these women are gaining more and more control over the production of the material and therefore the creation of the images themselves. It is a business in which women are

gaining creative and economic power. To be on the side of the censor is to be on the side of those who wish to keep that creative and economic power out of the control of women.

I would also like to inform you of the existence of our porn star rap group in New York. This group is called "Club 90" and consists of Veronica Hart, Gloria Leonard, Candida Royalle, Annie Sprinkle and me. Originally we were seven members with Kelly Nichols and Sue Nero also members but now and for most of our five years of existence we have been five. Club 90 is a support group that meets approximately every month. We have also staged a dramatic re-enactment of our group at the Carnival Knowledge feminist art festival and are developing that performance into a full-length play. In addition to our individual achievements, Club 90 recently wrote and directed six erotic videos released as "The Star Director Series" which was produced by Candida Royalle's "Femme," a company gaining much recognition as the foremost producer of erotic videos made from a woman's point of view. We are card-carrying members of NOW (National Organization for Women) and have introduced ourselves to that organization and asked them to consider our views in the formulation of NOW policy regarding pornography. The women of the sex industry are committed to the idea of women working together for our mutual benefit. [Since the time of this report, a second porn star support group was formed in California among the women currently active in the x-rated movie industry. This group is called The Pink Ladies.]

DISCUSSION

Editor's note: The relationship of pornography to prostitution, both in terms of the work women do and the degree of government control/censorship varies from country to country. In some countries, like Norway, pornography is censored but prostitution is decriminalized, while in the United States pornography flourishes and prostitution is illegal. Some countries, like Canada, produce almost no porn, yet are regular consumers of what comes over the border; other countries, like Denmark, produce porn for export while consuming relatively little of it themselves. Western pornographers sometimes go to Third World countries, such as Thailand, to produce pornography with cheap labor and "exotic" models. The borders between prostitution and pornography are not always clear; some sex workers feel free to migrate between modeling and prostitution, while others feel there is a

hierarchy separating the two industries. The discussion that follows touches on a few of these issues but mainly focuses on divisions and alliances between women.

Brigitte Pavkovic (Austria): I have a question: What is the difference between feminists and women who prostitute themselves?

Margo St. James (U.S.A.): There is no difference. I see all prostitutes as feminists, especially those who are here. It's a matter of terminology. Prostitutes need to identify politically as feminist women just as feminists need to identify personally as working girls.

Gail Pheterson (U.S.A./Netherlands): As a feminist, I know my freedom is limited as long as whores are stigmatized and criminalized. Like prostitutes, I want sexual and economic rights. It is the task of a group like this to define a feminist stance on prostitution. The essential missing voice in the women's movement is the prostitutes' voice.

Lynn Hampton (U.S.A.): I think that the woman of whatever nationality who defies her family, her country, her religion —and often, her husband— and becomes a prostitute by choice is the most liberated of all women.

Doris Stoeri (Switzerland): I think that there is something very important we must say here: Feminists who accept prostitutes as feminists are exceptions. The reason we are here is to make the exceptions become the rule, to make such acceptance common practice so that there will be understanding amongst women. So-called feminists who are not aware of prostitution and who judge prostitutes have probably got preconceived ideas, images and biases, things they've heard about prostitution.

Helen Buckingham (England): I am from London. I have been campaigning to decriminalize prostitution for about ten years and I've always found the same problem with feminists: However nicely our meetings may begin, there always comes a crunch point when feminists cannot seem to accept women providing sex for men. There always seems to be this crunch point. They barely can tolerate it when there isn't any money involved but they seem to find it absolutely impossible to countenance it when money is involved.

Gill Gem (England): I agree with Helen there actually. I think there needs to be a lot more talk about that as well between women. But also, I think the pornography thing is quite important. Normally I think there's probably an awful lot more exploitation than the examples today because the men make so much more money than the

women. The examples you got today show the women beginning to take control themselves. There is an awful lot of money made in pornography and most of it is made by men. And that is why it gets produced with very little hassle, or it did. Except now, I suppose feminists have actually some effect in the amount of censorship that is beginning to happen. I was quite interested in what was said because there were a lot of things I actually hadn't thought about because I don't particularly like porno. I thought, My body and the punter, that is a straightforward thing, but I get a bit scared of some of the porn that gets a bit sadistic and, you know, I don't know at what point you should bring in any censorship. Certainly there are some things I see I don't like—I know certainly there are a lot of videos I don't like. When you get to the point where there are sadistic acts or actual killings, or pseudo-killings, that's the ultimate where everybody would draw the line, I am sure. I don't know if I can draw any sort of conclusion. But I was very interested to see that just like with prostitution, people have preconceived ideas that the porn worker is just a victim. What feminists don't realize, and men don't realize, is that actually you are very powerful. Obviously that can be true. I just realized that I have always thought in a way that you are less powerful in the porn business than in prostitution until I heard these two women today. They've obviously managed to get some power and do it their own way which I think is great.

CHILDREN

Gail Pheterson (U.S.A./Netherlands): There are no children here but perhaps one way to give voice to their situations is to hear from those of you who began working as prostitutes under the age of eighteen. Would you raise your hand if you had the experience of working as a child and would like to tell about it?

Miriam (Cyprus/England/Netherlands): My first experience was when I was sixteen and I answered an advertisement in the newspaper for dancers. At that time I didn't quite know what kind of dancers they wanted. I was interested in dancing anyway. They kept promising me that I could start soon but this promise kept going on too long and I got myself in a little financial scrape. The owner of this dubious agency knew that and told me I could earn eighty pounds in one night, which blew my mind at that time. So I asked him how and he told me if I could make an old man happy it was mine. I ended up in a motel on the A22 in Brighton thinking, What the hell am I doing here? What

am I supposed to do? The old man suggested that I take my clothes off and leave my high-heeled shoes on and dance around the room making him cups of tea. . .just a hot kinky old man. "Well," I said, "okay, that's it and we can go home," me with my eighty pounds. He said, "No, my dear, this is not it." I had to roll on the bed and do my job. At the time, I was frightened because it was my first experience like this, of course. But then, once the money was in my hands, I thought, Hell man, this is easy. I thought, Wow, if that's all I have to do for money, this is my profession. So, nine years later I am still working and I'm happy.

Maggie (West Germany): I am from Frankfurt. I was born in Austria and I began at thirteen. We were in a girls' school and during the noon recess we had to leave school. So, I took the telephone book and went through all the bars and everyday I went to a different bar. We looked at what could be of interest to a thirteen year old. Then I got to know a pimp, a real pimp. Then I was raped and I was beaten. I was a virgin until that time. Now I have been in the business for ten years and today I have absolutely no regrets. I was educated by women and I am happy with the way things turned out.

Sai (Thailand): I was born in Bangkok. I start at fourteen year old. [Sai began speaking in Thai and Mae translated her story into English as follows]: Sai was saying that first when she was fourteen she was working as a waitress in a steakhouse, a kind of restaurant where there is music and the waitresses sometimes go out with the clients after the restaurant closes. At that time she was free to go with the clients or not. She had to do that partly because she had to earn her own living. She was not taken care of by her family; she had to take care of herself.

Alex (England): I left home at fifteen when I was pregnant. And I made a deliberate decision to be a prostitute. Everyone I told was appalled but I went ahead. It seemed like a really good idea to hustle, much more exciting than work, but it didn't quite work out so well as I thought. I thought it would be glamorous and exciting—one would wouldn't one?—but it turned out really boring and dreary. I was excessively lusty at this time and had the insane idea that hustling would be conducive to good sex. It was not. I found it boring and I hated being thought to be stupid, thought to be an idiot—I found that really degrading—not being treated as a serious person. People appeared to think that I had no integrity. And I actually bought into what they be-

lieved! If you hear enough about prostitutes all being dumb victims, it's very hard to stand up and say that things are not like that. However, the money was excellent if the actual process was ego battering. I had been influenced by a surfeit of Zola, an overactive imagination and little real choice. I regarded the working part of my life—three hours a day perhaps—as a charmless necessity.

There is a widespread misconception that prostitution is an unskilled job. Not so! I proved to be lacking in even the most rudimentary talent. I had a knack of making men resent me as much as I resented them; only the perverse would come back and the overwhelming majority, I am convinced, scuttled home, chastened, to their wives for solace and joy! I worked at the upper end of the market in London and actually preferred the freedom of the street. I once worked for a short while in a flat as a call girl and thought it hideously boring. There were gaggles of quite excellent women on the street and the less serious workers among us had a huge amount of fun after work.

After ten years of whoring I married, a lot duller and safer. I have been involved as a feminist for twelve years in many campaigns and see no dichotomy between feminism and prostitution, and feel that the prudish among the feminists would do well to have dialogue with sex workers. I feel that this is "Nobody's business but my own" and would like to continue to be known as Alex, a pseudonym.

Christa (Switzerland): I began at sixteen. I was in a home. I didn't know any way out. I got to know a man and I was in love, I thought. He turned out to be a pimp and I had to stand on the street. The other girls explained to me what I had to do there. I was quite angry. "I'm not going to do this," I said. Then I stood there and then I went with my first customer. Then the police came and I was arrested. At eighteen, it began again. And then I worked for one year, it's been just barely a year. The entire year has been good for me. I made good money but I had some bad experiences.

Ina Maria (West Germany): I am from Stuttgart. I left home right before my sixteenth birthday. I took care of an old lady. Then I had an accident and had to wear crutches so I had to go back home. My mother and father were divorced and my mother received alimony from him which she used to feed my brother and me. It wasn't enough so I had to go to work. So, I went in flat shoes and stood in front of a movie and then I went into this sex movie and did what they asked me

to do for fifty marks. Another girl more or less trained me and I stayed there for three years. In March of this year, I left. Now I work sort of off the books.

Dolly (Italy): This situation of children also applies to transvestites. Unfortunately, a transvestite in a family situation...well, often the parents don't want to admit that the son is different than other boys because they would like to see him as a normal man. But, I'm sorry, when you feel like a woman in your mind, and this happened to me, you can't change your mind to just become a man. And so, when I was fourteen, I had to leave home in Switzerland (family had immigrated to Switzerland from Italy) and go to Milan so that I could earn my money. Our situation, that of transvestites, is quite a special one because we are rather halfway. We are not accepted by our families and our nearest and dearest.

Gail Pheterson (U.S.A./Netherlands): I'm sorry we have so little time. This topic of children in prostitution is a very difficult one. We can get our cues for the kind of support and the kind of changes that are necessary from those of you telling your stories. The International Committee for Prostitutes' Rights recognizes prostitution as *adult* work. Children have a right to support from families, communities and the state. Services for children in poor or abusive families and services for homeless or runaway children should be priorities in every society. Resources which truly meet the needs of children are extremely inadequate throughout the world.

SEXUAL SELF-DETERMINATION

Terry van der Zijden (Netherlands): This morning there was a lot of talk about condoms and about cunnilingus and fellatio and then suddenly I thought, We are looking exclusively at male sexuality and well yes, lesbians should also be included. I didn't really want to say anything about it this morning, but now I have taken my courage in my hands and I want to say that if we are talking about sexual self-determination, we shouldn't forget that first of all you can make a choice between choosing a male partner or a female partner or both or many. There is a whole range of sexual activities which all have to do with sexual self-determination and, of course, with myself. Am I going to do it at home in my own time? Am I going to work with men and then be with women in my private sex life?

At a certain moment, as a decent married woman, I decided to earn my money by giving sex services to men. My next step after that

was starting to have sex with women in my private life. And then, I took another step: I decided to have sex only with women. I just had to be a lesbian, but I would have sex for money with men at work. I would often have liked to offer sex servies to women, but I have to note that many women don't have the possibility of buying sex. Thinking of everything I've done and experienced and then thinking of sexual self-determination, I think that I should be able to say "yes" or "no" to whatever sex. And, I should be able to say "yes" or "no" to other things in this world, not just sex. I should be able to say "yes" or "no" based upon my own conditions, and that would be that.

Let me just say something about lesbianism. I assume that in this room there are a lot of lesbians. There must be, or at least there must be women who find it important to share their lives with another woman or who find it important to share their sexuality with another woman whether they are prostitutes or not. And, I would like to ask to prostitutes who are not lesbians: "How did you feel when you were in a trio?" "How did you feel when customers encouraged you to make love to another woman?" "How did you feel when you talked about sex between women in your work time without doing it in your private life, how did you feel?" "What did you feel when you had a woman's arm around you?" Perhaps she was not lesbian, but you supported each other in your work and you felt the warmth of this other woman. Whether or not you are lesbian, if you share warmth with another woman and you are a woman yourself and if you note that sexuality with another woman can give you as much enjoyment as sex with a man, well, then for me I think that there are a hell of a lot of lesbians in the world who can do their work as prostitutes extremely well and can also be lesbians and have sex with men or women or both.

Margo St. James (U.S.A.): Just one note of explanation: "Trio" is the Dutch prostitute's term for two working women and one male customer. In the States we call in a "double" because we don't count the customer [laughter].

Sai (Thailand): I would like to speak about the lesbian. Right now, also in Thailand, we have got many lesbians. But some people don't accept this. Also, we've got young ladies, thirteen or fifteen years old, who start off being lesbians. And why?

I would like to tell about my story. Sometimes my family doesn't understand me. My mother just plays cards all day long; my father is a drunkard. Sometimes I came home from school and I wanted to ask my parents something, but nobody took any notice of me. They don't

even bother about my brother or young sister. But now I've got good friends. I go and speak with my girlfriends about my problems and they listen to what I have to say. And one day my friend told me, "Come on, let's make love together." And, after that I became a lesbian. Now I have been working for about seven years as a prostitute. I have to look after the customers so that I get good money from then. We have to give the man everything he wants; when he wants any kind of sex, we give it to him. But the man doesn't understand the girl's feelings. He doesn't understand what she wants. But, when I come home, I see my girlfriend and she cares for me, she worries about me. And, when I come home in the morning, she says, "Are you tired?" And then she goes and makes me breakfast or she makes me a warm bath or something like that. And I think that it's very nice when you have a lesbian relationship like this. I feel good in it anyway and it's especially good for me as a working girl. I don't want to say bad things about men but, well, some of them are really awful. . . some of them are okay but some of them are pretty awful. But I think girls are better. I love girls.

Miriam (Cyprus/England/Netherlands): For me, it's nice that people feel free to have any kind of relationship that they feel is good for them. But, the only problem that I have with lesbianism and homosexuality is that there is no procreation coming out of it, there's no babies coming forth. I find that a little difficult to cope with because I see the numbers of lesbians and homosexuals are growing in our society and the number of babies being born are dropping.

Margo St. James (U.S.A.): I would like to point out that the procreation argument is the argument of the fundamentalists who are totally against homosexuality. I must say that lesbians are mothers. Many lesbians are mothers. Many lesbians I know occasionally have sex with men, once a year maybe; sometimes they have what's called artificial insemination and have children that way. So, I don't think that homosexuality is limiting population. That's not a problem.

Eva Rosta (England): I'd like to say a say a few things about prostitution and lesbianism. Many people, in particular the press, are shocked that prostitutes can be lesbians. You know, if you are fucking men, how could you fuck women?! I'd also like to say that after a hard day's work on your back or in front of a camera or whatever your style of sex work is, there's nothing like coming home to a woman, friend-girlfriend-lover, who is less likely to impose upon you sexually, who

might run a bath for you or make a cup of tea for you and sit down and listen to you or whatever. There's nothing like it.

Veronica Vera (U.S.A): I want to tell you about an ad I noticed in the lesbian sex magazine *On Our Backs*. The ad showed a photograph of a group of a dozen women all very happy together waving to the camera. Some wore street clothes, some lingerie as they smiled from a back stage dressing room. The copy under the ad ran something like this: "We are lesbians and we are working in the O'Farrell Theater, a San Francisco burlesque house whose clientele are mostly men. We find this a viable place to work. We dance for men, but we are lesbians." The ad was paid for by the Mitchell Brothers who own the O'Farrell. *On Our Backs* is published by Debi Sundahl who is a dancer at the O'Farrell working under the name Fanne Fatale. The first issues of *On Our Backs* were financed by lesbian strip shows, women stripping for other women. So you see how a woman's professional sex life can be different from her personal sex life but how these can go hand in hand to accomplish other goals. The strong point is the camaraderie of the women.

Margo St. James (U.S.A.): One of the myths about whores is that we're all dykes. It's been sort of a way to write off autonomous women and to trivialize their analyses and their opinions. When I was in Houston in 1977 at the National Women's Year Conference in the States, I got to town a little early and was taking a cab. In the cab I said to the driver, "Do you know that twenty thousand women are coming to Houston next week?" And he said, "Oh yes, women libbers—they're all whores and dykes." So, if you're a feminist, you're gonna be called a whore and a dyke. You might as well understand it and deal with it. Anyway, it's a way of labelling and dividing and writing off the kind of powerfulness that we have here.

Pieke Biermann (West Germany): One more item, a murderous example: Women persecuted by the Nazis were put into the concentration camps as women and marked with the black triangle, naming them "asocial." The black triangle was the lowest level within the camp's hierarchy, on the same level with badges for "racial reasons," Jews and gypsies. The black triangle was worn by prostitute women and lesbians who most often were one and the same person. "A-social women: Women who don't fit into the state's plans. . . . "

Roberta Tatafiore (Italy): I just wanted to say something very briefly about lesbianism and prostitution, something I learned from

books. I have studied the regulation of prostitution in France in the
17th and 18th centuries. I found reference to the fact that they
thought at that time that it was important to close women up (in
brothels) and monitor them to impede lesbianism.

Brigitte Pavkovic (Austria): I myself was a lesbian for a few years in
Germany. I am a bit upset but I think it's a good thing that this subject
is being discussed. After I returned to Austria, I had no contacts. But
through newspaper ads, I got to know some lesbians and then there
was discrimination against me in my own family and in my home town.
So, I went over to men. It was not much fun but I gave up my les-
bianism. I did it because of social pressure. That was at age thirty-six. I
decided to marry a man through a newpaper ad who was also looking
for a woman who wanted to marry. Now I am divorced. All men want
the same thing: they all want to sleep with women on the first night.
So, I concluded, why not get paid for it. That is the most sensible pro-
cedure. And so, I became a prostitute.

One more thing: Today the youth office gives me problems in
living with my seven-year-old daughter because of my divorce. My
child would be taken away from me if I lived with a woman or if I
engaged in prostitution.

Margo St. James (U.S.A.): Custody of children is a problem for les-
bians and prostitutes in many countries. Authorities assume that if you
are a lesbian or a prostitute, you are automatically an unfit mother,
even though many mothers who are prostitutes have more time to
spend with their children and more money to take care of them than
other women.

Gill Gem (England): Obviously it's very important that we can
define our own sexuality and have the guts to stick up for whatever it
is, but I think that it also works both ways. I mean I have got loads of
friends who are lesbians but I remember a few years ago a group of
people, mostly homosexual men actually, were absolutely determined
that I was a lesbian which I am not. I had the guts to come out as a
whore when I was a very middle-class child and, if I was a lesbian, I
would bloody well come out as one. Possibly I'm bisexual. If I met a
woman and fell in love with her, I would come out. I know perfectly
well that no social stigma would stop me doing it. I can understand
when you've been working with men all day that it's nice to go back to
a woman, that you don't just want to be screwed. But I think that it is
quite important as well that you have the power when you are working
not to let your job totally put you off sex or, especially if you are

heterosexual, off men. I think perhaps that it's very much harder someplace like Bangkok because women have less economic power. I'm sure I get much more for a trick than Sai, even though I'm half as attractive. She's had it much harder and men have treated her much more badly. You know. And I think it's quite important that we fight so that sort of thing happens less and less. I know that there's someplace I think in Bangkok where a woman shoves a bottle up herself every night; she takes the top of a coke bottle with her fanny, right, every night. And every night her fanny bleeds and the crowds roar. Now, that is just sick. But that is because of the economic position of women in Bangkok. I am in a stronger position. Everybody who's been whoring has had the odd nasty experience. Once you've got on your feet, you are in a position to say, No—I won't do that. Most of the men that we see are civilized and I think that it is quite important that we get rid of them if they are not.

Mae (Thailand): I don't know if I heard right what you said about the experiences of Sai, about maybe her becoming a lesbian because she was mistreated by clients and about whether it's her own choice, right?

Gill Gem (England): I was not saying that at all. I was saying that even as a non-lesbian I can understand that you want to come back to a woman. I am not saying that she is not a lesbian, of course she is a lesbian, of course she wants to be a lesbian. I was just saying that I think it is important we don't let ourselves be treated badly. I just think on the whole from what I have heard, not just from you, but on the whole that prostitutes are not treated as well in the Far East because they have less economic control; prostitution tends to be more controlled than in England which is my experience. But I certainly was not saying that she thought she was a lesbian just because she had nasty experiences.

Mae (Thailand): Loving women and being a lesbian has nothing to do with being treated badly. Many women may chose to be prostitutes while being treated badly because of bad economic opportunities but that has nothing to do with being a lesbian.

Gill Gem (England): Okay, fine.

Italian speaker: Just concerning homosexuals and solidarity, we want very much to express solidarity with lesbians because they love women and we love men. People don't like to see two women or two men kissing, whereas when they see a man kissing a woman they couldn't give a damn. I really think that gay men have to stand with gay women and

express solidarity with them. Well, now I am a woman but I was a man
and then I became a woman—that is another subject. But, I must say
that we want to express solidarity because we go men with men and
women go women with women.

Pieke Biermann (West Germany): I want to speak very briefly
about eroticism and women. I'd like to give an example of that. I
worked in a bar which was a sort of starting point for meeting custom-
ers. Women in the women's movement could not even imagine what I
experienced there with the women working in the bar when there
were no customers around or when only two customers were there
and we were not all busy. I'd just like to call the subject "eroticism
among women at the workplace." When I wanted to talk about it in
the women's movement, people reacted in panic. They said that
women can't behave erotically among one another in "enemy terri-
tory," that women have to defend themselves against any feeling when
men are there.

Terry van der Zijden (Netherlands): Now that we have talked
about lesbianism, could I say something else about sexual self-
determination regardless of whether you are going for a woman or a
man. I want to say something about sexuality and autonomy. If I have
sex with someone, a woman or a man, unpaid or paid, then I can de-
cide whether or not I want to enjoy it and how I am going to experi-
ence that enjoyment, if I want to cooperate with someone or if I am
going to simply have that enjoyment all to myself. But some people
feel that if you are aware like that, then you are experiencing your sex-
uality without any feeling. I want to contest that out of my own experi-
ence. I think that if you are rational with your own sexuality, just as I
have described, it means that you can experience the best way of en-
joying sex without any other aspects sticking their nose into the mat-
ter. I am not saying that people have got to separate sexual enjoyment
from anything else but apart from other link-ups like sex and love, it's
quite possible to just experience sexuality, pure sexuality in itself. You
can experience it and you can enjoy it. And I think that working in
prostitution is one way to become sexually autonomous. I have experi-
enced sexuality outside prostitution and often it can easily be mixed up
with other things such as the relationship you have with your partner
or trying to be sweet and nice to someone because you love them.
Very often we as women cannot experience all this properly. I want to
wind up by saying that if we experiment with sexuality within the
framework of prostitution, we have the possibility of arriving not just

at sexual self-determination, but also at self-determination in all other areas of our existence as women.

Frau EVA (Austria): Very briefly I just want to give my opinion. I have always approved of sex. I have been curious about it. I grew up among adults. I began at twelve and a half, not in prostitution but with sex. I have three marriages behind me and all my husbands said that my orientation was grounds for divorce. They said that with my orientation, I should live alone. At thirty-four, I started to prostitute myself completely voluntarily. I have never had a pimp. I engage in prostitution because I cannot pay my debts otherwise.

Eva Rosta (England): I'd just like to say that sometimes when and if I go with men for pleasure, they act like clients. And, if they act like a client, I'll treat them like a client and ask for the money.

Flori Lille (West Germany): We are talking about sexual self-determination which is a very important point we should perhaps bring out more emphatically. We have also heard a great deal about violence against women. Sexual self-determination and violence against women are very basic disputes within the feminist movement. Very often in discussing lesbianism, people say to me that I am a tool of men, my sexual behavior, my sexuality is determined by their needs. I know that as a prostitute in the Federal Republic of Germany with my education, my possibilities, I am quite highly privileged but I would say that in the sexual relation of prostitution, I always pick what is going to be done with the customer, with the john. I determine my sexuality completely, professionally and non-professionally. Prostitution was my coming out, so to speak. Before I was an appendage of men. I lived very promiscuously and didn't know exactly why. Then, when I began in prostitution, I began to define myself as a woman and to state and impose what I wanted. So, I learned to know what I want in sexuality, both from men and from women. And that is what occurs to me about sexual self-determination. We have a great deal of power in our relationships to men but we've got to know that and use it properly. The process of self-discovery as women is something we can learn a great deal about in our jobs as prostitutes.

VIOLENCE

Margot Alvarez (Netherlands): I am going to speak to you about violence. I think we have to go back to the sexual contacts that we mentioned earlier because I think sex and violence are very linked. In the sexual revolution of the 1970s, everybody was making love with

everybody and if you didn't you were ostracized. I did it with just about everybody. At sixteen, I started living with a guy. Before that I had accepted money for sex when the offer was made and so I had worked a bit. I did it mostly out of curiosity. To think that men would pay an awful lot of money to enjoy a prostitute...well, I was curious and wanted to see what it was like. And then I met a guy with homosexual contacts who charged for sex. He had a boyfriend and he wanted to keep the money coming in but he didn't want to keep having sex for it. He wanted to introduce me to a guy who would pay and...I thought it might not be so bad to be kept, to be paid well. So, I agreed to prostitute myself; however, it was illegal at sixteen. And then my boyfriend wanted me to stop. He wanted me to be a normal woman, so to speak.

I lived with him for nine years. I was mistreated. I was beaten twice a week. I didn't know where to go, what to do. I wasn't doing anything wrong, wasn't doing harm to anyone. I tried to get support from other women but I was hesitant to do so because I was ashamed of what was happening. Also, there were women who spoke about violence but I thought it couldn't happen to me. Mostly I was afraid to speak to other women because I thought that the fact that I did not oppose the violence or did not react would not be accepted. After four and a half years, my boyfriend decided that I should become a prostitute again because of the money. I had just finally become a housewife. Well, I did not know what was going on. I did not under stand why first of all he beat me so I would quit being a prostitute and now he started to beat me so I would go back to being a prostitute.

Initially I thought it was great to be able to have sex with someone else. I realized I liked having sex with others. And, when I started working again, I was beaten a lot less. I started becoming more self-assertive and I saw how much money I could make. Finally I became smart enough to start saving money on the side. During the four and a half years that I was working for this man, I became a lot more sure of myself. At twenty-five, after eleven years of sex with men, I had my first orgasm. So, it was by working that I learned how I was able to develop myself sexually. Having an emotional relationship with the customer was an accessory; it wasn't really important. I was able to affirm certain things and I was able to express what I wanted and what I did not want. This enabled me to develop, to blossom sexually. Then, a little bit later, I packed my bags and went to a battered women's shelter. I stayed there for a couple of weeks and then I moved.

I changed cities and in the new city where I settled I was able to insert myself into society because I was not distinguishable from other people. I wasn't stigmatized. I didn't want to keep working as a prostitute. I wanted to become just a woman like everyone else. Then, last year I realized that I missed prostitution. I decided to work just a couple of days a week, not to do it on an everyday basis. Now, having a nice car and other things also enables me to be independent from men and to have a certain standard of living on my own. Thanks to my work, thanks to prostitution, I've been able to gain a great deal of independence and also to assert myself in different relationships with other people, particularly sexual relationships. Besides the economic independence, prostitution has enabled me to be independent sexually and emotionally.

Ceciel Brand (Netherlands): I am a social worker and I work with prostitutes in The Hague in the Netherlands. I have to say something. I am not just sitting here for the hell of it. Last year I met many women who are in prostitution. Very often they are under pressure and they experience violence. A number of these women are aware of the fact that this congress in being held and they asked me to report back because they are unable to attend themselves. I just wanted to tell that because I think it is very important to go back to them. I hope that all of us sitting here, this large group of women, can support each other and other prostitutes. I think that is of essential importance.

Margot Alvarez (Netherlands): Can I add something briefly? I once worked in The Hague and I know Ceciel as a social worker; in fact, I ended up in the center where she works. The Hague is rather an aggressive city for prostitutes. I know most of the women working there pretty well. I have also noted that many of the women who were abused came out of The Life for some years and then years later went back into the same situation and sometimes it was even worse. I think it's very difficult to save yourself from this kind of situation. I myself had to make a certain decision and say, "Look, it's just too much and I'm not going to do it anymore." Too often women are depicted as victims. I have tried to talk many women out of violent situations and they said, "Okay, fine," and then a week later they are back again. I do think there are lots of abused women in The Hague, very many.

Kate (Australia): On the subject of violence, I would like to tell of my experience when I was in a relationship with a man during a time when I was working in prostitution. After the first time he beat me— more as a jealous reaction than anything else—of course I kicked him

out of the house. But, after a time, he wiggled his way back into my life. And I told him that he was not to beat me again and that if he threatened me one more time I was going to beat the shit out of him. Well, the time came when he did threaten me in a public bar where we were quite well-known, where not many women went. And he took me by the throat and threatened my life. I started punching and kicking. It took two rather large men to drag me off him. I called the police because I didn't want him coming home to me that night and I wanted my door keys so that he couldn't get in. As it turned out, the police parked in an alleyway nearby and they waited for him and picked him up on drunken driving and found old warrants on parking fines etc., and they put him in jail for two weeks on these old warrants. The next night I ran to his sister—she had left a note for me concerning him being in jail—and I told her what had happened. She was going to pay sixteen hundred Australian dollars to bail him out which, of course, she didn't do once I told her what had happened. He had to stay the whole two weeks. Until that time he had never really taken me seriously. We do see each other from time to time now and he certainly listens to what I have got to say. He would not dare touch me like that again.

Carla Corso (Italy): I want to point out something that has not come up which I think we need to talk about today. Prostitutes, apart from the violence that they put up with from the police and the state and people in general and from rape and murder, are also subject to violence from other prostitutes. I want to say something about violence of prostitutes toward other prostitutes who are perhaps younger or newly arrived in the city or drug addicts. This is very widespread in Italy. Women who are already working attack a new woman, sometimes there are three or four who beat her up until she has to go to the hospital. We in the Italian group totally disagree with this practice and we are fighting to stop it. We think that the freedom to circulate is very important and an inviolable right. I would add that it is absolutely shameful that we should beat up one of our own kind. I think that we've got to be very united and we've got to protect our younger and more fragile sisters because their freedom is our freedom. And so I wanted to know if this is something which is widespread also in other countries and what you think of it.

Maggie (West Germany): Yes, this problem exists in all countries. I think in Germany you have the situation where if you're working on the street, you need a spot to work. I don't know how much I should

discuss this. If I have my own spot on the street which I've defended, I don't want a younger colleague or another colleague to take that place away from me because then I can't make any money. I've just got to have a place for myself and defend my turf, so to speak.

Gill Gem (England): I'm afraid I actually don't agree with that. I mean I don't think it's necessary. I think it's a self-perpetuating thing once you start to believe that. I think you can work the streets and I have worked the streets and never seen that happen in London. You know, people go everywhere. I have never heard of it being widespread amongst women themselves, I thank God. I think it is quite despicable.

Gloria Lockett (U.S.A.): It certainly happened in San Francisco and the Bay Area. It happened a lot. I worked on the streets for like ten years. You have to say what was your turf and you have to claim it: "This is Mine." The police also played a part in that because they allowed you to work only in certain areas. If you let other women come into those areas, then you weren't able to work. So, you have to say, "Hey, this is my turf...you can't work here." That was among women.

Terry van der Zijden (Netherlands): The fact that we have no work places is why we're struggling. We've got to be able to extend our businesses and that's what we've got to fight for, not among ourselves but with the authorities.

Erica (West Germany): I would like to talk about violence and what happened to me three years ago. We don't have official stretches. We work in bars. I went drinking with a friend. When we wanted to leave the bar, we were stabbed by a guy. "Only once," said the police, so they called it aggravated assault instead of attempted murder. I was in the hospital; I lost a lot of blood. The Turk was released since he had a job and his papers were all right. At the end of the trial, he left for Turkey. He had to pay some money but in the final analysis I got a raw deal just because I was a prostitute.

Terry van der Zijden (Netherlands): I really have to protest against the fact that here we're talking about a Turk while it's totally unimportant to know the nationality of this person.

Roberta Perkins (Australia): Violence on people working in prostitution has been a very very big issue with us in Australia for a long long time. Three and a half years ago, actually before the collective was formed, I was in the position to do some research with 121 women who work in the Sydney area. The survey showed that some-

thing like half those women were victims of very serious attacks like knifings or bashings or even being hit by a car when they were working on the street. A third of them had been violated through rape attacks. So, it is a very big issue and when the collective was formed, the issue was forefront in our minds. Of course, the police weren't going to do anything; they just weren't going to do a thing. As I mentioned before, they just completely ignored us. So, we devised a system which we called an "ugly mug list." An ugly mug is the Australian equivalent of the American "bad trick" because Australian prostitutes call their clients "mugs." So, we devised this "ugly mug list" and what happens is this: Women and men who work in prostitution contact us at various points about some experience they have and give us a full description down to even the name, address (if it happens to be an escort job), car registration, whatever. We print this description on the list—we leave off the names and the precise address to avoid libel or something but we'll give the street name—and then we distribute the list widely across Sydney and Canberra and various country areas. And let me tell you, it's probably the most successful service we do. I mean, everybody just loves it and I am sure that it is actually going to decrease the amount of violence.

Brigitte Pavkovic (Austria): I want to talk about the violence of pimps, which is growing worse. There are a great many of them in Austria; it's just boundless. Violence occurs among women when a pimp chats up a new girl and then takes money from a girl already working. The girls who work for this man see him making love to that new girl with their money. And, violence begets violence, as you know. It gets worse. It gets worse through lack of work, joblessness.

Eva Rosta (England): I'd just like to say a few words about police violence against prostitutes. We have not talked much about it yet, probably just because we don't have time. But the police, as we all know, abuse their powers. If you are a prostitute, particularly on the street, particularly if you are a black woman, you know what I'm talking about when I say that they abuse their powers. When a woman is raped, she has a hard enough time trying to tell the police her story. If her sexual history is revealed, it's even worse. If she's a whore, forget it! And when I go with a client and he doesn't pay me, I consider that rape and I'm unable to go the police and say that. Why is that? I think it's very important because of the way cops treat us, the Yorkshire Ripper and all the murders of prostitutes all over the world, that maybe we can think about a statement as prostitutes in solidarity about the

violence that we experience from the police. Maybe we can think about a letter, a statement we can send to the police.

German speaker: I should like to say something rather provocative. This may cause a lot of anger. It's with regard to pimps. There's always violence in the profession, between men and women and among men too. You can tell from the stories that have been told. I think the idea that all the badness comes from the pimp is a bourgeois dream, a bourgeois illusion. Women become victims when they allow themselves to become victims. I mean, there is a kind of built-in possibility of violence between prostitutes and pimps but also between prostitutes and any man they live with. There's also the possibilitiy of having healthy relationships as exists between solid women and healthy men. There are many stories of beatings, stabbings, rapes . . . but, I think that we must not concentrate too much on pimps as the source of this violence.

Margo St. James (U.S.A.): There was a study in the States that showed that 20% of violence against prostitutes came from the police, 20% from the pimps, and 60% from the clients. I think that is universal. I think the clients are the worst offenders, certainly. [See: Jennifer James, "A Formal Analysis of Prostitution," Department of Social and Health Services, State of Washington, 1972.]

Brigitte (Switzerland): I'd like to add a personal comment concerning pimps. I would like to explain why when I started ten years ago—I was a prostitute for seven years—I organized a pimp for myself. The only image, the only idea I had about prostitution was this miserable type of prostitution and I thought that the only way to become a prostitute was to have a pimp who took all your money from you. I thought I was intelligent. I thought I was smart. I had both emotional and financial problems which made me choose to become a prostitute, but I thought that, well, since I am a smart woman, I am not going to give all my money to a pimp. I'll find my own pimp and bargain with him, so to speak, for a spot, my turf on the sidewalk. I thought that the pimp was linked to the underground and into the whole circle of prostitution. At the same time, I thought that I was real smart because I told him I'd give him only half of what I earned. I thought I was being real intelligent, real clever, and I thought that I would be doing a lot better than my future colleagues. It was not until later that I realized that I had a basic false impression and that I kind of made someone into a pimp who would have never been a pimp prior to this and who never worked as a pimp after me. Obviously, later on I changed

my way of working. I worked for myself exclusively. This is very important. I realized that many women can work for themselves. I just wonder if many other women weren't like me and thought initially that you had to have a pimp if you wanted to work. I think it's really important to provide information on this. We should make sure that people realize that prostitutes don't go hand in hand with pimps. We should speak about prostitutes who try to lead a different type of life, who try to be independent. Many women are finally realizing today that they can be independent. If I can help other women not to fall into the trap of thinking they need a pimp, then I'd be very happy, to do at least that.

Helen Buckingham (England): I think we should be clear about who the pimps are. It seems there are two types of pimps: there are the pimps we choose, that is the men in our lives or the men who act as agents for us, and there are the pimps we don't choose, like the state or the police or the internal revenue and people like that or even, I am afraid to say, like lawyers that we often have to pay a lot of money to.

Gail Pheterson (U.S.A./Netherlands): A note has just been passed to me which asks what this discussion of violence against prostitutes has to do with feminism. Violence against women is often justified by calling us "whores." Feminism must stand for the integrity of whores if it is to secure safety for any woman. This brings us to our next topic.

ALLIANCE BETWEEN WOMEN

Pieke Biermann (West Germany): I am from Berlin. I began to work as a prostitute in the year of the woman, 1975. It was called that by the United Nations. I think every year is women's year but that's not the point. That year had several wonderful battles but there is one in particular that should be remembered. In 1975, there was the general strike of the French prostitutes beginning in Lyon. No one has mentioned that yet, but let's remember it. Is someone from that strike here? [several women raise their hands] In the same year, I decided to earn money on the "game." I was a student then. I always needed money, as everyone does. I had always had jobs during the holidays. I decided to earn my money as a prostitute, because other women, friends from the university, told me you earn more there. I wanted to check that out. I emphasize that I made that decision on my own and after reflection. I was completely lucid and in complete possession of my spiritual and intellectual and physical faculties. I tried it out the

first night, and experiencing that working as a prostitute has nothing mystical about it, I returned whenever I needed money and later worked regularly for some years. The five years that I worked in the sex industry helped to *increase* my capacities and powers in every way: spiritually, physically, and intellectually. I could say it another way. I could say that I am damn proud of having been a prostitute.

I was born in 1950 and raised in a family of women. I am a woman. I am a woman in action, a woman in movement. I didn't stop moving when I became a prostitute. The separation between feminism, that is the women's movement, and the prostitute's movement is an artificial one which, according to my experiences, has not been invented by prostitutes and probably not by feminists. But I have experienced that many feminists, a large part of the feminist movement, have made themselves advocates of the split.

In 1980, about the time when I stopped my work in the sex industry because I was offered a "decent career-job" in the publishing industry, I wrote a book called *We Are Women Like All Women.* Saying "I wrote it" is not correct, because five other women from various branches of the sex industry participated, women I had met through the work, some of them still working. But I was the only one who could give her name for it, being the least blackmailable of us, having no kids, no family pressures. The book also includes a contribution by a professor of history, very active in women's studies. She writes about Nazi politics concerning prostitute women. And there is a calendar of prostitutes' struggles, notes about German legislation and public opinion. The main line, though, is a long conversation between five working girls who exchange their experiences about work and money. And not a single one of us can be misunderstood as the usual poor victim which the official feminism loves so much. All of us have made a decision, have clear minds and can name very precisely the advantages and disadvantages of our work. And we can speak out about our demands. And, worst of all, we all walk backbone-upright and don't accept being morally condemned. And that is a fact that the mainstream feminist movement cannot and will not tolerate.

Of course there are friends, women who are feminists and *do* understand, support and like us. But they are individual women. They are still the exception. The mainstream feminist opinion, which I call establishment feminism, state-loyal feminism, still proclaims prostitute women are sick, stupid, easily forcible and manipulatable— inferior in one word. And, they say prostitutes are women unable to

speak for themselves, kind of degenerate women who live through men—through one man, their pimp, or through their customers. That is my experience.

The sad thing is, women who have never had our experience and don't want to work in the sex industry also don't want to *hear* what we can tell them. Things that would help them understand us. We could tell them for example a great deal about men, about how ridiculous they do look once the power relation has been kicked. Once men have paid and have to wait for us to do or not do what they expect. Once they are no longer "the powerful." The "decent women" could learn a lot from us.

But they don't want to. They'd like to continue to force their wrong images about "whores" upon us. They prefer to not listen and to not look, but to ask, instead, "and the pimps...?" They prefer to search for the man and oversee us.

Also they don't accept what we say. The prostitute women on strike in France have declared: "Don't call us sluts, bitches and all these names of contempt. We are prostitute women." When my, or better, our book came out in 1980, the only nationwide feminist magazine, *Emma*, wrote, "This book is not for the emancipation of whores, but represents the whorification of emancipation." If that is not contempt for prostitutes!

Very briefly to conclude, officially the women's movement has done zero point zero to provide the help which we need and to which we are entitled. Aside from individual feminists, it has done nothing about violence against prostitutes, better working conditions, or all of the other problems. It has done nothing to defend the honor and dignity of prostitutes. Feminists are worse attackers and enemies of prostitutes than some men. So long as prostitutes are stigmatized and can be stigmatized, any woman can be stigmatized and that is clear. All women can be blackmailed and exploited. Lesbians, prostitutes, and all racially oppressed women can be and so can all other women. So, officially and publicly and openly, we must assert ourselves for our right to live and work as we choose.

Roberta Tatafiore (Italy): I am from Rome. I am a feminist and I am not a prostitute. I think it's very important I underline that. I haven't got much time but I just wanted to add something to what Pieke Biermann has said. I think it is extraordinary what she said and I endorse all of it, even speaking as a non-prostitute feminist. I just want to say how difficult it is as a non-prostitute to get other women, espe-

cially non-prostitutes, to understand that we really want to support the prostitutes' struggle. Very frequently we lack credibility. The reason why I have always supported the prostitutes' struggle is that I am convinced that women who fight to erase the difference between prostitutes and non-prostitutes are *for* women because they think that women should have the choice. They feel that it's important to be aware of one's own condition as a woman if you are a prostitute or not. I think it is so simple to understand, but I find it's still very difficult to get it accepted as a premise for supporting the prostitutes' struggle. The reason, I think, does not actually lie in the organization of feminism as such but in the problem of solidarity amongst women, and that is not dependent on the political party to which you belong. The idea of commercial sex has always frightened people off. After the initial idea about it being via women's sexuality that you get sexual oppression, feminism didn't get very far. The money which prostitutes earn frightens women.

I've heard very interesting things in this congress and I think that the prostitutes, rather than worrying whether or not the feminists are with them, should really develop their own capacities with their own money and their own economic power to offer possibilities of self-management and self-organization and alternative ways of life.

Eva Rosta (England): I think that all women, at some stage in their lives, prostitute themselves to men, whether they do it with their husbands, you know just before the bill comes or Christmas comes. They need extra household money, so they're extra sweet to their husbands. I think that we all do it, just a lot of feminists and a lot of women don't recognize it.

Helen Buckingham (England): On this question of feminism, I am a very old-timer. Back in the seventies when the feminist movement first came to London, I was working as a nightclub hostess, which meant that I was dressed up to the nines by seven or eight in the evening ready to go on the job. That was the time when the feminist meetings were starting and I went to one of those first meetings. I was wearing a wig, long flowing eyelashes, a cocktail dress with my boobs sort of out, flashy nails and make-up and I might just as well not have existed. They passed the coffee past me, they passed the biscuits past me, they just didn't even shake hands with me, they just pretended I wasn't there. I went on to the nightclub and I mentioned this to one of the hostesses and I said, "I have been to a feminist meeting because it should be about people like us, it's about women and money and our

chances in this society." And she said, "Oh, is it? I thought it was about burning bras and I'm not burning mine, it's much too expensive."

Then, we had some problems, some really quite bad problems in London a couple of years later and many of us were very angry, angry enough for one or two of us to brave it and come out to the press and so on and start saying things. I went to *Spare Rib*, which is a feminist paper, and said, "Look, I am a woman, I am coming here on behalf of other women who work the way I do, we've all had a big discussion about what the police are trying to do to us, can we have a page of your paper to write what our problem is as women?" And, they turned around and said, "But we know what your problem is, we have already analysed it." So, that seemed to be the course that things were going to run and, I am afraid to say, have run with my experience of the feminists and my campaigning for a whole decade and more.

Pieke Biermann (West Germany): The fact that we are here today and that we are sitting here in this building over the past few days testifies to the existence of feminists who have spoken out in our interest and for our benefit. We need such support to be acknowledged as part of the women's movement rather than dependent on a few individuals. The women's movement during the last twenty years has taken power in organizations, it *has* gotten money, it *has* gotten possibilities for getting money, it has caught the public imagination, and it has public means. We want to have the resources of the women's movement made available to us. We want to feel that the women's movement is a movement for us and that if we can't speak for our own rights, feminists will speak for us. We want the women's movement as our lobby so that together we can put political pressure on the state and the political authorities.

Margo St. James (U.S.A.): Thank you all very much. We don't have time for any more speakers.

Danny Cockerline (Canada): Just one point: Female prostitutes are oppressed as prostitutes and as women and obviously male prostitutes are not oppressed as women, but we are oppressed as prostitutes and, in a lot of cases, as gay men too. I would like the position paper on prostitution and feminism to clearly state that the rights we're demanding for female prostitutes, we're demanding for male prostitutes too.

Another voice: . . . and for transsexual prostitutes.

Another voice: . . . and for transvestite prostitutes.

"THE BIG DIVIDE"
Feminist Reactions to the
Second World Whores' Congress

The Women's Organization for Equality (WOE) in Brussels, Belgium, is an English-speaking international group of feminists. Initially, the ICPR met women in WOE when invited to give a lecture on prostitution. Once it was decided that the whores' congress would be held at the European Parliament in Brussels, contact between the ICPR and WOE intensified. We held discussion evenings on political issues with invited prostitutes from Brussels, Amsterdam and Paris. Many WOE members decided to support the congress by offering housing and skills as interpreters or graphic artists. Several women attended formal meetings at the parliament, many more attended just the evening sessions at the Rue Blanche women's center, and many spent informal time with prostitutes in their homes. Except for the discussion groups on the second evening, WOE feminists were silent guests at the congress. Most of them had never before met sex workers.

Nationalities in WOE include Belgian, Danish, Dutch, English, German and North American (Canada and United States). Both lesbian and heterosexual women of all adult ages are well-represented. The group is predominantly white, middle-class and Western. Obviously, the organization does not represent feminists worldwide. Nonetheless, the reactions of WOE members may reflect the feelings of diverse women throughout the world who have been divided from whores in space and identity. The following speakers, recorded a few weeks after the congress, explore their experience as feminists in crossing "the big divide."

Speaker 1: I thought prostitution would be a nice interesting topic like any other topic but I didn't expect it to be so explosive, not for WOE and not for myself. I'd never given the subject much thought. Prostitutes were like women or men living on another planet...they didn't seem to really exist except in some articles, mainly about violence and murder, and in pornography which is always much criticized by feminists. I sort of automatically followed suit with the

173

feminist line because I didn't give it any thought of my own. So, when Gail came first with Margo and then with working prostitutes, I thought, Am I going to feel very strange meeting them? Am I going to feel like a different woman? And I didn't. That is very surprising. I expected to feel some kind of upheaval. And I didn't. They were just other women—drinking coffee, having sandwiches and going to bed. So, that was the first barrier which was apparently very easy to overcome, in fact surprisingly easy.

What do I think about prostitution? I still wish that people would do without. It's that simple. And I find it very hard to say why. Do I think it is degrading? Well, meeting all those women who didn't think it was, why should I think it is degrading in their stead? You know, it's like deciding what other people like and what they don't. It's not my business, it's their own. I just wish that prostitution wasn't necessary, that there wasn't this need to create a whole special world for sexuality, that it would be a part of daily life . . . much nicer, much more natural.

I had porn workers staying at my home. They were quite nice women. And they ENJOYED doing that porn stuff. Now then, am I going to tell them that they mustn't? I'm not their mother! I mean, I have no education to offer them. If I did start to be really moral about the whole subject, then I'd have to be moral about the behavior of a lot of feminists who engage in free sex. I mean what's the difference between being promiscuous and being paid for it, and just being all free and not getting paid for it. I can't make up my mind. If one is allowed, then the other must be allowed, I can't see any difference. Of course, I remain very strict on the idea of violence and child porn and child abuse and abuse of Asian women and all that, you know, or people getting drugged into the trade. Never will I allow that. But if laws can be changed the world over to protect sex workers, I'm in favor.

Did meeting prostitutes change me as a feminist? Yes, I think it did, because I can see their points, especially when I listened to them at the congress. I thought they were right in asking for human rights and I certainly would never be in the way of that, no matter who they are. I do realize that in WOE the subject has created quite some tension and we seem to have fewer members this year. People don't come to general meetings that much anymore. But, surprise surprise, they do come to the prostitution meetings. So tell me, isn't all this very a

biguous? They stay away because they hate the subject, on one hand, and on the other hand, when they do come it's for the subject.

Personally, I won't find it difficult to go on with supporting prostitutes' rights. I can see that this movement may help liberate all women. You can't have so many women oppressed and stigmatized in the world and then expect that anyone who is not a sex worker is free.

Speaker 2: I can't say that I've sorted anything out about this business really. I was interested that it took me back to when I was at college because every evening I went home down the Bayswater Road where "the girls"—as we used to call them in those days—came out at half past four, thereabouts, just when I was going to get my supper. We were always warned to keep well away. This was also the time of the Christine Keeler- Profumo Affair. My impressions about prostitution were perhaps a bit hypocritically British.

I wasn't actually able to go to the conference at the parliament, but I came over to the evening things and I . . . I felt the odd one out really. I felt kind of odd and a bit prissy and so on, you know. But I enjoyed the good-humored atmosphere that there seemed to be. And I very much enjoyed the show with the feminist and the prostitute [see cabaret/photo of Natascha and Betty]; I thought the points they put over in that were terrific.

I got a bit of a shock when we were in the small group meeting. In the one that I was in, there was a feeling of absolute hostility toward *us* from some of the prostitutes. I had not come across that before. It was very strong and I didn't know what to do about it at all. I felt that here was the big divide. I didn't feel hostile toward them, but if hostility was coming toward me, then they must have felt it toward them, somehow. The leader of the group tried to bring things together and it was perfectly okay. But it was just the strength of that feeling, you know, the divide. It did really shock me. Apart from that, I haven't gotten further. I too basically feel I'd rather prostitution wasn't there. But, I don't really know why. Or perhaps I'm not prepared to say or I'm not prepared to actually think it through yet, possibly.

At my office I got adolescent snickers from all the lads who knew I was going to the congress. My boss said to me, "How did you come to get involved in that then? I suppose it was all very interesting. . . ." Well, I said everything and nothing, you know how you do. I didn't quite know what his reaction would be. He immediately jumped on

the subject of AIDS that he seemed to have gotten wind of. And then at one point he looked at me and said, "I don't know what lesbians do and I don't want to know!" [loud laughter in group] I nearly fell off my chair. And then he turned away.

Speaker 3: Before the conference I hadn't given this whole issue of prostitution and feminism much thought, but I have had some earlier contact with sex workers. And when we started to talk about this topic, I remembered them. On one occasion, many years ago, I went to a bar with a couple of friends and there was a stripper. She stripped naked. Then I went to the bathroom and she was there. We started to talk, about just ordinary things like "isn't it a nice day" or something like that. And so I said to her, "Do you want to come have a drink with us," and she did. So that was a very early contact that I had, but I didn't think anything of it. I did want to find out more about her. The only thing I remember her saying was that she preferred working for women managers because she felt they treated her better. That's the one thing that sort of stuck with me.

Another time, when I went to university, Xaviera Hollander, the Happy Hooker, was on a lecture tour through Canada. She came to the university and they had reserved a lecture hall for her that was too small. EVERYBODY went to hear her. She was quite explicit about her work and what she did. She was saying that she got into prostitution after one of her many lovers said, "You should charge for this." That was her story.

Although I didn't think much about prostitution, not consciously at least, my attitude was feeling sorry that women had to do that kind of work. It wasn't a moral thing. I just didn't see it as very nice work, that's all. Talking with the women at the conference gave me a different idea because some of them actually like what they are doing, which was something I found hard to believe before. But after talking to them, I now can see that some women do this out of choice. I still don't think that there are very many, but some said they liked doing it.

I certainly do believe that conferences to bring women together are important. I think the isolation, the division between prostitutes and non-prostitutes, is very acute. Driving along the Avenue Louise [a streetworking district in Brussels], I sometimes thought, I wouldn't mind talking to these women and finding out what kind of lives they lead: do they have other relationships, do they have children, do they cook, do they wash, and all of this, do they wash clothes, do they do

housework, what else do they do, do they read, what do they read, do they go to movies? And so, this is what I found out by talking to the women during the conference. I also was very surprised because I thought that prostitutes wouldn't want to talk to women who were not prostitutes. I thought they would find that very...well, they just wouldn't want to talk to us. And I found it easy to talk to the women. They were very willing to tell their story and to talk about their lives, which was a surprise to me, a very pleasant surprise.

Since the conference, I've thought quite a bit about my attitudes about prostitution as an institution and I can't say I'm getting any clearer. One of the questions that arises with me is that I see this as a service that is being provided solely by women for men, and even if it's provided by men, it's usually provided for men. There are lots of other services, waitresses and factory workers and so on, but these are for both men and women. I have a feeling that, just like marriage, prostitution is an institution that was invented by men for men. Therefore, I have a lot of trouble with it. I don't think prostitution is something that women, if they had been making the society, would have invented.

Speaker 4: Part of my ambivalent feeling toward the whole issue of prostitution was a sort of vague envy of the men as well as the women, of the men that they could get their sexual needs fulfilled so easily and so relatively cheaply and without any of the usual emotional hassle and also envy of the women that they are able to meet men on this sexual equality footing and don't need to get all involved with them in order to give or get service. I too resent the servicing of men by women; I would feel half as ambivalent if prostitution existed also for women. As to whether it would have been invented by women, I'm not sure.

I had volunteered a year ago to offer my house for the congress. Nearer the time, I felt myself in a very difficult period and I really didn't feel up to it. Also, about two days before the date, I suddenly thought, Oh my God, what about diseases?! Well, all that worry disappeared when the women arrived because they were just very nice and very understanding. I could say exactly how I wanted to be treated as a host and how I wanted my house to be treated. That was very good and we became good friends in a short time.

I haven't thought much about the issue of recognizing prostitution. Of course, if you had asked me, do prostitutes have human rights like everybody else, I would have said, "Yes, of course." What it ac-

tually means for them to have rights was brought home to me very forcefully there at the congress. I also feel that if human rights were given to prostitutes, the whole face of prostitution would profoundly change. And I have this very idiotic feeling, it's not a hope—it's almost a conviction—that prostitution would disappear. So I'm very much in favor of their fight. I do have my doubts about the hard porn issue, the child porn issue, and some of the perverse games, the sadomasochist things. I don't feel happy about those things at all.

Some seemingly unrelated note is about secretaries. When we go on about being angry at prostitutes providing this service to men, I sometimes can't help thinking that I'm angry at secretaries for doing so many things that men should do for themselves, like arranging tennis dates. I've always felt that if secretaries and prostitutes went on strike, we would have our human rights in no time flat. I don't mean to hurt or offend any secretary, I know that we have some here. I do the same thing; I find myself itching when I'm sitting at a table with twenty men and somebody comes up and asks for some sort of service like getting coffee. I really have to hold on to my chair not to volunteer.

What I missed as subjects for discussion at the congress was discussion on the phenomenon of prostitution as such. Why is it there? What is it there for? Isn't it inherent in the way that men relate to women and to sexuality and to emotionality? I'm always missing men in this sort of discussion because they are the ones who go there. If they didn't go there, prostitution wouldn't exist.

One of the touching things at the congress was to see how high the prostitutes were about being able to come into the open, how happy they were just to be recognized. I felt ashamed in a way that they were so grateful, there's something awful about the fact that they needed to be grateful for just being accepted in a group like that. And, when I talked to them, they all felt moved, without my asking them— I'd already gone through the process of recognizing them in my own heart so I didn't doubt any of their rights—but they all felt moved to explain to me why they had become prostitutes, in an almost defensive way, and I hadn't asked the question. Very touching, very touching stories, but they felt the need to tell them and I thought that was significant. More negative stories came out in private than in the public meetings. And there was often an element of violence in what they had to tell, even among the ones that said, "Oh, we like doing our job."

Something that surprised me, that I loved at the congress, I think we all enjoyed it, was the freedom of speech, oh yes, that's a thing that I LOVED, the total disrespect for any, ANY of the established values, that was so liberating, so wonderful, wonderful. [Other WOE women chime in: "Yes, oh yes." "I enjoyed that too." "That was lovely."]

Speaker 1: I remember two or three details: The first evening at Rue Blanche, there was a very good atmosphere already and by the end of the evening someone found some music on the radio and some of the women started dancing. That was very nice. I joined because I love dancing. The next day there were the men, there were the doctors present as well, and what I saw happening was the same thing that used to make me feel uneasy when I was in my teens at school dances: This adoration of the male. About three or four men were surrounded by about a hundred women and all these women had big big smiles, starry-eyed for these men, they all wanted to dance with these men, even the lesbian prostitutes. I was shocked. I thought, Now if this adoration for the male goes so far, just because this chap happens to be a doctor supporting the movement, then we'll never get anywhere as feminists. [Another WOE member: "He's a potential customer."] Well, precisely, I mean if this attitude goes that far even outside working hours...that really shocked me that evening and I didn't dance again.

And then in one of the discussion groups, a prostitute was going on about how powerful she felt with her customers, especially when they were great executives, very powerful men outside her bedroom, and how powerful she felt when a customer said, "Lick my toes or beat me up" and that kind of thing. And I thought, Why do I think this is not power as she says? To me it is comparable to the kind of power women have been allowed to have so far. It's like wives being powerful in their husband's lives because they have the power at home and they push him to make a career, and without her washing up and doing the children, he couldn't make that big career. It's invisible power again for women and temporary power, depending very much on a temporary contract or manipulation. I think that power by manipulation is very different from openly sharing power.

Also, being a lesbian myself, I found it very difficult to understand how all the lesbian sex workers who were there could so easily service men several times a day. I will never understand that, really! And I wanted to ask them, but they were amongst the most aggressive ones

present so I was a bit scared, I'll admit, and I never asked the question. They also seemed to be the biggest fighters at the parliament. Either transsexuals or lesbians were the biggest fighters most of the time, not always. . . the way they put their points forward for their rights, and the way they knew how to express themselves, and the way they really totally ignored the establishment. In the middle of parliament, they were very happy to say, "You know we are surrounded by our clients." I guess lesbians in general are big fighters. Even among the staff of the European Parliament, lesbians were the most vocal supporters of the whores' congress.

Speaker 5: This will probably be very disjointed because the whole thing is so difficult. I've been listening to different people here and I agree with a lot of what people have said, like about prostitutes seeming to be women on another planet. For me they were more like another class, really, very much the poor, lower middle-class or the real rock bottom ones who are the victims of society. I thought that in a socialist society all that would be sorted out because people would be more equal. Then there wouldn't be this terrible, craven poverty where women had to go and sell their bodies and get into prostitution. Prostitutes were victims to me for the most part, but at the same time rather scary people because you have to be tough to survive in that sort of environment. You know, they were people I'd be afraid of, I wouldn't dare go and talk to anyone, go and address those people, I'd be afraid I'd have my head bitten off. They're intimidating, as a group they intimidate me. They must be strong to live. Anyway those were my attitudes, my background, when we started off with this congress thing.

I was interested in discussing the topic and trying to get my ideas a little clearer. So I went to the meetings. Gradually I started saying, "Well, after all now this is a profession that's been around for a long time, it's not going to go away overnight, if they're asking for their rights, why shouldn't they have them, perhaps we've got to accept that they should have human rights." And I learned about different things that I didn't know, that they were discriminated against on so many different levels and so on. So, those sort of ideas became clearer for me. Okay, it's a profession, if you like, therefore they should have rights.

One thing led to another and then at one meeting a prostitute said

that she thought no woman under twenty-five should be a prostitute. But, in many countries young girls start when they are sixteen, fifteen, fourteen or even younger, terribly early. So when she says that no woman under twenty-five should be a prostitute, what does that mean for the millions of young girls who are roped into it at such an early age? When I was at the congress for the prostitution and feminism session, I was looking at those terribly articulate women up on the panel there, and I was thinking to myself, Well, they seem to be women who have seen a lot, they've been around a lot, they are articulate . . . and I was thinking, with my moral conscience, why can't they do something GOOD with their lives, you know, morally, socially useful? . . . Okay, that's my moral parenthesis. But why can't those women who seem to have a lot of clear ideas on a lot of things help the younger prostitutes or the young women who are in those sort of peripheral and little jobs that lead to prostitution, like you know in those bars and other dicey places where they have to make the customers drink. Aren't the older prostitutes the ones who should be helping the younger girls to see what they're letting themselves in FOR, you know, what's in store for them? I was speaking to a prostitute who said that young girls are just naive. They start in a bar and it's a bit glamorous maybe or they get easy money and one thing leads to another and then they're registered with the police on a computer, and then, there you are, they've had it for life. Perhaps they should be helped by the other prostitutes who have been through it. Anyway, I'm just thinking that prostitutes could start a consciousness-raising group.

I do wonder about the sadomasochist thing. When you see a film, like *Mona Lisa* for example, you see this beautiful black prostitute tied up and this man running around with a whip with his underpants on. Does prostitution pander to these weird things in men? I mean the fact that men can pay to act out the funny ideas in their heads, that they can pay women to do this. Is that a good thing? Does prostitution pander to their weird cravings, their every whim??

There was one other point, oh yes, that was about the idea of how we, the non-prostitute feminists . . . I don't want to make a distinction between prostitutes and feminists because maybe there are prostitutes who are feminists and there are perhaps feminists who are, you know . . . [laughter], so anyway, how can we non-prostitute feminists and the prostitutes continue a sort of dialogue? Human rights are their

issue, they've got to fight for them, the prostitutes who are thinking prostitutes have got to be the ones to be the leaders, got to do it. But perhaps they think that we could give some type of support in some form or other. In what way can we, the non-prostitute feminists, help them to acquire their human rights and to do away with the whore stigma?

Speaker 6: I hadn't really thought much about prostitution before the congress. I think I thought that there wasn't a prostitute who chose to be a prostitute, it just happened. Somehow they were so poor or they had a pimp or they were drug addicts or...I thought it would be a pretty awful job because it's really based on what you look like. You've got to look good to earn money and you get to a certain age, fifty or sixty, when you're not going to earn anything anymore. But, I hadn't thought about it really. And then we had this meeting and we talked about providing housing for the congress. I just presumed that I've got rooms so people can stay and I still didn't think about it much, despite our meetings. And just two days before the congress, I suddenly thought, I've got young children, I've got boys, what the hell are they going to think?! I had talked about the congress so I asked them if they realized that these women were coming in two days. One of the kids said "Yeah, I told them in school about it." [laughter in group] And I asked, "Oh, what did they say?" "They were really shocked. In fact, the neighbors haven't talked to us since." [loud laughter in group] I didn't care, I didn't care about the neighbors. I just had a peculiar feeling that it's a strange way to introduce kids to prostitution: Here are three prostitutes. But, in fact, they turned out not to be three prostitutes; they were two prostitutes and one woman doing other work. It would have made no difference because they were just women.

The only thing that really bothered me was what they were going to think about me. They were going to find me so boring and conventional. And then I thought of what one of the visiting prostitutes said in a meeting about nobody being able to have an opinion about prostitution without having "played a trick" or whatever you call it. So, when I went to a cafe to meet a friend and a rather repulsive old man came and sat next to me, I thought, I'll play along with this. He asked, "What are you doing?" and I said, "I'm waiting for a friend." "What do you do?" I said I was studying. "What do I do in the evenings?" "Oh,

not a lot." "What are you doing tomorrow night?" And I said, "When?" In fact, I looked at him and I thought Yuk, you know. But it was very tempting just to try, except I was frightened. I thought AIDS and also, How much would I ask? and, Was he one of those men who beats women up? I wouldn't want to risk that. Anyway, I changed my opinions about prostitution. I thought, It's really very easy. And it's perhaps a way of earning a living, if I weren't frightened.

The women who came to stay were so nice, they were probably the best guests I ever had. They weren't too nice, you know they didn't rush to wash up like some people do, they were just normal. And we stayed up late and we talked and talked about all sorts of very personal things and we got around to talking about how much you charge and so on. ["What did they tell you?"] About their lives? ["No, about their charges?"] Well, I can't remember, it was something like nine hundred Belgian francs for ten minutes and I said "That's not very much" and then I thought, Bloody hell, that's a lot of money. [loud laughter] But I didn't meet any women who said that they actually liked the job. I can't imagine that anybody could like it. I think it must be very powerful, perhaps, to be able to choose who you want and to charge them for it. And I sort of envy them that in a way, to be able to say, "Well this is going to cost you nine hundred francs," you know, and take the money, that must be quite a good feeling. I wonder whether it's that that they like. I can't imagine them actually enjoying sex with these males so often, it must be so awful. Is it my morality talking here or is it, I don't know what it is, I suppose it's...sexuality, not morality. [laughter; other speaker: "That's a big question for all of us."]

Now I think of it just as a job, but I still think that it's a job with pretty rotten conditions and no rights. And prostitutes should have rights, they're working. So they ought to be having the same rights as other workers. You know, they should have a union, they should have..ahh, then they have to pay taxes unfortunately...but they'd have to pay taxes and at the end of their service, they should get pensions like anybody else. It's a job.

Speaker 7: I never really thought about prostitution in great depth before but it was always around. In my youth there were *Playboy* magazines, and although the women in them weren't prostitutes, they were sex workers and...they were rather lovely-looking women. They were beautiful and clean and elegant and people to revere somewhat.

And there were the streets in my hometown where the prostitutes went and everyone looked, wondering, Which ones were the prostitutes?! There was interest because their work was so unusual and taboo. Also, there was a woman who lived across the street from us whom my father used to call the local prostitute. I don't think she was, she worked at a radio station. But it was his joke, and whether it was funny or not, I don't know, but she called herself that too. These prostitutes were very interesting, rather exotic, but also people not really to be considered too seriously, like you didn't mix with them, they were naughty.

Then when I was getting older, some of my male friends used to go with prostitutes. They said they could get sex without any emotional hassle. I found it quite intriguing. And so I thought, maybe I'll just try it. I was recently divorced and I was willing to try anything. After I'd make love with men, I'd break down how I felt and sometimes it was nice and sometimes I felt nothing. But anyways, I was going to try it. In the end, I decided not to do it and I went on a skiing holiday instead.

I didn't think about prostitution again and then when it was decided that WOE would support the whores' congress. I was quite afraid. I don't really know why I was afraid except that I wasn't sure I wanted to get confronted because I didn't know how I felt. But then we talked about it a lot and through what other people said it made a lot of sense to support prostitutes. They were women, they worked, they had rights and they had every reason to fight for these rights. So, looking at it in that way, fine. I agreed with WOE supporting them.

I think I feel that prostitution is a job, a very unpleasant job. I don't think I would like to do it. But I don't think I put anything moral on it. I don't know, I might even be jealous but I don't think so. When I think of prostitutes doing their work, I have trouble picturing it. Like I would never picture my mother and father and when I look at my sister or my friends who are married, I don't picture them either. For some reason it must be taboo in my head. So, when I think of prostitutes working, I don't picture what they do.

One of the things that struck me at the congress was how, by being feminist, I was categorized, labelled. I didn't like this but it helped me to understand the rage that prostitutes must feel by being labelled and dismissed. Since the congress, I have been thinking that there are a lot of women out there doing a lot of things that in the past I never thought were very feminist. But speaking to some of the prostitutes or

listening to them, I realized that a lot of them are feminists and are supporting themselves and that they have feminist ideals. I started to realize that there were a lot of other women too who would never call themselves feminist but that doesn't matter, they're still doing things that feminists believe in. And I realized that it would be nice to be able to have some more links with a lot of different groups.

Speaker 8: When I was younger I thought that being a whore had nothing to do with money. It had to do with sex because you were a whore if you slept with somebody before you were the age they had decided you should be or if you slept with quite a few guys. I didn't realize that what distinguished a whore from other women was getting paid for it. It had much more to do with morality and sexuality. When I got old enough to understand that there was a real word "prostitution" and what that meant, I was at a point where I wasn't thinking much about it one way or another, I was already into other stuff. But, as far as I knew, I didn't have any connection whatsoever with prostitutes. Nobody that I knew growing up or even at university ever talked to me about being one or having been paid for anything in that sense. If you were paid to do other things, then it wasn't prostitution. If you were paid because you went in and cleaned up a guy's room at college and did whatever else, that wasn't prostitution. Prostitution was paid sex. Everything was very clear and I didn't have to think about it.

Then with feminism, I took over a lot of ideas about prostitution and pornography without giving it too much thought. The ideas made sense, but we didn't talk about it that much either. Then the idea of the conference came up, and I offered my house as a headquarters. All these women were going to come to stay at the house and that was all going to be fun. I also absolutely wanted to go to the prostitution discussion meetings. When somebody said, "Why are you going to those meetings?", because I'd been missing so many others, I said, "I keep having these arguments with myself, in my head, and I'm not getting anywhere with this issue. I need to hear what other people are thinking and I need to have input from prostitutes."

So then the women came to the house. I was leaning heavily toward thinking, Prostitutes are great; it's all great, all these other sides don't make that much sense. But now that the congress has happened, I still have lots of questions going on in my head. I think overall the conference and having contact with the women themselves changed

the level of my thinking about prostitution but it didn't change my going round and round about it. I think the human rights issue is fairly clear-cut because if you are human you deserve certain rights, period. But, I still have troubles with pornography. I think in the global sense of what it means for women in general, of how men see women. Oh, I have a lot of feelings about the whole thing. I can feel very angry, angry about the issues themselves and angry about society and the way that women are treated. I can feel angry about the way the prostitutes are feeling about me and my attitudes. I can still feel moral about prostitution. Sometimes I feel sorry for the women, sometimes I feel very jealous of them, sometimes I can put that all aside and just want to connect with them as women. I found there were prostitutes at the congress who I really liked, and there were some I didn't like, just as women.

One of things that was fun for me at the congress was that it was not easy to tell the prostitutes from the non-prostitutes. If you thought that you could tell somebody was a prostitute, she usually turned out not to be one. That was fun. But I had a lot of problems with the afternoon on feminism and prostitution. I was very very shocked by the hostility coming from the prostitutes in the conference itself, their anger was enormous. I did not like the fact that it was directed towards me or towards feminists as a group.

Speaker 9: I used to feel sorry for whores. I thought that being a prostitute was a bad thing. But now after this whole congress, I don't feel sorry for them anymore and I feel stronger myself, because we are together. When the prostitutes were talking about the feminists, I enjoyed it because I saw that here we could have contact. I enjoyed the fight. At the beginning it was like they were asking for something but I was frustrated because I didn't feel able to answer and I didn't recognize the feminism they were talking about—it's not what I know. But once they expressed their anger, there was contact and in the evening we feminists could respond. I felt that the fight made more authentic contact between us possible.

Speaker 10: When I was a little girl, I never even heard about prostitutes. In high school and college, prostitution was something that I heard about and read about but it was not real. When I went to Japan, I went to Yokohama, which is a big navy port, and I remember, I must have been twenty-two or twenty-three, walking down this

street which was just shocking: All these little stands with these young girls and all these men...these pimps telling people the prices. It was so beyond me that I just practically closed my eyes, went on, and very quickly was able to put it off. When I lived in Turkey, I remember hearing from Turkish friends the plight of women in Turkey who for various reasons get thrown into prostitution and get actually cloistered in places they can't get out. Once you are no longer a virgin and you're not married, you're not saleable and the only way to earn a living is prostitution. For example, if a girl is raped and people find out, she has literally nowhere to go and no way to earn a living, she's put in one of these places and once she's in, she can't get out.

I had a mind-boggling experience for old bourgeois middle-aged me a couple of years ago. I'd heard there was a room for rent down by the Gare du Nord [red-light district of Brussels] that might be appropriate for our WOE meetings. So I went down there. It was my first time in the area. The woman who was going to show me around knows the neighborhood very well because she used to work there in a bar. After seeing the room, we went to a bar which was run by an ex-prostitute. A woman came into the bar who was obviously a prostitute. I'm saying that because she fit all my stereotypes, all the worst stereotype images you could imagine: She was wearing an Afro-wig, she was white, and her make-up was caked, her eyelashes were clumped together and she was wobbling on high heels and her fur was tatty and her skirt was short. She was just exactly what you would see in some movie. She sat down and I was introduced to her. When she found out that I was a teacher, she began to tell me in real bad French—I guess it was her language but she did not speak it well—about her problems with her little seven-year-old daughter. Her daughter was illegitimate, of course; she had placed her in a boarding school from Sunday night to Saturday morning. The child was doing very poorly in school and she didn't dare go talk to the teacher because she knew what kind of impression she would make. She had no self-confidence. She asked me, "What shall I do with my daughter?" I really got clutched by this. The experience made a big impression on me. I also felt like a voyeuse because later on, when another prostitute walked in, the conversation turned to getting back at somebody who had stolen a client or something. They talked about taking off a shoe and breaking a window for revenge. The best way to fight was your shoe...that high heel was a weapon! So there I was sitting, as I say this kind of over-aged, overweight teacher, thinking, wow, I thought I

was living in the world. I really became aware, truly aware that there
are all kinds of worlds here in Brussels.

When the idea came up of helping out with the prostitution con-
gress, I really didn't feel one way or another. I thought it should take
place and I thought we should support the prostitutes. At the congress
itself I went beyond the level of just seeing prostitutes, I was able to
listen to prostitutes and that was great. That already opened the door a
lot wider. But when I get in a large group of people who I don't know,
I have a personal tendency to just kind of fold within myself. I prefer
not to go to gatherings like that if I can avoid it, and if I do go, I stick
like a burr to the people I already know. Well, that was certainly the
case at the congress. I was one of those WOE women who was
clustered in this little group, admiring my friends who were actually
reaching out and getting to know the prostitutes. . .which is the third
level. You listen to them, but the next level is a two-sided exchange. I
haven't yet gotten to that stage. I have a little barrier that I put up with
prostitutes. I am afraid about how I appear to them. I mean I'm afraid
that they will put me down or automatically assume that I'm going to
judge and think I'm superior to them. I'm not worried about what I
think of them because I know it and I know that I'm open and curious
and would like to get to know them better. But the thought that went
through my head on the two evenings that I spent at the maison (Rue
Blanche) was, Here I come like some lady with my furs, you know I'm
going to do good. . .I was afraid they would think that I was patroniz-
ing and so rather than confront them and maybe get put down, I
preferred to talk to all my friends from WOE. I was sitting at the table
feeling uncomfortable and thinking, Damn it, here's the first chance
I've ever had in my whole life to get to really talk with them and I'm
too scared to go over and start a conversation because I'm afraid
they'll say, "Who are you lady, fuck off" or something.

I don't have any problems, I think, about accepting them for the
work they do. I do have my opinions too about what they're doing, and
why and how and all that. But, my goal would be to make contact with
a group of human beings with whom I've never had contact before. I
consider it a very rich resource for myself. I don't know how much
time I've got left on this earth but I want it to be fruitful and I want to
do things that I've never done before and talk to people that I've never
talked to before and become perhaps more open. I've been feeling a
little bit smug lately about how open I am. I've been working for eight
or ten years now on not making judgments but every once in a while I

catch myself doing it. Still I think I've come a long way. I want to become a completely accepting person and loving and caring and to do something. I don't mean I want to be a do-gooder, not in that sense. I would do it for myself.

Speaker 11: As you know, I'm quite involved with this subject, and I've wondered why that is. When I see movies with whore characters—and of course harlot images come up all the time in films—I often identify with the whore. In fact, if I had to say whether I was more whore or madonna, I would say that my identity is whore and my position is madonna. I've gone a straight safe education route from Monday through Friday during the academic year and then, on weekends and summer holidays, I've been kind of a whore. That balance was really important to me in my life. I came more to myself on the weekends and during the summers. And, a lot of what that meant, a lot of what that involved, was a sexual exploration and also an exploration of the world. I never thought of myself as a prostitute but I know I travelled around Europe on hardly any money because I was sleeping with men—which allowed me to get a place to stay and a free meal and a free trip and access to various worlds. I know that it felt powerful for me to look around and decide who was safe, who was smart, who was interesting, who was going to have a ticket for the best concert, and so on. I certainly went through some years, maybe from age nineteen to twenty-three, when I played with life that way and thought of knowing what makes men tick as knowing them sexually. Things changed a lot for me when I came out as a lesbian. But, when I came out as a lesbian, I really got to know sexual stigma. I hadn't known it in my promiscuous period because I was the white middle-class privileged girl who was exploring sexually, and that was okay. But as a lesbian, it wasn't okay at all.

So I think that my promiscuous past with men and feeling that I often used men and wanted to have more power than them plus my knowing sexual stigma as a lesbian were a big part of my identification with prostitutes. Also, when I met prostitutes, I felt I could reclaim my heterosexual past and I could laugh and make the old jokes. For my first six or seven years as a lesbian, I really didn't enjoy being with heterosexual women. I found it boring to hear the way they talked about men and I went through a rather separatist period. And, for some reason I felt freer as a Jew among prostitutes then I did among non-Jewish non-prostitutes. I felt that it was okay to talk about taking

control of a situation without being afraid of anti-Semitism, and to talk about survival tactics, and to laugh...I could relax and just be myself.

I think I understand very well why prostitutes sometimes censor negative stories in public. When I first came out as a lesbian, I was very aware of all the prejudice and I would never talk about my problems publicly. The more homophobia I sensed, the more I presented my relationships as perfect: the sex was fabulous all the time and the relationships were always equal and every handicap of heterosexuality was gone. Some people assumed that I was idealizing lesbianism. Actually I was defending myself.

With whores, I felt free. There always seemed to be a lot of energy and honesty in their presence. I think at first I experienced them as mentors. I've gone through a lot of changes because, well I don't know if it's exactly changes, but I have really done a lot of thinking. In the beginning I wondered whether prostitution would be a nice supplementary income. In my promiscuous period, never did I take money. Still, it was very clear in my head that there was an exchange going on and, at the same time, it wasn't so that I didn't enjoy the sex. I didn't necessarily enjoy it either, but it was a part of this package of what I was doing and there was usually something in the whole thing that I did enjoy—whether it was the intimacy, the feeling that I was knowing this man, or whether I was getting something in particular, or whether I somehow felt more powerful because I saw his vulnerability. It didn't feel like the men saw my vulnerability or saw me at all really, which was the reason I finally decided that I wasn't very interested in intimate relationships with men.

When I started to talk about my life with prostitutes, very often they would say, "Oh, you should have gotten paid for that." It was a new light on my own life and on my own history. I saw so many paradoxes in my life as a woman. Everything started coming up for me, especially my areas of privilege and my areas of oppression. I was with women from all different classes. There were so many differences together. I've always been drawn to marginality, especially when a lot of different kinds of marginality are wrapped in one world. I'm also just plain curious and I like talking sex and enjoy that freedom with prostitutes.

In the political work, I don't know how to put my finger on it, but I've never been so moved and I've never felt so close to what I love and what I hate. Somehow, I think a part of feeling moved must have to do just with what it's like for people to come through such heavy

isolation, that in itself is very moving and gives me a really satisfying feeling if I can be a part of it, if I can break through my own isolation. But also, I think there's the sadness of the separation that's been there for so long, the separation from women who are prostitutes but also the separations in my own life. There's a correctness in most circles that's. . .that's not very much fun and that's such a shame really, because there's so much laughing in breaking through barriers.

STATEMENT ON PROSTITUTION AND FEMINISM
International Committee for Prostitutes' Rights
European Parliament, Brussels
October 1-3, 1986

The International Committee for Prostitutes' Rights (ICPR) realizes that up until now the women's movement in most countries has not, or has only marginally, included prostitutes as spokeswomen and theorists. Historically, women's movements (like socialist and communist movements) have opposed the institution of prostitution while claiming to support prostitute women. However, prostitutes reject support that requires them to leave prostitution; they object to being treated as symbols of oppression and demand recognition as workers. Due to feminist hesitation or refusal to accept prostitution as legitimate work and to accept prostitutes as working women, the majority of prostitutes have not identified as feminists; nonetheless, many prostitutes identify with feminist values such as independence, financial autonomy, sexual self-determination, personal strength and female bonding.

During the last decade, some feminists have begun to re-evaluate the traditional anti-prostitution stance of their movement in light of the actual experiences, opinions and needs of prostitute women. The ICPR can be considered a feminist organization in that it is committed to giving voice and respect to all women, including the most invisible, isolated, degraded and/or idealized. The development of prostitution analyses and strategies within women's movements which link the condition of prostitutes to the condition of women in general and which do justice to the integrity of prostitute women is therefore an important goal of the committee.

1. *Financial autonomy*

Financial autonomy is basic to female survival, self-determination, self-respect and self-development. Unlike men, women are often scorned and/or pitied for making life choices primarily in the interest of earning money. True financial independence includes the means to earn money (or the position to have authority over money) and the freedom to spend it as one needs or desires. Such means are rarely available to women even with compromise and struggle. Financial dependency or despair is the condi-

tion of a majority of women, depending upon class, culture, race, education and other differences and inequalities. Female compromises and struggles are traditionally considered reflections of immorality and misfortune rather than of responsibility, intelligence and courage. The financial initiative of prostitutes is stigmatized and/or criminalized as a warning to women in general against such sexually explicit strategies for financial independence. Nonetheless, "being sexually attractive" and "catching a good man" are traditional female strategies for survival, strategies which may provide financial sustenance but rarely financial independence. All women, including prostitutes, are entitled to the same commericial rights as other citizens in any given society. *The ICPR affirms the right of women to financial initiative and financial gain, including the right to commercialize sexual service or sexual illusion (such as erotic media) and to save and spend their earnings according to their own needs and priorities.*

2. *Occupational Choice*
The lack of educational and employment opportunities for women throughout the world has been well-documented. Occupational choice for women (especially for women of color and working-class women), and also for men oppressed by class and race prejudice, is usually a choice between different subordinate positions. Once employed, women are often stigmatized and harassed. Furthermore, they are commonly paid according to their gender rather than their worth. Female access to jobs traditionally reserved for men, and adequate pay and respect to women in jobs traditionally reserved for women are necessary conditions of true occupational choice. Those conditions entail an elimination of the sexual division of labor. Prostitution is a traditional female occupation. Some prostitutes report job satisfaction, others job repulsion; some consciously chose prostitution as the best alternative open to them; others got into prostitution through male force or deceit. Many prostitutes abhor the conditions and social stigma attached to their work, but not the work itself. *The ICPR affirms the right of women to the full range of education and employment alternatives and to due respect and compensation in every occupation, including prostitution.*

3. *Alliance Between Women*
Women have been divided into social categories on the basis of their sexual labor and/or sexual identity. Within the sex industry, the prostitute is the most explicitly oppressed by legal and social

controls. Pornography models, strip-tease dancers, sexual mas-
seuses and prostitutes euphemistically called escorts or sexual sur-
rogates often avoid association with prostitution labels and workers
in an effort to elevate their status. Also among self-defined
prostitutes, a hierarchy exists with street workers on the bottom and
call girls on the top. Efforts to distance oneself from explicit sex
work reinforce prejudice against prostitutes and reinforce sexual
shame among women. Outside the sex industry, women are likewise
divided by status, history, identity and appearance. Non-prostitutes
are frequently pressured to deliver sexual services in the form of
sex, smiles, dress or affection; those services are rarely compensa-
ted with pay and may even diminish female status. In general, a
whore-madonna division is imposed upon women wherein those
who are sexually assertive are considered whores and those who are
sexually passive are considered madonnas. *The ICPR calls for al-
liance between all women within and outside the sex industry and
especially affirms the dignity of street prostitutes and of women stig-
matized for their color, class, ethnic difference, history of abuse,
marital or motherhood status, sexual preference, disability or fat.
The ICPR also affirms solidarity with prostitutes who are
homosexual men, transvestites and transsexuals.*

4. *Sexual Self-Determination*
 The right to sexual self-determination includes women's right
to set the terms of their own sexuality, including the choice of part-
ner(s), behaviors and outcomes (such as pregnancy, pleasure or fi-
nancial gain). Sexual self-determination includes the right to refuse
sex and to initiate sex as well as the right to use birth control (in-
cluding abortion), the right to have lesbian sex, the right to have sex
across lines of color or class, the right to engage in sado-masochistic
sex and the right to offer sex for money. Those possibly self-
determining acts have been stigmatized and punished by law or
custom. Necessarily, no one is entitled to act out a sexual desire that
includes another party unless that party agrees under conditions of
total free will. The feminist task is to nurture self-determination
both by increasing women's sexual consciousness and courage and
also by demanding conditions of safety and choice. *The ICPR af-
firms the right of all women to determine their own sexual behavior,
including commercial exchange, without stigmatization or punish-
ment.*

o

5. *Healthy Childhood Development*

Children are dependent upon adults for survival, love and development. Pressures upon children, either with kindness or force, to work for money or to have sex for adult satisfaction, is a violation of rights to childhood development. Often the child who is abused at home runs away but can find no subsistence other than prostitution, which perpetuates the violation of childhood integrity. Some research suggests that a higher percentage of prostitutes were victims of childhood abuse than of non-prostitutes. Research also suggests that about 50% of prostitutes were not abused and that about 25% of non-prostitutes were abused. Child abuse in private and public spheres is a serious violation of human rights but it does not mean that the victims cannot survive and recover, especially given support and resources for development. A victim deserves no stigmatization either in childhood or adulthood. *The ICPR affirms the right of children to shelter, education, medical or psychological or legal services, safety and sexual self-determination. Allocation of government funds to guarantee the above rights should be a priority in every country.*

6. *Integrity of All Women*

Violence against women and girls has been a major feminist preoccupation for the past decade. Specifically, rape, sexual harassment at work, battering and denial of motherhood rights have been targeted as focal areas for concern, research and activism. Within the context of prostitution, women are sometimes raped or sexually harassed by the police, by their clients, by their managers and by strangers who know them to be whores. Prostitute women, like non-prostitute women, consider rape to be any sexual act forced upon them. The fact that prostitutes are available for sexual negotiation does not mean that they are available for sexual harassment or rape. *The ICPR demands that the prostitute be given the same protection from rape and the same legal recourse and social support following rape that should be the right of any woman or man.*

Battering of prostitutes, like battering of non-prostitutes, reflects the subordination of women to men in personal relationships. Laws against such violence are often discriminately and/or arbitrarily enforced. Boyfriends and husbands of prostitutes, in addition to anyone else assumed to profit from prostitution earnings (such as family and roommates), are often fined or imprisoned in various countries on charges of "pimping" regardless of whether they commit a violent offense or not. Boyfriends and husbands of

non-prostitute women are rarely punished for battering, even when the woman clearly presses charges against them. *The ICPR affirms the right of all women to relational choice and to recourse against violence within any personal or work setting.*

Women known to be prostitutes or sex workers, like women known to be lesbians, are regularly denied custody of their children in many countries. The assumption that prostitute women or lesbian women are less responsible, loving or deserving than other women is a denial of human rights and human dignity. The laws and attitudes which punish sexually stigmatized women function to punish their children as well by stigmatizing them and by denying them their mothers. *The ICPR considers the denial of custodial rights to prostitutes and lesbians to be a violation of the social and psychological integrity of women.*

7. *Pornography*: *"Writings of Harlots"*

Sexually explicit material or pornography refers specifically in original Greek to the writing of "harlots" (prostitutes). Today, pornography has been taken over by a male-dominated production industry wherein the female models and actresses rarely determine the content of their products. Moreover, like prostitutes, pornography workers are stigmatized as whores, denied recourse after abuse and are often blamed for abuse committed against them. They are also denied adequate financial compensation for distribution of products in which they appear. *The ICPR claims the right of sex workers (as opposed to managers) to determine the content, production procedure and distribution procedure of the pornography industry.* Such empowerment will require solidarity among sex workers, solidarity between women both within and outside the sex industry and education of women in the production of sexually explicit material. In support of such a feminist self-determining movement, the ICPR calls for public education campaigns to change the demands of a market which eroticizes children and the abuse of women.

8. *Migration of Women through Prostitution/Trafficking*

"Trafficking of women and children," an international issue among both feminists and non-feminists, usually refers to the transport of women and children from one country to another for purposes of prostitution under conditions of force or deceit. The ICPR has a clear stand against child prostitution under any circumstances. In the case of adult prostitution, it must be acknowledged that prostitution both within and across national borders can be an indi-

vidual decision to which an adult woman has a right. Certainly, force or deceit are crimes which should be punished whether in the context of prostitution or not. Women who choose to migrate as prostitutes should not be punished or assumed to be victims of abuse. They should enjoy the same rights as other immigrants. For many women, female migration through prostitution is an escape from an economically and socially impossible situation in one country to hopes for a better situation in another. The fact that many women find themselves in another awful situation reflects the lack of opportunities for financial independence and employment satisfaction for women, especially for "Third World" women, throughout the world. Given the increased internationalization of industry, including prostitution, the rights and specific needs of foreign women workers must be given special attention in all countries.

The ICPR objects to policies which give women the status of children and which assume migration through prostitution among women to be always the result of force or deceit. Migrant women, also those who work as prostitutes, deserve both worker rights and worker protections. Women who are transported under conditions of deceit or force should be granted compensation and choice of refugee status or return to their country of origin.

9. *A Movement for All Women's Rights*

It is essential that feminist struggle include the rights of all women. Prostitutes (especially those also oppressed by racism and classism) are perhaps the most silenced and violated of all women; the inclusion of their rights and their own words in feminist platforms for change is necessary. *The ICPR urges existing feminist groups to invite whore-identified women into their leading ranks and to integrate a prostitution consciousness in their analyses and strategies.*

Gamma

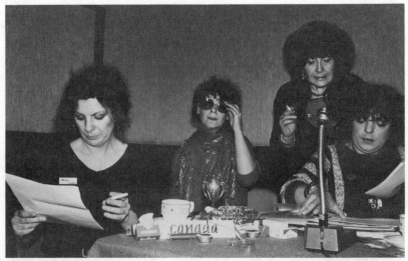

Janet Wishnetsky

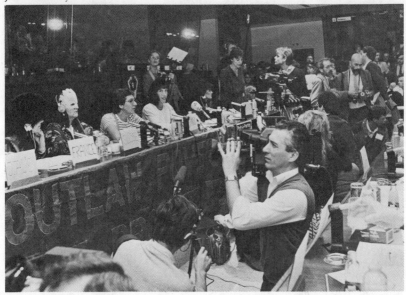

Top: First World Whores' Congress, Amsterdam, February 1985. From left to right: Peggy Miller (Canada), Celina (England), above, Grisélidis Réal (Switzerland), Katya (France)

Above: Second World Whores' Congress. European Parliament press conference, Brussels, October 1986. Banner in front of table reads: "Outlaw Poverty, Not Prostitutes"

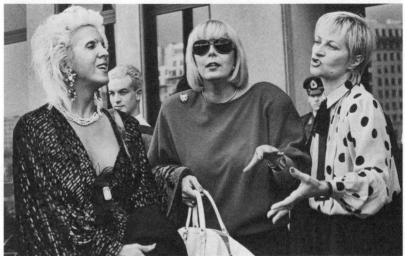

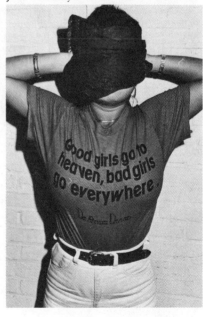

Top: Italian delegates in front of European Parliament, from left to right: Dolly, Carla Corso, Pia Covre

Above: Prostitute advocates at Second World Whores' Congress, from left to right: Jean D'Cunha (India), Tatiana Cordero (Ecuador), above Marjolijn Keesmaat (Netherlands), Maria Isabel Casas (Columbia)

Right: Sai (Thailand)

Janet Wishnetsky

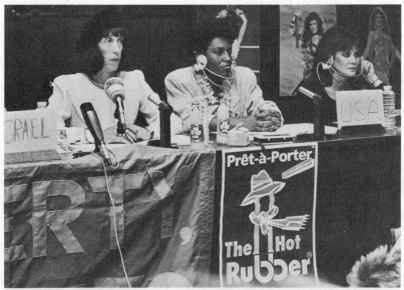

Janet Wishnetsky

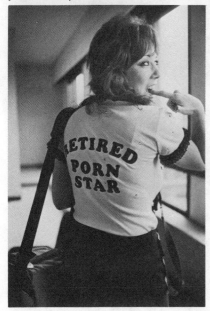

Janet Wishnetsky

Top: Press conference from left to right: Margo St. James (President, ICPR), USA delegates Gloria Lockett and Norma Jean Almodovar

Above: Lin Lap (Foundation Against Traffic in Women)

Left: Annie Sprinkle (USA)

Above: Conference Room at the European Parliament, Brussels, Second World Whores' Congress

Right: Constance (France)

Annie Sprinkle

Annie Sprinkle

Janet Wishnetsky

Top: English delegates at Second World Whores' Congress, from left to right: Eva Rosta, Gill Gem, Helen Buckingham

Above: Australian delegates at Second World Whores' Congress, from left to right: Julie Bates and Roberta Perkins

Right: Danny Cockerline (Canada) and Geoffrey Fishe (Australia)

Janet Wishnetsky

Annie Sprinkle

Annie Sprinkle

Top: Cabaret, Second World Whores'
Congress: The Feminist and the
Prostitute, Natascha Emanuels and
Betty Paerl

Above: Austrian delegates at the
Second World Whores' Congress,
from left to right: Brigitte Pavkovic
and Frau EVA

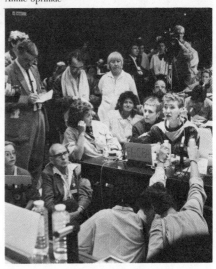

Right: Dutch delegates presenting at
press conference: Speaking is Terry
van der Zijden, to the right, Violet,
Ans van der Drift, and at end of table
Margot Alvarez.

PART THREE

MIGRATION AND PROSTITUTION

MIGRATION AND PROSTITUTION

Since the Second World Whores' Congress, the topic of migration has become more and more central to discussions within the International Committee for Prostitutes' Rights. We have begun to recognize first of all that a majority of prostitutes in many cities around the world are migrants. We have also begun to recognize the inadequacy of a politics that views native prostitutes as self-determining agents and views migrant prostitutes as helpless victims of abuse. Migrants are often unrepresented in prostitutes' rights organizations, even when they form a majority of that country's sex workers. And advocates for migrants in prostitution often focus exclusively on the abuse of women and the punishment due their exploiters rather than on migrant self-determination.

Although migrants are themselves excluded from political debate, they are a major subject of national and international politics. Many governments rely upon the revenue migrant prostitutes bring to their sex (tourist) industry. Numerous social services are organized to rescue migrant women from violence and degradation in prostitution. And some radical theorists, especially leftists and feminists, use migrant prostitutes as symbols of capitalistic and patriarchal domination. Such economic interests, social services and political ideologies do not rest upon illusions: Migrant sex work is financially profitable (mostly to third parties); migrant prostitutes are often exploited and abused; and the lack of alternatives to sex work for women, especially in developing countries, is certainly tied to male imperialism.

Migrant prostitutes are usually even more isolated than their native co-workers, due to language barriers, illegality, racist discrimination and/or ghettoized work situations. The political context of their lives is complex. Their degree of autonomy or coercion, their perceptions of prostitution, and their personal and cultural histories vary widely, as do their reasons for migration. Prostitution may be a horror or an adventure; it may be periodic or part-time work or it may be a lifelong occupation. For some, prostitution is an escape hatch; for

others it is a trap. Most often, migration from rural to urban areas or between urban areas or from one country to another is a decision motivated by a need for money, a resistance to abuse and/or a quest for autonomy. There is no question about the existence of international networks of "traffickers" who trick women with promises of false marriages or desirable jobs in foreign countries and then force them into prostitution. There is also no question about women's (and sometimes homosexuals', transvestites' and transsexuals') conscious migration through sex work as either a desperate or chosen flight from unbearable or undesirable home situations. And it is well-known that parents especially in poor world regions sometime see no survival alternative to selling their children into urban prostitution.

Migration by decision or by force is often related to poverty, violation, tedium and/or social restraint in all world regions. And sex work is often the only means of survival. Policies which automatically remove adult migrants from prostitution or automatically send them back home generally serve the state and the consumer more than the migrant. Laws which forbid particularly women the right to migrate and laws which forbid women the right to engage in commercial sex often force women to take their chances with criminal, exploitative and abusive trafficking agents. Human rights must include the right to migrate (also as legal immigrants or refugees), the right to work (also as prostitutes), the protection of children against sexual exploitation, and the right of all people to be protected against coercion, deceit and violence (in or out of prostitution).

The articles in this section are based on interviews with prostitutes whose voices are not heard elsewhere in this anthology. The first article elaborates the continuum of sexual-economic work in the lives of African women, especially from Niger in West Africa, and the relation of that work to escape, migration and autonomy. The next two articles describe the situation for diverse groups of migrants in two West European countries, the Netherlands and Italy. The final piece is an interview with an Argentinean transvestite who migrated through prostitution from Argentina to France. In addition to those articles, migration is a theme running throughout the book. In the transcripts of the Second Congress, the presentation on Thailand divides prostitution into three types: forced, migrant and free. The trafficking presentation specifically addresses forced migration as do various country reports. Presentations on childhood prostitution address motivations for leaving home and entering prostitution as teenagers,

such as Alex who ran away from home in England when she was pregnant, or Dolly who left home in Switzerland to flee family disapproval of his transvestism, or Sai who left her village in Thailand because her parents did not have enough money to support her. A number of presenters refer to police harassment of migrants, such as the Italians who speak of the police order which forces non-local prostitutes to return home; others, such as the U.S. presenters, tell how police harassment forces prostitutes to migrate "from state to state." One clause of the position paper on prostitution and feminism is about migration (see pages 196–7). In Part IV, "New Voices," Susanna emphasizes the oppression of migrant prostitutes in Spain and Gabriela Silva Leite emphasizes the need to give more attention to migration issues in Brazil.

Migrant rights, prostitute rights and migrant prostitute rights are crucial to liberation struggles everywhere. Those rights call for a politics in which neither "home" nor "purity" are idealized and imposed.

G.P.

I'M THE MEAT, I'M THE KNIFE
Sexual Service, Migration, and Repression
In Some African Societies*
Paola Tabet

1915, Nigeria: British colonial officiers pass the following measures to deal with the "free women"[1] or *karuwai* in the city of Katsina: "Prostitutes to be driven away. Natives of town to be given seven days to marry..." (Pittin, 1979: 284).

1948, Kenya: Large numbers of Nandi women had migrated as prostitutes into the big towns of Kenya during the 1930s and 40s: "Many prostitutes returned to Nandi with their earnings, bought land and cattle, and resettled in Nandi as independent house-holders...The apparent attractiveness of this potentially economically profitable option led to concern among Nandi men over loss of control over women. In 1948, the Local Native Council passed the so-called *Lost Women Ordinance*, which stipulated:

(1)No Nandi woman or girl over the age of twelve years shall travel from the Nandi District to any place outside the Nandi District without the written permission of the Chief.

(2)No African driver of any vehicle shall convey in any such vehicle any woman or girl from the Nandi District to any place outside the Nandi District unless such woman or girl is in possession of a valid permit to travel issued by her Chief. The ordinance was of limited effectiveness! (Oboler, 1985: 173-4).

1960s, Kenya: The Luo Welfare Association of Mombasa "uses force to capture, secure and transport a woman back to her home (village) if

* My material is drawn from data on women in African cities, both from my interviews with migrant single women in Niamey, Niger, and from other researchers' work. The themes here presented receive a fuller elaboration not limited to African data in my UNESCO report (Tabet, 1988; see also Tabet, 1987). This text owes much to discussions with Gail Pheterson. Since our meeting in Madrid, she has been an intellectual partner and a stimulus for a more political vision. Before going to Niger, I had long conversations with Carla Corso and Pia Covre (leaders of the Italian Committee for the Civil Rights of Prostitutes) who helped me formulate some of my research questions. To these friends and to the "free women" of Niamey who spoke with me about many difficult or even painful aspects of their lives, I wish to dedicate this paper.

she steps out of line. There are no Luo prostitutes in Mombasa." (Wilson, 1961: 111).

1970s, 1980s, Zimbabwe, Gabon, Zambia, Tanzania, Mozambique, Burkina Faso, etc.: Police raids to "clean up" cities are reported. Women unable to prove that they are married are rounded up as prostitutes and subjected to various forms of abuse.

These are only a few examples of the repression that African women face when they pursue independent existence outside of marriage. Who are these women, why do they leave their villages and settle in the cities?

"When a woman has left her village alone, it means she has had to do it," says a prostitute of Foulankoira (Niamey, Niger) "and that she has the desire to try other experiences that she hopes will be happier."[2] Some common stories:

> Mariama (Hausa woman/Niger) is about thirteen years old when she is forced to marry by her family. Her husband beats her and rapes her. This goes on for some time. "Marriage, you have to do it to know what it is." She finally runs away to a nearby city.
>
> Rachida (Beri-Beri woman/Niger) leaves her marriage because of quarrels with her co-wives, goes to a city.
>
> Fatoumata (Peul woman/Nigeria) is deserted by her husband after twenty years of marriage. Life with her in-laws becomes unbearable and one day she secretly escapes, taking only a kerchief and the money for bus fare to Niamey.[3]

Many women leave their villages because they are widowed, divorced or repudiated and have to find some way to survive. Others go away because their husband doesn't provide for them. They migrate to escape an intolerable marriage, to avoid being beaten by a husband or being forced into another marriage, to get out of the control of their families, and/or to get economic autonomy. Some have to move far away, and might then gradually reestablish ties with their families. And cities are the places where most opportunities are available. "'Town air makes free,'" is an old saying very relevant to the motives of many women migrating into African towns" (Bujra, 1975: 220).

SEX IS ALL WOMEN'S WORK

There are not many jobs accessible to women and few are well-paid. In the cities, women earn a living by waitressing, beer brewing, petty trade and other small businesses. A few, among those who have some education, get into white-collar jobs. In addition, all women can supplement their income or make a living entirely by engaging in different kinds of sexual-economic exchange. This exchange lies along a continuum from marriage to occasional or longer lasting relations with friends, "paying fiances," "subscription lovers," and regular clients. As the Hausa people of Niger put it: "Women's only livelihood is their sex" (Echard et. al., 1981: 345). And sex is "women's work" in the village as well as in the city. In the villages, giving sexual service is integrated with the other services women give in marriage: domestic labor, reproduction, and all the tasks allotted to women by the sexual division of labor (water-carrying, wood-collecting, grain-pounding, farming, etc.). In the cities, sexual service can be in the context of marriage or it can be in a variety of other relations, sometimes including domestic labor and sometimes not. There is a continuum of forms of sexual service, not a dichotomy between marriage and the other relations implying sexual-economic exchange. In any case, the woman is giving sexual service and the man is paying, be it in money, food, rent, clothes, jobs, or access to various resources (farming land for example) and so on. How much the man cares is assumed to be shown in the amount he gives. For instance, among the Ashanti of Ghana:

> The transfer of food or money from man to woman occupies a central place in marriage and lover relationships in Ashanti. "Chop money," the Ghanaian-English phrase for "money for food," is the subject of much marital strife... Sisters living together and in a position to observe the contents of each other's cooking pot are easily aware of how well each is supported by her husband or lover... "Chop money" is both a practical economic arrangement and a symbol of love. A man's interest in a woman is indicated by how much effort he makes to supply her with her needs (Abu, 1983: 160-161).

The economic transaction is central to the relation between the sexes and to the sexual relation itself. Money or gifts are not only a sign of men's power but also a way to measure eroticism. One small example: In Niger there are different kinds of aphrodisiacs in powder or cream that women use to make the vagina tighter and stimulate pleasure,

mainly men's pleasure. The "free women" (the *wey kuru*, to use the Zarma term), the divorced or widowed women who live independently and give sexual service to men and who like to be well-kept, use the aphrodisiacs (and so do wives sometimes). The most powerful aphrodisiac is very expensive. It is a cream called "car, villa, or trip to Mecca." A tiny jar of it costs a third of a white collar worker's monthly salary, a dip of it (one-night dose) would cost the equivalent of a day's pay. Women tell me its effects: "Once a man mounts, he v.on't be able to stop and he'll say, 'that's good, that's good', and he'll cry out, 'WHAT DO YOU WANT? A CAR, A VILLA, OR A TRIP TO MECCA?'"[4]

* * *

One aspect along the continuum of sexual service concerns time length; there is a whole range of sexual-economic relations between the two extremes of lifelong marriage and few minutes intercourse in prostitution. The women of Mathare (a poor area of Nairobi, Kenya), for instance, who make their living by brewing beer also "have a variety of sexual relationships with men that vary in duration and in the directness with which payment changes hands. They (the relationships) form a continuum from something called 'Quick Service' (a twenty-minute stint) to a form of 'Town Marriage' that could last for years" (Nelson, 1987: 225).

Let's take another example: the institutionalized relation called "temporary marriage." Both in Africa (in Ethiopia for example) or outside of Africa (as in Iran) a man can contract a "temporary marriage" with a woman to whom he pays a salary for her conjugal services. It can last a day, a month, a year, etc., and the contract can be renewed with new payment. Children born of this union are supposed to have some formal rights as heirs; temporary marriage, as opposed to prostitution, is thus a completely legal relation. On the other hand, like prostitution, it is a commercial contract with explicit negotiation and, above all, explicit payment for the services to the woman herself. Another well-known situation that can vary widely in duration (and explicitness of negotiation) is that of the mistress or "kept woman."

A second aspect of the continuum regards the woman in sexual economic relations. In the course of their lives, women frequently alternate periods of marriage with periods of sexual service to more or less steady clients or boyfriends who pay with gifts or a fee. Many women I interviewed in Niger of different ethnic groups (Hausa, Peul, Zarma, Tuareg) had careers in and out of marriage and in and out of

explicit sexual service. This pattern is particularly clear for the Hausa women both in Niger and Nigeria who are called *karuwai*. A *karuwa* is "a woman who is living with neither her husband, nor her parents or other kin, and who is dependent, totally or in part, upon gifts from one or more men, for whom she provides sexual services" (Pittin, 1983: 292).

As to the life patterns of a *karuwa*:

> All the women [of the over 500 *karuwai* the researcher inter-viewed in Katsina, Nigeria] had been married at least once before beginning *karuwanci* (occupation of *karuwai*), and doubtless most would marry again; an important feature of *karuwanci* is its optional nature. Not only do *karuwai* remarry but also they may well marry men who are wealthier, and of higher social status, than the men they left behind in the village (Ibid, 294).
>
> *Karuwanci*, especially in combination with some commercial ac-tivity on the side can also lead to complete economic indepen-dence from men (Pittin, 1979).

The life of Amina is one story like many others: "I left M. [a town in the north] not because of hunger but because of marriage." Her first marriage was a forced marriage. She was only thirteen. She ran away from her husband's house several times. Her husband forced sex on her. "I even had a baby in his house. Even then I tried to es-cape . . . The child was a year and seven months old when I abandoned him at his father's home." And then, "they [the family] again wanted to marry me, to another man. So that's why I left." She went to the city and became a *karuwa*. She married a second time and had four chil-dren. Her husband died and she became a *karuwa* again for five years. She married a third time and had three children. Upon divorce she decided to get out of sexual service entirely. "I'm not a wife, I'm not a whore." She became a trader, went to Mecca, leads a "wise life," "no more dirt on my body."

This moving between marriage and other sexual relations like *karuwanci* is not true for only a few isolated women. Women I inter-viewed in Niamey were quite clear about the fact that selling sexual service was a common situation for divorcees and widows; it is ex-pected that *wey kuru* live or at least get a lot of help from men's "gifts." The Zarma word *wey kuru* itself means both "divorcee" and "prostitute":

The divorced woman is called *wey kuru*, a term which by extension has come to designate the prostitute. This is quite understandable as only the repudiated or widowed woman can at any moment receive a man's visit. *Be she a widow or a divorcee, she is a virtual prostitute even if she is not an actual one.* (Diarra, 1971: 57, emphasis added).

Giving sexual service in exchange for a compensation does not distinguish a "free woman" from a wife; as noted for the Hausa women in Nigeria, "any woman expects to benefit economically from her man be he husband, suitor, or lover...Women do not bestow their bodies, their time, and their lives gratis; they expect some recompense" (Pittin, 1979: 354). Women of different ethnic groups I talked with in Niamey, and not only the poorer women but also white collar workers, told me they would not waste their time with a man who gave them nothing. One of the "free women" I interviewed, a forty-year-old employee, said, "What would I be doing with a man who doesn't give me anything? You can always find a guy to sleep with. But I won't lose my time with him if he doesn't bring me anything, if he doesn't help me."

And Hadiza (twenty-four years old, high school education; married once and deserted, two children, works in bars):

Love and money, they go together for me. Even if I like a man and I desire to be with him the first time, if the second or third time he doesn't give me anything, it's over. I want the money. My boyfriend understands that now. When he sees me he offers me his wallet. He says, "You, it's always money you want." That's it. If he doesn't give me money who is going to feed me, who is going to pay for the things I need? [What if you marry and your husband doesn't have money?] If he doesn't have money, he can let me go, divorce. I'll go to bed with someone who will give me money.

The same attitude is among young white-collar workers who immigrated to Accra from several small towns of Ghana (Dinan, 1983). In this case it is not women between marriages or after marriages entering sexual relations to support themselves but women who, despite the high pressure to marry coming from the families and the media, had chosen to remain single. They integrate their salaries with all sorts of allowances from boyfriends, patrons and "sugar daddies" in exchange for their sexual services. This pattern of educated and semi-skilled women postponing or evading marriages and promoting their career

and financial interests with sexual relations is common in many African cities and is the object of frequent attacks from the press. For example, in Ghana they are branded as "selfish, worldly, irresponsible, sexually promiscuous, and grasping" (Ibid: 362).

A "free woman" can become a wife and a wife can become a "free woman." Because of this frequent change in situation and because of the admitted commonalities of sexual-economic exchange, "free women" and wives are not isolated from each other. This lack of separation between women involved in different forms of sexual service is clear in everyday life. During my interviews in Niamey women who had led regular married lives were often sitting and chatting with their friends who were quite explicitly prostitutes. It would not be correct, however, to think that no stigma is attached to explicit sex work. It is, and the more explicit the negotiation of money for service, the more stigma there is. It is also due to stigma that women try to go back to marriage, stigma on themselves and, in many ethnic groups, stigma on their children born out of marriage. Marriage is considered the ideal relation, that which is socially validated. Great pressure, often very great pressure, is put on women to make them marry and stay married.

The continuum of sexual exchange is present also in the kinds of services given. The variety of relations and the services they involve is so great that researchers have difficulty defining them. They speak of quasi-uxorial relations, not completely commercialized relations and so on; these relations don't fit the image of prostitution as sex work with fixed fee, a fixed time and explicitly negotiated services.

Take prostitution in Nairobi in the 1920s and 30s. One form of prostitution was that of the *malaya*. *Malaya* is the common Swahili term for prostitute. But in the early days of Nairobi the term *malaya* defined one particular way of selling sexual service, as opposed both to street walking, i.e. *watembezi* prostitution, and to the explicit soliciting and setting of prices for sexual service separate from domestic service of the *wazi wazi* prostitutes. The *malaya* worked in their houses where they waited for their clients:

> In addition to sexual intercourse, prostitutes sold individual domestic tasks, or sets of tasks... For a portion of a man's wage, prostitutes routinely provided bed space...cleaning, cooking, bathwater, companionship, hot meals, cold meals, and tea, and adhered to an ideology of sexual relations in which women were unfailingly deferential and polite (White, 1986: 256).

In other words, *"malaya* prostitution mimicked marriage"* (Ibid, 258). Also today, the *malaya* of Mathare (Nairobi) define the sexual services they give as a "wife's work" and their short-term relations as a kind of "mini-marriage." But they see the domestic services men frequently request as something to be avoided if possible. As one *malaya* said:

> I love "it" (sex) with a man I am attracted to, but I never let a man stay in my room until daylight. If they stay, they start wanting tea, and then food, and then before you know it, you are washing his clothes. I don't have time (Nelson, 1977: 154).

One definition of a *malaya* is: "a wife that doesn't clean for her husband" (Ibid: 173). However, many explicit sexual economic relations of the *malaya* of Nairobi other than "Quick Service" continue to involve some domestic service (Nelson, 1987: 225).

The *malaya* stress the differences between marriage and their present forms of sexual service (in the control of one's sexuality for example). A husband is considered "a barrier to one's freedom." But despite the *malaya*'s degree of autonomy, their lives are not without danger. Police raids and client violence are threats against which they try to protect themselves by helping one another. Their solidarity is especially striking toward women arriving from the villages; newcomers are helped with lodging, utensils for beer brewing and the teaching of skills (Nelson, 1978).

Social stigma on the *malaya* is quite strong:

> Because of their economic independence, their free sexual mores, and their rejection of the normative role for Kikuyu women (ethnic group of most Mathare *malaya*), Mathare women are stigmatized by others as bad women: parasites leading men astray with drink and sex. . . Indeed, Mathare is known as the "place of *malaya*" (Ibid: 89).

But to the women leaving their villages where life was impossible for them, widowed or deserted women or women escaping oppression and violence in marriage, Mathare is seen differently. These women go to Mathare "because they have heard that Mathare is 'a place of women'" (Ibid: 90).

❋ ❋ ❋

What are the differences between the various forms of sexual-economic exchange and particularly between marriage and relations outside of marriage? What differences are crucial to women?

In marriage the husband acquires: (1)the right to direct physical usage of the person of the wife, i.e. sexual and reproductive usage (2)the right to (sometimes almost unlimited) usage of her labor.[5] And in many societies the man can enforce these rights with rape, beatings, and so on. The set of exclusive rights men acquire over their wives makes marriage a relation of "private appropriation" (Guillaumin 1978) near to serfdom. But there is another basic point: Marriage is an exchange of women between groups of men. This exchange, or "traffic in women," as it has been defined (Rubin, 1975), implies that women are not partners in the transaction, but are themselves the objects of the exchange which can involve payments (brideprice or bridewealth as they are called) from the man and/or his kin group to the woman's kin. And the meaning of these payments is becoming clearer to women who now start refusing them. In Zimbabwe (according to Gaidzanwa) women who have begun to contest bridewealth point out that:

> if you have bridewealth paid for you, you are mortgaging your rights to your children and to yourself. . . In reaction, women who refuse to have bridewealth paid for them are considered "bad" women and accused of being prostitutes (Barry, 1984: 35).

Marriage is obviously not the only case in which women are exchanged by men. There are many historical and ethnographic examples of "trafficking in women":

> Women are given in marriage, taken in battle, exchanged for favors, sent as a tribute, bought, and sold. Far from being confined to the 'primitive' world, these practices seem only to become more pronounced and commercialized in the more 'civilized' societies. Men are of course also trafficked—but as slaves, hustlers, athletic stars, serfs, or as some other catastrophic social status rather than as men. Women are transacted as slaves, serfs, prostitutes, but also simply as women (Rubin, 1975: 175-76).

Marriage is the transaction in which women are trafficked "simply as women." Women who resist this trafficking are most often forced to migrate. Unlike the movement of women by men from one kinship group to another, this form of migration is an attempt to escape both subordination to a husband and kin control, that is the integrated "private" system of male domination. Women going to the cities leave relations where they are objects of exchange, where the length of the relation is indeterminate and the man acquires *global rights* over their

body and their work; instead, they get into sexual-economic relations in which they are *partners* of the transaction and where *specific services* are negotiated. These differences between marriage and the other relations are so important that in many populations (like the Digo of Kenya to whom this quote refers):

> an increasing number of young and middle age women leave their husband for a life outside any permanent or semi-permanent cohabitation, in which state they exchange sexuality for cash and kind with a great deal of individual freedom (Gomm, 1972: 96).

They are so vital to the women that they sometimes buy their freedom by repaying the brideprice which ties them to marriage with the money earned as prostitutes (Ardener, 1961; Wilson, 1977).

Let's look at some individual experiences: "Free women" in Niamey and the *malaya* of Mathare compare their life in marriage with their life outside of it. They contrast the rights the husband had had on them with the control they now have over themselves. For *malaya* women this control over their bodies means also freedom to choose their sexual relations and the moment they want them. The same point was made by "free women" in Niamey: "Marriage is contracted before God...the woman must be subservient. (In *karuwanci*) I can choose the man I want...when you don't want to accept, you say 'no, go on your way.'"

Freedom from wife beating is another point made by both *malaya* and "free women." It is important to note that *malaya* of Nairobi, like the "free women" of Niamey and like many prostitutes throughout Africa, work independently and not under the control of men.

Many of the "free women" (both young and old) had started their marital careers with a forced marriage when they were very young, twelve to fifteen years old, sometimes even younger. In the city, especially when girls are going to school, marriage tends to be a little later; in the village marriage is most often around puberty. Of these first marriages, most are decided by parents and the young girls have no say.

> It should be noted that Niger has adhered on December 1, 1961 to the United Nations Convention on the consent to marriage, the minimum age for marriage, and the registration of marriages, a convention which unfortunately in reality is not applied (Fourth Session of Congress of the Women's Association of Niger, 27-8/1er-9/84).

Custom and also Muslim law give the father the right to marry off his daughter as suits him. And there are traditionally established ways of breaking the girl's resistance and making her "accept" her husband. For example, among the Zarma, her father or uncle take her to a field where she is forced to pound an enormous quantity of grain until she collapses from fatigue and agrees to consummate the marriage (Diarra, 1971, see also Echard, 1985 for the Hausa).

Cultural norms (as to how one speaks about marriage) and shame often made it difficult for the women I interviewed to talk about what forced marriage really means. When I asked why they had divorced, they first told me things like: "A marriage, you know, there are problems. . . ." "Well, it was a marriage my parents decided, I didn't like him." Only after I got to know some women better, and I kept asking, did they tell that forced marriage is something that marks you forever, that it can be constant torture and rape:

> I cried and cried; he took a knife and said, if I didn't accept he would cut my throat (Beri-Beri woman). From the morning you don't even want the sun to go down because you know what will happen after. . . Every day I had fear, I felt sick, I tried to escape. Every day I escaped to my parents and every day I am beaten and taken back. . . You are there, you see him pass, you feel contempt—you can't stand the sight of him—and hate, yes hate. And then if you refuse him again, he will beat you and beat you and beat you (Zarma woman).

Girls run away, sometimes across kilometers and kilometers of savannah. Some hurt themselves badly: several older women showed me deep permanent scars from wounds they had gotten falling and stumbling during their flight. Also suicide is not uncommon in these cases, I've been told. All know that "a village marriage made by parents, that's not easy to break."

Marriage, even when it does not have the violence of forced marriage, gives the husband rights to women's work. This includes the heavy tasks of water carrying, wood fetching, grain pounding and the rest of domestic work such as cooking, washing, childcare, etc.. In many African societies, also the bulk of agricultural work is done by women. As a result, the women in the villages are usually overworked. And frequent wife-beating to enforce obedience and service is so common that women get to consider it normal, almost unavoidable,

male behavior. As Fati, a Hausa *karuwa* who had been beaten by sev-
eral husbands, puts it, "Can you keep a man from beating? You
can't. . .men beat." Women going to the cities, making a living
through sexual service, react to this violence of men and to the rights
men have over them. They react to forced intercourse. They react to
too much work.

> Find a husband in my village? No, I don't want to go pound,
> uuh. . .I'll pound, I'll draw water, I'll cook, all the work, ha, ha,
> ha. . .no, no, no, no. I'll run away from the village. . .Down at the
> village there's too much work. Here I have peace.

Migration patterns may differ. Some of the women I interviewed
had first moved to towns in their area, lived there as "free women,"
and eventually made their way to Niamey; others had gone directly to
the bigger city, whether from some other region of Niger or from
other West African countries. Life as a "free woman" is in fact almost
by definition linked to migration, or at least some form of leaving
home. For *karuwanci*, for instance, "the spatial criterion is crucial in
that a woman away from her husband and relatives is no longer con-
trolled by them" (Pittin, 1983: 292). Statistics confirm this pattern.

Let's take the example of Niamey in Niger and of Katsina in
Nigeria. For Niamey some statistics are available for "declared
prostitutes," both professional prostitutes and part-time prostitutes
working as waitresses or bar hostesses in restaurants, cafes, etc.[6] In
1975, about one-fourth of the professional prostitutes and three-
fourths of the part-time prostitutes came from other African countries
(such as Nigeria, Togo, Benin, Ghana). Of the Niger prostitutes only a
small minority were born in Niamey (Sidikou 1980: 194 ss). For the
prostitutes of Katsina (Pittin, 1979:234-242), considering the women
in *karuwanci* less than eight percent were born or raised in the city of
Katsina. Many of the prostitutes were from the province of Katsina
and about a third to a fourth were from other regions of Nigeria. In
the case of Katsina it appears clearly that the woman who will enter
karuwanci goes "far enough from her home that neither will she be
found and abducted by her kinsmen, nor will she be subject to the
wrath and castigation" she would face if caught at the first moment of
her flight. (But at the same time, the Katsina data show that these
karuwai do not move to very distant places and tend to reestablish
communication with their families after the initial period).

The fact that so many women choose to migrate to the city does not mean that city life and prostitution are easy for them: "Sometimes you don't sleep at night because of all the problems," says Kadidjatou, a Hausa woman about thirty-three years old. While I was interviewing her, people kept coming in to ask her to pay some debt or other or to take back something she had bought on credit and hadn't been able to pay. Clients were few and she often had to accept them at the price they could give.

"If you say one thousand (francs CFA) and he says I don't have it, I have only 500, you say let's go. You take it because you cannot pass the night with nothing. You have to take it... Sometimes, one or two days you find no work"[7].

Kadidjatou tells me about her first marriage. She was eleven years old, she wasn't menstruating yet. It was a forced marriage:

> I refused to have sex, and that is why he used to beat me. I escaped all the time in the bush. I tried to hide. I refused the marriage. I suffered a lot in this marriage. It was because I was not used to having sex. All the time I run away and all the time my parents take me back. I escape, they take me back, I escape, they take me back. Then I ran away and went to stay with an old woman in F. [a town] in a compound of *karuwai*. She is a sort of *magazia* [leader] of *karuwai*. I live there and go on errands for them. They send me to buy food, beer... When my parents find out that I am there, they come and take me back. One night I jumped over the wall and escaped so they saw I just wouldn't stay and they broke the marriage.

She goes to live in Niamey at an older *karuwa*'s house. The men come, give her "presents": "I take the money, I go off to the bars. I ate up the money but I didn't give, I refused to give them my ass. So the men when they come again the next day, they slap me, they beat me: 'Why did you go off, you took the money...'" Kadidjatou is called into the house by the older *karuwa* and one of the men. "He managed to have sex with me. I screamed and screamed; at the end I gave in. That's how I got used to *karuwanci*." The older *karuwa* said, "'Look, so and so, those are not 'presents' they give you. You have to have them taste it from time to time.' Little by little I accepted. That's how I got used to work as a *karuwa*." She lives for a certain time at the older *karuwa*'s house, gives her most of her earnings, and gets room, food, and clothes.

She marries a second time and goes back to the village: "The second [husband] also beats me up. I work a lot. So I thought I'd leave and I came again to Niamey." After a new period of *karuwanci*, she marries a guy she loves. This husband deserts her. He disappears and she goes back to Niamey.

At this point, Kadidjatou feels she is autonomous: "I have my own house now. I'm independent. I'm not under anybody's orders. What I earn is for me." She has two children, and an old mother who she brought from the village. Her children and her mother depend totally on her: "Even the soap I have to buy; food, it's me; their rent [they live separately from her], it's me; clothes, it's me. *I'm the meat, I'm the knife.*"

Kadidjatou's story is a grim one. It poses first of all one problem: What can be termed choice? Kadidjatou is raped into marriage and she is raped into prostitution. She then goes back and forth between these two poles, seeking the most livable or escaping the totally intolerable situation. What appears here from Kadidjatou's voice and the voices of other women is the lack of any real alternative. Here and elsewhere, women depend on men both as individuals and as a group for their access to means of survival. This is the basic point. Women's access to resources, especially where the great majority of women have no paid jobs, is largely dependent on some form of sexual service. Still, for some women giving sexual service outside of marriage can lead to an autonomy both on an economic and on a personal level that they can rarely reach otherwise. In any case, they escape the burden of (unpaid) domestic work and of the agricultural work they were forced to do in the marriage context.

* * *

There are great differences in how independent women use the money they get from men and in their economic success and in the autonomy they can achieve. We must keep in mind that I am not speaking only of the most explicit form of sexual service (street or bar full-time prostitution) but of the whole range of sexual-economic exchange out of marriage including part-time sexual service to supplement a salary.

On the economic level, relations of sexual service can go from those barely permitting subsistence, like that of Kadidjatou, to the better situation of prostitutes working with foreigners, to that of well

to-do courtesans. Obviously the less urgent the economic need, the more choice the woman has as to the clients and working conditions she accepts and also as to what she can do with the money.

One use even women in the poorest kinds of prostitution make of money as soon as they can afford it is the stocking of furniture and other items (like cloth and sets of pans) both as savings and as generous gifts for their family on various occasions like marriages. This helps to keep their ties with their home community and can be important if they want to go back home. Showing how well one fares helps to get acceptance from the family.

Setting up a business is an ideal for many women and sometimes they manage to realize it. In Yaounde, Cameroon, for example, bars, restaurants, nightclubs, beauty parlors, and European ready-to-wear boutiques are largely set up by prostitutes and former prostitutes. Out of seventeen cafes in Yaounde, seven belong to prostitutes or ex-prostitutes and four of these are also restaurants. Of the twenty-five ready-to-wear boutiques, twelve belong to prostitutes or ex-prostitutes. And, prostitutes own the majority of beauty parlors (Songue 1986: 119-126).

Another very important way women use their money is buying houses, or buying plots of land and building houses in the cities and sometimes in the villages. In Nairobi (similar situations are known also for other cities like Kampala):

> Through prostitution and beer brewing (women) accumulated savings which they invested in building or buying houses, and occasionally in petty trade. Their ability to accumulate savings in this way equalled or surpassed that of men in the earliest phase of Nairobi's history, and until today women own half the houses in Nairobi's oldest existing "African location," Pumwani (Bujra 1975: 213).

House building is better security for a woman's future than a marriage:

> No wonder that one old woman, an ex-prostitute, when asked if she had ever been married, replied crossly, "Why do you insult me? My house is my husband" (Ibid: 224).

In Niamey, several women I interviewed had bought lots and were building houses for themselves. Some have bigger projects and get to build one house after another and rent them. Rich men's "help"

is instrumental in this operation. One woman speaks of herself and of other courtesans:

> WE EAT MEN...I don't do IT with just anybody, that is the point..."You want it, you're going to suffer, I must eat you up thoroughly before you can get it." He'll have to spend enormous amounts before getting me. He must spend, buy me things, give me money, and I hold out, I don't give him anything. [How do you manage to be so successful?] I don't know, I myself can't explain it. I think it's a gift God has given me. I wonder sometimes...

So, with God on her side, she pursues her building project:

> A man comes around. I tell him I have a problem...Recently, not even two months ago, a guy came in and I say, "Ah, I am building but I need some things." He called me, I went to his place...he gave me 100,000 francs (CFA), bills of 10,000, 10,000...100,000!

And finally, even one of the most traditional male economic preserves, livestock, is bought by prostitutes. Aicha, a Peul woman from Niger, puts money she earns into cattle "for tomorrow," thinking of her future children. Other women, like the Nandi prostitutes of Kenya, buy land and cattle and become independent family heads. And Nandi men feel menaced (see first page of this article). Control of women in marriage and exploitation of their labor is based on male monopoly of resources and means of production. When women have access to other forms of income, marriage and direct male control are threatened.

By entering relations of explicit sexual-economic exchange, women transgress the basic rules of their societies concerning the property of women's persons. Women's transgression and male reactions mark a breaking point in the continuum of sexual-economic exchange. Here we have an area of open political conflict between the sexes, an area where some important aspects of the relations between men and women are being redefined. Independent migration is a sign of women's transgression. Family control against flight from marriage is reinforced by city and state institutions. Women in African cities often have no legitimacy other than as wives.

REPRESSION

By using their bodies as tools in sex work, "free women" break the crucial link between men's direct rights over women's sexuality and reproductive power and their direct rights to women's work which constitutes the specificity of marriage. Through negotiating and getting paid for sexual service out of marriage, women try to achieve personal and economic autonomy. This is a threat to the structure of male power and the response to this threat is repression.

Women who are not under the direct control of a man are "outlaws." Women in such illegitimate situations must be put back under a man's control. Again and again "free women" are put into marriage. In Nigeria from 1915 on, for example in 1958, 1969, and 1972-73, many towns (Sokoto, Kano, Zaria, Katsina and others) take a series of measures to make *karuwai* marry, banish *karuwai*, or otherwise force them to leave (Pittin 1979: 283-89). In 1958, in Katsina "an edict was passed that independent women should marry...The rapid, forced and extremely inexpensive marriages to the *karuwai* known as *auren gwanjo* (second-hand marriage: *gwanjo* means second-hand goods) could be completed for as little as ten shillings..." (Ibid: 286). In the 1972-3 the *karuwai* face threats, physical assault and destruction of their property in many towns. *Karuwai* are forced to leave the cities or marry. In Sokoto, within a few days of the Sultan's appeal (May 1972) which "advised" them to marry, about 200 *karuwai* had gotten into marriages. In Katsina, in the two weeks following the eviction from their houses, about half of the *karuwai* had married. When things calm down, "the women gradually filter back into the cities, emerge from hiding, and leave marriages into which they were precipitately pushed" (Ibid: 283-289).

Women's independent access to resources through sexual economic exchange out of marriage is stigmatized and punished; other independent activities, especially if they give women a good income, tend to be curtailed if not suppressed. One example: In Sefwi Wiawso State, Ghana, in the 1920s women's agricultural work load had increased with the development of cocoa farming. Up to then women had disposed of the food crops they grew, but with cocoa the situation was different: cocoa was the husband's property. Moreover, wives were denied rights to the cocoa farms on which they were investing years of labor. Opportunities for independent income were opening

for women with the growth of market towns. Women leave marriages and go to the towns; they become a concern to the state authorities.

The first, and perhaps most startling intervention of the State Council was to seek to stamp out the "free women" of Wiawso: the traders and alleged casual and full-time prostitutes who had abandoned their husbands or who had no known male guardians. The Free Women's Marriage Proclamation, issued in 1929, ordered that such women were to be arrested, locked up in the outer courtyards of the *omanhene's* palace in Wiawso and held there until they were claimed by a husband or by any other man who would take charge of them. The male claimant was required to pay a fine of 5/- to release the woman and to prevent her from carrying on her unacceptable activities (Roberts 1987: 61).

Among women's unacceptable activities was controlling their daughters' marriages and divorces and receiving brideprices for them.[8]

Another case: In Zimbabwe in 1982-3, military sweeps arrested several thousand women. Women from different social classes and occupations were imprisoned in detention camps as prostitutes. The women picked up on the streets had to "produce proof of marriage if they wanted to be let free" (Gaidzanwa, 1985). Drastic sweeps were conducted in Harare in an area inhabited by

> young professional people, some of them being single black women. We understand that while some women arrested were prostitutes, many young women picked up were not. They felt they had been arrested **because** they were young, single, and showed evidence of earning their living (Jacobs and Howard, 1987: 42).

In the detention camps, soldiers were reported to have sexually abused the women as they considered them prostitutes. During the same period, other police measures prohibited the sale of cooked food. "It is notable that the definition of 'illegal'...has come to include some of the main means of income-generation for women" (Ibid: 42).

Finally repression appears in its rawest form: physical violence and rape are used as a punishment and as a radical "cure" for women who violate men's laws.

In Gabon in 1985, women who were said to be prostitutes were

rounded up. These women were to be given to soldiers in the barracks to sleep with and presumably to cure them of their prostitute lifestyles. (Gaidzanwa, 1985: 3).

❖ ❖ ❖

Traditional and modern states as well as family and local authorities try to restrict women's freedom of movement, deliver them to husbands, chase "free women" out of the cities and imprison them.

Migration is women's answer to unbearable situations of poverty and subordination. Leaving their homes, making their living on their own, facing male reactions and repression, women look for ways of surviving and of gaining some autonomy. In this sense, the history of African prostitutes, of African "free women," must be seen as a history of resistance.

Paris, July 1988

Footnotes:

1. "Free women," or in French-speaking West Africa *femme libre*, is the common term indicating an independent woman out of marriage, especially a divorced or widowed woman, and is also used as a synonym for prostitute (see, for instance, Sidikou 1980: 195n.)

2. Cited in Sidikou, 1980: 197. All translations are mine.

3. Unreferenced quotes and information on Niger "free women" come from my field work and my interviews in Niamey in 1986.

4. To have accomplished a pilgrimage to Mecca gives a person social prestige and the title of *Hadji* (male), *Hadjia* (female), i.e. Meccan pilgrim, by which this person will be addressed from then on.

5. The effective extension of these rights and with it women's margin of control over their work and sexuality can vary in different societies and also in different kinds of marriage in one society. It must be also kept in mind that colonialism has generally led to a deterioration of women's situation. It has undermined the areas of women's autonomy reinforcing (or, according to another view, creating) men's economic and general control (see Boserup, 1970 for women's loss of rights to land). Some researchers link prostitution in non-western countries to this process which transformed the economic relations between the sexes (also in marriage) in a way that was detrimental to women. According to Etienne, women are transformed into "valuable commodities. This frequently leads to widespread prostitution, perhaps facilitated in some cases by precolonial standards of sexual freedom, but primarily determined by women's understanding of their generalized dependency on men and their desire to seek the least disadvantageous adjustment to it—for prostitution was often seen as preferable to marriage" (Etienne and Leacock eds., 1980: 21). Etienne (1980: 214-238) gives an example for the Baule of Ivory Coast of the transformation of production relations in marriage

and of the new dependency of wives on their husbands for access to cash and cloth, access women had independently before.

6. After independence of Niger from France, a police file was established for prostitutes. All prostitutes must be declared on this police file called "Fichier de Preservation Sociale" and they have to pass a medical test each month for VD (Sidikou 1980: 194). They are generally treated with antibiotics for prevention and they have to pay for all medical treatment.

While prostitution like that of *karuwai* or other women waiting for clients at their home doors is "tolerated" when the women are registered prostitutes who regularly pass their obligatory medical tests, streetwalkers, especially in the center of town, face police raids, fines and jail (up to one month I have been told).

7. Five hundred francs (CFA) is the standard price for intercourse in these poorer forms of prostitution. Women working in bars and nightclubs, especially with foreign clients, can get much higher fees.

8. This politics was not a peculiarity of Sefwi Wiawso. Other states in this area (Gold Coast) were taking similar measures (Roberts 1987). In the thirties, the Sefwi Wiawso State Council made other attempts at marriage reform and passed laws which "potentially eased men's access to wives" (by lowering marriage costs) "and reduced wives' alternatives to laboring on their husbands' farms" (Ibid: 65-66).

Bibliography

ABU K., 1983, "The Separateness of Spouses: Conjugal Resources in an Ashanti Town," in C. OPPONG ed. *Female and Male in West Africa*. London, George Allen and Unwin: 156-168.

ARDENER E., 1961, "Social and Demographic Problems of the Southern Cameroons Plantation Area" in A. SOUTHALL ed., *Social Change in Modern Africa*. London, New York, Oxford University Press (for I.A.I.): 83-97.

BARRY K. 1984, "The Network Defines its Issues: Theory, Evidence and Analysis of Female Sexual Slavery," in K. BARRY, C. BUNCH, S. CASTLEY, *International Feminism Networking Against Female Sexual Slavery*. New York, The International Women's Tribune Center, Inc. 1984: 32-48.

BOSERUP E. 1970, *Women's Role in Economic Development*. London, Allen and Unwin.

BUJRA J., 1975, "Women 'Entrepreneurs' of Early Nairobi," *Canadian Journal of African Studies*, IX, 2: 213-234.

DIARRA F.A., 1971, *Femmes africaines en devenir. Les femmes zarma du Niger*. Paris, ed. Anthropos.

DINAN C., 1983, "Sugar Daddies and Gold-Diggers: The White Collar Single Women in Accra," in C. OPPONG ed., *Female and Male in West Africa*. London, George Allen and Unwin: 344-366.

ECHARD N., 1985, "Même la viande est vendue avec le sang. De la sexualité des femmes: un exemple," in N.C. MATHIEU ed. *L'Arraisonnement des femmes. Essais en anthropologie des sexes*, Paris, Editions de l'E.H.E.S.S. (Coll. "Cahiers de l'Homme").

ECHARD N. 1981, "L'Afrique de l'Ouest. De l'obligation a la prohibition: sens et non-sens de la virginité des filles," in *La Première Fois ou le Roman de la virginité perdue a travers les siecles et les continents*, Paris, Ramsey.

ETIENNE M. 1980, "Women and men, cloth and colonisation: the transformation of production-distribution relations among the Baule," in M. ETIENNE and L. LEACOCK eds. *Women and Colonization: Anthropological Perspectives*. New York, Praeger.

ETIENNE M. & L. LEACOCK eds. 1980, *Women and Colonization: Anthropological Perspectives*. New York, Praeger.

GAIDZANWA R. 1985, "Rural Migration and Prostitution," in UNESCO - International Meeting of Experts on the social and cultural causes of prostitution and strategies against procuring and sexual exploitation of women. (Madrid, Spain, September 1985) SHS-85/CONF.608/7.

GOMM R. 1972, "Harlots and Bachelors: Marital Instability among the Coastal Digo of Kenya," *Man*, 7 (I): 95-113.

GUILLAUMIN C., 1978, "Pratique du pouvoir et idée de Nature. (1) L'appropriation des femmes," *Questions féministes* No. 2: 5-30.

JACOBS S.M. and HOWARD T., 1987, "Women in Zimbabwe: Stated Policy and State Action," in H. AFSHAR ed *Women, State and Ideology. Studies from Africa and Asia.* London, MacMillan.

NELSON N., 1977, *Dependence and Independence: Female Household Heads in Mathare Valley, A Squatter Community in Nairobi, Kenya.* Unpublished Ph.D. dissertation, University of London.

NELSON N. 1978, "Women must help each other," in P. CAPLAN & J. BUJRA eds, *Women united, women divided. Cross-cultural perspectives on female solidarity.* London, Tavistock: 77-98.

NELSON, N. 1987, "Selling her kiosk: Kiosk: Kikuyu notions of sexuality and sex for sale in Mathare Valley, Kenya," in P. CAPLAN ed. *The Cultural Construction of Sexuality.* London, Tavistock: 217-239.

OBOLER R.S., 1985, *Women, Power and Economic Change. The Nandi of Kenya.* Stanford, California, Stanford University Press.

PITTIN R.I. 1979, *Marriage and Alternative Strategies. Career Patterns of Hausa Women in Katsina City.* Unpublished Thesis. School of Oriental and Asian Studies, University of London, December 1979.

PITTIN R.I., 1983, "Houses of Women: A Focus on Alternative Life-Styles in Katsina City," in C.OPPONG ed., *Female and Male in West Africa.* London, Allen and Unwin: 291-302.

ROBERTS P.A., 1987, "The State Regulation of Marriage: Sefwi Wiawso (Ghana) 1900-1940," in H. AFSHAR *Women, State and Ideology. Studies from Africa and Asia.* London, MacMillan.

RUBIN, G. 1975, "The traffic in women: Notes on the 'political economy' of sex," in R.R. REITER, *Toward an Anthropology of Women.* New York, London, Monthly Review Press: 157-210.

SIDIKOU A. Hamidou, 1980, *Niamey, étude de géographie socio-urbaine.* Thèse pour le doctorat d'Etat de Geographie. Université de Rouen, Haute Normandie.

SONGUE P., 1986, *Prostitution en Afrique. L'Exemple de Yaounde.* Paris, l'Harmattan.

TABET P., 1987, "Du don au tarif. Les relations sexuelles impliquant une compensation," *Les Temps Modernes*, No 490 mai 1987: 1-53.

TABET P., 1988, *Etude sur les rapports sexuels contre compensation.* Report presented to the Division of Human Rights and Peace, UNESCO. May 1988.

WHITE L., 1986, "Prostitution, identity and class consciousness in Nairobi during World War II," *Signs* 1986, vol. 11 No 2: 255-273.

WILSON G., 1961, "Mombasa. A Modern Colonial Municipality," in A. SOUTHALL ed. *Social Change in Modern Africa*. London, Oxford University Press.

WILSON M., 1977, *For Men and Elders: Change in the Relations of Generations and of Men and Women among the Nyakyusa-Ngonde People, 1875-1971*, London, International African Institute.

MIGRANT PROSTITUTES IN THE NETHERLANDS
Licia Brussa

Among the women involved in prostitution in the Netherlands, there are an increasing number of foreign origin, particularly from the Third World. In January, 1985, I began a pilot investigation of the position of these women in Amsterdam in order to gather information on the number of women, their nationalities, their working and living conditions, the way in which they came to the Netherlands, and their social networks. All through my investigation, a central place was given to the experiences of women: their vision of their situation, their ways to survive and their struggles for independence and a better future. Before describing the circumstances of diverse groups, here is the story of Maria from the Dominican Republic. Her experience is typical of many migrant women.

MARIA

I am thirty-five years old and have worked since I was ten. I have never experienced anything other than poverty and the struggle to earn enough for a meal a day. I grew up in a village. My parents were poor farmers and everybody had to work hard in order to earn enough for our food. My father did seasonal work on the big coffee plantations. And all of us worked on a small piece of land that surrounded our house.

When I was thirteen I went to Santo Domingo and found work as a maid with a rich family. The father of my first child, which I had when I was sixteen, was my employer. He threatened to fire me if I told his wife. But what could I do with a baby on the way? I was fired anyway, and sent away with some money, which was soon used up.

Then I went to live with the father of my other four children. We lived in one of the city's ghettos and my husband worked in a coffee bean factory. I was a washerwoman and what we both earned together was just enough for food. My children went to school. When my husband left me I stayed on alone with the children. I had to work even

harder and the two youngest children were looked after by my family in the village.

I was working then as a washerwoman with a rich family. One time, a Dutch guest of this family came to visit. He was nice to me and gave me presents for the children. After a little while he asked me if I would go back with him to the Netherlands to work for him as a maid there. He would arrange everything and I would pay back any expenses he incurred with my first wages. I agreed because I thought I would be able to earn enough in a few years to assure a better future for myself and my children. Then he said I had to marry a man from the Dutch Antilles in order to be able to get into the Netherlands. I was rather taken aback, but he said that it was the only way, I had no other choice.

It was with great difficulty that I parted from my children, who I had to leave behind with friends and family, promising them that I would send money and come back to visit them very soon.

I never met my Antillean "husband." Everything was arranged via the Dutch Embassy. I think the Dutchman had to pay out a lot of money in bribes in order to arrange everything so quickly. Even then I thought it was strange that he made such an effort for me, and spent so much money because of me. But he said he did it because there were so few good maids in Europe and because I worked so hard and he wanted so much to help me and that I would easily be able to pay him back from my wages. I had no other choice. I was twenty-eight years old at the time and wondered how long I would be able to still find work. Apart from that, my children were getting older and I wanted them to be able to study. And, finally, I also wanted to get my other two little ones back to live with me again.

When I arrived in the Netherlands I was brought to this man's friend. He told me I had to stay with his friend for a few days and then he would bring me to his own house. I had believed everything up until the day when the second man said to me that my life of luxury was a thing of the past and that I now had to work, immediately, because they had invested such a lot of money in me. I thought they would bring me to the house of the man who had brought me to the Netherlands but they drove me to a house outside the city.

There was another Dominican woman there who explained to me what kind of work it was and that it would be wise of me not to make a scene, or I would be beaten up. There was no point, she said, since I couldn't run away, could I?

I was crying all the time I received my first clients. The other women let them in and told them I was new to the business.

I was brought to this room in the afternoons and at night after I finished work, I was brought back to a house where ten other Spanish-speaking women lived. We weren't allowed to go outside and didn't dare to anyway, we didn't know the city, and the man told us that we'd be picked up by the police if we went outside.

He came along the windows where we worked twice a day and took all our money from us. I managed to hide some of it sometimes, but our handbags and clothing were often searched for money. After one year of living like this I managed, with the help of another Dominican woman, to run away and move to another city.

I began to work there as a window prostitute, since I really needed the money. I hadn't been able to send money to the children for a whole year, and I was really worried as to whether they were still being well looked after. And everyone back home thought that I had good work and that I would become a rich woman.

After three years of hard work I'd saved a bit of money and had a place to live. I could only keep going the first few years with the help and support of my copatriots. We do everything together, and even when we argue, we still care for each other. I wouldn't be able to do anything without them. If I had to, life would be very bleak.

But I missed my children very much and worried about them so much that I eventually decided to have them come over here. Life together is better than life apart. But in the meantime I'd had another baby and the children were alone in the house all day—I had to work even harder then, and I was away from early in the morning until deep in the night. The children couldn't go to school because they had no residency permit and I was too scared to get some information concerning this, scared that we would be found by the man I had run away from, scared of the police, scared that we would have to leave, and what was there for me there, back home, with no money. I do want to go back, it's better for the children, but only if I have enough money for a better future, without having to worry so much. Then I can open a shop and my children can also work there and we won't need anybody else.

But I had a big baby-sitting problem. The children were looked after by other friends of mine, but that couldn't go on forever because everyone had the same problem.

And the children also had to have lessons. Finally, I got a cousin of

mine who is an unemployed teacher to come over and look after the children and give them lessons. We've organized a sort of school, for other children as well, everyone pays something for it.

But sometimes I don't earn enough to pay for everything, the living expenses for me and my family, and then I can't pay the wages of my cousin that we agreed on. If we really can't manage, or if she wants some extra money, my cousin also works in the window. But she doesn't like doing this all the time, and only works for a certain price.

Life isn't easy for me. Everyone takes advantage of us here and I don't speak the language, I can't do anything to defend myself. Our only source of strength is the solidarity between us.

Sometimes I become ill, as a result of all the worry and the problems I have, and when I'm ill it's a catastrophe because then there's no money coming in for the six of us, and on top of that I have to pay for a doctor.

Whenever anyone asks me if I think about the future I say no. My future is just a black hole, and I can't allow myself to think about this sort of thing too much, otherwise I become ill with sorrow.

But at least we are all together now. I don't want my children to have to stay in the Netherlands for much longer, it's not much of a life for them.

We're all trying to survive right now and that's quite enough. We keep on hoping that we'll be able to save up enough money to go back home and open a shop and never have to be dependent on anybody.

AN OVERVIEW

Migrant prostitutes in Amsterdam, the Netherlands, come mostly from South America, Southeast Asia and Africa. Seventeen years ago during the "golden years," exclusively Dutch prostitutes were working in the red-light district together with a small group of Surinamese and Antillean women. During the last ten years, the character of the district has changed radically; the Surinam women left and the remaining Dutch women broke ties with the neighborhood. Drug dealing arrived on the scene and with it other types of sex businesses with new underground figures and rapidly rising criminality. Some parts of the district started to deteriorate and many rooms were left vacant. Prostitution spread over the whole city of Amsterdam in a variety of forms. There is now street prostitution, housework (i.e. call girls), window prostitution, brothels, and prostitution in cafes, hotels, saunas, mas-

sage parlors, private clubs and escort services. There are also sex theaters, peep shows and sex shops. What used to be local and tied to neighborhoods has become a wide circuit with even international connections (for example club owners with businesses in different European cities). This circuit also accommodates an international network of traffickers who deceive or force foreign women into prostitution and/or who impose exploitive working conditions.

The fundamental change in character of Amsterdam's sex industry is typical of many big cities. Major factors accounting for these changes include: (1)the increasing demand for black women in the West European market; (2)the big profits made by traffickers; (3)in some cases, sex tourism and/or a link between prostitution and drug dealing and; (4)the absence of effective policies of prosecution and suppression of traffickers on national and international levels. On the side of the women, migration has been reinforced by: (1)poverty in countries of origin; (2)a rosy picture in the developing countries of job opportunities in the rich West; (3)absence of legal ways for women to travel to the industrialized countries. In many countries (Thailand for example) it is almost impossible for women to leave as independent laborers.

Depending on location, it is estimated that thirty to sixty percent of the prostitutes in the Netherlands are women from South America, Southeast Asia and Africa. Forty to fifty percent of the foreign women are living in Holland illegally. There are no signs that the number of foreign prostitutes will decrease, rather the contrary.

The first to arrive about twelve years ago were Asian women who were recruited for sex clubs, nightclubs, exclusive houses and peep shows. Five to six years ago, South American women arrived in Amsterdam in great numbers. Most of them are of Dominican, Columbian, Argentinean or Chilean origin. During the last four years, Ghanaian women and women from other African countries became more "popular." In addition, women from Morocco, Surinam, the Antilles, Indonesia and the Mollucas work in less visible sectors of prostitution like private houses, sex clubs and escort services. Finally, there is an increasing number of "second-generation" Moroccan woman in prostitution.

The group of migrant prostitutes is not homogeneous. Next to differences in country of origin, three sub-groups can be distinguished: (1) women who arrived in Holland through trafficking networks; (2)

women who settled in Holland independently; (3) women who came to Holland as political refugees but could not obtain legal refuge status.

South American Women

Among foreign prostitutes in the Netherlands, South American women constitute the largest group. The majority of these women work behind the windows and are therefore literally visible during working hours. They have a strong sense of comradeship and often go out as a group, for example when they go for medical examinations. Fifty to seventy percent have Dutch nationality. This may mean that a great number of them came to Holland by way of a marriage-of-convenience. Those marriages were usually arranged in the Dutch Antilles with an Antillean man (i.e. a Dutch citizen). There are indications that the line between Aruba and Netherlands is maintained by a large organization with many agents. Some women arrive in Holland via other European countries or with a tourist visa.

Women are recruited from several South American countries, particularly the Dominican Republic but also so from Columbia and Chile. Occasionally marriages are arranged though the Dutch embassies in the native countries. One informant stated that the large organizations responsible for the trafficking of women have lines running not only to the Netherlands but also to other European countries and to the United States. Interviewed prostitutes recall cases of women having to sign debts for marriage and travel costs ranging from 10,000 to 50,000 Dutch guilders. The women did not reveal the identity of the benefactor. Often that person is not the pimp or boyfriend in Holland. The network within which the women are involved from the time of their departure to the time of their arrival in the Netherlands is unclear, as is the network of exploiters upon arrival.

There are also a number of women who have migrated on their own initiative. They are in fact illegal immigrants who came to the Netherlands because they knew relatives, friends or fellow-villagers who had migrated before them. In some cases, the friends or relatives were themselves involved in prostitution and brought them here to work as babysitters or housekeepers. After some time, the women ended up in prostitution, an easy step given their illegal status, inability to get other work and connections in prostitution. When their host family ran out of money, they were obliged to work.

The last category of foreign prostitute is the political refugee.

Many of these women lived under a dictatorial regime and managed, often under perilous conditions, to flee their country. Some of them escaped prison or fled circumstances of torture and intimidation. Once in Europe (usually they arrive in France), they are not able to obtain refugee status. Many of them arrive without legal papers and without resources to find the legal channels which could possibly help them plead their case. So, they begin wandering though Europe as illegal immigrants, sometimes without a valid passport, unable to return home. For many of them this wandering has been going on for over ten years. Prostitution is their only work possibility.

Looking at the hierarchy within prostitution, the majority of South American women are in the lowest rank. They cannot communicate with the client when they have complaints or want to negotiate about price because they do not speak Dutch. Many times they are victims of racist behavior from the clients. They are afraid to report cases of battering or intimidation to the police. Also among women residing legally there is great fear of the police. They may have Dutch nationality but often they do not have access to their passport which was confiscated by their "protector." Among political refugees, fear of the police is even more acute. Some women manage to free themselves from the organization that originally brought them to the Netherlands. They become independent, free to choose their working location and to move from one window to another. But most often South American women work in the cheapest part of the district, sharing small rooms with poor sanitary facilities.

The average age of South American prostitutes lies between twenty-five and thirty-five. The majority of them have children in their native country; some of them also have given birth to children in the Netherlands. They are not well-informed about contraception; for example, some women take penicillin as a contraceptive. The women come from the lowest class of the urban population in their own countries. Most of them send money home not only for their children but frequently to support their whole family. Apparently, the main factor motivating their entrance to prostitution was poverty and the hope of providing a better future for their children. However, they hide their life in prostitution from everybody at home since the disgrace would make it impossible to ever return. South American women in the Netherlands form a solid unit which is their only power and source of protection.

°

Southeast Asian Women

The second largest group of foreign prostitutes is formed by women from Southeast Asia, particularly women from Thailand. There is a smaller group from the Philippines and some women with another nationality (Malayan, Indonesian, Taiwanese). About ten years ago Southeast Asian women began to arrive. Philippine go-go dancers and combo-bands began to arrive about eight years ago. During the last few years especially the number of Thai women has increased.

Southeast Asian women are in less visible sectors of the sex industry than South American women and are therefore more difficult to reach. They work in bars and private clubs and they circulate from one club to another and from one town to another all over Europe. They therefore have no contact with social workers and field workers as do some of their more visible colleagues. A large number of them are illegal.

Speaking of Thai women, the trafficking center is West Germany because Germany does not require a visa for travelers from Asia. Once in Germany, it is not difficult to travel to other European countries. The recruitment of Thai women, their journey to Europe and their transference to a certain club is arranged by agents working in trafficking organizations. The German traffickers are organized on a far larger scale than the Dutch. Frequently women are sold from one club owner to another and are forced to circulate between clubs. Some recruiting goes through intermediary agencies under covers like "artist bureau" or "employment bureau."

The women who become Dutch citizens through marriage usually come to Holland directly. The Dutch marriage partner may be found in Thailand among drug addicts, tourists or Dutch people living in Thailand. The marriage is arranged by an agent upon whom the woman remains dependent. Sometimes one Dutch man accompanies several women to Holland; the women receive a tourist visa by showing adequate money and a return ticket. Another circuit recruits mostly Philippine women into the entertainment industry and nightclubs. Regular agents contract the women, mostly under false pretenses, for six months or a year. According to several respondents, all of the above women are forced into prostitution. Resistance is impossible. After three or six months their contract expires but their visa is then invalid; they become illegal and without housing or income.

There is also a small group of Southeast Asian women in prostitu-

tion who came to Europe independently through friends, acquaintances, or relatives residing here illegally. And finally, there is a group of women who came to Amsterdam after fleeing brothels in West Germany, Switzerland, Belgium or France. They have the idea that Holland is a better place to live and work than other European countries, and certainly better than Germany. Thai women in particular said that many women who want to leave Thailand to work (whether or not as a prostitute) would like to come to Holland. This makes things a lot easier for the trafficking agents.

Southeast Asian women work in several different branches of prostitution, such as sex clubs, bars, brothels, peep shows, live-show sex theaters and escort services. Only a small number of them work as window prostitutes. In some clubs the women earn ten to twenty percent of profits on drinks and thirty to fifty percent on sex. In businesses where the women dance or act, they get a steady income of three to five hundred guilders per week. Some of their income goes to the club owner for room and board. The women's earnings contrast bitterly with those of the bar or club owner. In some clubs clients pay a fixed fee of two to three hundred guilders. This entitles them to drinks, women and entertainment. Working hours and sanitary conditions vary from club to club. Some women work and live in small compartments. Usually the women work from eleven in the morning to late into the night and often they still have to clean their room and the club afterwards. Exploitation by club owners is common. One respondent told me about small clubs and private houses where Thai women earned only three or four hundred guilders per month; sometimes the wages were not even paid to the women themselves but were sent straight to their families or bank accounts in Thailand. This is a way of keeping them dependent. Some club owners try to convince the women that they are controlled "for their own good"; they forbid them to go out as "protection" from the police and from the dangerous outside world. So the women live essentially in a prison with no outside contacts except the clients.

In Thailand, women are recruited for prostitution in the large cities or country towns, not in the countryside. Mostly the women's motives for coming to the Netherlands are economic; many of them have children, many are saving to buy land for the family, some want to support the education or business venture of a brother or sister. The duty of the oldest sister to support the whole family is an important element of Thai culture. If there is not enough to eat in the fam-

ily, the oldest daughter will go to town to find a job. Untrained girls find work in the growing tourist industry, often strongly connected to sex businesses. They work in hotels as waitresses, hairdressers, masseuses, dancers and possibly as call girls. Not all Thai women in Holland were working in this circuit back in their own country; some educated women had other jobs. But, European agents seem to recruit especially women within the (sex) tourist sector.

The average age of the women is between eighteen and twenty-five. Some cases have been reported of girls under age but not of child prostitution, something the Thai government has been fighting against for a number of years. In general Thai prostitutes speak little English or Dutch. They are very isolated due to this language barrier, their hidden position in the sex industry and often their illegality. Day and night, they know only the life in the clubs. Unlike the South Americans, they do not operate in groups; social contacts are usually restricted to a few girlfriends. Those few women who have some freedom meet in the new Thai temple in Amsterdam and in the few Thai restaurants. The Thai temple is one of the only outside places tolerated by club owners. Several informants told about the extreme physical and emotional stress under which the women live. They suffer from exhaustion, depression, isolation, separation from their families, racism and constraints within their work. Women who were prostitutes in Thailand experienced nothing like the circumstances in the Netherlands; at home they were working free-lance and could return to their families on weekends. Prostitution is stigmatized in Thailand but as long as daughters support their families and keep good relations, their work is tolerated. The experience in Holland isolates them from their families and produces shame, thereby making them even more dependent on club owners and traffickers.

African Women

In the last four years the presence of Ghanaian women became more conspicuous in the Dutch prostitution world. A small percentage of the African prostitutes come from other countries (such as Somalia, Mozambique, Senegal or Ethiopia) but most of them come from Ghana. It is difficult to come into contact with the Ghanaian women because, like Southeast Asian women, they usually work in clubs, bars, private houses, peep shows and to a small extent behind the windows in the red-light district. Also, they live in a closed community and sixty percent of them are illegal. They tend to consult private doctors and

not to use social services; they prefer solving their problems through informal contacts within their own community. Due to their background and their social-cultural position in their own country, Ghanaian women are business-like, active and independent, also in relation to men.

The presence of many Ghanaians among illegal immigrants is linked to Ghanaian trade. Generally the immigration pattern is like a chain reaction; the man leaves Ghana first, followed by his wife, followed by other relatives and fellow-villagers. In this situation of illegal family re-uniting, the man usually cannot support his wife and other relatives on his small, unsteady trade. Periods of extreme poverty are not uncommon.

Little data is available on traffic in African women. Some women did talk about networks between Ghana and Europe. Important connections are said to exist with French criminal organizations and some cases are known about cooperation between European agents and the African underworld. Women are sometimes transported to Europe by way of marriages-of-convenience, arranged in Britain, France, Gibraltar or Germany. Thus, a certain percentage of the Ghanaian women possess a Dutch passport because of marriage to a Dutch man. It seems unlikely, however, that the traffic in African women is set up by a large-scale international organization.

Dutch Government Policy

Traffic in women, a phenomenon which represents the situation of many migrant prostitutes has recently entered not only feminist and judiciary debate, but also Dutch policy-making. In February 1988, during a meeting between the Parliamentary Commissions of Justice and Emancipation, penalties against traffickers were increased (from five to seven years prison) so that suspects could be taken into custody and, most important, the Parliamentary Under-Secretary of Justice promised that women who report instances of trafficking to the police will not immediately be confronted with expulsion (as was the usual procedure) but will be granted a temporary residency permit. Application of the above measures remains to be seen. Of course, as this paper shows, trafficking does not describe the situation of all migrant prostitutes nor the total or long-term situation of many women who first arrive in Europe through a trafficking network.

During the last few years, prostitution has been a frequent topic of discussion in the Netherlands. Prostitutes founded their own labor

union, *De Rode Draad* (The Red Thread), and helped organize two international congresses. The prohibition of brothels (article 250 *bis*) came into question and, after much debate, it was decided by the parliament in 1987 to eliminate the prohibition and to introduce a licensing system for prostitution businesses. During the initial planning of the licensing system, migrant prostitutes were ignored, despite their majority in many sectors of the Dutch sex industry.

The focus on licensing of legal brothels on the one hand and punishing of traffickers on the other is leading to a sharp ideological and judicial division between perceptions of white Dutch prostitutes and Third World migrant prostitutes.[1] Dutch prostitutes are seen more and more as a group that has its own profession; prostitution is beginning to be regarded as work. In contrast, foreign prostitutes are seen not as workers but as victims; prostitution in their case is regarded not as work but as violence against women. In other words, images are being created of the "emancipated, independent, political native prostitute" and the "poor, pitiful, underdeveloped, weak foreign prostitute." Those images justify policies which recognize worker rights for only native women and policies which justify increased control and stigmatization of migrant women from developing countries. Such policies widen the gap between the regulated, legal, "white" prostitution circuit and the invisible, illegal, "black" circuit. This makes the foreign prostitute even more attractive to the client who wants anonymity, cheap prices and "harems" of sexually obedient women. And, this adds to the vulnerability, exploitation and subordination of migrant women. When a Dutch prostitute refuses to put money down for a bad room or when she refuses to work for a low price, there are dozens of foreign women who can't afford to refuse such conditions. Inevitably, competition rather than much needed support arises between native and migrant women.

An analysis of migrant prostitution must be placed within the framework of international migrations of women. Those migrations are motivated by women's flight from poverty and injustice and search for a better future. These women are often ambitious, assertive and strong. They are severely discriminated against and violated as women of color, migrants and, for prostitutes, as sex workers. The many factors impeding their free migration and forcing them into dependency should not define or discredit them. Whether they end up in a brothel or as the housekeeper of a rich family is often a matter of chance. They are deceived, exploited and abused in every situation. Those

women have the right to an independent form of migration and movement. They have the right to engage in prostitution or not with the same liberties and protections due all women.

July, 1988
Amsterdam, The Netherlands
Translated from Dutch and Spanish

Footnote
1. It should be noted that Third World prostitutes who are residents of Holland, for example women from the (ex-)colonies Surinam and Indonesia, usually find themselves in the same closed circuits and oppressive conditions as their foreign colleagues. Often these women do not work on a full-time basis but only when money gets tight. Most of them feel ashamed of their work and, in their own and their group's interest, conceal their activities in prostitution.

MIGRANT PROSTITUTES IN NORTHEAST ITALY
Carla Corso

In the northeast of Italy, stretching more or less from Trieste and Gorizia to Verona, there is a large migration flux of Yugoslavian prostitutes. This area, excluding the city of Verona, has about three hundred Italian and Yugoslavian street prostitutes. Besides Yugoslavian migrants there are also prostitutes from Southern Italy and from Africa and Asia.

Southern Italian Women

If I think of the Italian women who do my work, the first thing that comes to my mind is that many of them come from the south, from very harsh realities of poverty, isolation and oppression. Also among transvestites, the majority come from the south. As Rita, one of my colleagues, said, "I came from the deep south where there was nothing. I couldn't find work there. I decided to go to Milan. I found a job, I worked a year, I got sick of it. Too much·work, too little pay. . . I didn't have freedom, I wanted freedom." She, like other women from the south, refuses to do underpaid work, undeclared jobs, and turns to prostitution instead.

There's no migration at all from the north to the south, not even to Rome. The fees are lower, competition is very high, and there's more violence. The jobs here in the north are very much in demand. Also southern prostitutes don't go back because of the working conditions. As another prostitute, Tania, says:

> In the south it's impossible. The women of the south, first of all they work for a man. If you don't have a man with you or near you, you can't work. There's the racket; if you say you don't want their protection then they start making trouble, you are in danger. And you have even the women against you because they have to bring the money to the men, and obviously what you get is yours, and so there's rivalry and jealousy. They send people to insult you and beat you up. In the north if I've got a problem I can solve it myself because there's no racket.

240

But southern prostitutes in the north do face police repression and specifically the threat of the *foglio di via* [police order to return home; see the presentation on Italy in transcripts of the Second Congress].

Yugoslavian Women

As for Yugoslavians, they are the large majority of prostitutes in the border area from Trieste to Udine. Most of them are women about forty years old who go back and forth between Yugoslavia and Italy with their tourist visas. They're one of the most repressed groups of prostitutes in the sense that they are sent back to Yugoslavia again and again with the *foglio di via* and eventually, after repeated offenses, they are officially expelled from Italy. If they come back after that, they get arrested and put in jail for a minimum of two months and fifteen days. They don't want to immigrate to Italy. The Yugoslavians are sort of patriotic. They come and stay for awhile to work and then return with their bag of money. I think they're known at the customs, and the customs people know very well that they're coming with foreign currency but they're not checked very often. Most of the women have a man but it's not an organized racket; it's obviously just men who are eating off them. Some of the women, on the other hand, have very solid relations; they have husbands and kids who stay in Yugoslavia and don't even know what the women do in Italy, or maybe they imagine and somehow accept it.

Prostitution is prohibited in Yugoslavia, like in all communist countries. The prostitutes get arrested and put in jail because supposedly there's work for everybody so nobody should have to be a prostitute. Of course, you can find prostitution also in Yugoslavia. The women go to these big tourist hotels or to the casinos—there are some big ones—just like in Russia. I think some of the high-class prostitutes are put in the hotels for spying. The rest of the women are at their own risk. Yugoslavia is a very poor country. The currency is very weak and you can't find even basic necessities. So Yugoslavians come here for the Italian currency, they also spend it here, maybe do also a little black market; they buy coffee, detergent, blue jeans, dresses. It's like immediately after the war, because on the other side of the border you find nothing. The Italian lire is considered very valuable.

A few of the women have managed to settle in Italy. They have married a little old man from an *ospizio* (home for poor old people) to get a residency permit, giving him a few coins. They settled down here ten to fifteen years ago.

On the street there is strong solidarity between Italian and Yugos-
lavian women. Yugoslavians have been coming for years and years,
since the border was opened, and there's never been a big fight. But
as for friendships, there are small groups: Yugoslavians meet with
Yugoslavians, Italians meet with Italians. Their market has always
been a little freer than ours in the sense that they are much more will-
ing to do things because they are hungry. They are the first to lower
prices, give extra services. But the rules of the street are real hard
here. For example, when the Yugoslavian women work in Italy they
are almost forced by the Italian women to use condoms, or else the
others beat them up. If it is known that one woman works without a
condom, it undermines our market rules. This has been so even way
before the AIDS crisis.

Italians would never go to Yugoslavia to work although there is a
migration of clients near the border. Italian men, for example from
Friuli, take advantage of the lower prices in Yugoslavia, and also they
find Yugoslavian women exotic. In the past, men paid with articles like
stockings, but the women became clever and now they have fixed
prices. Foreign men still pay with things like stockings in Rumania and
Bulgaria. I know about this.

African and Asian Women

All over Italy there is a big migration from Third World countries;
women from Asia and Africa are the "latest fashion." Recently there
have been television interviews with prostitutes coming from Africa
who had been imported as house servants; they were arrested by the
police because they were here illegally and then found to have no
papers because the organization that imports them took away their
passports. These women hadn't even thought about prostitution, at
least that's what they say, and I think it's true because prostitution
here is very hard for them. They don't know the methodology, the way
we work.

African women, and in a few cities South American women, are
put mostly on the street. In areas where there's very strong competi-
tion, they are protected by the organization behind them from the lo-
cal women who would otherwise send them away. In my area there
are African street prostitutes (in the city of Verona) and some Africans
working in nightclubs. Asian women are mainly in the nightclubs.
They are exploited by the clients because they don't know the market
in Italy and so they're not able to give themselves a realistic value.

They are exploited by the owners who pay them the minimum established by law and then force them to be very accommodating with clients and to drink enormous quantities of alcohol. I've done night-club work and I can assure you that it's a very heavy job because you start at ten in the evening and you have to go on and on non-stop until four or five in the morning and most of the time you go to bed drunk.

I tried talking with the women in the night clubs but . . . well, first of all, they don't like being identified as prostitutes because they consider themselves artists. And I was also kept back by the owners of the places. I had talked to some clients who had told me that they had passed a whole afternoon, that is two or three hours, for 80,000, 100,000 lire. If I talk with these women and I tell them what the market price is, they just fall dead. They're giving their time for the lowest price, not to mention the kind of services. They are completely obedient; everything men ask them, they do. I think that the owners of the nightclubs want these women to stay in complete ignorance, they don't want them to have contact with the locals and get this kind of information about the market. They consider me dangerous, like a person from the trade unions. So if I go there and I start speaking about their pay and how they're treated, I alert them. I put "a flea in their ear."

August, 1988
Pordenone, Italy
Translated from Italian by Paola Tabet

"DESPITE EVERYTHING, WE ARE MEN"
Sonia

with Maud Marin
interview by Gail Pheterson

Sonia: In my country prostitution is not possible, not for men or women or transvestites. Especially at the time I left Argentina in 1980, prostitution was impossible. There was a military government. It was impossible at that time to go out on the streets because it would mean prison immediately. And there were no brothels. There was a sort of soliciting in bars and restaurants, but not really prostitution. There was no negotiating, like this costs so much for one night. You just look, you wink, you make a rendezvous. . . and you try to get men especially between forty and fifty years old. It was quite clear that if this man wanted a woman, he had to pay. For homosexuals, it was very difficult. There were no discotheques, no restaurants, no bars like I found in Europe when I arrived.

Maud: In Argentina, Uruguay and Chile it was really very very hard.

Gail: What do those governments do to people?

Maud: Physical punishment. . .

Sonia: There are the arrests, the physical violence, and there is prison, months and months of prison for nothing except the fact that you were on the street. For homosexuals, the problem was that one could go out in the street. . . but if you happened to have pants that were too tight, the police would arrest you, ask for your papers, and take you to the police station. When they took you to the police station to verify your identity. . . as they were trying to put people in jail who were against the military regime, all they had to do was to sneak a little piece of paper in your pocket with communist propaganda and then those people were tortured, imprisoned, maybe killed. That happened. That happened because they didn't manage to find those who were really against the government. I must say that homosexuals, transsexuals, people like that, we are very easy targets because we are afraid. We know we are marginals and we are scared. So they took advantage and there are a lot of people that have disappeared without knowing anything, anything at all, of politics. Nothing. They were arrested only for the fact that they were homosexuals. And they may

244

have paid with their lives. There is no respect for human rights in my country. We Argentineans, we hate our country, we hate it, because we have suffered a lot, we don't love that country.

Maud: When I was a lawyer I demanded political refugee status for these people, since they really face persecution in their countries, especially in Chile, Uruguay and Argentina. In one case, I succeeded and there is now one Argentinean in Paris with the status of political refugee due to persecution as a transsexual.

Sonia: Not so long ago there was talk that there might be another military coup, a military government again. And if there's a military government, I'll get my family—all that counts for me is my mother and sister—and I'll make them leave immediately. I will bring them here to France, or to Spain . . . my sister will soon be a teenager and I don't want her to live her adolescence the way I lived mine. I lived my youth with a lot of fear. It happened to me that I had to leave a university meeting with students hand by hand with guns in front of us, and it wasn't even the military, it wasn't the police, it was paramilitary groups that didn't want meetings at the university. There was a political front at the meeting but I didn't know about it. I thought the meeting was only for discussing things about the university, that we had to do this exam in one year or a month or things like that. I didn't know anything. And there were moments when I had to escape through tunnels and everything, and I hadn't ever done anything. I wasn't a militant at all. I'd never been engaged in politics. I was never interested in politics.

Gail: Did you migrate to Europe to escape all that?

Sonia: My migration story is totally personal. I had almost finished my studies. I was studying to be a veterinarian. And I also worked in a business with my mother, a boutique. I couldn't get along with my mother, that's something that happens often among us. One day I was bored, it was too much for me, and I decided to leave everything and go away. So I just left everything without knowing at all what I would do. In Argentina I was living all my life like a young man, just like any young man. Well, there was a side that people noticed in me that was different from other young men, but I was never attacked on that side because I was leading a regular life. I didn't have homosexual friends, I saw my colleagues from the university, I didn't know transvestites. But a friend of mine had some transvestite friends, girls° in cabaret,

° Unless clearly specified as women, all "girls" and feminine pronouns ("she," "her") refer to transvestites.

and one wrote me three or four letters that I could bring to friends of hers in Spain. So, I went to Spain, to Barcelona. It was the end of the year 1980. I went to the shows, the cabaret, and met the girls who were friends of my friends. And I had these letters: "This person is very nice, see if you can do something for him." I had never been in prostitution before. I found myself an apartment, that's much easier in Spain than in France, at least at that time. And *voilá*, I dressed up as a woman and I went out on the street.

Later I met people who were living in France who suggested that I come here because it was a better situation for the kind of transvestite that I was. I was almost a transformist with a wig, make-up. . . it was more interesting for me in France. So I came and I stayed. That was seven years ago. But even before knowing I could live here I already loved Paris. I already spoke French because I loved this language. In Argentina there is a special enchantment with France.

Gail: Did you expect to work in prostitution before arriving in Europe?

Sonia: Well, I knew that was the only thing, at least at the beginning, to eat. . . I had brought some money but it was just not enough, it couldn't last all my life.

Gail: Was your situation typical?

Sonia: No, my family is bourgeois, fairly upper middle-class, nouveau riche. But this is quite exceptional. It's not that I consider myself different but I know I don't correspond to the prototype of the transvestite. Normally they come from the very low strata of society, from enormous poverty, people who have almost no schooling. They come from the villages and first migrate from the country to the nearest big city. And after, they help each other: one with a friend in Europe comes and she easily earns the money for a plane ticket, and she sends it to a another friend who comes and gives her back the money and maybe gives her a little present besides. And *voilá*, yet another one is settled here. That's how it went with the Brazilians. There was no network of prostitution, as some argued, there were no pimps, there was nothing of that. It was the girls who came, who opened the way, and that's how Brazilians flooded Paris. It is simply because they helped each other. They really come from very low classes.

Those outside of Brazil who can't get to Europe go to Brazil because there is much more liberty in Brazil than in the rest of South America. So, for instance, from Argentina you can go by bus to Brazil ⁀h is not too expensive. There they have operations, they get

prostheses of breasts and so forth. Now it is possible in Argentina, but not since long. In Brazil, it's been going on a long time. So girls in Argentina who wanted to be transformed went to Brazil. And the operation was always paid for through prostitution.

Maud: There are also many operations in Europe.

Sonia: Yes, the majority of South American girls are operated on in Europe. The latest vogue is London because it's the best operation. Before London it was Casablanca, Morocco.

Gail: And everybody expects to work as prostitutes?

Sonia: Yes, they come to do this.

Maud: There is no other solution.

Sonia: There are girls who tried to stay in cabaret, show business and all, but all that is badly paid. My case is exceptional: the proof is that I now have other work (beauty specialist) and I can do very well. I can live from other things than prostitution. And I can still stay in the milieu because my clients are transvestites. I also continue to go out. I have to buy an apartment so I need money, and I can go out in the evening, once or twice a week, but that's all. Maybe next year I won't need it and I'll just live off my profession. I feel happy with it. I stayed in prostitution (full-time) only a year and a half.

At times I go out almost for fun, for a little diversion. For example, Friday I went out and I didn't work, I didn't earn. I just went out for some fresh air. I dressed, I talked with friends...You can ask, why don't you go elsewhere for fun? I could but...I don't drink alcohol, I don't smoke, I don't use drugs, I don't like modern music...I like the pleasure of dressing, of dressing as a woman. I feel more like a transsexual than a homosexual. I feel nearer to Maud than to the boys who may be hairdressers during the day and go to discotheques in the evening, the homosexuals. There's a gay discotheque right nearby and I've never been in it. I don't feel good there because really I like men who are completely masculine, completely virile. I'm transvestite, I'm not transsexual, I didn't make the change—who knows, I might decide to change—but in any case I feel okay this way.

Gail: It seems that more men migrate through prostitution, as transvestites, from South America than from other parts of the world. Is that true, and if so, why?

Sonia: It has been mainly a phenomenon of Brazilian transvestites. Transvestites can be totally a part of the Brazilian spirit, of their way of life...they go well with the customs. At Carnival, everyone is transvestite. The people mask themselves, there is a side that is permitted,

there is a gayness. Brazilians are a people who have so much need of change, to forget all that poverty, misery, illness and everything, because it is really very very poor. And because of all this, those people allow themselves things, can disguise themselves, dress as women, have clients. Prostitution goes well in Brazil, unlike the rest of South America like Chile, Argentina, and Uruguay.

In Paris, when they see a transvestite, they ask, "Are you a Brazilian?" It is because of the great quantity of Brazilians. And they make themselves quite outstanding, they are noted in every way . . . especially for their beauty. And I must say, they did everything to be beautiful, beautiful transvestites. Clients are very stunned. Brazilians have marked a period in Paris. And French men have loved the beauty of Brazilian transvestites.

Gail: What about migrants from other South American countries?

Sonia: Paris is full of Columbians right now. Just to speak of my working area, there are sixty of them. There must be more than one hundred fifty Columbians in Paris, it's the great mafia at this time. They are taking the place of Brazilians.

Gail: And why do these people migrate?

Sonia: All of South America is terribly poor . . . there are not many possibilities there. At home in Argentina, I know lots of young men who would very much like to come to live in Europe and to have success, to make money. But they are handicapped because they can't work. In all of Europe there is an enormous problem of unemployment. It's hard enough for natives to get jobs but it's impossible for immigrants. Except for us, for those homosexuals who have the courage to put on a wig and go work in prostitution. For us, migration is possible. If you have the courage, because there are also homosexuals who don't have the courage to do it, for prostitution is quite difficult, it's very hard. But to be a homosexual is an advantage in terms of migration. We can settle ourselves and get through this way. I have a lot of friends who are not homosexuals in Argentina who say to me when I go back, "You're really lucky, you've been able to leave." Obviously I won't tell them what I do. I have friends who have wanted to leave for years, all the young people feel that way, and me, what can I do, obviously I can't tell them that all you have to do is put on a wig and go to the Bois de Boulogne [a park] in Paris. It is a question of mentality. A man who is not a homosexual would prefer stealing to prostitution. He couldn't do it. Being a homosexual is an advantage for succeeding in life, it's a way to get money.

In Brazil, as in Argentina, when there are transvestites who return to see their families and who come back with several thousand dollars in their pockets, this clearly opens the eyes of others. They say, "Why, if she succeeded, I must succeed also—it works—prostitution works." So, from then on these people will do everything to come. And it does work, it goes well. Above all, in France, in Paris. Paris is the place where the transvestite is the king. The French man, he LOVES transvestites. And that's why everybody comes to Paris and they don't stay in other places. Because in Spain and also in Italy, it has happened to me that a client looked surprised as if he didn't know. That way he put a distance, he acted unhappy. It was sort of like, "Well, we're at it and I already paid, let's do it...but it's not really what I like." Maybe he knew, maybe he didn't, I don't know. On the other hand, in Paris even men who are mistaken—and sometimes they really are mistaken—it attracts them. Maybe they are less hypocritical than the others, I don't know. In any case, it makes less problems for the transvestite. The French are much more open, there has been a much greater sexual freedom and openness for much more time in France than in Spain, with Franco, or Italy—surely.

Maud: Yes, that's it.

Gail: And heterosexual men, how do they manage to migrate?

Sonia: A normal man, migrate to Europe, that's impossible. There's an enormous problem of unemployment, there's discrimination against migrant workers, so a young man who wants to come to France, what can he do? He has no possibility of working, and in Italy it's the same thing, the same in Spain, everywhere in Europe... They can come with a woman and then they make the woman work and then they live off this woman. And that's what happens very often in Italy. There's an enormous migration, from Uruguay for instance, of women who come with their pimp. It's the usual situation. Women, I think, fall in love easily, and when one falls in love one accepts everything, it's a folly. And the man, if he doesn't really love her will take advantage of her, and that's just the same in Uruguay or Argentina or France. And what does the man do in Europe? Nothing. If he can, when he gets into the milieu, he can do a little robbing, a little thievery, but he always needs a woman to be able to live, because there's no possiblilities of work for him.

Gail: And the women who come with men, are they usually already prostitutes in South America?

Sonia: Yes, yes, surely they are prostitutes in their countries.

Gail: Are there also women who come alone, independently?

Sonia: Women alone? No, women alone, no. Because women don't have the courage that we have. Despite everything, we are men. Women cannot come alone. A normal woman, I think, is afraid of everything. She is afraid to fall into a prostitution network, afraid the network will get hold of her and take her money and beat her. It's not the same as the women who come with a man; the man is a pimp and the woman works. Not that men are superior but we, the homosexuals, and I think that you also are one, we have very developed senses, all of us, because we are marginals, and different. We are more awake, more courageous, and more defiant than normal people. All we need is to be told "no" and we do it. There are many things that we notice much quicker than the others.

Gail: Are there many contacts between men and women who are here now or are there separate worlds?

Sonia: Well, we are really a separate milieu, a separate group. I don't even know South American women who work. There had been one or two women who were working in the group of transvestites, they just stayed with us . . . they were like other transvestites.

Gail: Are transvestites and transsexuals in one group?

Sonia: What happens is that the transsexuals have trouble leaving the group of transvestites. Isn't it true, Maud? It's a problem for them to leave the transvestites in prostitution.

Maud: It's true, women prostitutes don't easily accept us . . . but there are not many transsexuals in France.

Sonia: No, there are not many transsexuals . . . there are many in Barcelona, there are many in Italy, but in France there are not many.

Gail: What about the contact between South American transvestites/transsexuals and the French?

Sonia: We're just like a big family, isn't it true, Maud? Just like a big family. We discuss all the time, we argue all the time, but we're a family.

Gail: Are you transvestites of South America like only one family or are you divided by countries?

Sonia: No, we're a single group, we mix together very well because we're all from far away.

Gail: How are you and other transvestites accepted in your family back home?

Sonia: I was in a very Catholic country. It is difficult for a couple that

has a boy to accept that the boy does not take the male role and above
all that he wants to become a woman. The parents are shocked.

Gail: Do your parents know that you work in prostitution?

Sonia: No, my parents don't know I work in prostitution. My mother
knows I'm a homosexual but she doesn't know I'm in prostitution. Last
year she came for a visit and saw how I earn my living [beauty special-
ist] and that took away any doubts. There are families that know their
relatives are in prostitution. But these people are so poor that they are
glad to be able to close their eyes and eat everyday, and be able to ar-
range their home a little bit. What happens is this: When we go back
to our country, even if before we were hated. . .at the moment we go
back we are admired. If we didn't have brothers, we get brothers.
When we go back, the whole family considers that, well, although he is
a homosexual, he is the only one that is successful. I have a friend who
was kicked out Christmas Eve from her own home because the older
brother wouldn't accept her..she was a homosexual, she was a shame
to the family. And now when she goes back full of presents, he says,
"Oh, my brother. . .are you my brother or my sister. . .what do you
want to be called?" That's hypocritical, it's just because of money. But
you also have to understand these people. They are in such an extreme
state of poverty that with a little money, you can just buy them. You
can buy their love. You just say, "We're doing cabaret, show business"
or maybe "We are working in a hairdressing salon." Whatever we say
is accepted, the family is glad with what we say, even if they know
what we really do. The presents, the money, covers everything.

Gail: Do many men send money home?

Sonia: Yes, many of us help our family a lot. Most of the girls help
their parents, their brothers and sisters, I would say all of us help, even
me, maybe not enormously because I have a family that doesn't need
it but I do it. I like to have them get some little pleasures, some extra
little things, that pleases me, like any son who helps his mother. That's
it.

Gail: Is there much contact with families?

Sonia: Yes, we come and go all the time. For us it's a way of showing
that, despite our being like this, we can be successful. And that we're
not marginals and we're not thieves. I go to see my family once or
twice a year. And that's not unusual.

Gail: At a certain age, what does everyone do? Do they go back to
stay?

Sonia: That depends. . .somebody wants to stay, somebody wants to go. . .somebody puts money aside for their future, others have no conscience about this, they use drugs, they dress up very well, they have no idea that time is passing, and it will happen at a certain moment they will not have money to do other things. This is what happens many times with prostitutes, also the women. One takes advantage of life, of what one earns, and then it happens that one gets old, one has all the wrinkles, one doesn't earn anymore. That's everywhere, but most of the girls from South America have suffered so much from the misery of poverty that they know how to put money aside. Most of them take care, they buy a house, they buy a car, they have a little account in the bank.

Gail: Are there also many non-Brazilian South Americans who go back to Brazil rather than to their own countries because of the greater freedom there?

Sonia: There are those who think about that. . .there are for instance Argentineans who say, "Well, I wouldn't go back to Argentina but I would get an apartment in Brazil so I'll be near my family."

Gail: Are many of the transvestites political?

Sonia: I think not, there's no political group. There are really not political subjects in that sense. The cultural level as a whole is very low.

Gail: What about their legal position in Europe?

Sonia: People who are still here take very many pains to be legal, because they know that if you're illegal, you might be expelled. And expulsion means goodbye to France, so they do everything, all they can, to be legal. It took the police years to crack down on Brazilians but they have driven many out. Next they'll be running the Columbians out, it won't take long.

Gail: Will you talk a little more about the police? Are there differences in the treatment of transvestite and women prostitutes?

Sonia: It's not a question of gender, it's a question of nationality. When the police come to arrest everybody, if they see you're French, they say, oh, *bon, ca va*, okay, just stay there. That is a problem of racism that is very strong in France generally and very very much stronger among the French police. There's an enormous problem of racism. They say that 80% of policemen vote for Le Pen. For foreigners, if the person doesn't have a visa, she might be imprisoned, kept for three or four days, and then put on a plane for her country. They expel her.

Gail: What happens when a person gets expelled, sent back to her

country? Does she try to come back to France? Are there many people who come and go?

Sonia: Oh, it has even happened with Brazilians—it was really very funny—some Brazilians were put on the plane one evening, they got to Brazil the next morning, and then that evening they took the same plane and were back here in France the next morning, with a false passport. At that moment with Brazilians, there were false passports. There were not the visas yet, they used the passports of a brother or cousin.

Gail: Are there still a lot of false passports?

Sonia: No, there were, but now there's not anymore. Now the girls try to have their papers in order, to be regular. This is less costly.

Gail: How can they get a legal status?

Sonia: They come as tourists. We still get some visas in Argentina; otherwise there are girls who go to Uruguay and Columbia and other places to get visas. Others go to Belgium, Holland, Spain, Switzerland, Austria, and maybe they get a visa there. Those places are only points of passage because it's easier to get into France by bus or train than through the airport customs. As soon as they can, they come to France. Here prostitution goes well for the transvestite, here you get lots of money.

Gail: What about prices? Are they the same for men and women prostitutes?

Sonia: Yes, they're the same. The prices vary according to place not to gender. For instance there's a part of the Bois de Boulogne that's called "Porte d'Auteuil" where you work for more than at the "Porte de Passy."

Gail: Are transvestites in a different area than women?

Sonia: Yes, we don't mix. Just very few women feel good with us, most of them are separate. If there's a transvestite that goes to the street of St. Denis, where there are only women, he won't work because a man goes there to find a woman. And even if he might desire to go with a transvestite, he won't go because he's ashamed, because over there, there are women. But in the Bois de Boulogne, even if there's a woman, you know that the man who goes in the night, he goes for a transvestite, he doesn't feel embarrassed even if there's a woman. He will just go and get the transvestite because that's what he's going for. Anyway, there's a reaction, a behavior that's not very kind among women. Well, it's true that we get their clients, we take away their clients.

Our prices are one hundred francs for a blow job and two hundred for making love. That's what I get because I work in a car, and I'm not interested in working for less. So if they propose less, I don't do it, because anyway I don't do it to earn my living, I go there just for fun or to get a little extra money at the end of the month or to put money aside, to buy this or that but it's not for my living. But there are others who, according to how they value their own beauty or according to their needs of paying the hotel and food and cigarettes and taxis everyday, they do it for fifty and a hundred francs. But normally almost everywhere it's a one and two hundred. And then starting with that, you can raise a lot more money. The more the client asks for, the more we make him pay.

Gail: Are your clients homosexual?

Sonia: No, if I was dressed like a man, they would never come with me. I have to put on a blond wig and make-up and that changes everything for them. What does it mean to be a homosexual? It means being attracted to one's own sex. And my clients are not attracted to the same sex. The one who comes with me in the evening, what does he see first of all, he sees a woman. He is attracted by this feminine look.

Gail: How does he make love? Does he look at your body?

Sonia: Well, there can be any kind of person. There's the one who ignores it completely, there's the one who touches and even more than that, there are people who don't say anything, there are people who are disturbed, there are men who prefer making love from behind because they think that in front it's not good, there's an enormous variety. Every client is a different case.

Gail: Do you use condoms?

Sonia: Always. We know all about AIDS. The girls tried to get information because they felt very concerned. So, they took precautions and they used condoms. There are still very few who don't use condoms because they think it's stupid, because these girls aren't intelligent enough to understand, but it's very few. There was a big consciousness-raising about AIDS and I must say that among transvestites we have been affected by AIDS very little. I mean we had very few losses. There are some sero-positives, but very few. I think that it's because our clients are not homosexuals. And as AIDS burst out with the homosexuals, we were informed and warned in time. And so we were able immediately to start with condoms. We use them in every relation, in every kind of work, also blow jobs. This is obligatory, it is imperative.

Gail: Do you use condoms also in your private relations?

Sonia: I personally have had a friend for the last seven years, I don't use condoms. . . I'm only with him.

Gail: Are there many couples in your community?

Sonia: Yes, we have couples, South American tranvestites with above all French men. There are no men from our countries. The couples are made of us and French men, or Italian men. As for relations between transvestites, do they exist? I don't know of any.

Gail: Is the relation with a transvestite often a secret in the French man's life?

Sonia: Well, it depends upon the social milieu of the man. There are girls who are introduced to his family: "Look, this is my wife." And they say, "But it's not a woman. . . ." And he might say, "That's right, it's not a woman, it's a transvestite but she's my wife." And there are others who completely hide this. If the man is married, then it's like having a lover, an affair, hidden.

Gail: Do the French men often go back and forth to South America with their partner?

Sonia: Yes, many people spend their winters in Rio and their summers in Paris. They can't deal with the cold in Europe. Most of the men follow when the girls go back. It might be the woman who pays, or the man might pay for himself, but they often go together. It's the same group that go from one place to the other. For the Brazilians, everyone goes to Carnival. They meet each other in Brazil, they get very beautiful costumes and after Carnival they all come back. It is very very expensive, not the flight, that is just seven thousand francs, but the costume! Really, very expensive. Brazilians spend fortunes on their costumes. They might work the whole year and all they can save they spend on one costume. There are tons of sequins and very expensive feathers, and the more feathers you have and more sequins you have, the more beautiful is the costume. It is important to be the best.

April, 1988
Paris, France
Translated from French

PART FOUR

REPORTS AND NEW VOICES

REPORTS AND NEW VOICES

Organizing among people who speak different languages and often live extremely isolated or hidden lives is a difficult task, especially given scarce resources for global communication. The following reports and new voices of prostitute activists show the organizing process in various stages. It is tempting to delay publication because new contacts are being made literally day by day. For example, we have recently met prostitutes in Greece and Portugal and participated in an Asian congress attended by prostitutes from the Philippines, Thailand, South Korea, Taiwan and Japan. In the coming months we expect to expand our network as we organize the next World Whores' Congress, a meeting which will prioritize the rights of sex workers from developing countries.

The range of speakers in this book testifies both to the commonality of struggle among prostitutes around the world and also to the widely diverse circumstances that determine their lives. The numerous nationalities not represented point to work yet to be done in building a truly world movement of whores. This anthology is meant to be an historical document and an impetus for a new politics of prostitution. It is meant to invite, not exclude, those who are absent. The ICPR is a young organization which began in the West. Different cultural settings point to different specific needs and different strategies for change. Those strategies include everything from literacy training to health care to legal reform to public education. This is a movement in need of many allies.

G.P.

A VISIT TO BURKINA FASO
Annemiek Onstenk

This telegram from President Thomas Sankara of Burkina Faso was delivered to the Second World Whores' Congress:

We have respectfully and admiringly learned about your Second World Whores' Congress. We salute this initiative and congratulate you for dealing with this important matter. Our point of view is that prostitution is nothing other than a consequence of social injustice and the philosophy of exploitation which leads societies to deterioration. This is why in Burkina Faso we are fighting prostitution. However, our strategy very clearly states our obligation to kill the disease without killing the patients, which means that we should eliminate prostitution while protecting prostitutes. Yes, for us in Burkina Faso, a prostitute is only an innocent victim of societies which have been changed into a jungle where everything is used to live, or simply to survive.

Prostitution is organized thievery of the graces of women. It's nothing less than the savage exploitation of the body of an other. It's the exploitation of human beings through the force of buying power.
In Burkina Faso we struggle to offer prostitutes jobs which would liberate them from exploitation by others and would allow them to blossom and to recover their dignities and their rights.

It's important for us to state that in this permanent struggle Burkina Faso has acquired experience that we would communicate with pleasure to your community.

And if one day you should feel moved to widen your circle and include your African sisters, we would be available to welcome you here for future gatherings.

One has to fight for every right and it's only through persistent struggle that you will seize your right to extricate yourself from police-like

methods and harassments intended to marginalize you and reduce you to resignation to palliatives that organize and protect what unfair societies would like to hypocritically present as your job.

Don't capitulate,
don't resign.

All the success to your Congress.

In winter 1987/88, I visited Burkina Faso. Too late to meet Thomas Sankara who had been murdered two months before during a coup d'état. I spoke with waitresses, prostitutes and bargirls, members of the National Women's Union, and social workers. They told me about Burkina's prostitution politics, a politics still connected to the person of Sankara.

Since August, 1983 the country formerly called Upper Volta has been governed by revolutionary militaries with Captain Sankara as President until the coup in October, 1987. At the first anniversary of the revolution the country was named Burkina Faso (*pays des hommes integres*). Women's liberation is high on the list of priorities according to the revolutionaries. And one of the main aims of women's liberation is "to safeguard women from prostitution," a message often repeated in the President's speeches and revolutionary programs. Within classic Marxist ideas, prostitution is considered a degrading form of capitalist exploitation that must be conquered. Prostitution is called the "social lepra." The lack of jobs is seen as background for a woman's choice to sell sex. Therefore the women should be supported to find alternative work. Thus far hardly anything is new compared to ideologies about prostitution in other countries or other parts of the world. There is but one distinct feature in Burkina Faso: respect rather than contempt for prostitutes seems normal and is politically articulated by the leaders.

Whereas in most societies with an abolitionist approach to prostitution successful people hypocritically disassociate themselves from prostitutes at the official level, Sankara organized a meeting with prostitutes in 1986 to discuss politics. On the other hand, Women's Union officials remarked several times to me that "real prostitutes" were foreign women from Ghana; in other words, their own Burkina women don't do this sort of thing. Nor was Thomas Sankara just an angel. Regretfully, he also had a despotic face: During the summer of 1987 he took the repressive and discriminatory measure of prohibiting

women from walking down the streets at night without their husbands or boyfriends. Three hundred women, most of them walking alone, were arrested and kept in jail for one night during that summer.

Although Burkina (prostitute) women face repression and discrimination like that in most other countries, my impression is still that prostitutes are less stigmatized and more integrated in Burkina Faso than in at least West European and North American societies. Maybe the reason is that paid sex is not exclusively for professionals nor is unpaid sex exclusively for (married) couples. Men as well as women have many sexual contacts outside their marital or partner relationships, both unpaid and paid (by men—sex exchange is still gender determined). There seems to be a wide range of sex and sex work, without sharp distinctions between the one and the other. This apparently lessens the need to create distinct categories of "good" and "bad" women, prostitutes and non-prostitutes, let alone categories of "good" and "bad" men. Sex, or companionship, is paid with money, but also with food, clothes or "luxury." In bars and restaurants I met many girls and young women, often single mothers, who entertained for free entrance and drinks; some try to pick up a guy for the night.

During my visit there remained a gap between what non-prostitute women and men said and what the concerned or working women were saying. The non-prostitutes easily talked about what prostitution looks like in Burkina Faso and what has to be done. But the girls and women I met in bars and restaurants didn't speak about prostitution as such. We talked about sex, about having children at fifteen (and how I managed to have none at thirty), about living with their mothers without a husband, and about money worries. We discussed sex and money separately, although to me they seemed related. Some women showed me their nice motorbikes, others their medical pass with the results of their three-monthly medical check-ups. Apparently those women were registered with the authorities as prostitutes although their lives seemed to differ very little from other women's lives. Some women indeed came from neighboring countries; they felt extremely lonely and exhausted from working day and night. Others complained about their lack of means for survival.

With some of the women I became good friends; we exchanged beer, eau de toilette and chicken. At first I was looking for "proof" of their being prostitutes in order to link the revolutionary talks from the leading Front to real human beings. But I realized that the divisions

between sex workers and "non-sex" workers that I'm used to in Europe were not there. You can simply say that many women and girls are involved in a variety of (sexual) services.

It won't be easy for them to organize as prostitutes and host an ICPR meeting, as Thomas Sankara was suggesting. But I left Burkina Faso with the belief that we have sisters and allies in this country.

June, 1988
Brussels, Belgium

"NIGHT LIFE" IN KENYA
Laurel Meredith Hall

In the context of a research project about prostitutes and AIDS education, I visited the Netherlands, Kenya and Sweden during the year 1987-88. While in the Netherlands, I met political prostitutes and prostitutes' rights advocates from the International Committee for Prostitutes' Rights (ICPR) and decided to extend my purpose in Kenya from studying awareness about AIDS and health education for prostitute women to studying also the political situation. The ICPR asked me to interview sex workers about their working conditions and legal position and, if possible, to help build communication between the International Committee and Kenyan prostitutes.

I had many conversations and spent many hours with women working in Nairobi and Mombasa. I will not refer to these women as prostitutes because "prostitute" seems to be an offensive word even to the women who do speak openly about sex work. The women took me to their bars, introduced me to their friends and lined up clients in my presence. Still, even in private, they frequently made a point of telling me that they were not prostitutes, "not whores like some women." One woman threw a drink in the face of a potential client because he called her a prostitute. A number of women, when asked what they did, said that they were studying or planning to start a course soon or going to college. One woman advised me to do the same: "If anyone bothers you, just make something up, just tell them you have to go to school tomorrow."

Prostitution is very common in Kenya but extreme social stigma and shame are attached to it. The government prohibits prostitution and for the most part denies the existence of prostitution in Kenya. However, worldwide the press has blamed prostitutes for the spread of AIDS in Africa, and the few posters about AIDS which have been permitted by the Kenyan government tell people to "avoid prostitutes—or men who go with prostitutes." It is also important to understand that under the current political system there is not "freedom of speech," and meetings of the kind it would take to orga-

nize a discussion or support group for sex workers are strictly forbidden. Consequently, the women are not able to speak for themselves publicly at all. When I asked about the existence of support groups for working women in Nairobi, a health educator said to me, "I can't talk about prostitutes' rights. You see, prostitution is illegal here and so we can't meet even in an informal group. In Europe it's so easy. It's all open. Not here. We could never have meetings here."

∘∘∘

In Nairobi, I visited three spots which were known as "great places to meet prostitutes": The Modern Green, Buffalo Bills and The New Florida (also known as the VD Mushroom). The Modern Green, referred to as a "low-class bar," is near River Road which is a rundown but active part of town. The cheapest hotels and restaurants in all of Nairobi are nearby. Local men, so-called world travellers, and other low-budget tourists frequent the area. A simple drunken sit-down atmosphere prevails. The majority of people in The Modern Green bar are East African men though a few *mzungus*[1] pass through on most evenings.

Buffalo Bills, on the other hand, is referred to as a "high-class bar;" it is also a restaurant. The decor mimics the Wild West with saddles for bar stools, covered wagons around tables, and a county jail. I saw a woman at Buffalo Bills put a drunk man in the jail, shut the door, and walk away pleased. The women at Buffalo Bills are known for being particularly aggressive when approaching their potential clients. The bar is always full and hopping and most of the clients are white or Indian. (Indians are a prosperous commercial class in Kenya.) The bar is attached to a hotel called The Heron Court. After six in the evening when women begin to arrive at the bar, the door connecting the bar to the hotel is bolted shut. A sign at the front desk of the hotel reads: "No prostitutes allowed in the rooms." Any unacceptable woman can be turned away as a prostitute. For example, an ex-patriate man married to a Ugandan woman was called to the desk and told that he was not allowed to have "her" in the hotel room.

The New Florida is a classy disco. Admission is one hundred Ksh for men and fifty Ksh for women. I paid the women's fee; however, all of the women I spoke with there said they always get in free. Later I learned that as a rule *prostitute* women are let into discos free. In The New Florida there were many foreign white businessmen, wealthy black Kenyan men and sometimes Indian men. It is a circular building

which stands on a pillar, hence the "mushroom." There are seats around the sides and a dance floor in the middle. Women dance together or alone for the male audience, their potential clients. Once a man has danced with a woman, he will often spend the rest of the evening dancing with her and then they leave together.

I asked the women I met about police harassment but it was clearly a touchy subject. Some answered abruptly and started talking about something else: "No, it's not usually a problem... unless you're walking on the streets, or something, you know." "In here it's pretty safe." One woman in Mombasa said: "There's no reason for the police to bother us." But the same woman was nervous about walking from one bar to another in the evening because of the police. A woman who is not herself a sex worker but who knows the working women well was less on guard: "Oh yes, sometimes the police will round up a whole group and take them in for the night." She went on to say that the following morning the police drop the women off at the hospital, supposedly for VD testing.

Despite their disgust about what they considered the nasty oral and anal habits of Western men, most of the women I met expressed a preference for white clients or Indian clients. "You want to know how you could make a lot of money—the Indian way. If they can't find a white one, they come to me. I don't know what it is, but they like white skin, yah, really. See, me, I'm kind of, well, I'm chocolate. But if they can't find a white one, they come to me." She continued to explain that she always prefers going with Indian men because they pay the best: "Whatever you ask for they give and they treat you by far the best as well. They'll take you for a nice dinner, take you to their houses, treat you really nice, and they're gentle too. I like that." And further: "I always try to go with an Indian or maybe a white guy... though some white guys, like the American kids, they'll take you out to dinner and think they can do whatever they want, *without* paying you, like dinner was enough or something." Another woman said, "I never go with an African man 'cause he'll be rough, you know. Except the married ones, they're okay. They're just playing naughty on their wives."

I asked several women in Nairobi about men using condoms. They answered, "You just tell 'em. If they don't want to then you don't go with them. It's not worth it." "I would never do it now without a condom. You know, with this new disease—you can die!" A client told me that when he expressed fear of AIDS to a prostitute, she pulled

some condoms out of her purse and said, "We all use them." It is clear that at least some of the women involved in sex work in Kenya are not only aware of AIDS, but are taking precautions to protect themselves and their sex partners against it. This contradicts the response of many other Kenyans I met who frequently referred to AIDS as a trivial matter or a joke—"the American Invention to Discourage Sex." Those who thought it existed often believed that there was a cure available. The awareness of the women I met can probably be attributed to a combination of things from being blamed by the press for the spread of AIDS in Africa to needing to guard their own business and health interests to seeing friends become ill. The admirable work of Elizabeth Ngugi, who works at the Department of Community Health at Nairobi University, to educate prostitute women about the transmission of AIDS and to encourage their use of condoms, should also be credited.

Although none of the women I met spoke directly about their friends having AIDS, I was told that women who "get sick" usually go home to their villages, to their families. Many prostitutes have been disappearing from Nairobi because, according to one health care worker, they are "unable to handle the pressure of the work due to fear of AIDS or they're sick, or they have already died." She suspects the latter. The World Health Organization cites alarmingly high rates of seropositivity for antibodies to the HIV virus among some groups of prostitute women in Kenya.

I also asked women where they came from but they usually didn't want to talk much about their origins. Many came from villages; many from Uganda.

∗∗∗

I went to Mombasa with plans to meet a Kenyan friend, Olivia.[2] Mombasa is known for prostitution and it is often said that every African woman, except for the Muslim women who dress in *buibui*,[3] are automatically considered to be prostitutes. When Olivia arrived, we did the rounds of the bars and discos to search for her friend, Vera. At a certain point Olivia got quite uneasy about walking around: "The police, you know, they'll just pick me up." "Why?" I asked. "Because I'm an African woman and they'll think I'm not Kenyan because I'm too tall, so they'll arrest me both for prostitution and for being illegal. They always think I'm Rwandan. It would be okay if I had my ID but I lost it and they won't believe me." We walked together hoping my (white) presence would secure her from the police.

We found Vera standing in a doorway at the Jambo Club, a high-class bar run by a Northern European. Olivia introduced me and Vera welcomed me with huge smiles and deep laughter while she told Olivia how she'd been. "They told me someone was looking for me, just to wait here, so I stayed, yeah." Olivia told her that I wanted to see the "night life." Vera introduced me right away to a friend of hers, Louise. Louise said: "A ship was supposed to come today but it didn't come—they're fighting in the Gulf. It's really fun when they come, the American boys, the white ones and the black ones too, they're real fun. The whole place will be filled—dancing on the tables and everything. We just like to have fun, you know, it's nothing, just get crazy."

For over a week I spent every evening with Vera and Louise. In Mombasa, like in Nairobi, the women were always in twos. Each day they came by my room in the early evening or sent someone by to tell me where to find them. Vera and Louise frequented three or four clubs, one of which served as a sort of home base. They stopped in there at least once every two days, and most often would stay a large part of the late evening, early morning. When it was time to go home, Vera and Louise would leave with a client or go home alone, depending on how the evening had gone. Even though their work was obvious, they denied being prostitutes. They often referred to their clients as boyfriends, each day speaking about a different boyfriend.

Louise also had a boyfriend whom she lives with on a regular basis. He is a very wealthy Kenyan man who manages a business. She often spoke of his wealth and her access to it. One evening we went to his luxurious apartment; he was out of town for a few days. I heard people refer to men who support women for a long time as "keepers." I was told that, regardless of their "keepers," women usually don't leave their work. They want to remain independent and insure themselves of a good income.

On the coast, there is also a lot of male prostitution, especially north of Mombasa in a city called Lamu. People talked about it all the time. The prostitutes are called "beach boys." I was told that most of them are bisexual but do business mainly with women. Often they marry the women, who are usually giving them lots of money. I met one woman who had just married one of the beach boys.

The women often learn later, if they stay around, that they are a second wife. The women I met seemed independent and their situation seemed typical. Neither the richest nor the poorest women living in Kenya, they worked in the bars, spoke English, and most of

them had some education. During the time I spent with them, I felt a developing trust and rapport and at the same time an enormous barrier of denial and silence. The Kenyan State denies the existence of prostitution and demands the same denial from Kenyan citizens and foreigners residing in Kenya. Even the most open of my official contacts candidly expressed their fear of speaking about prostitution. I was told at one point that I was lucky I hadn't been thrown out of the country because of my interests. It will not be easy to organize publicly with Kenyan prostitutes. Still, getting to know them and to understand the controls and taboos and needs which govern their lives may open a way for international solidarity.

May, 1988
Stockholm, Sweden

Footnotes:
1. *Mzungus* is a Swahili word used when either Swahili or English is spoken to refer to whites or foreigners.

2. Everyone I met, not only prostitutes, were fearful of punishment if they were identified by the Kenyan government as givers of information about prostitution. I have therefore changed all names in this text.

3. *Buibui* is a black piece of clothing which Muslim women in coastal Kenya use to cover their body and head, sometimes referred to as "the veil."

NOTES ON PROSTITUTION IN INDONESIA
Saraswati Sunindyo and Syarifah Sabaroedin

GENERAL INFORMATION FROM JAVA
Saraswati Sunindyo, Jakarta

There are three paragraphs concerning prostitution in Indonesian law which call for prosecution not of prostitutes but of:

> (1) men and women who earn their living from and who consciously make it easier for the occurrence of any act of adultery or prostitution (Article 506); (2) those who are involved in the trading of adolescent women (Article 279); (3) those who act as the sponsor of the prostitutes and those who play an important role in procuring the prostitutes' customers and who profit from it (Article 296).

The laws in practice do target prostitutes. Streetwalkers are often arrested for "making the city unclean." The police can come anytime, put all the streetwalkers in a truck, treat them like a pile of garbage, drive them somewhere and leave them in the middle of nowhere. Sometimes they are taken to court or forced into state-run brothels.

Every local authority has its own regulations to tolerate prostitution in what they call "localization and rehabilitation centers for prostitutes." This is a term for gigantic brothels which are run by the authorities and tolerated by the society. When the police raid streetwalkers their aim is to take them to these localized sites. There is much extortion and the women have to pay a lot. Also the women have to follow the "rehabilitation program" including religious preaching, handicrafts, sewing and sports.[1]

Call girls, hotel prostitutes and other high-class prostitutes' networks seem to be untouched by official regulations or authority. Laws are applied more consistently with them. For example, they do prosecute hotel owners once in awhile and call the women to court only for testimony as witnesses.

The high-class prostitutes tend to hide their work from their

friends; the lower-class prostitutes usually have friends within their own oppressed group. There is a certain degree of toleration for prostitution in Indonesian society. People might talk behind someone's back but her own family will pretend they don't know the nature of her work; they know that she works as a prostitute for economic reasons, also to help out the family.

Health

Though condoms are widely available, most still don't use them. Customers resist because they are uninformed about diseases. The women use condoms only when the customers ask for them. Syphilis is still common among the lowest class prostitutes. They are embarrassed about it and wait until the disease in the last stages to go see a doctor.

The women are not forced to have vaginal exams or blood tests but, worse than that, in the "localization and rehabilitation centers" they are forced to have their body injected with penicillin every week whether they have venereal disease or not. There is no consideration of the hazards of penicillin overdose or the long-term effect of years and years of penicillin. Most doctors I talk to here defend the program.

Pregnancy is still interpreted as one of the hazards of this work. Most women in the centers or "localized sites" do not use any birth control. They use traditional massage or herbal remedies, but then, when they get pregnant they see it as an expected risk. The long-term effects of massage and strong herbal remedies to induce early abortion are still unknown.

Organizing

It is very repressive here but no one protests. Not only prostitutes are not revolting, but no one else either. The way of resisting here is to leave the unbearable place and move somewhere else. There is not yet any prostitutes' organization but I have met some strong women whom I hope could start organizing their friends. There is one so-called prostitutes' co-op which turned out to be run by outsiders and the prostitutes are not involved in any activity except saving their money without interest. They are allowed to deposit savings but not to borrow money.

◦

SETIAWATI

Interview by Saraswati Sunindyo

My name is Setiawati. In Javanese, *Setia* means faithful and *Wati* means woman or feminine woman. . . . I found myself one day living in a brothel, but being able to support myself, earning my own money, buying my own clothes and able to buy some golden jewelry.

I started from a low-down cheap localized prostitution site, licensed by the local government. I thought that was all I could do for myself, not to depend on anybody's pity for money. Then a client took me away. It cost me a lot. I left my golden necklaces [meaning her savings] and all my clothes there. I pretended I was going home to visit my family. This client took me to what he called "a better place for me," a kind of call girl network. Of course it was illegal. He was right that I got paid better. It's about five times what I got in my first place. The clients were much better than those who come to the licensed brothel. The only thing I don't like is that we got no days off. It was in Jogya, a city. . .the first time in my life living in a city like that. I knew nobody.. . . . The moment I found myself living in a brothel, which for me was a lot better than living with my parents or my husband, I thought it meant I had to give up all the people I used to know. I thought that's what a prostitute's life is about. So why would I need a day off anyway? I could save a lot. I got four layers of golden necklaces, bracelets, rings and earrings. I also bought a motorcycle to go shopping. That was my life there. Going out with a client, maybe for thirty minutes or an hour with my motorbike, and work again. Days and nights.

This went on for about two years, until one day when I was crazy in love with one of my regulars. And I got ripped off. He said he needed capital to start a small-scale poultry farm. I gave him a big amount of money. I sold all my golden jewelry. Then I bought four hundred ducks and I don't know how many hundred chickens. . . I had a hope of starting a new life with him as soon as he could earn something from this farm. . . I was really stupid about it. . .a nephew of my boss told me that this guy was getting married with his girlfriend I never knew existed. I lost everything.

Well, this was not the last one. Again there was a guy who showed his pity for my fate. He preached to me telling me to start a new life. He turned out to be a jerk who took. . .again. . .took all my savings. Three hundred thousand rupiahs in cash and my jewelry. I locked my-

self in my room and cried. . . I decided to leave the place. I didn't have anything with me and I didn't work for a week, so they let me go. Nobody said anything. The women were very competitive. They liked it when I left.

Well, I am here now, for almost two years. It's okay, not too many women but great numbers of clients each day. It's not as bad as my first place though this place is also licensed by local government and under the surveillance of the social welfare department. The minimum or the standard charge is ten thousand rupiahs. We have to pay twenty percent of what we get to the PTL (male guest guides). We've got no madame or pimp and we don't have to look for customers ourselves. We had to pay quite a lot when we first got here for the so-called administration. We've got to have a letter from our village head, another letter supposedly from our parents or husband showing that they agree to our work here and another letter from the police department stating that we are not criminals. Everybody knows that we could get all those letters by paying "those guys." Well, anyway, I think it's an okay place, though I've got the feeling that some women are very competitive here too. I'm glad that those who live in the same house with me are nice. We share a lot together.

We are about eighty women here, and there are forty PLTs. It was hard in the beginning. The PTLs really try to show their power. One night they all made a kind of demonstration against me (because) I refused to stay overnight with a client that I don't like. PTLs get at least three times more when a woman stays overnight than when she goes only on a short-term basis. So they were all screaming and calling me names. Yes, I was scared but I didn't regret what I'd done and I know I won't change my attitude. I won't stay overnight with a guy I don't like. The thing about working here is that one has to be strong and know how to balance the situation. I don't like some of those PTLs, but there are some whom I could trust. So that works out well.

I feel a lot better since I came here. I can think more clearly about my own life. I visit my mother once in awhile. . . maybe once a month. I think she knows about my work. I just pretend that she doesn't know. I told her that I am selling batik cloth from Solo in Semarang and Jogya. So I said that as a batik merchant I travel most of the time, therefore I didn't have a permanent address.

I feel sorry for my friends here who would sacrifice everything they had for their boyfriend. I keep telling them that if they want to

find a husband, this is not the place. One would only meet a creep who takes advantage of one's work, or an okay guy who already has a wife. Who would marry a creep or become a second wife? You know, I learned how men took advantage of my earnings. You can see in this place that women wear golden jewelry. I don't wear any. Last year I bought some land in Solo. I work five days a week. The other two days, I go to Solo and buy some hundreds of bricks, some sacks of cement or some other building materials I need. I pay the people who work for me. This house is very important to me. If I didn't do this, I really don't know where I would stay in my old age. No one knows how long I am going to stay in this work. I've got nobody.

PROSTITUTION AMONG WARIAS (TRANSVESTITES AND TRANSSEXUALS), GAYS AND LESBIANS IN JAKARTA
Syarifah Sabaroedin

Prostitution in the big cities of Indonesia can be generally distinguished in different categories: Heterosexual prostitution which takes place as *open prostitution* (in the streets and on location) and as *hidden prostitution* (in hotels, bars, massage parlors and in elite circles where prostitutes are called "entertainment women" or "plot women"); homosexual prostitution which includes lesbians, gays and *warias* (transvestites and transsexuals). *Waria* prostitution appears to be more open than gay and lesbian prostitution. The *warias* who work as prostitutes can be found every night from seven to ten-thirty at specific locations. Gay and lesbian prostitutes, on the other hand, are very hidden and mixed with heterosexual prostitution. Perhaps societal disapproval and condemnation of gays and lesbians explains the careful conduct of those groups. Being myself a feminist lesbian, I have concentrated my article on homosexual prostitution.

Measures towards preventing and abolishing prostitution by the public order system at present are manifested by raids, which are primarily directed at the street prostitutes. These raids have even caused some mortal sacrifices among *warias* who tried to escape the attack of the public order force. On October 25, 1979, the bodies of two "girls," Susi and Iin, were found in the river along S. Parman Street the morning after a police raid. Their ill fate has been experienced by other *warias* too. Siska (pseudonym) together with two of her mates operating in the environment of Pintu Air-Tanggerang [water lock in a town near Jakarta] were forced to jump in the water and found dead.

Working Conditions

Henny (pseudonym) has been operating as a *waria* in the Taman (park) Lawang surroundings for almost five years. She has completed her education at the Foreign Languages Institute in Jakarta and has been working in the field of hairdressing and beauty parlors together with a number of her friends who were also *warias*:

> ...I like men who are fatherly. They are usually prepared to pay big sums for one performance. They may pay ten thousand rupiah. Young men only dare to pay five thousand, even after a lot of bargaining beforehand. However, you'll accept even five or three thousand if you're in a spot. I can't very well go home chewing my fingernails, can I? But I get so furious, when exactly at business time, near the end of the month, while it is pouring rain, ooh...out of the blue the *polandia* (police) attacks...I am gone that minute...no use trying to stick around...not getting any money and getting arrested too, not me!! I won't let myself get caught.
>
> What I like most is white fellows...they are generous...There are also men here who we do not like to serve. If they enter, we just keep quiet...The problem is that they are sadistic and stingy. I have a friend, Lanny, who came back and her lips were swollen, she had a bump on her forehead, on her back were red marks from scratches, and she only got five thousand...(February, 1983).

Lesbian and gay prostitutes have a "luckier" fate than their heterosexual and *waria* colleagues. Their exclusively closed ways of operating make them less liable to be caught by the hands of the law. They choose homosexual places to work like bars, massage parlors, hotels and swimming pools. There are also places where a *germo* (pimp) or *pengelola* (manager) gets forty or forty-five per cent of the fee received by the prostitute. That is called *"memburu* sex" (hunting for sex). *Warias* pay a similar kind of "tax," in their case to those who claim to represent the local public order.

Truli (pseudonym) has a different story. She is a lesbian prostitute:

> I liked women better. There is no risk of getting pregnant, and I still earn money. One performance means five to ten thousand rupiah. But generally I get five thousand...that's reasonable. I need not give my fees to a pimp. We are very free here. We sit,

wait. . .here, and whoever wants to be served by me. . .comes to
me. A moment bargaining, and off we go. We may go to her house
or to a friend's, we have our play there. . .if I make the contact
through a friend (the mediator), it suffices to give her three pack-
ages of cigarettes or an amount of money of that size (March,
1984).

There are also some heterosexual women who prefer women clients in
order to avoid risking pregnancy. There are even a number of married
women who prostitute themselves by consent of their husband:

My husband does not forbid me to do this. After all, he joins in
eating from my money. Besides, I will certainly not get pregnant.
That means that my husband is very pleased. And I, certainly I
will not endlessly be doing this work. . .There will certainly be a
moment that I shall stop. . . . (March, 1984).

Lesbian prostitutes generally stay in a recreation place like a bar
in the Cikini region (a quarter in Jakarta-Central) or in a coffee shop
in Jakarta-South. In those areas, lesbians comprise about twenty per-
cent of all prostitutes; about eighty percent of their customers are
women, in particular lesbian women.

May, 1988
Djakarta, Indonesia
Part III is translated from Indonesian by Cisca Pattipilohy

Footnote:
1. Translator's note: Women in localization centers are officially referred to as WTS,
meaning "women without morals." One example of "rehabilitation": The transport of
two hundred WTS (i.e. prostitutes) on February 8, 1988 from Semarang in Central Java
to Ambon on the Moluccan Islands for the purpose of working in the wood industry.

PRELIMINARY REPORT ON ISRAEL
Esther Eillam

Tel-Aviv and its surroundings contain one-quarter of the Israeli population. Inside its territory, there is a suburban beach called Tel-Baruch where a concentration of prostitutes work. They work mostly inside the cars of their clients. Police patrol the place day and night. Most prostitutes have "their place" on the beach. The area was established about ten years ago under Tel-Aviv Mayor Shlomo Lahat. According to one spokesperson for the municipality, the police encouraged the formation of a working area on the beach as a deterrent to prostitution (and prostitution arrests) in town. Besides the beach, there are many "Massage Parlors" and "Company Services" which are sometimes very luxurious.

There are no statistics available from the government on prostitutes and no department in the Ministry of Labor and Welfare which deals with this population. On a municipal level, specifically Tel-Aviv, a public health official did call for prostitutes to come to the clinic for an AIDS test. She was unwilling, however, to answer my questions and showed no interest in the material I showed to her from the International Committee for Prostitutes' Rights. In fact, no one on a government level seems open to discussing the issue of prostitution or the rights of prostitutes.

On the other hand, there is a long list of detailed laws in the penal section on "Prostitution and Obscenity." In short, these laws outlaw: (1) Anyone who lives on the earnings of a prostitute (and this includes anyone who lives with a prostitute unless he can prove that he does not profit from her earnings); (2) Anyone who asks a woman to have prostitutional relations with another man; (3) Anyone who owns or manages a prostitution work place, including cars and ships; (4)Anyone who rents a place for the purpose of prostitution; (5) Anyone who asks someone to leave the country for the purpose of prostitution; (6) Anyone who allows a twelve to seventeen year old person who is under her or his responsibility to visit or live in a place of prostitution; (7) Anyone who tempts another in a public place, by gestures or talk, to

commit an immoral act; (8)Anyone who turns to a person under sixteen years or to a woman with promiscuous gestures; (9) A man, entering a woman's place dressed like a woman. All of the above are illegal regardless of force or contractual agreement and regardless of adult or child status although penalties are higher for conditions of force and higher for facilitating the prostitution of someone under eighteen years old. Prison sentences for each crime range from three months (for tempting someone to commit an immoral act) to five or seven years (for living on the earnings of a prostitute or for facilitating prostitution; five years when the party is an adult; seven years when the party is under eighteen). There is no probation for the above crimes. Exactly how the police, courts and local authorities apply the laws is an open question. Some members of parliament have been demanding the "legalization" of prostitution for many years. Legalization to them means more control. Clearly, prostitution in certain forms and in certain places is already tolerated.

It has been difficult to get information about prosecution of prostitutes from authorities and I am only beginning to make contact with prostitutes themselves. I have some connections with street prostitutes and massage women, and I hope to broaden the connections and to help connect feminists to prostitutes. This issue has not yet been taken up by feminists or other activists. It takes time and it's difficult in Israel. In the feminist movement we try to act toward peace and to support peace forces.

Tel-Baruch

I spoke with a few prostitutes in the beach area of Tel-Baruch, the "official" prostitution place near the center of Tel-Aviv. The main interviewee is Zippy, as she calls herself. She tells me that it is not her real name. She doesn't want to be publicly identified.

Zippy is willing to talk with me while undressing herself inside her car. While interviewing Zippy, another prostitute is standing with me but is silent. I introduce myself as a reference person for the International Committee for Prostitutes' Rights.

Zippy estimates that about three hundred to four hundred prostitutes work in this area of Tel-Baruch which till now has been a rocky, somewhat neglected beach. She has no complaints about the police; to the contrary, she praises them and is positive about their patrolling the area. She says that the police never arrest the women (or their clients) in Tel-Baruch. But she is very worried about something

else, a very essential thing: The area is being rebuilt by the municipality which means that prostitutes will not be able to work there anymore. Although the work conditions in the area are not satisfying at all—"We are freezing in winter and burnt from heat in summer"—now it will be worse. Prostitutes will be forced to return to the middle of town "among children" and will be arrested regularly by the police and held for forty-eight hours. "We are thrown to the dogs!" says Zippy. "Most of the women here are mothers, like myself, and they have to work," she points out. Outside the area, she doesn't tell what she is doing: "When officials ask my occupation, I say I am a housewife." But she wants to be recognized and to work in a house with official status and to pay taxes "like any decent worker." She has no roof over her head now as a worker.

About AIDS, Zippy says that of course everyone is worried. She and the other women work only with condoms, also for fellatio. When the Health Department of the municipality demanded that every prostitute have an AIDS test, the majority were willing to do it and cooperated. "They themselves were interested," said Zippy. She accuses the journalists of frightening the public which affects the clients who don't show up like they used to. "They have to be afraid of the amateurs, not us, the professionals [who use condoms]," she says.

Zippy is hesitant about organizing. She is afraid of a lack of cooperation, which is her experience till now, and she is afraid of being exposed, given her way of life. While talking, Zippy whistles to a passing car. "A regular client of mine," she explains, but he doesn't hear her. At the end of the interview another client (or the same one) comes by. Zippy is dressed suitably now and she hurries up to the car, waving her hand to me: "Excuse me, I must leave, see you."

I stay with the other woman who was silent most of the time. A car with young men is stopping in front of us and they ask us for a "sucking." The woman near me refuses. When they persist, she throws a stone at them and they go away. She says to me, "I have my own regular clients. I don't go with young men." She also says that it's a common practice to give discounts to soldiers. Unlike Zippy, who has a lot of friends, she does not want to make any friends here. "Everyone for herself," she says. I give her my phone number and ask her to pass it to Zippy too. I leave.

Fifty meters on I see Zippy and Dalia and Esther. I had met Dalia and Esther earlier in the afternoon but they had no time to talk then. I ask Esther about organizing. She thinks it's necessary, especially now,

facing the crisis of leaving this place to "god-knows-where." But she says that it is very difficult. I encourage her and promise to keep contact.

Later I went to town. In Tel-Baruch there is a safe and relatively free atmosphere. In town, however, I was impressed with the fear and violence. Near Ben-Yehuda Street in the center of town, I met Edna. While we were talking, I was witness to the harassment of a prostitute by her "ex-husband." When I tried to help her, Edna said not to get involved. Edna told me that she is afraid of the police who make arrests from time to time, sometimes arbitrarily and sometimes because of citizen complaints. When prostitutes are arrested, they are automatically held for forty-eight hours and then let out on bail. Later there is a trial: If the prostitute has no previous arrests, she is fined; if she has a record of prior arrests, she is sentenced to jail for some weeks or even months. Edna told me that the police sometime arrest clients, but only to get information. After the client's testimony, he is set free.

April, 1988
Tel Aviv, Israel
Translated from Hebrew

MEETING IN MADRID
Susanna

The city of Madrid organized a conference on prostitution in April, 1987. Although the topic was prostitution in Spain, invitations were sent to the ICPR, the GRAEL (Rainbow Group of the European Parliament) and prostitute groups from Italy and France. Only the last day of the four day conference included prostitutes as speakers. After their presentations, we held a meeting to discuss the possibilities of a Spanish association of prostitutes. About six street prostitutes enthusiastically founded the *Frente Unitario de Prostitutas* (United Front of Prostitutes). One year later, there has not yet been a follow-up to that eager beginning except for the contact between one prostitute, Susanna, and the ICPR. Susanna hopes to attend the next World Whores' Congress. And Pia Covre (Italian Committee for the Civil Rights of Prostitutes) is learning better Spanish in the hope of organizing together with her Spanish sisters. Pia Covre, Paola Tabet (Italian researcher and ICPR supporter) and I interviewed Susanna one afternoon about the concerns of prostitutes in Madrid. Thanks to Paola's fluency in Spanish, Italian and English, we were able to hold and transcribe our conversation.

G.P.

Pia: How's the situation in Spain? What's the biggest problem for prostitutes? In Italy, it's the police because the Italian Police Law can land you in jail.
Susanna: Here also for Spanish prostitutes the main problem is the police. And, there's no solidarity among prostitutes, there's not enough unity. The biggest fear is the police. When the police car comes, you'd better move on. Otherwise they stop you, they take your papers, they take you to the police station, and they keep you for a couple of hours. Or they just check your papers on the street, they don't care that people are passing, that kids are passing, it makes no difference to them.
Pia: In Italy, the police don't ask only for your papers. Italian law can dish out punishments, you have to get a lawyer, you have to go to

court, it's a serious thing. What happens here after they take your papers?

Susanna: They used to take us to the station and register us. . . if they got you in the morning they kept you. At six in the morning the next day they took you to the security police, registered you, and gave you a fine. If you didn't pay the fine, you went to court. There, if you got a judge who's a little kind, he let you go; otherwise. . . . There have been a lot of women in jail for prostitution. That stopped a year ago.

Pia: And now?

Susanna: Now they ask for your papers, they check you out, if you don't have any charges against you, well, they let you go. Otherwise, they take you to the police station for two or three hours.

Pia: Do the police stop the prostitute's man, her boyfriend?

Susanna: The police, especially in the area where I work, know a lot of *chulos* (pimps) and leave them alone. They know that half the women have a pimp but they don't pay any attention, they act as if pimps didn't exist.

Pia: When they do pay attention, what do they do? Do they put them in jail?

Susanna: They know they're pimps but they can't prove it. If the woman who lives with the guy turns him in, then they could put him in jail. But in Madrid, mostly what they prosecute is *prossenetismo* (facilitation of prostitution). . .

Pia: That is the room renters, the people who solicit clients. . .?

Susanna: Yes.

Pia: We in Italy don't have separate legal categories for *chulos* and *prossenetas*. But, the *prosseneta*, if he rents you a room or brings you a client, is giving a service to the prostitute, isn't he?

Susanna: Right, but here, the *prosseneta* and the *chulo* are considered the same because they both live off the whore.

Paola: Is that what the police think or what the prostitutes think?

Susanna: In my whole working life I never saw a prostitute denounce either the *chulo* or the man who lives with her or the *prosseneta*. I never saw a denunciation.

Paola: But what do the women think? They don't denounce them, that's for sure, but in their minds. . .?

Susanna: They wouldn't think of denouncing. Because they think that if they turn him in, *he* might go to jail but then send someone else to beat them up or kill them or anything. They're terribly afraid.

Gail: And what about drugs?

Pia: Aren't addicts a majority on the street?

Susanna: Yes, on the streets there are more addicts than non-addicts, they're the majority. There are many more addicts on the street than in the clubs. Five years ago when I started working, there weren't as many drugs as now on the streets. Now drugs are sold right on the street, they pass, they sell you pills, heroin, they sell everything...

Pia: On the legal level, what is your first demand to the government? Abolition of police laws?

Susanna: I think the first thing is to get rid of the Law of Social Danger (*Peligrosidad Social:* a law imposed in 1970 which allows the state to prosecute anyone for "being in a situation likely to lead to the commission of a crime"). Then make an agreement with the police that if they want to clean the streets of drugs, of addiction, they shouldn't involve the prostitute who makes a profession of her work. They should assist the addicts but not confuse drug addicts with professionals. The police shouldn't think, as many do, that the professional prostitute is an addict.

Pia: Right, basically the drug addicts have to be helped out of the drug circle and into the larger social context. As the addicts at the conference (on prostitution in Madrid) were saying, there's no help to get off drugs.

Gail: About what percentage of prostitutes work on the street and how many work in the clubs or bars?

Susanna: In Madrid we are so so many...many more on the streets than in the clubs or in the Baras Americanas...

Gail: What age are the women who work on the streets?

Susanna: On the streets there are girls of fifteen, sixteen years, seventeen, twenty, and many other ages. The absolute majority of young people that prostitute themselves do it for drugs. You can find girls of seventeen, twenty who are not addicts but the majority are there because of drugs.

Paola: And the others?

Susanna: The others have come from the villages or live with a guy who put them to work...they're afraid of leaving the man because, you can say what you want, they're afraid of his threats, that he could do anything.

Gail: And the age of women working in clubs and bars?

Susanna: Look, in the bars you have women of all ages, young women and also women of thirty, forty, it's very mixed.

Paola: And older women?

Susanna: When they can't work anymore in the clubs they go to the street if they don't have any other way of earning. If they're luckier and have sons and daughters, they can go to their children. They don't earn but at least they have something to eat...the children take them in.

Paola: And those who work even when they're old, those who have nobody, what work do they do?

Susanna: When they can't work anymore in prostitution, they start begging, they go in the metro station, they sleep in public houses for the poor, and they eat on charity. [One of the first demands of the prostitutes in discussing their new organization was a shelter for old prostitutes, one with no rules and no restrictions.]

Pia: When you work, do you work in a car or...?

Susanna: I don't work in a car but there's an area here where one works in cars and also in rooms.

Gail: Can you tell us some details about how you work, where do you and other street prostitutes go with the clients?

Susanna: We, *callejeras* (streetwalkers), we work in pensions. We ask the client for the money, 1500 pesetas plus the room or 2000 pesetas plus the room. There are women who work for only 1000 plus the room. We go upstairs with the client, he pays the money that we've agreed on, we pay 300 to the owner of the pension or to the manager, we go in the room, close the door, we work, and we go out. That's the way it goes each time.

Paola: Aren't there prostitutes who rent an apartment to work so as not to pay for every client?

Susanna: Yes, there are women who rent an apartment in a group of two or three. They put aside some money every day for the rent of the apartment...or for a room.

Paola: Do the police intervene if three or four women work together in the same apartment? Are there any problems?

Susanna: In private apartments, no, there aren't any problems. If the neighbors don't denounce you, there's no problem. Here, as we are in a prostitution area, you can have problems or not. When there's a pension in this area with people coming in and out, the neighbors might turn you in if there's too much traffic.

Paola: Is the rent low or is it very high for prostitutes?

Susanna: Very very high. In the same area, it would be half the price if they weren't prostitutes.

Pia: Why are they paying so much? When you make the contract, do

you have to say it's for prostitution? Are you already known in the area?

Susanna: When we want to rent an apartment or room, the first thing they ask us for is a work contract. We never say we work in prostitution. If we say that we don't work or that we work independently, then the proprietor asks for someone to vouch for us, someone who works and will be responsible for the rent. In the prostitution district, they know we're prostitutes and so they ask higher prices.

Gail: What is the condom situation?

Pia: Which clients are more likely to use condoms, clients on the street, in the clubs, in the bars?

Susanna: Look, the clients don't like condoms. If you want to use one, they think you're sick, that you've got some venereal disease. There are some that have them themselves or ask you to put it on them. Lately, be they friends or clients, whatever, I make them all put on condoms.

Paola: You use them, but what about other prostitutes?

Susanna: The others don't because they're afraid of losing business.

Paola: Are there differences in the use of condoms between streetwalkers and women working in clubs?

Susanna: No.

Paola: So there are very few who use condoms.

Susanna: There are few because clients here, when you tell them to use a condom, they think the worst, they think you're sick. Still, there are a few who make men use condoms anyway.

Pia: But now everybody is talking about AIDS. Aren't prostitutes talking about AIDS, aren't they worried?

Susanna: Yes, we speak about it but because the clients aren't mentally conditioned to use condoms, there are many who don't want it.

Pia: I know that, but in Italy we're speaking a lot among ourselves about AIDS. Among prostitutes, we speak about clients. We tell each other which clients will use condoms, which won't . . . and we talk to our clients. What about you?

Susanna: Yes, we speak but, I tell you, as many live with men, and they have to give all they earn to the *chulo*, they're afraid that if they ask the client to use a condom and he doesn't want it, they'll lose money . . . and they're afraid that the *chulo* will beat them or something.

Pia: So the *chulo* doesn't care if the whore gets sick?

Susanna: No, he doesn't care, all he cares about is the money. There

are some *chulos* who have four or five women working for them; for them it makes no difference if the clients put on condoms or not...they want the money.

Pia: But why are these women working for the *chulos?* If he's her man, if she's in love...but a *chulo* who has three or four women, why the hell are they working for him?

Susanna: Look, this I have never understood and I think I'll die without ever understanding it. I don't understand.

Paola: Is it because they're afraid?

Susanna: Yes, women stay with them because of fear, not because they love them or anything else.

Gail: Are they afraid to organize?

Paola: You were telling me before that *chulos* don't like the idea of prostitutes organizing, especially for social security.

Susanna: I think *chulos* think that if we have social security and we have to pay for instance six or seven thousand pesetas per month, that will be less money for them. There are many women with *chulos* who have children, two or three children or four, and when they get into the social security system, they'll have to pay even more and that'll be less money for *chulos*. So, they're against it.

Paola: Have you heard *chulos* talking or this is something you think will happen?

Susanna: I think that when we start to fight, that's what will happen. Today I was speaking with the husband of one of my friends and I told him that what will come out of the prostitution meeting is surely social security...and he gave me a dirty look.

Pia: But if the *chulos* aren't interested in women being protected against AIDS and having social security, isn't it because they can easily get other women? If one woman is sick, they can find another...

Paola: Where do these women come from?

Susanna: Look, when the women they had put to work are of no use to them anymore, they go to the discotheques, to the young women, and they start "eating their minds"...and then they put them to work.

Pia: Is it easier for the pimps to exploit foreigners, since there are so many of them, than the Spanish women?

Susanna: I don't know, but there are more Portuguese or foreigners that put women to work than Spanish.

Pia: Do the pimps pay off the police?

Susanna: The pimps that have good relations with the police are mostly those that give them information.

Paola: Okay, for the pimps, but as to the women who get exploited. . .

Susanna: Many, many foreigners. Here in Madrid you have Portuguese, Africans, Columbians, Canarians, you have many. . .

Paola: And replacement is easy. . .

Susanna: Yes, for them it's easy, it's like they're brainwashing them, they make it look so good: "You'll have this, you'll have that." They might do this for a month or more until they've totally "eaten their minds". . .and then they put them to work.

Paola: Is it only psychological brainwashing, or is it also drugs?

Susanna: Also drugs, both things.

Gail: Susanna, would you like to say something about your own experience?

Susanna: Look, when I started to work on the street I had only my first child. And at that time I thought, if I have to have a guy who eats what belongs to my child, I don't want anybody with me. My child was small and I thought, I can feed two but not more. I already had to pay the boarding school for my kid and so on. Then I was living with a South American. . .he didn't take even a *duro* (five pesetas) from me. I came to work in the morning, he came to fetch me at noon. If I didn't go to work and if I needed money or anything, he gave it to me and didn't expect me to work. If I'm living with a man. . .just as I'm earning my living, so should he earn his. This has always been my way of thinking. Many guys have come and tried to sweet talk me but this has always been my thinking and I don't think that they will ever make me change it.

April, 1987
Madrid, Spain

"WOMEN OF THE LIFE, WE MUST SPEAK"
Gabriela Silva Leite

I was a prostitute in Sao Paulo, Brazil. I was working in the prostitution zone which is very big there. It was 1981, a time of heavy police repression. Two colleagues had been killed. I thought of organizing a big demonstration against police violence. So I went to all the houses of prostitution and we held this demonstration, throughout the city. We denounced tortures and such things. And, from that point on I started thinking of an organization. I thought it would be a good idea if we could organize ourselves as a movement and deal with the fundamental questions concerning prostitutes. As Brazil is very big, I started travelling all around the country. I travelled in the Northern States, in the Northeast, in Gerais and so on . . . working as a prostitute. And I talked about our problems. I worked and I talked.

When I arrived in Rio de Janeiro, I was invited to participate in a conference of women from the *favelas* [slums] and suburbs. And there I spoke in public as a prostitute for the first time. After that I was very much in demand by the press. Then I thought it would be very important for us to have a national meeting and to hold it in Rio de Janeiro because of the press. So I started systematic organizing work, travelling all around.

It is not by chance that I was the first person to speak out publicly. I am an exception in prostitution because I come from the middle class. I was at the university up to my third year in the department of sociology. I participated in the sexual revolution of the sixties, I was quite lost in life and I got into prostitution. I was twenty-five years old then. That also is an exception because the great majority of my colleagues start to work in prostitution at twelve or thirteen. I could speak out publicly because I had an education. It is now a year and a half since I stopped working as a prostitute and I am working in our "National Network of Prostitutes" (*Rede Nacional de Prostitutas*). I travel, I am working on a health project. We get a certain support from European institutions, also for building our medical center.

There are three major types of prostitutes in Brazil. Poor women work in the low prostitution, on the street, which I know very well because I worked as a low prostitute. This type has the biggest number of women. Then there is the middle prostitution which is the prostitution of nightclubs, whose main attraction is the mulatto women. That has the most publicity, it is the prostitution for tourists. It is from this type of prostitution that women go into the international traffic. And then there is the high prostitution which includes the massage parlors and newspaper advertisements. That's the prostitution we don't trust because a big part of it is controlled by the Brazilian mafia, the mafia which also controls the drug traffic. We are now working with the prostitutes of the low prostitution, to begin with, the street prostitution and zone prostitution. In this type of prostitution there are also a lot of transvestites and in our organization now, little by little, we have some transvestites.

Our first national meeting was in July, 1987. Fifteen states of Brazil were represented by about seventy prostitutes. We didn't have more because we couldn't pay for everybody's trip since the distances are great and the fares are very expensive. This first meeting was to define our needs. We discussed the following subjects: education, health, police violence and sexuality.

Education

The topic of education is very important for prostitutes because here in Brazil the great majority of prostitutes are illiterate. They are girls who come from the North and Northeast and they never went to school. Many of them really would like to learn because they want to have access to information. Prostitutes are very isolated. They are heavily discriminated against. We are in a society which is patriarchal and as a consequence a prostitute is sought after but at the same time ghettoized. There is a big problem for their children too because the school discriminates against them. Here in a big city, like Rio de Janeiro, this is not a problem because you can be hidden; but in small cities, in provincial cities or towns, it is a very serious problem. Most of the children of prostitutes have no schooling; they are excluded from school. We are working on this now; we stay with the children for six months and then we present them to the public school.

Health

The issue of health is very serious. For the poor population, even for non-prostitutes, health is an enormous problem. Only two percent of the federal budget is for health. That's nothing. The public hospitals are horrible, hospital infections are terrible, public health services and day care are terrible, you have to wait two months for a medical visit. If health care is already so terrible for poor people in general, you can imagine what it is for prostitutes... because the prostitute is not considered a citizen. She doesn't even get social security. There is no public effort to prevent venereal disease. Nothing. There are a great number of clandestine abortions among prostitutes and then they go to the public hospitals in the worst condition and they are abused.

We are organizing for health, we are working on this in the prostitution zone here in Rio and we are going to the other states. We are doing all this work because, can you imagine, here in the zone women are accustomed to using antibiotics as condoms. Instead of using condoms for prevention, they take penicillin and antibiotics the whole week and are totally weakened. And then they easily catch tuberculosis; there are still a lot of cases of tuberculosis here, and they catch hepatitis and all these things. The health situation of prostitutes is very deteriorated.

There is a big drive to use condoms. But there are two problems: Condoms in Brazil are very expensive and sometimes men don't want to use them. Sometimes the women end up not using condoms when they have to pay their rent or things like that. But women are doing everything possible to use the condom and to educate the men so that they will use them.

We have some cases of addicted prostitutes but addiction is not as serious a problem as this general problem of health. We know from American research that a lot of the prostitutes who have tested positive (on the AIDS antibodies test) are IV drug-users; so the drug cases are reason for concern. And in Brazil there isn't any politics for drugs.

There's no education about AIDS. Here in Rio de Janeiro, in the zone, we haven't had any cases of AIDS. The problem is very complicated because the government gives no incentive for scientific research. It's difficult to get tested. There isn't even testing of blood. In Brazil, any person who has an accident on the road and has to go to the hospital and needs a blood transfusion has a high chance of getting contaminated blood. In this country, nothing is being done about

AIDS, a politics of AIDS does not exist. But the propaganda on television is putting the blame on prostitutes and transvestites. Right now we are trying to answer an article written by a feminist, Marta Supplici. She is from the Labor Party in Sao Paulo. The title of her article is "AIDS Contaminated People" and she writes, ". . . Prostitutes don't have any means of income other than their own contaminated bodies. . ." This progressive feminist puts the blame on prostitutes. . . we are writing an article in response.

Penal Code

Prostitution is a police matter in Brazil. We are in the framework of the penal code. To be a prostitute is not a crime, there is no law preventing the women from selling sex. What is a crime is the exploitation of prostitution, pimping and everything that has to do with exploitation. But what actually happens is that when the police go to get somebody, they don't get the exploiters, they get the prostitute. And since there is not a law against prostitution, they charge her with vagrancy or with indecent behavior, unless she has money and can buy her freedom. There is a lot of police corruption. Police violence is the most serious problem prostitutes face in this country, especially in the smaller towns where prostitutes have even been killed. In the big cities, the women of the street are totally without protection. The police seize her and take all the money she has; if she has no money, they take her to the police station and all the men at the station have intercourse with her. She has to clean the police station, she has to clean the toilets and everything. A few days ago a woman was found tied to a tree in the garden behind a police station. She was left there naked. A journalist, a photographer, took a picture of her and published it on the first page of the newspaper.

Very little reaches the courts. And when it does get to the courts, it takes years before there's a decision.

Pimps

We of the low prostitution don't have pimps any more because life here is very hard and inflation is very high. As a consequence women don't earn enough money to keep supporting a man. What you find at most is a man who is as poor as she is, who is just a pimp for food to eat. Before, around ten years ago, there used to be professional pimps, but you don't see that anymore, not even in the zone. So the partners

of prostitutes are marginals just like them, thieves and such people who live like that, from day to day.

Migration

The migration pattern of transvestites is very different from that of women prostitutes. A few years ago it was the fashion for transvestites to go to Europe to get the operation, to put in silicone, etc. Transvestites always travelled with their own money, they had their own money to go and come back. There was a lot of coming and going. But the situation for women prostitutes is very different, it is a serious problem. It is part of the international traffic. Very few migrate independently. I don't think I'm mistaken that most of those prostitutes went to Europe through the international traffic. If you notice, the great majority of Brazilian women who are there in Europe are not white, they are mostly mulattos. Mulattos are propagandized as the Brazilian national product, also in pornography. Through the international traffic, they get there and all their papers are taken away and they don't even have the possibility to get out anymore. They stay illegally in the country. We haven't yet worked on this problem. It is a very important issue for us.

Pornography

Pornography is very big in Brazil. There's a complete contradiction between the treatment of prostitutes and the tolerance of the porn industry. In Sao Paulo there is a district where there are a lot of producers of porn movies. These producers earn a lot of money and they are the only producers who earn money in the Brazilian film industry. There are a lot of porn movies and porn theaters. The people who work in these movies are for the most part prostitutes who have contracts. There are also a lot of publications, magazines, about twenty monthly magazines sold at the newspaper stands. The Brazilian *Playboy* sells the most copies, about 800,000 per issue. There are also little books showing explicit sex images.

Human Rights

Human rights are not considered very important in Brazil. All human rights of prostitutes are violated, especially for prostitutes of low prostitution: the right to health, the right to education . . . protection from police violence. And, the first human right prostitutes don't have

is that of being considered a citizen. The prostitute does not have any rights, even to the precarious health system because she is not considered a citizen. Also a prostitute's family has no rights to health care, unless she is with a man who has a profession and puts her down as a dependent or unless she manages to get a certificate or proof of another profession.

National Network of Prostitutes

We cannot legally register our association because we would be considered exploiters of prostitution. Everything is considered exploitation. So right now we are constituting local groups of prostitutes. We exist in reality but not in law. Even to speak about prostitution is considered exploitation. If I were a teacher and I was giving a lecture or a class to a prostitute, I would be considered an exploiter.

Brazil is in the process of making a new constitution and after that comes the reform of ordinary laws. We want to have a project ready and to be able to register our association and to change the laws on prostitution. We are making a survey of all the jurisprudence on prostitution. We need the help of the International Committee to know the laws in other countries.

The name of our organization is *Rede Nacional de Prostitutas* but we want to choose a nicer name so we are having a competition in the prostitution zone. Our slogan is *Mulheres da vida e preciso falar* which is a pun meaning both "Women of The Life, We Must Speak" and "Women, We Must Speak About The Life."

July, 1988
Rio de Janeiro, Brazil
translation from Portuguese by Germaine Mandelsaft

Telephone interview from Paris by Paola Tabet and Germaine Mandelsaft; the editor had sent a list of questions in advance to Gabriela Silva Leite.

Resources

ICPR, International Committee for
Prostitutes' Rights
Postbus 725
1000 AS Amsterdam
Netherlands
Phone (Netherlands): 31-20-
168597/594
Phone (France): 33-67-966483

Co-Directors:
Margo St. James
Gail Pheterson

Regional Coordinators:

WEST EUROPE:

Centre de Documentation
International sur la Prostitution
Grisélidis Réal
24, Rue de Neuchatel
CH – 1201 Geneva
Switzerland
41-22-328276

Comitato Per I Diritti Civili Delle
Prostitute
Pia Covre and Carla Corso
Caselle Postale 67
33170 Pordenone
Italy
39-434-625940

Rode Draad
Postbus 16422
1001 RM Amsterdam
Netherlands
31-20-243366

Hydra
Kantstrasse, 54
D – 1000 Berlin 12
Germany
49-303-3128061

PLAN, Prostitution Laws Are
Nonsense
Helen Buckingham
Eva
42, Thornhillsquare
London N1
England

NORTH AMERICA

COYOTE: National Task Force on
Prostitution
Gloria Lockett
Priscilla Alexander
Box 6297
San Francisco, California 94101-
6297
United States
1-415-558-0450

CORP, Canadian Organization for
the Rights of Prostitutes
Valerie Scott
Danny Cockerline
P.O. Box 1143
Station F
Toronto, Ontario
Canada M4Y 2T8
1-416-964-0150

ASIA

Women's Information Center
Orapan Boonrak SAI
P.O. Box 7-47
Bangkoknoi 10700
Thailand
66-2-4335149

Gabriela National
Adul De Lean
Rm. 204, Estuan Bldg.
41 Timog, Quezon City
Philippines
63-2-985140, ext. 218

AUSTRALIA

Australian Prostitutes Collective
P.O. Box 470
Kings Cross 2011
Sydney NSW
Australia
61-2-357-1300

LATIN AMERICA

Gabriela Silva Leite
National Network of Prostitutes
ISER
Largo do Machado 21 – Co
Rio de Janeiro 22211
Brazil
55-21-205-4796

MIGRANT PROSTITUTES
COORDINATOR

Lin Lap
Postbus 9769

3506 GT Utrecht
Netherlands
31-30-620221

GAY PROSTITUTES
COORDINATOR

Danny Cockerline
c/o CORP
P.O. Box 1143
Station F
Toronto, Ontario
Canada M4Y 2T8
1-416-964-0150

HEALTH COORDINATOR

Marjo Meijer
Postbus 2246
1000 CE Amsterdam
Netherlands
31-20-274180